Patronage in the Renaissance

PATRONAGE IN
THE RENAISSANCE

Edited by
Guy Fitch Lytle and
Stephen Orgel

PRINCETON UNIVERSITY PRESS
PRINCETON, NEW JERSEY

Copyright © 1981 by Princeton University Press
Published by Princeton University Press, 41 William St.,
Princeton, New Jersey
In the United Kingdom: Princeton University Press, Guildford, Surrey

All Rights Reserved
Library of Congress Cataloging in Publication Data will be
found on the last printed page of this book

This book has been composed in Linotron Sabon

Clothbound editions of Princeton University Press books
are printed on acid-free paper, and binding materials are
chosen for strength and durability

Printed in the United States of America by
Princeton University Press, Princeton, New Jersey

CONTENTS

v

Contents

The Visual Arts

LIST OF ILLUSTRATIONS

List of Illustrations

List of Illustrations

PREFACE

This volume had its origin in the Folger Institute symposium *Patronage in the Renaissance*, organized by Guy Lytle and held at the Folger Shakespeare Library in May 1977. The topic is one that has been of increasing importance in Renaissance studies, initially for historians of the arts, but more recently for political, social, and cultural historians as well. Patronage, it has become clear, was a complex system functioning not merely on the surface of society to provide luxuries, but as an essential and inevitable element in Renaissance culture.

Eight of the fourteen essays in this volume—those by Professors Gundersheimer, Harding, Peck, Lytle, Orgel, and Janson, and by Drs. Hope and Lewis—derive from papers delivered at the symposium. The remaining six have been contributed by scholars whose work in the field has seemed to the editors particularly original or challenging, and touching on areas not discussed by the original participants.

We have not attempted to achieve geographical coverage here. We have been more concerned with illustrating the broad range of methodologies employed by the most interesting recent work on patronage, and in pointing out directions and interrelationships. Werner Gundersheimer's essay provides a general theoretical introduction to the subject as a whole, and the more specific articles address themselves not so much to particular areas and situations as to particular kinds of questions and problems. Most of our contributors are concerned with aspects of patronage in Renaissance England. In part this reflects the interests of the sponsoring institution, the Folger Institute, but it also indicates an area in which especially fruitful work is currently being done. The concentration on England seemed to us to represent less a bias than a promising test case. Thus, our three pure art historians deal with Italian subjects; but read in the context of the more broadly conceived essays of Professors Kipling and Smuts, they reveal vividly to what extent and in what ways the Italian situation provided the norms for those other societies which came to the Renaissance later. Taken as a whole, the volume exemplifies the genuinely interdisciplinary, indeed unitary, nature of the topic, the centrality of the patronage

xi

system to Renaissance culture, even when (as Professors Marotti and van Dorsten show) it failed to operate effectively. Artistic patronage is thus an aspect of political patronage, and concepts like flattery and corruption must be continually reassessed in the light of the real aims of the system.

Perhaps a word should be said about our use of the term *Renaissance* in our title. It is admittedly a convenience, covering more than a strictly historical construction would allow. To call the court of Charles I a Renaissance court is, no doubt, to weaken the term almost fatally as a useful description. At the same time, it does indicate the extent to which England, and the northern countries generally, were still deeply imbued with Renaissance ideals, even in the early seventeenth century; and the very latitude of our subject seemed to justify some expansion of our vocabulary.

<div align="right">S.O.</div>

CONTRIBUTORS

DAVID M. BERGERON, Professor of English at the University of Kansas, is the author of *English Civic Pageantry 1558-1642* (London, 1971) and *Shakespeare: A Study and Research Guide* (New York, 1975). He is a member of the *Shakespeare Quarterly* Editorial Board and is Editor of *Research Opportunities in Renaissance Drama*.

WERNER L. GUNDERSHEIMER is Professor of History at the University of Pennsylvania and Director of its Center for Italian Studies. He has written *Ferrara: The Style of a Renaissance Despotism* (Princeton, 1973) and other works on Italy and France in the Renaissance.

ROBERT HARDING is Associate Professor of History at Yale University. He is the author of *Anatomy of a Power Elite: The Provincial Governors of Early Modern France* (New Haven and London, 1978) and various articles.

CHARLES HOPE is a Lecturer in Renaissance Studies at the Warburg Institute, University of London. He is the author of *Titian* (London, 1980).

H. W. JANSON is Professor Emeritus of Fine Arts at New York University. He is the author of *The Sculpture of Donatello* (Princeton, 1957), *Apes and Ape Lore in the Middle Ages and the Renaissance* (London, 1952), and *History of Art* (New York, 1962; 2nd revised edition, 1979). He has been series editor of *Sources and Documents in the History of Art* and *Artists in Perspective* (both Englewood Cliffs, N. J.).

GORDON KIPLING, Professor of English at the University of California, Los Angeles, has written widely on ceremonial forms in Tudor culture and on the Burgundian backgrounds of the English Renaissance. He is the author of *The Triumph of Honour* (Leiden, 1977).

DOUGLAS LEWIS is Curator of Sculpture at the National Gallery of Art in Washington and a Visiting Professor at Georgetown University. He has written *The Late Baroque Churches of Venice* (New York, 1979), *The Villa Cornaro at Piombino* (Vicenza and University Park, Pa., 1981), and *The Drawings of Andrea Palladio* (Washington, D. C., 1981).

GUY FITCH LYTLE teaches history at the University of Texas at Austin. He is the author of numerous articles on medieval and Reformation universities and the editor of *Reform and Authority in the Medieval and Reformation Church* (Washington, D. C., 1981).

ARTHUR F. MAROTTI is Associate Professor of English at Wayne State University. He has written essays on psychoanalytic criticism and on such

Contributors

English Renaissance poets and dramatists as Edmund Spenser, Ben Jonson, Thomas Middleton, and John Donne.

STEPHEN ORGEL, Professor of English at the Johns Hopkins University, is the author of *The Jonsonian Masque* (Cambridge, Mass., 1965), *The Illusion of Power* (Berkeley, 1975), and, in collaboration with Roy Strong, *Inigo Jones* (Berkeley, 1973). He has edited Ben Jonson's *Complete Masques* (New Haven, 1969) and Christopher Marlowe's *Complete Poems and Translations* (Harmondsworth, 1971). He is the Senior Editor of *English Literary History*.

LINDA LEVY PECK teaches history at Purdue University and is the author of several articles on patronage and administration in seventeenth- and eighteenth-century England. Her book *Northampton: Patronage and Policy at the Court of James I* will be published in 1982.

MALCOLM SMUTS is Assistant Professor of History at the University of Massachusetts at Boston and the author of an article, "The Puritan Followers of Henrietta Maria in the 1630s," in the *English Historical Review*, 1978.

LEONARD TENNENHOUSE is Associate Professor of English at Wayne State University, where he is the Editor of *Criticism*. He has published articles on Renaissance and Medieval literature, and he has also edited *The Practice of Psychoanalytic Criticism* (Detroit, 1976).

JAN VAN DORSTEN is Professor of English Literature at the University of Leiden, The Netherlands. His publications include *Poets, Patrons, and Professors* (Leiden and London, 1962), *The Radical Arts* (Leiden and London, 1970), and the edition of Sidney's *A Defence of Poetry* in *Miscellaneous Prose of Sir Philip Sidney* (Oxford, 1973).

PART I

⬚

Introduction

ONE

Patronage in the Renaissance: An Exploratory Approach[1]

WERNER L. GUNDERSHEIMER

PATRONAGE, broadly defined as "the action of a patron in supporting, encouraging, or countenancing a person, institution, work, art, etc.," has been clearly established as one of the dominant social processes of pre-industrial Europe.[2] It is virtually a permanent structural characteristic of all early European material high culture, based as it is on production by specialists. The effects of patronage are also pervasive in such diverse areas as appointments to secular and religious offices; the conception and creation of the structures and spaces within which people work, pray, and live; the execution of the artifacts of material and intellectual culture; the systems of transactions into which the behavior of social groups—families, clans, guilds, classes (whether economic, social, occupational, or sexual)—is organized, and through which the re-

[1] Earlier versions of this paper were presented to the History Workshop of the University of Pennsylvania and to the Departments of History and History of Art at the Hebrew University, Jerusalem. I am grateful to participants in those sessions for many useful observations, and I would cite in particular the observations of Yehoshua Arieli, Nancy Farriss, and Michael Heyd.

[2] *The Oxford Universal Dictionary*, rev. and ed. by C. T. Onions (Oxford, 1955), p. 1449. Several recent studies have called attention to the centrality of patronage as an institution. For example, Michael Levey, *Painting at Court* (New York, 1971); Hugh Trevor-Roper, *Princes and Artists: Patronage and Ideology at Four Habsburg Courts, 1517-1633* (London, 1976); and the classic study by Francis Haskell, *Patrons and Painters: A Study in the Relations between Italian Art and Society in the Age of the Baroque* (New York, 1963). The latter has a useful bibliography and a particularly interesting theoretical introduction. Most recently, there is the collection of essays edited by A. G. Dickens, *The Courts of Europe: Politics, Patronage, and Royalty, 1400-1800* (London and New York, 1977); and the review by Keith Thomas, *New York Review of Books*, 26 January 1978, pp. 12-14.

lationships of such groups to one another are expressed. Though for scholarly purposes we normally tend to use the term in more limited senses appropriate to the analytical objectives of our particular disciplines, it is important to recognize that particular patrons, and individual acts of patronage of all kinds and degrees, should be understood not only within their own immediate cultural context. They may also be subsumed within a more encompassing theory concerning the systemic effects of patronage in European social and intellectual history.

In order to develop such a theory fully, one would have to go far beyond the objectives and the limits of this essay. Such a task would require sophistication and skill in applying to an enormous mass of historical data concepts derived from the various social science disciplines. One can at best hold this up as a long-term goal for collective scholarship.

In the meantime, perhaps one may frame an approach to patronage as an early modern institution by taking a *via negativa*. Can there be a Renaissance society without patronage? What would be its essential characteristics? What aspects of patronly societies would anti- or a-patronly societies help us to comprehend? I shall try to trace out an answer to these questions in both theoretical and practical terms, or perhaps more accurately, fictive and historical, terms.

To the extent that Renaissance literature embodies social thought, systems of patron-client relations tend to be taken for granted. Both in the courtly societies depicted by Ariosto and Castiglione and in the somewhat less centralized aristocracies portrayed by Boccaccio, Alberti, and Machiavelli, people are expected to defer to, or accept protection from, their superiors.[3] Even the most genuinely idealistic Italian texts of the fifteenth century link social aspiration with patronly sponsorship. Filarete's model city, Sforzinda, derives its name from the author's own patron, Francesco Sforza.[4] More substan-

[3] See, for example, Leone Battista Alberti, *Opere Volgari* (Bari, 1960), ed. Cecil Grayson, esp. I, 13-81, which is Book I of *I libri della famiglia*; translated by N. Watkins as *The Family in Renaissance Florence* (Columbia, S. C., 1969), pp. 33-91. There is much further supporting evidence in Alberti's *Momus* and *De Iciarchia*.

[4] See Filarete (Antonio Averlino, called Filarete), *Treatise on Architecture*, trans. John R. Spencer (New Haven, 1965). This edition includes a facsimile of the Florence manuscript, Biblioteca Nazionale, Magliabechianus II, IV, 140. Interesting observations on Filarete's work and its implications for Renaissance patronage are found in C. W. Westfall, *In This Most Perfect Paradise: Alberti, Nicholas V, and the*

tively, every social class in the city has its own distinctive architectural style, and, as Luigi Firpo observed, "crowning it all [is] a contradictory and useless element, a Renaissance prince."[5] Contradictory and useless perhaps to Firpo, who wanted to advance Filarete's claims as an innovator, the first Renaissance Utopist. But for Filarete there could be no Sforzinda without the Sforza, no ideal city without a precisely articulated social hierarchy. While modifying and rationalizing them considerably, Filarete accepted the terms of social and political organization, and of cultural sponsorship, that he observed in the Italian urban world.[6]

Although it is not difficult to find Renaissance Italians rejecting particular patrons (a tendency which in the case of artists has sometimes led scholars to infer a greater degree of independence of the system than most artists could have imagined), the most conspicuous instances of genuine attacks on patronage that I know of during the Renaissance come from Northern Europe. Here we may note in passing the position of Erasmus, as usual complex and equilibrated. Erasmus lived on patronage, as J. Hoyoux proved years ago, but he always appreciated its dangers.[7] While willing to accept the occasional purse filled with golden coins, or a horse, or a case of some good wine, or even prolonged hospitality, he would not agree to the role of client as a definition of himself. For this reason he rejected many kinds of preferment, and in his writings referred with grave misgivings to those who permitted themselves to be so seduced.[8] His was the privilege, relatively rare in his time,

Invention of Conscious Urban Planning in Rome, 1447-55 (University Park, Pa., 1974).

[5] Luigi Firpo, "La Citta Ideale del Filarete," in *Studi in Memoria di Gioele Solari* (Turin, 1954), p. 56; quoted in the interesting article by Eugenio Garin, "La Cité Idéale de la Renaissance Italienne," in *Les Utopies à la Renaissance*, Université Libre de Bruxelles: Travaux de l'Institut pour l'Etude de la Renaissance et de l'Humanisme (Brussels and Paris, 1963), I, 13-37.

[6] A qualifying circumstance here is the writer's desire or need to flatter a real or potential patron. Such a motivation complements rather than supplants the writer's interest in producing a plausible and persuasive piece of work. Of itself, this wish to ingratiate should alert us to the writer's possible hypocritical stance. But it is in no way a proof that the author's views are held lightly or advanced for merely self-serving reasons. Ideology and self-interest have an odd way of coinciding, though the writer's personal circumstances should always be taken into account.

[7] "Les Moyens d'existence d'Erasme," *Bibliothèque d'Humanisme et Renaissance*, 5 (1944), 7-59.

[8] A classic instance may be found in *The Praise of Folly*, trans. H. H. Hudson (Princeton, 1941), pp. 93-99. Erasmus nonetheless believes that princes had a duty

of what might be called the cultural "superstar." This is a colloquial way of expressing the fact that an identification with him produced greater benefits for his patrons than he could derive from prolonged attachment to them.

But Erasmus' reservations, both behavioral and doctrinal, are far from constituting a theoretical antithesis to patronage. For this we must turn to his intimate friend Thomas More. The *Utopia* confronts both social reality and ideality. It is, in the first instance, a ruthless indictment of a social world embodying extremes of dysfunction. As Martin Fleisher has observed, "Enclosures and rural depopulation, price revolution and debasement of coinage, unemployment, mendicancy, and vagabondage, gentlemen highwaymen, rebellious elements among the nobility and rural unrest, the transformation of the agrarian economy—we have here almost all the ingredients which go to make up what has been called 'Tawney's Century,' England in the period from 1540 to 1640."[9] More's solution, embodied in Book Two, is an egalitarian society designed to prevent the appearance of economic, social, and political distinctions among men. There are, of course, differences in aptitude and ability, but these are not permitted to develop into permanent, let alone hereditary, differences in status. More's social egalitarianism is reinforced in various ways—patterns of work, styles of dress and housing, and many others—but the crucial and overarching element in the Utopian system is the abolition of private property. Though a great deal of very distinguished scholarship has been devoted to More, I think it has not been fully appreciated that one major effect of the distribution of wealth in Utopia is the eradication of patronage. That this is part of a more general "transvaluation of values" in More should be obvious.[10] Gold, the Boethian *pretiosa pericula*, a "precious bane," loses its function as a medium of exchange when relegated to the manufacture of chamberpots. In this reversal, it also loses something more subtle: its attractiveness as an element of ornament or decoration. Both social

to support humane letters. See *Opus Epistolarum Des. Erasmi Roterodami*, ed. P. S. Allen and H. N. Allen (Oxford, 1926), VI, 51, where he makes this point in a letter to Willibald Pirckheimer.

[9] *Radical Reform and Political Persuasion in the Life and Writings of Thomas More* (Geneva, 1973), p. 34.

[10] Fleisher, *Radical Reform*, applies this concept to More's *Utopia*, but he borrows it from Walter J. Kaiser, *Praisers of Folly* (Cambridge, Mass., 1963), pp. 51-83, who applied it to Erasmian satire.

and artistic criteria are overthrown here. Equally striking, however, is that More eliminates the social as well as the material basis of patronage. There are no aristocrats. Everybody works. The physical labor is shared. The amenities of life are not overlooked. They are merely public.

Though More understandably has little to say of the arts, it is worth considering his often neglected passage on pleasure gardens. Here is a subject close to the concerns of all students of private patronage in the Renaissance, for by its very nature it transcends the parochial boundaries of our disciplines. The garden as an image of Paradise, as an earthly paradise, as a mythological program, or as an attempt to assert man's dominance over nature abounds in literature and the visual arts.[11] To understand the actual creation of such gardens engages the energies of historians of art, architecture, the classical tradition, the building trades, and other special areas.[12] More's gardens suggest neither physical complexity nor intellectual conceits. More imagines, in describing the blocks of houses, "which are far from mean" in the capital city of Amaurotum, that

> On the rear of houses, through the whole length of the block, lies a broad garden enclosed on all sides by the backs of the blocks. Every home has not only a door into the street but a back door into the garden. What is more, folding doors, easily opening by hand and then closing of themselves, give admission to anyone. As a result, nothing is private property anywhere. Every ten years they actually exchange their very homes by lot.[13]

The sense of openness and public accessibility here takes on added meaning, if one adopts as a point of reference the ideal courtly, monastic, or even bourgeois garden of the late Middle Ages, with

[11] For studies of this theme in various forms of artistic expression, see A. Bartlett Giamatti, *The Earthly Paradise and the Renaissance Epic* (Princeton, 1966), with good bibliographical essays; R. Turner, *The Vision of Landscape in Renaissance Italy* (Princeton, 1967); and the interesting comments on the garden motif in David R. Coffin, *The Villa d'Este at Tivoli* (Princeton, 1960).

[12] See the remarkably suggestive article by Terry Comito, "Renaissance Gardens and the Discovery of Paradise," *Journal of the History of Ideas*, 32 (October-December 1971), 483-506.

[13] I have used the *Complete Works of Thomas More*, ed. Edward L. Surtz, S.J., and J. H. Hexter (New Haven, 1965), IV. The passages on gardens are to be found on pp. 120-21.

its enclosing walls. The *hortus conclusus*, the *locus amoenus*, the *giardino segreto* are fantasies (sometimes fulfilled) of exclusiveness, reserved, to quote the title of a recent symposium on elites, for *The Rich, the Well Born, and the Powerful*.[14] Yet More's gardens are not mere open commons or playing fields, for he tells us:

> The Utopians are very fond of their gardens. In them they have vines, fruits, herbs, flowers, so well kept and flourishing that I never saw anything more fruitful and more tasteful anywhere. Their zest in keeping them is increased not merely by the pleasure afforded them but by the keen competition between blocks as to which will have the best kept garden.[15]

Thus, competitive instincts are sublimated in the pursuit of agriculture, which for the Renaissance Epicurean is naturally a variant form of culture. The result is productive both aesthetically and economically. It is the product of collective effort and commonly shared pleasure: the antithesis of patronage.

One could multiply other examples from *Utopia*—the priesthood, which is established by popular election and may include women; the judicial system, which treats all men as equals; and so on. The general point is evident: in eliminating hierarchy, More has at least theoretically annihilated political, religious, and apparently artistic patronage, the very existence of which depend on differences of wealth, occupation, and status. During the Reformation, less systematic but more direct attacks on Renaissance hierarchies also surface. As we turn to them, we may remember Thomas More cheerfully paying with his life for his final refusal to serve an earthly patron.[16]

It has always been recognized that the major leaders of the Reformation, however radical they may have been in their Scripturalism, were deeply and literally conservative in their political doctrines. Basing themselves on Romans xiii, Luther, Zwingli, and Calvin always insisted that lawful authority must be obeyed. In so saying, they gave support to most existing social hierarchies. Often, in return, they received protection from urban and magisterial elites.

[14] Frederic Cople Jaher, *The Rich, The Well Born and The Powerful: Elites and Upper Classes in History* (Urbana, Ill., 1973).

[15] Surtz and Hexter, ed., *Complete Works*, IV, 120.

[16] For a very perceptive discussion of the meaning and style of More's martyrdom, see Fleisher, *Radical Reform*, esp. ch. 5.

While allying themselves with such political patrons, they challenged some other forms of patronage. The ecclesiastical hierarchies of the Church were toppled and replaced by synodal and consistorial arrangements. In sacerdotal theory and sacramental practice, distinctions among men, and to some extent between men and women, came to be softened. Ecclesiastical patronage of the visual arts in some areas came to a virtual standstill, owing to the literal acceptance of Biblical injunctions against graven images and the battle cry against idolatry, a shorthand term of opprobrium connoting a wide range of Roman Catholic practices (all of which enjoyed, while in part abusing, the hallowed sanction of *traditio*). Some of these developments, not consciously conceived as attacks on diverse manifestations of the patronage system (and often popular in their origins), are functionally indistinguishable from deliberate attacks. To reinforce this point, it will be useful to speak briefly of Reformation iconoclasm, a phenomenon quite different from the Byzantine imperial version. This, of course, is not to deny the patronly relations that obtained between certain reformers and the secular rulers who protected them.

During the sixteenth century in Northern Europe, thousands of paintings and sculptures were seized in convents and churches and then destroyed. A list of these objects, if one could be made, would form an interesting visual martyrology. What I wish to suggest here is that it may be too simple to explain these acts merely as the expression either of a theological critique or of the unbridled enthusiasm of a mob. That there was another, perhaps unconscious, method to this madness may be at least surmised from a few examples. The destruction of images appears to have begun in Zurich as early as 1 September 1523. A few months later, following the sermons of Leo Jud and the treatise against images by Louis Haetzer, a group of zealots destroyed the great crucifix at Stadelhofen, near Zurich. This is one of the rare instances when we know what happened to the destroyed object. The chopped-up pieces were distributed to the poor as firewood.[17] One can hardly imagine a more eloquent denial of sacerdotal paternalism, nor a more powerful symbolic affirmation of a new sense of social concern. Similar instances occurred in the Netherlands in the 1560s and elsewhere.

During the Calvinist revolt in the Netherlands in 1566, one finds attacks on images taking almost systematic form. This seems to be

[17] G. H. Williams, *The Radical Reformation* (Philadelphia, 1962), pp. 91-92.

a function of increasing popular involvement in religious conflict. Pieter Geyl informs us that while the States-General had in the past given evidence of national consciousness, "never on former occasions had the people participated so generally and with such enthusiasm as they did at this time." What forms did this public participation take? First they flocked to hear sermons and take part in the singing of psalms outside churches. Then, seeking a more active role, they found it in the breaking of the images. Here is how Geyl describes the movement:

> The movement started on the linguistic frontier, in the area where the new cloth manufacture had created an industrial proletariat . . . whose religious ecstasy was nearly allied to social unrest. A transport of rage suddenly possessed the multitude. Crowds surged into the churches to destroy all the most treasured symbols and ornaments of the old religion. . . . For the most part . . . these excesses caused surprise and discomfiture to the leaders whose fanatical phraseology had roused the temper of the mob to the right pitch. In any case it was a truly Calvinistic work, fierce and honest, restrained by no respect for art or beauty.[18]

There are many ways to be cynical about these events, not to mention Geyl's almost joyous evocation of them. It is easier to smash sculptures than to stand up against the legions of the Duke of Alva. But to dwell on such aspects of the revolt would be to miss its cultural meanings. These are especially interesting in that artisans and craftsmen generally carried out these attacks. They, like their Catholic counterparts, could have chosen to kill people instead. Also, they had some idea of what was involved in the production of a work of art. Men from their own social rank had for centuries been the creators of these precious objects. Yet demolition was clearly the goal here, and looting seems to have played little if any role. What we may be seeing is not merely the venting of social frustrations and religious grievances. It can perhaps better be understood as the conscious symbolic eradication of a past. The images—saints and heroes, father-figures and mother-figures, objects of deference and veneration—were part of the social ecology of everyday life. Like the lay and ecclesiastical patrons who commissioned them, they stood immutable and made their demands of every man. The-

[18] *The Revolt of the Netherlands (1555-1609)* (New York, 1958), pp. 92-93.

ologically, it would have been enough to remove the images, or even to refuse to defer to them. But Reformation iconoclasm goes beyond this, implying an attack on the very system that calls into existence both celestial and terrestrial hierarchies.[19]

The kinds of theories and behavior I have tried to characterize until now as more or less direct challenges to a patronly social and economic order are quite different from principled rejections of the system on the individual level. It would be anachronistic to expect these for this period, when concepts of human freedom were still rudimentary and little known. What artist, let alone patron, in the Renaissance would not have been taken aback by Dr. Johnson's famous definition:

> Is not a patron, my lord, one who looks with unconcern on a man struggling for life in the water, and when he has reached ground encumbers him with help? The notice which you have

[19] A number of recent studies have called attention to the cultural meaning of sacred objects in pre-industrial European communities, and to the symbolic implications of their destruction. Some of the best work has been done by anthropologists, such as William A. Christian, Jr., *Person and God in a Spanish Valley: Studies in Social Discontinuity* (New York, 1972), esp. ch. 2: "The Saints: Shrines and Generalized Devotions." Particularly relevant for the present argument is section VII, "Images in the Churches." Also page 100, where Christian summarizes the implications of some iconoclastic riots during the Spanish Civil War: "The role of active patron [saint] is deep and profound: it has a hold on the heart: it should not be underestimated or lightly dismissed. Its power can be measured precisely by the violence with which images of cherished devotions were pursued and, if possible, destroyed during the Civil War. . . . The degree to which the images were destroyed is a measure of the degree to which they constituted a kind of cultural shell, a nexus of values."

Some enlightening comments are offered in a recent article by N. Z. Davis, "The Rites of Violence: Religious Riot in Sixteenth-Century France," in *The Massacre of St. Bartholomew: Reappraisals and Documents,* ed. Alfred Soman (The Hague, 1974), pp. 203-342; published also in *Past and Present,* 59 (May 1973), and in Davis's collection, *Society and Culture in Early Modern France* (Stanford, 1975), pp. 152-88. See also "Pilgrimages as Social Processes," in Victor Turner, *Dramas, Fields, and Metaphors: Symbolic Action in Human Society* (Ithaca, N. Y. and London, 1974), pp. 166-230. Related aspects of popular religion in our period are treated by A. N. Galpern, *The Religions of the People in Sixteenth-Century Champagne* (Cambridge, Mass., 1976). An older but still useful study is J. Toussaert, *Le sentiment religieux en Flandre à la fin du Moyen-Age* (Paris, 1960). The views of the leading reformers on images are deftly summarized in Hans von Campenhausen, "Die Bilderfrage in der Reformation," *Zeitschrift für Kirchengeschichte,* 68 (1957), 98-128.

been pleased to take of my labours, had it been early, had been kind; but it has been delayed till I am indifferent, and cannot enjoy it; till I am solitary, and cannot impart it; till I am known, and do not want it.[20]

A recent study shows that this perception of the patron as a conservative investor who appears only after the risks have been taken and the prizes won was widely held by English men of letters in the eighteenth century. Its appearance had to wait upon the development of very different markets for literary talent from those that existed before 1600.[21] More typical of the Renaissance is the perception of patronage and its economic leverage held by such beneficiaries as the historian and diplomat Francesco Guicciardini, who wrote:

I know of no one who loathes the ambition, the avarice, and the sensuality of the clergy more than I—both because each of these vices is hateful in itself and because each and all are hardly suited to those who profess to live a life dependent upon God. . . . In spite of all this, the positions I have held under several popes have forced me, for my own good, to further their interests. Were it not for that, I should have loved Martin Luther as much as myself.[22]

Such attitudes should be kept in mind when one begins to consider the complex relationships between patrons and clients in the Renaissance. They forge a perceptual link with the realistic More of the first book of *Utopia*, who observes that the role of counselor to princes imposes a hypocritical deference to the will and opinions of others.[23] Both of these learned politicians thoroughly grasped the essentially political character of patronage as an institution. In societies ranging from tribal New Guinea to ethnic groups in contemporary Britain, observers of human social systems have detected

[20] *Boswell's Life of Johnson* (Oxford, 1924), I, 174. The passage appears in a letter to Lord Chesterfield, in which Johnson rejects his sponsorship. The passage continues: "I hope it is no very cynical asperity not to confess obligations where no benefit has been received, or to be unwilling that the Public should consider me as owing that to a Patron, which Providence has enabled me to do for myself."

[21] Paul J. Korshin, "Types of Eighteenth-Century Literary Patronage," *Eighteenth-Century Studies*, 7 (Summer 1974), 453-73.

[22] *Maxims and Reflections of a Renaissance Statesman*, trans. M. Domandi (New York, 1965), p. 48.

[23] Surtz and Hexter, ed., *Complete Works*, IV, 90-95.

a structure of which there are, to be sure, innumerable variants, but a structure that entails the dominance of "a leader who will gather his own network of allegiances powerfully around himself and create a centre of force for the rest of society." The leader's success in achieving such dominance breeds further triumphs. As Mary Douglas observes, "there are few overriding community interests to check the leader's impetus. The greater his influence, the more support he attracts."[24] Such a figure may have rivals, but this does not threaten the integrity of the system itself. In the anthropologist's vocabulary, societies exhibiting this structure are called "Big Man" systems.

The presence of such Big Man systems all over the world—in Melanesia, among the Indians of the Pacific Northwest, in the Philippines, and elsewhere—may alert us to their possible impact in pre-industrial Europe. Indeed, the terms in which some anthropologists describe tribal societies of an authoritarian type are very close to those used by some historians to portray the emergence of the Italian *signoria* or of the so-called bastard feudalism of the Wars of Roses.[25] The same elements are there: the growing accrual of power in the hands of Big Men; the evolution of patterns of deference and patronage; the competition between rivals and their client groups, both in politics and the arts.

There are several ways in which such a scheme of Renaissance social hierarchy may serve to clarify typical aspects of patronage. In the remainder of this essay I should like to provide some examples, clustered around the theme of the ideal ruler. A convenient starting point might be the engraving included here as Figure 1.1. Here the Pope—the Holy Father, perhaps the biggest of all Big Men or surely a perennial rival for that status—appears to accept a volume of music from its composer. The humility of the composer

[24] Mary Douglas, *Natural Symbols* (London, 1973), pp. 89, 90. Further discussion of the theory occurs on pp. 156-57, 170-71, where a collapse of the system is specifically compared to the European crisis of the seventeenth century. See, too, the empirical studies cited by Douglas.

[25] What is of interest here is the descriptive language used by historians, not the political evaluations they derive from or impose upon their perceptions. See, for example, the classic works of Ernst Salzer, *Über die anfänge der Signorie in Oberitalien* (Berlin, 1900); Luigi Simeoni, *Le Signorie* (Milan, 1950); Jakob Burckhardt, *The Civilization of the Renaissance in Italy*, trans. Samuel G. C. Middlemore (London, 1898), esp. part I, "The State as a Work of Art"; and even a work as recent as the popular school text by Daniel Waley, *The Italian City-Republics* (New York, 1969).

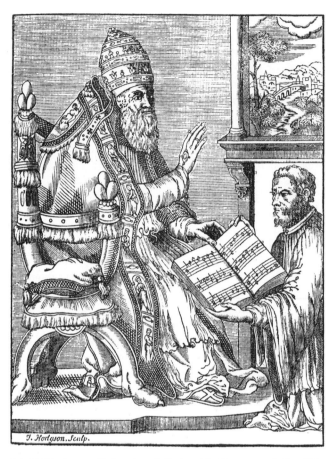

1.1 T. Hodgson. *Palestrina Offering his Masses to Julius III.*
Illustration.

is signaled not only by his kneeling, but by his placement below
the dais where the papal throne is set, the extreme simplicity of his
dress, the deference of his expression, and the hieratic scale of the
two figures (as in medieval donor and saint images, or feudal images
of fealty or homage). He does not look at his patron but averts his
eyes and gazes into the middle distance. Meanwhile, the Pope ac-
knowledges this presentation with a gesture of benediction. His
manner is appropriately paternal. All of his appurtenances bespeak
his power. His cope, adorned with images of the saints, an eccle-
siastical analogue of *uomini famosi*, links him with the upper

14

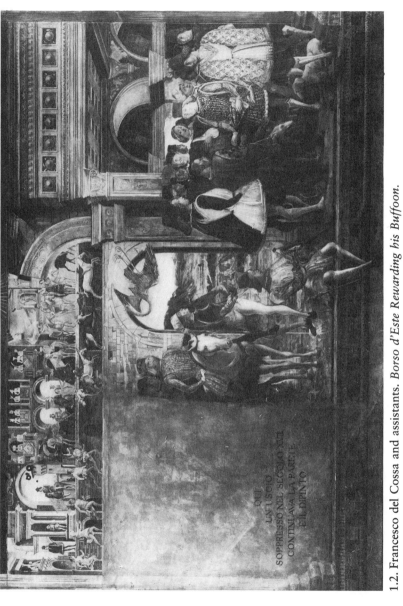

1.2. Francesco del Cossa and assistants. *Borso d'Este Rewarding his Buffoon.*

reaches of spiritual as well as worldly hierarchies. Such images of presentation are not uncommon, and the same expressions of deference and benevolent acceptance are normally present.[26] This holds true of the pendant relationship as well—that of the patron bestowing some gift on his client. Here again, one example may suffice, as we consider the resplendent figure of Borso d'Este, surrounded by faithful dogs and loyal courtiers as he rewards a favored buffoon (Figure 1.2). In this scene, as throughout the surviving Schifanoia frescoes, courtly distinctions of hierarchy are meticulously observed.[27] The same might be said of Mantegna's Gonzaga frescoes at Mantua and of other works, some of which are known only through verbal descriptions.

It would seem from such instances that in Renaissance hierarchies, the patron-client relationship dictated at least a formal or behavioral deference. But life was more diverse than its idealized representations, even in the northern courts. Artists occasionally protested the terms of their employment or sought to put off or even refuse a particular patron. It would be a mistake to interpret these actions in any programmatic sense as rebellions against the system as such. What they seem to me to suggest is the need to be alert to two hierarchies besides the one implicit in the patron-client relationship. These are the hierarchies among patrons considered as a social group, on the one hand, and those among artists as an occupational cadre, on the other. These varied according to time and place, and with individuals, but some general observations may be suggestive.

The existence of patronal hierarchies may be effectively demonstrated in the Italian city-states. In the first instance, each individual city has its own internal, if implicit, ranking of patrons. For the *signorie* this implicit ranking is relatively easy to deduce. It normally begins with the *signore* and his immediate family, who enjoy the

[26] See, for example, plates 6 and 11 of Gundersheimer, *Style of Renaissance Despotism* (Princeton, 1973). My colleague Professor Paul F. Watson and I are engaged in a joint study of such images of presentation.

[27] See, most recently, Michael Levey, *Painting at Court* (New York, 1971), ch. 2; Paolo d'Ancona, *Les Mois de Schifanoia à Ferrara* (Milan, 1954), with a useful bibliography. A similar concern for patronal relations of hierarchy in Ferrara's fresco cycles is revealed by the contemporary descriptions of Giovanni Sabadino degli Arienti. See *Art and Life at the Court of Ercole I d'Este: The "De triumphis religionis" of Giovanni Sabadino degli Arienti*, ed. Werner L. Gundersheimer (Geneva, 1972), esp. bk. V.

largest income and—a point frequently overlooked—who must sustain the most varied and extensive obligations.[28] They, and a select group of their most immediate associates, are unique in their ability not only to attract the most distinguished local talents, but also to draw from a wider network beyond the boundaries of the city, the region, and even Italy itself. Their emissaries and listening posts in distant places serve as a constant funnel of information enabling them to compete as rivals within a wider network—that of urban leadership in what might be called a national context.

The urban elite of each major city—consisting of the dynastic house and its collateral lines, the court, and a small group of aristocratic families—is by virtue of its dominant local role forced to raise its political and intellectual sights and to measure its achievement against that of similarly placed elites in other cities. Such local elites know that their own clients will judge them in comparison with their peers elsewhere. This is no less true for republics controlled by oligarchical factions and clans than for signorial regimes. A subtle rivalry of Big Men is thus set in motion. Given an abundance of local talent, which is likely to be less expensive than distinguished imported practitioners of any given art or skill, local patrons will choose from the available pool, a decision in which considerations of economy and taste may support one another. This may help to explain in part the emergence of fairly consistent patterns of internal stylistic development within a given art form—the development of regional schools. Given a dearth of local talent, patrons will immediately have to choose between forgoing some particular area of activity and recruiting help from abroad. If they go abroad, they are obliged to compete in a wider and more complex, as well as a more expensive, marketplace. Unless they are deeply committed to what they are doing, they may be unwilling or unable to pay the price and will end up having to content themselves with clients of less than the highest quality.

In Ferrara, for example, the Estensi supported a number of local painters over a long period of time with significant results. Though these artists accepted other commissions, the court provided a center for their efforts and contributed to their reputations to the point where they became attractive to outside patrons and occasionally

[28] I have commented on the obligations of Renaissance princes with respect to patronage in "The Patronage of Ercole I d'Este," *The Journal of Medieval and Renaissance Studies*, 6 (Spring 1976), 1-18; and in *Ferrara*, esp. chs. 6 and 7. See also Douglas, *Natural Symbols*, pp. 170-71.

left. The famous letter from Francesco del Cossa to Borso d'Este indicates that artists recognized that they too had a determinable place within a market system that transcended local limits. "Let me humbly remind you," he says, "that I am Francesco del Cossa, who on my own did the three panels on the wall next to the anteroom. . . . Having now begun to get something of a name, I am treated and judged and compared with the poorest apprentice in Ferrara."[29] What Cossa has experienced here is what sociologists call status dissonance. His sense of attainment within his professional group makes him feel entitled to rewards that have not been conferred. If the expectations of a person in this situation are not satisfied to some degree, he will exercise whatever mobility he has, taking new risks in the hope of attaining more appropriate rewards. Cossa's departure for Bologna seems to exemplify the system in its most rational form, especially because Tura was clearly receiving the favors to which the younger man aspired. Such decisions generally involve psychic and social as well as financial rewards.

If the Estensi lost Cossa, they managed to retain other fine painters and attract an increasingly distinguished array of non-Ferrarese masters to their service. Under Ercole I (1473-1505) the family was also willing and able to compete with the Papacy, the dukes of Milan, and the kings of Naples for the services of the best Flemish singers and composers. During the same period, however, it is clear that the Estensi were quite content to hire sculptors of no particular distinction, which indeed was the traditional Ferrarese pattern.[30] If decisions of patronage reflect personal tastes and passions, one must not lose sight of the consistent patterns of rational calculation that often underlie them as well.

Scholarly discussion about patrons and clients—and especially about patrons and artists—tends to concern itself so exclusively

[29] Translated in David Sanderson Chambers, *Patrons and Artists in the Italian Renaissance* (Columbia, S. C., 1971), pp. 162-63. See also Gundersheimer, *Ferrara*, ch. 5. Professor Charles Rosenberg of the State University College of New York at Brockport is currently working on a systematic study of the artistic patronage of Borso d'Este.

[30] Gustave Gruyere, *L'art Ferrarais à l'époque des princes d'Este* (Paris, 1897), esp. I, 503-54. On music at Ferrara, see the recent articles of L. Lockwood, "Music at Ferrara in the period of Ercole I d'Este," *Studi Musicali*, 1 (1972), 101-31; "Pietrobono and the Instrumental Tradition at Ferrara in the Fifteenth Century," in *Rivista Italiana di Musicologia*, 10 (1975), 115-33. Professor Lockwood is now completing a book on this subject.

with the central binary relationship that one begins to lose sight of the networks of mental attitudes and social connections that provide its supportive structures. It would be foolish to deny the relevance of a particular patron's tastes, means, and interests to the understanding of the work produced in his ambiance. Indeed, recent writers on courtly patronage, like Francis Haskell and Hugh Trevor-Roper, have offered fresh demonstrations of the utility of this approach.

But no patron, however wealthy, powerful, or exalted, is an island, at least in the Renaissance. The traditional Burckhardtian insistence on the rise of the individual may have served to obscure what is itself a Renaissance perception of society. I would like to suggest here that for purposes of understanding patronage in the fifteenth and sixteenth centuries, it is necessary to begin to view the boundaries between the individual and corporate varieties as more fluid and less exclusive than has traditionally been done. After all, decisions affecting corporate patronage—whether that of guilds, communes, confraternities, convents, or whatever—were made by individual human beings. Even if they spoke for, or had to answer to, some sort of constituency, they nevertheless had to rely on their own aesthetic and programmatic judgments and to accept the limitations of their resources as patrons.[31] Conversely, and this is likely to be more controversial, an individual patron, however self-indulgent or idiosyncratic, functioned as part of a corporate network no less real, if more elusive, than his corporate counterpart.

I have already tried to show, both here and elsewhere, that while the precise forms may vary with the individual patron, the role of patron is itself thrust upon people in positions of authority as an inherent and essential structural aspect of the Big Man system. But the Big Men in the Renaissance, with rare and transitory exceptions, are sustained by their links with corporate structures. Of these, the most important are their own families. Some historians make a firm distinction between corporate and familial institutions.[32] Despite its heuristic value for other topics, such a distinction is unhelpful

[31] Evidence of how these processes work is provided in the anthology edited by Chambers, *Patrons and Artists*; and the subject as a whole is considered by Peter Burke, *Culture and Society in Renaissance Italy, 1420-1540* (London, 1972), with some statistical observations.

[32] Such a distinction is implicit in the work of Francis William Kent, *Household and Lineage in Renaissance Florence: The Family Life of the Capponi, Ginori, and Rucellai* (Princeton, 1977).

in analyzing patronage. In manifesting his own *magnificentia*, the Renaissance patron functioned not merely as an individual man of taste and culture but as the figurehead of a family, and generally an extended family. The court may be regarded as a more broadly based variant of the same phenomenon. To say this is to disagree with one conclusion advanced in the recent and brilliant work of Richard Goldthwaite, who in my opinion sounds a premature death knell for the extended family in late fifteenth-century Florence, holding that the great palace construction of the late *quattrocento* is the product of a new concept of the nuclear family.[33] Recent study by Francis William Kent, more convincing on this point, demonstrates beyond a doubt that the notion of the extended family, or clan, is very much alive among the Capponi, Ginori, and Rucellai even well into the sixteenth century. Kent's luminous chapter, "Neighborhood, Patronage, and the Ancestors," shows that crucial decisions affecting building programs, decorative schemes for churches and chapels, and the like reflect a kind of family corporation.[34]

What is true for the aggressively competitive and territorial Florentine family is equally valid for the northern dynastic cities. When contemporary humanists praise, and artists represent, the *house* of Gonzaga, or the *house* of Este, this cannot be dismissed as mere atavistic rhetoric. It has the same cultural resonance as the saints on the Pope's cope, for it suggests that the present leader is part of a great continuum, extending deep into the past and far into the future.[35] Naive and minor representations of such themes may be repulsive to modern sensibilities, but it is hard to remain unmoved by the genealogies of the Estensi in the Third Book of *Orlando Furioso*, or unimpressed by the outrageous presumption of Vasari's *Apotheosis of Grand Duke Cosimo de' Medici*, a later Florentine analogue of dynastic glorification (Figure 1.3). Renaissance patrons sought to transcend time, leaving it to later generations of governmental patrons to try to transcend space.

[33] R. W. Goldthwaite, *Private Wealth in Renaissance Florence* (Princeton, 1968), pp. 258, 261.

[34] Kent, *Household and Lineage*, pp. 227-93.

[35] Genealogical treatises and manuscripts provide excellent examples of this will to discover dynastic continuity. Such manuscripts often involve the free invention of portraits of ancestors, and sometimes even the fabrication of the ancestors themselves. See, for example, Biblioteca Estense, Modena, MS. Alpha L.5, 16 (Ital. 720), *Genealogia Estense*, for a typical instance of this genre.

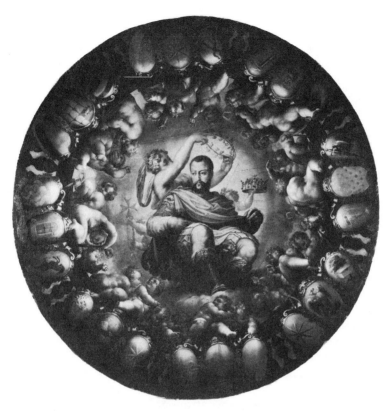

1.3 Giorgio Vasari. *Apotheosis of Grand Duke Cosimo de' Medici.*

Before concluding this somewhat general and exploratory approach to patronage, I should like to take brief notice of the lower ends of the scales of patrons and artists. How can we, as students of social behavior and artistic production, avoid the elitist bias that has been imposed on us by the accidents of survival and by the preferences of connoisseurship? While we probably cannot avoid it altogether, we can seek to offset it with a broader awareness of the effects of patronage throughout the society. Just as not every patron is a Maecenas, not every artist is a Horace. If in general the rule of hierarchies which I have proposed holds true, there will be a quantity of less wealthy and prestigious patrons teaming up with minor clients or sponsoring the less ambitious works of major ones,

21

further down the scale. Aesthetically, such works may seem crude and unrewarding in comparison with what is being done at the top of the scale. But they can be the most enlightening on many aspects of social and religious history, the history of taste, the history of the organization of work in the arts, and related subjects. Topics of this sort recommend themselves increasingly to students of patronage, owing both to their inherent significance and to the professional incentive of discovering subjects that have not been done. Ellen Callman's recent book on the workshop of Apollonio di Giovanni may serve as an example of what can be accomplished.[36]

But here modern scholarship faces great limitations. In pre-industrial Europe, men whom we confidently call artists, particularly toward the lower end of their occupational hierarchies, were commonly commissioned to produce material of a purely situational and ephemeral character. No one will ever be able to calculate the quantities of papier-mâché statues, masks of mummery, symbolic pennants and blazons, playing cards, stage sets, table decorations, dower chests, birth salvers, and sheets of congratulatory doggerel with which generations of relatively privileged Europeans surrounded themselves—nor to say very much on the individual level about the people who commissioned or created them. Little of this so-called minor or decorative art, not to speak of the written record of its creation, has survived. But much remains to be done with that surviving remnant. We may also gain access to changing styles and tastes among the less affluent patrons of Europe through systematic study of texts such as dedicatory epistles to printed books, not to mention the entire field of the graphic arts.[37]

This is not meant to suggest in any way an invariable correlation between the wealth of patrons and the quality of the works they commissioned. Lavish patronage has often been squandered on inferior talents, while genius has languished in isolation or struggled with great hardships. To observe that the Renaissance system generally worked is not to say that some other system might not have worked better, that great talents were not ignored or destroyed by its arbitrary aspects, or that certain rare individuals were not able

[36] *Apollonio di Giovanni* (Oxford, 1974).

[37] Eugene F. Rice, Jr. "The Patrons of French Humanism, 1490-1520," in *Renaissance Studies in Honor of Hans Baron*, ed. Anthony Molho and John A. Tedeschi (DeKalb, Ill., 1971), pp. 687-702. Also Robert M. Kingdon, "Patronage, Piety and Printing in Sixteenth-Century Europe," in *A Festschrift for Frederick B. Artz*, ed. David H. Pinkney and Theodore Ropp (Durham, N. C., 1964), pp. 19-36.

to create in effect a new and more broadly based patronage through the revolutionary power of their art. Here it may be fitting to mention as a case in point the name of William Shakespeare.

Like More and Montaigne before him, Shakespeare could imagine a world without hierarchy, and this too is unsurprisingly a world without patronage. It is that uninhabited island for which in *The Tempest* Gonzalo fantasizes an antithesis to Europe under his own kingly rule:

> . . . no kind of traffic
> Would I admit; no name of magistrate;
> Letters should not be known; riches, poverty,
> And use of service, none; contract, succession,
> Bourn, bound of land, tilth, vineyard, none;
>
> No sovereignty. . . .

But he has already built into this ideal commonwealth an elite of one, as Sebastian and Antonio quickly perceive:

> *Seb.* Yet he would be king on't.
> *Ant.* The latter end of his commonwealth
> forgets the beginning.[38]

As Harry Levin has observed of this passage, "The crux in the problem of anarchy is that someone must take office. Responsibility presupposes authority; authority imposes responsibility."[39] And, we may add, responsibility includes patronage. The political and social orderings in European societies in the Renaissance are mirrored in their structures of patronage. Could Shakespeare's awareness of this point have led him to prefer the support of the London crowds to that of a single *patronus*? If so, we may view his career less as a product of, than as a departure from and perhaps a challenge to, the traditional relationships that define patronage in the Renaissance.

[38] *The Tempest*, II.i.144-48, 152; 152-54. Quoted from the Pelican edition of *William Shakespeare: The Complete Works*, gen. ed. Alfred Harbage (Baltimore, 1969).

[39] *The Myth of the Golden Age in the Renaissance* (Bloomington, Ind., 1969), pp. 125-27.

PART II

Patronage in the Church and State

TWO

Court Patronage and Government Policy: The Jacobean Dilemma[1]

LINDA LEVY PECK

WHEN analyzing politics in the Renaissance state, historians have emphasized the importance of patronage practices to the stability of monarchy. Functioning informally within the constitutional elements of the state, patronage provided both the essential means by which Renaissance rulers gained the allegiance of the politically important and the primary method by which they integrated regional governments and elites into the state. In the case of England, striking differences have usually been drawn between the care with which Elizabeth husbanded the bounty at her disposal and the indiscriminate and lavish dispensing of patronage which characterized James I. Writers have emphasized that the monopoly of patronage by favorites for their own benefit and the distribution of reward without regard for service produced dissatisfaction among those whom the state sought to conciliate.

In his influential essay, "The Elizabethan Political Scene," Sir John Neale argued that Elizabeth used her patronage to play off one faction against another and thus promote efficiency and prevent abuses, but this balancing act broke down under James I, "and the scandal and discontent caused by a putrefying political system helped to provoke the Civil War."[2] Hugh Trevor-Roper, using Neale's interpretation in his provocative essay on the general crisis

[1] My thanks to Peter Clark, Lester Cohen, Conrad Russell, Lois Schwoerer, and Phillip VanderMeer, who read drafts of this article and gave me the benefit of their comments.
[2] "The Elizabethan Political Scene," in J. E. Neale, *Essays in Elizabethan History* (London, 1958), p. 84.

of the seventeenth century, traced the uprisings of the period to the overgrown Renaissance state, bloated, bureaucratic, and corrupt, weighing ever more heavily on contemporary society. In England the weight of the Renaissance court fell on the politically active gentry, who, identifying themselves as the "Country," took up arms against it.[3] While Trevor-Roper's argument has come under attack, his dichotomy of "Court" and "Country" has remained part of the lexicon of English historians, and it has been generally agreed that the breakdown of the political elite into factions of Court and Country, caused in part by the abuses of the patronage system, set the stage for the English Civil War.[4]

The Jacobean court, however, requires reassessment, for its activities were much more complex than usually portrayed. While Jacobean patronage did have dysfunctional aspects, the Court's positive handling of patronage has been overlooked. First, Jacobean officials made conscious efforts to continue Elizabethan practices and to maintain patronage networks linking the Court and localities. Second, attempts to reform the bureaucracy by diagnosing and changing patronage practices originated within the Court itself. In fact, Court patronage was used during the Jacobean period to bring experts into government to advise on policy and to rationalize administration. Third, the failure of these efforts to reform patronage practices and to use patronage to integrate regional elites stemmed from structural difficulties as well as from the personal failings of monarch and ministers. These general propositions may be made more concrete by looking at the activities of one official, sometimes regarded as a typical Jacobean courtier. In analyzing the relationship between Court patronage and government policy—whether the latter concerns administration, finances, domestic politics, or diplomacy—the aim here will be to emphasize the interaction of means and ends in Renaissance statesmanship, which were sometimes in harmony, but stretched near to the breaking point in the Jacobean period.

The basis of English politics in the sixteenth and seventeenth centuries was the patron-client relationship between the monarchy

[3] H. R. Trevor-Roper, "The General Crisis of the Seventeenth Century," in *Crisis in Europe, 1560-1660*, ed. T. S. Aston (London, 1965), pp. 82-83.

[4] See, for instance, Perez Zagorin, *The Court and the Country: The Beginning of the English Revolution of the Mid-Seventeenth Century* (New York, 1970).

28

and the most important political groups in the state, the peerage and the gentry.[5] Patron-client ties suffused the Court, including the Council, the royal household and central administration, Parliament, and the law courts, and reached out to the countryside, where positions in local government as well as royal castles and manors were filled through Court patronage. The complex of feudal relations had given way by the sixteenth century to a set of civil relationships by which the Crown secured loyalty and service in exchange for position and privilege. Lacking either a standing army or paid local bureaucrats to enforce its will in the countryside, the monarchy had to rely on the good will of local authorities. But, as Wallace MacCaffrey has suggested, "by the expert sharing of those gifts of office, prestige, or wealth at its command, the government could secure the continuing goodwill of the politically pre-eminent classes."[6] And the Crown had expanded the offices and privileges in its gift as the state took over the functions of church and guild in the early sixteenth century. The functional role of this patronage system was to centralize politics in the Court and to bring a greater degree of stability to an English society plagued periodically in the fifteenth century by fragmentation and violence.

The suitors who thronged the Jacobean court and those who solicited favor from afar were drawn in the main from a small homogeneous group of landowners, composed of the peerage and the landed gentry. They were augmented by a small number of others who because of education, such as the civil lawyers, or wealth, such as important London merchants, sought favor at Court.[7] On this base the Crown built the network of relationships that lent stability to the state.

The first requirement of the favor seeker was a Court patron, for the patron was the key to royal reward. Kinship ties, family allegiances, regional ties—all were invoked by suitors who sought out

[5] Much of the following discussion of the Tudor-Stuart patronage system is based on Wallace MacCaffrey, "Place and Patronage in Elizabethan Politics," in *Elizabethan Government and Society, Essays Presented to Sir John Neale*, ed. S. T. Bindoff, J. Hurstfield, and C. H. Williams (London, 1961), pp. 95-126; Neale, "The Elizabethan Political Scene," pp. 59-84; G. E. Aylmer, *The King's Servants, The Civil Service of Charles I, 1625-1642* (London, 1961).

[6] MacCaffrey, "Place and Patronage," p. 97.

[7] Brian Levack, *The Civil Lawyers in England, 1603-1641* (Oxford, 1973). Levack points out that the civil lawyers, because of their lack of landed estates and because of the limitation of civil law practice to the central law courts, had to rely almost completely on the Court for their income.

courtiers known to have the King's ear. At the Jacobean court, the relationship established between patron and suitor was not necessarily a permanent or exclusive one. Ever hopeful of advancement, suitors often applied to several important courtiers at once and were quick to change allegiance when their patron lost influence. This continuing search for patronage characterized all levels of Court life. Even important officials needed to ensure the continuance of favor through the mediation of the King's favorites. In this mutually advantageous relationship, the suitor might offer his patron both the tangible gift of gratuities and the intangible gift of prestige, depending on his own status, ability, or wealth. By swelling the ranks of his followers, the suitor enhanced the patron's influence and status.[8] In return the patron offered his client access to the range of royal bounty.

In 1603 the rewards at the Crown's disposal were of three types: honors, privileges, and offices. While honors were the traditional rewards of the monarchy for its supporters, the Court also furnished privileges that provided very real and substantial profits equally attractive to the great peer, the London businessman, the substantial landowner, and the ambitious new man with his way to make. These included annuities or pensions, and land let or sold on favorable terms. Profits were also made from the delegation and exploitation of royal rights as well as from the enforcement of economic and religious legislation. Monopolies, conferring the sole right to manufacture and import products and the lucrative privilege to license dealers, were the major source of income for several of the most important courtiers.[9] But office provided the largest category of royal bounty. It conferred the benefits of power, as in the case of the King's chief ministers; of status, as in the case of a lord-lieutenantship of the shire; of influence in the distribution of Court favor, as in the case of the gentlemen of the bedchamber; and of profit. Far more important than the salaries, often pegged at centuries-old levels, were the gratuities, frequently involuntary, that were assessed on top of the traditional fees. The total amount of fees and gratuities collected yearly in the early seventeenth century has been estimated in a range from £250,000 to £400,000, equal

[8] Neale, "The Elizabethan Political Scene," p. 70. Neale points out that the patron's entourage of household servants, followers, and clients constituted a minor court within the royal Court.

[9] Lawrence Stone, *The Crisis of the Aristocracy, 1558-1641* (Oxford, 1965), p. 247.

to perhaps 40 percent of the yearly royal revenue.[10] Offices were treated to some extent as the holder's private property and were bought and sold. Thus in this era of patrimonial bureaucracies, which were by their nature unsalaried, without achievement norms, staffed through kinship and clientage, the patronage system provided the Crown with its civil servants as well as rewards for the politically important.

One of the major functions of the Tudor-Stuart patronage system was to integrate local political elites into the state, so as to establish and maintain links between the central government and localities. The breakdown of this link, usually traced to the dysfunctional working of Jacobean patronage in the hands of the royal favorites, is said to have brought about the polarization of Court and Country. Yet recent work by Conrad Russell and Derek Hirst on parliamentary politics up through the 1620s suggests that this polarization is too neat. The Country, they have suggested, was not so stable an opposition (if it was that) as previously thought. Local leaders and members of Parliament often identified by historians with the parliamentary opposition continued to hope for and to get Court patronage into the late 1620s.[11] An examination of the Court reveals that up until Buckingham's domination of the patronage machine in the 1620s several members of the Privy Council maintained their own patronage networks, building up clients in the regions under their influence who in this way were connected with the Court.

The patronage of one Privy Councillor may serve as illustration. Attacked by the great English historian S. R. Gardiner as having an unmatched regard for the royal prerogative, described by a Civil War pamphleteer as "famous for . . . fortuning flatteries," now known to have been a secret Roman Catholic and Spanish pensioner, Henry Howard, Earl of Northampton, may be considered the prototypical Jacobean courtier.[12] The younger brother of the fourth Duke of Norfolk, who was beheaded for treason in 1572, Howard had been out of power throughout most of Elizabeth's

[10] Aylmer, *The King's Servants*, p. 248.

[11] See Conrad Russell, "Parliamentary History in Perspective, 1604-1629," *History*, 61 (February 1976), 1-27; Derek Hirst, "Court, Country and Politics before 1629," in *Faction and Parliament: Essays on Early Stuart History*, ed. Kevin Sharpe (Oxford, 1978), pp. 105-37.

[12] S. R. Gardiner, *The History of England, from the Accession of James I to the Outbreak of the Civil War*, 10 vols. (London, 1883-84), I, 93-94; "Truth Brought to Light," in *Somers Tracts*, 2nd ed. (London, 1809), II, 267.

reign. He allied himself with Essex in the 1590s and then, light on his feet, became associated with Robert Cecil in the secret correspondence that assured James's peaceful accession to the throne. Once assured of royal favor, Northampton needed to construct a set of patronage relationships that would perpetuate the promise for the continuing benefit of himself and his family.

Appointed the first absentee Lord Warden of the Cinque Ports, Northampton nonetheless jealously guarded his patronage. When in 1612 the Captain of Sandown Castle removed his lieutenant, Northampton wrote angrily to rescind the order:

> I may not endure this affront by a servant that assails my honor. . . . he shall know that his command . . . though he hold it by grant from his Majesty, is subject to a supreme power divined from the same spring. I will teach him to know the Lord Warden and himself to be Captain of Sandown Castle by my favor; and that his power extendeth not to remove the meanest soldier in the garrison but upon due conviction of the party before me.[13]

At first glance this might be taken to epitomize the shortsighted maximizing of patronage that was ultimately to bring the Jacobean court into disrepute. In fact, close analysis of Northampton's patronage in the Cinque Ports indicates his strong support for the traditional country elites and his recognition of his responsibility to provide them with Court patronage.

In the Cinque Ports Northampton's patronage operated both to continue the Elizabethan policy of allying local leaders with the central government and to provide offices and profit to Northampton's own clients. Many town officials who had served under the previous Lord Warden, Henry, Lord Cobham, an enemy of Northampton's, now became identified as Northampton's retainers with the change in administration (and would in fact become Lord Zouche's clients when he succeeded Northampton as Lord Warden). Regarded by Northampton as "my people," they were rewarded with appointments to positions within the castles under his jurisdiction, positions which were nicely paid sinecures. Through his patronage, country officials thus became part of the Court.[14] Those

[13] British Library, Stowe MS. 743, fol. 26, 26 February 1612.

[14] See Linda Levy Peck, "Patronage, Policy and Reform at the Court of James I: The Career of Henry Howard, Earl of Northampton," Ph.D. dissertation, Yale University, 1973, pp. 38-51.

whom Northampton placed in the Cinque Ports were mainly town oligarchs with a sprinkling of Kentish gentlemen reflecting the invasion of the country gentry into the affairs of the boroughs that Neale described.[15] Furthermore, Northampton brought into his own household two sons of Cinque Ports oligarchs and later named them to important positions in the towns.[16] Despite the decline in economic power and status of the Cinque Ports in the seventeenth century and the region's dependence on the Lord Warden to look after its interests at Court, Northampton was careful to reward the local elites for they wielded influence that the central government needed to oversee. It was a measure of the success of the contemporary patronage system that it enabled the central government to control such regions as the ports without a standing army or a professional bureaucracy.

Northampton's concern both for the integration of traditional elites and for the establishment of central control can be seen in the assertion of his rights of patronage over parliamentary seats. He effectively extended the claims advanced but not realized by previous Lord Wardens by naming one of the two members of Parliament for each of the seven (not five) towns: Dover, Hastings, Hythe, New Romney, Rye, Sandwich, Winchelsea. To the 1604-10 Parliament he named twelve of the port's members of Parliament; in 1614, ten. Again, while this might be interpreted as the heavy-handedness of a Jacobean courtier, it is important to note that the majority of those named by Northampton were local men—either Cinque Ports oligarchs or Kentish or Sussex gentry. In 1614 eight of Northampton's ten nominees were locals.[17] Until his death in 1614, this Jacobean courtier and absentee officeholder tried both to assert his patronage rights in the region under his sway and to placate local elites. Court and Country links were thus maintained through Court patronage.

It must be emphasized that administrative reform was undertaken within the Jacobean court. In analyzing efforts to reform the Renaissance state from within, Trevor-Roper has contrasted French

[15] J. E. Neale, *The Elizabethan House of Commons* (London, 1949), pp. 140-61.

[16] William Bing and Thomas Godfrey; see British Library, Lansdowne MS. 235, fols. 1-13ᵛ.

[17] Peck, "Patronage, Policy and Reform," pp. 52-59; John K. Gruenfelder, "The Lord Wardens and Elections, 1604-1628," *The Journal of British Studies*, 16 (Fall 1976), 1-23. To Gruenfelder's list for 1604-10, I have added George Bing, who sat for Dover, as one of Northampton's nominees.

success with English failure.[18] Through sale of offices on the French Crown's behalf and the rationalization of a wide range of administrative and financial departments, Sully, Richelieu, and Colbert were able to create a stable administration lasting into the eighteenth century. J. H. Plumb finds similar rationalization of administration in England in the period between 1660 and 1715 when officials, enamored of Colbert's reforms, sought to make English bureaucracy more efficient.[19] He notes that at this time experts in "political arithmetic" were recruited to advise on economic and administrative policy. In fact, such efforts to reform the bloated bureaucracy and to seek expert advice took place within the Court throughout the Jacobean period. The administrative work of Robert Cecil, Earl of Salisbury, culminating in the Great Contract—the exchange of the King's feudal revenues for a yearly parliamentary grant—is well known, as is the work of Lionel Cranfield. The Earl of Northampton, however, has not generally been seen as a reformer. Yet his activities illustrate how Jacobean patronage was used to bring able men into government and to initiate administrative change.

As a member of a Privy Council where members had undifferentiated responsibilities and were called on to advise the King on all manner of policy, it was advantageous for Northampton to build up a clientele of advisors. His own standing depended on his ability to generate solutions to the many financial and political problems that confronted the Crown. As a result Northampton put together a Jacobean brain trust of antiquaries, merchants, and office holders from whom he sought advice on policy, particularly in his investigation of the navy, the customs administration, and the office of arms. Sir Robert Cotton, the antiquary, and Lionel Cranfield, the merchant and later Lord Treasurer, were his principal advisors. To illustrate Northampton's reliance on those he considered experts, witness the letter he wrote to Cotton on the matter of union with Scotland. In it Northampton requested "not only your own reasons of the difficulty or facility but whatsoever else you can borrow from your friends either learned in the law or skilled in trade and traffic."[20] Cotton prepared advice for Northampton on such topics

[18] Trevor-Roper, "The General Crisis of the Seventeenth Century," pp. 88-95.

[19] J. H. Plumb, *The Origins of Political Stability, England, 1675-1725* (Boston, 1967), pp. 11-13.

[20] British Library, Cotton MS. Titus C VI, fol. 163ᵛ, Northampton to Sir Robert Cotton, n.d.

as the Spanish peace treaty negotiations, the means of increasing royal revenue, and the privileges of the House of Commons.

Renaissance historiography created a new role for the antiquary, not only as propagandist, but, I would suggest, as government advisor. For the antiquary sought the origins of institutions by means of a critical methodology applied to original sources. In a society that tended to look to the past for solutions to present problems, with the Crown and Parliament basing competing claims on historical precedents, the antiquary was an expert.[21] Sir Robert Cotton was a close friend of William Camden's, a founding member of the Elizabethan Society of Antiquaries, and a country gentleman with a wide range of acquaintance among scholars and the politically preeminent.[22] While Cotton provided the historical underpinnings for Northampton's speeches and position papers, he also provided the Earl with counsel on fiscal and administrative reform. For instance, to his work on the "Means to Repair the King's Estate," prepared at the Earl's request, Cotton appended four hundred folios of mostly original documents dating from the Conquest on, in the hope that the past might provide a treasury of devices applicable to the present. But Cotton did not leave the matter there, for he was as politically astute as he was historically minded. He took a sharp look at why the Crown was in debt and how it might be relieved, stressing those measures that would not antagonize the landed gentry. For instance, in proposing that the King might profit from farming out wastes, Cotton, sensitive to the interests of the local gentry and other tenants, put forward a strategy of local initiative:

> But in the carriage of this business there must be much caution to prevent commotion, for in them there are many that have right of common sans nombre. And the resolution in agreement with them must be sudden, and confident, for multitudes are jealous and inconstant. And the instruments to effect this must be such as are neighbours, interested and popular, not strangers; And the first demise to the inhabitants and at under and easy values.[23]

[21] Peck, "Patronage, Policy and Reform," pp. 142-93.

[22] For a recent and extensive study of Cotton's career see Kevin Sharpe, *Sir Robert Cotton, 1586-1631* (Oxford, 1979).

[23] J. H., Esq., ed., *Cottoni Posthuma* (London, 1651), p. 183. This volume contains the printed version of Cotton's "The Means to Repair the King's Estate." Reprinted anonymously in 1715 as "A Treatise of the Rights of the Crown Declaring How

Cotton's strategy of local initiative obviously impressed Northampton. When the Earl drew up his own "Considerations for Repair of the King's Estate," he insisted that "to make the best of wastes and commons, skillful surveyors must be chosen to bring on some by example of others and working the motion to come by the joint suit of tenants and homeless."[24] He added this caution that "the subject of enclosing wastes commons . . . further than the tenants themselves shall make suit upon consideration . . . is not holden fit for improvement . . . before the next Parliament."[25] It was clear to both Northampton and Cotton that the implementation of government policy was going to be dependent on the acquiesence of the local gentry.

When analyzing the Court itself, Cotton focused on the most important leakage, the King's openhandedness. Ultimately all suggestions for repairing the King's revenues were founded on the assumption that James was seriously willing to curtail his spending and cut off new grants. Cotton drew Northampton's attention to a pertinent precedent: "Hence was it that the wisdom of former time, forseeing the mischief that the open hand of the Sovereign may bring, the state made a law 21 Richard 2 that whatsoever cometh to the King by judgement, escheat, forfeiture, wardship, or any other ways, shall not be given away, and that the procurer of any gift, shall be punished."[26] Cotton's point was that reform demanded the safeguarding of the royal bounty and its dispensation in line with the requirements of policy.

Cotton's most important role came as Northampton's aide on the naval commission in 1608. During the year-long investigation of corruption, the antiquary interviewed witnesses, organized the testimony presented to the commission, and prepared a lengthy report on corrupt practices in every department of the navy. Northampton's and Cotton's analysis of the deficiencies of the naval

the King of England may Support and Increase his Annual Revenues . . ." (London, 1715), it was attributed to William Noy, who served as attorney general under Charles I in the 1630s. Since Noy himself had made efforts to reform the bureaucracy, the misattribution suggests an interesting link between the reformers of the 1610s and the 1630s.

[24] British Library, Cotton MS. Cleo F. VI, fol. 102. Northampton requested Cotton to "bring the book with you that you showed me yesterday touching all the grants from the subjects to the King because I desire very much upon that point to confer with you at some leisure." British Library, Cotton MS. Titus C VI, fol. 145ᵛ, n.d.

[25] British Library, Cotton MS. Cleo F VI, fols. 99-99ᵛ.

[26] J. H., Esq., ed., *Cottoni Posthuma*, p. 170.

administration located the difficulties squarely in the patronage system, and the distribution of patronage without regard to the needs of the King's service. This was their diagnosis.

> Favor is distributed by faction, not by desert. It is not asked what a man can perform but observed upon whom he depends.
>
> .
>
> At this instant, two of the chief officers by their credit, travail and procurement, have conveyed all or most of the chiefest offices of trust and profit either by possession or reversion to the hands of their own followers, allies and instruments, holding it a very poor improvement of their fortune during their own time (by the King's loss) unless to cover their own shame in future ages they settle and stabilize a succession of frauds in a perpetuity of partners.[27]

Northampton argued that the divorce of patronage from policy in naming officials to posts in the naval administration was dysfunctional: enormous waste and rotting ships were the results. The loss of royal patronage to middle-level officials served the needs not of the Crown but of its office holders. Northampton distinguished between Court offices whose duties were routine and those whose duties required administrative ability. In his recommendations for the reform of the navy, Northampton insisted that there should be no deputies, no outside employment or reversions, no life tenure, and no sales of office.[28] Attacking literally all aspects of the contemporary English bureaucracy, Northampton's efforts to reform the navy foundered on the entrenched interest of the venal officers he was trying to uproot. At the conclusion of the year-long investigation in 1609, however, their interests were upheld by the King himself. When the King himself disregarded the Crown's needs, there was little his officials could do. Still they tried.

Perhaps the primary achievement of Northampton's patronage of experts in the fields of law and trade was to discover and recruit for the royal administration the man who was to fight most vig-

[27] Cambridge University, Trinity College MS. R.7.22, fol. 4ᵛ; Public Records Office S. P. 14, XLI, I, fol. 8. The Cambridge manuscript is a copy of Northampton's introduction, "The Report of the Committee appointed by King James I to inspect the Navy." The report itself, drafted by Cotton, is Public Records Office, S. P. 14, XLI, I.

[28] See Peck, "Problems in Jacobean Administration: Was Henry Howard, Earl of Northampton, a Reformer?" *The Historical Journal*, 19 (December 1976), 831-58.

orously for its reformation, Lionel Cranfield. Northampton first turned to Cranfield in 1612 during the conflict with the Archduke of Spanish Netherlands over his ban on the importation of English cloth. He described him as "a special friend of mine own, more witty and of better judgement . . . than any of those that in respect of their trade into those countries were thought most fit to undertake the search."[29] Northampton brought Cranfield to James's service, as the King himself later recalled: "The first acquaintance that I had with him was by the Lord of Northampton . . . who often brought him unto me a private man, before he was so much as my servant; he then made so many projects for my profit."[30] Providing advice on the ever-shaky position of government finances and developing projects to bring in revenue, Cranfield entered government service as Northampton's client.

If Cotton provided aid and historical analysis, Cranfield drew on his own experience in trade to expose inequities in the King's share of the customs farm and in international trade. As a result of Cranfield's analysis, Archduke Albert capitulated and the customs farmers were forced to increase the King's share of the Great Farm of the customs and of the wine farms. Recognizing ability when he saw it, the King gave Cranfield the office of Surveyor-General of the Customs. Northampton was a satisfied patron. To the King's favorite, Robert Carr, he wrote:

> I do the less wonder at . . . Sir Lionel Cranfield in strengthening and seconding not only the King's gracious conceit of his deserts but beside the bounty of so gracious a prince in rewarding his endeavors. For herein his Majesty . . . and your Lord as a worthy instrument do not only encourage the party but also honor him that sets him on works because it is certain that by such visible effects the faithful ministers of powerful princes are either foiled or favored and by such marks all lookers-on take aim for their level. . . . In the satisfaction of those whom I employ my own interest is likewise involved that am employed.[31]

[29] Public Records Office S. P. 14, LXX, 46, Northampton to Rochester, 12 August 1612.

[30] *Journal of the House of Lords*, 22 vols. (London, 1846), III, 343b. This was said by James during the impeachment proceedings against Cranfield in 1624.

[31] British Library, Cotton Titus C VI, fol. 135 (after 4 July 1613).

The twin themes of Northampton's letter are that patronage is the most important index of prestige and that the able official glorifies his King and patron alike. Naming such officials to government office was one way patronage could be used to rationalize Jacobean administration. Northampton also recognized that in order for an able administrator to exercise requisite authority, he had to make it clear to others that he had the ear of the favorite.

Cranfield continued his rise in government service under Buckingham's aegis. Between 1617 and 1620 Cranfield instituted a program of reform and retrenchment, establishing commissions to investigate and reform the Household, the navy, and the Office of the Ordinance. His program has been described as the "first effective effort of the Stuart period to improve Crown finances."[32] Paralleling Northampton's commissions a decade earlier, Cranfield's achieved greater success, perhaps due to the support of the favorite. In the case of the Household, for instance, Cranfield was able to reduce expenditures from £77,000 to £59,000 a year, not much more than the Crown had spent under Edward VI and Mary, and comparing not unfavorably with Burghley's expenditures of £48,000 a year. Cranfield's hard work can be seen even in the minutiae of the household investigation. Having ascertained from the officers that there were 40 pieces of beef in every ox, and 24,450 pieces of beef served every year, Cranfield calculated that he had accounted for 535¾ oxen. But the Household had bought 668 oxen. "What became of these 132¼ oxen?" Cranfield triumphantly asked, and then questioned as an afterthought, "how do we even know that an ox contains only 40 pieces of beef?"[33]

More seriously, procedures used by Cranfield and the commissioners reflect the use of patronage in pursuit of reform. Cranfield circumvented entrenched officials in the Wardrobe by naming his own personal servants to handle accounts. As a result Wardrobe spending was cut from £48,000 to £20,000.[34] In the navy Cranfield's commissioners tried to reassert central control over patronage

[32] Menna Prestwich, *Cranfield: Politics and Profits under the Early Stuarts* (Oxford, 1966), p. 211. It is necessary to acknowledge the important work of Robert Cecil in the early years of James's reign; see "Church and State, 1558-1612: The Task of the Cecils," in Joel Hurstfield, *Freedom, Corruption and Government in Elizabethan England* (Cambridge, 1973), pp. 79-103.

[33] Prestwich, *Cranfield*, pp. 210, 208.

[34] Prestwich, *Cranfield*, pp. 228-30.

by ending the practice of granting reversions and gradually, as patents fell in, by changing the terms from tenure for life to service during pleasure. They saw to it, moreover, that offices were to be granted only on the nomination of the Lord Admiral.[35] Thus, both high and low officials would be dependent, not on their superiors, but on one of the Crown's chief officials. (Unfortunately in this case the Lord Admiral was the Duke of Buckingham, soon to lose interest in reform.) Menna Prestwich, by no means an uncritical biographer, likens Cranfield's program as Treasury Commissioner to those of Sully, Richelieu, and Colbert.[36]

While Cranfield was premier in these efforts, he was not alone. Bacon too participated, as did other officials such as Sir John Coke and Sir Richard Weston.[37] With the appearance of more studies of Jacobean officials, we are learning that many did try to exercise oversight, to manage the King's resources more effectively, and to cut down on government spending. That they also looked out for their own profit while in government service does not vitiate their efforts, for this grew out of the nature of Renaissance government and reflected contemporary mores (although Bacon was to learn to his chagrin that such mores were changing).

If reform, then, was undertaken throughout the Jacobean period, if the Court always contained reformers who, in the period 1617-20, even had the backing of the King's favorite, Buckingham, if

[35] Prestwich, *Cranfield*, pp. 216-17.

[36] Prestwich, *Cranfield*, pp. 223-26. It is, of course, necessary to distinguish the work of these French ministers. For instance, Orest Ranum has stressed that Richelieu emphasized *fidelité*, placing men into office who were loyal and dependent on him (*Richelieu and the Councillors of Louis XIII* [Oxford, 1963]), whereas Colbert is traditionally viewed as systematically rationalizing French administration and instituting the merit system, as in Ernest Lavisse's magisterial *Histoire de France*, VII (Paris, 1911). Colbert too, however, had to function within the limits of early modern administration, and recent work indicates that his reforms may have been less systematic than usually thought. In reforming the navy, for instance, he placed in office a new hierarchy of officials dependent on himself, but did not abolish the old administration; see Henri Legohérel, *Les Trésoriers généraux de la Marine 1517-1788* (Paris, 1965). (I am grateful to Geoffrey Symcox for this reference.) Thus it may not be completely possible to disentangle *fidelité* and merit in seventeenth-century administrative reform.

[37] See Michael Young, "Sir John Coke (1563-1644)," Ph.D. dissertation, Harvard University, 1971; Young questions Cranfield's role in reform of the ordinance in "Illusions of Grandeur and Reform at the Jacobean Court," *The Historical Journal*, 22 (March 1979), 53-73. Michael Van Cleave Alexander, *Charles I's Lord Treasurer: Sir Richard Weston, Earl of Portland (1577-1635)* (Chapel Hill, 1975).

experts were being consulted to help formulate government policy, and if Court patronage was being used to implement government policy, what went wrong?

For the answer to this question, it is necessary to stress that the failure of reform in the Renaissance state was due at least in part to structural difficulties.

The basic structural problem was that the patronage resources of the Crown, particularly government offices, were decreasing at the same time that the numbers of those seeking favor were increasing. It is clear that in the Jacobean period, the tenure of office was increasingly for life and appointment was increasingly in the hands of middle- and lower-level officials. While the French monarchy established new offices and sold old ones to carry on the actual work of the government, the English Crown remained at the mercy of its officeholders. G. E. Aylmer has pointed out that the Crown's freedom of action was limited by officeholders who opposed the creation of new offices as well as by the number of reversions attached to offices and life tenure.[38] Those who sought to reform the bureaucracy—whether Cecil, Northampton, Cranfield, or the proponents of Thorough—sought to regain the Crown's patronage power. The prescription for reform was that the dispensation of favor should remain in the hands of the government's chief officials.

The growth (if not the rise) of the gentry changed the character of the Jacobean patronage process from that of earlier periods. Of great social and political significance, such an expansion in the sixteenth and seventeenth centuries, due to population increase and prosperity, land distribution, and greater access to education, was attested to by the larger numbers of justices of the peace and those claiming gentility.[39] This growth in the political elite had crucial consequences. On the one hand, it meant a greater strain on the Court's ability to reward and maintain the Tudor balance of patronage. On the other, it meant increased use of allocative devices in the sharing of rewards as competition for favor intensified under the early Stuarts. What has been called market corruption, the dispensation of patronage on the basis of payment, was characteristic of the early Stuart period, and a significant change from earlier

[38] Aylmer, *The King's Servants*, pp. 136-37, 465.
[39] Stone, *Crisis*, p. 38, A. H. Smith, *County and Court: Government and Politics in Norfolk, 1558-1603* (Oxford, 1974), pp. 51-61.

times.[40] Everything seemed to be for sale at the Jacobean court: titles, honors, offices, privileges, and monopolies. Such sales raised revenue for the Crown and its favorites at a time when other sources, including parliamentary subsidies, were drying up; meanwhile, they allocated rewards in a system in which demand greatly exceeded supply.[41] In the long run, however, these practices produced dissatisfaction within the political elite.

An excellent example is the creation of the baronetage, for it illustrates Jacobean efforts to use patronage to reward the politically important and the inexorable pressure of numbers seeking reward. Sir Robert Cotton was instrumental in developing the notion of the baronetage, the sale of titles for the Crown's benefit. In the years from 1611 to 1614 while selection remained under the control of Salisbury and Northampton, the distribution of baronetages was judicious; the numbers kept low. A clear case of the complementary nature of Court patronage and government policy, the creation of the baronetage raised revenue at the same time that it rewarded the politically important.

But the market price dropped from £1,095 to £220 by 1622, and the conclusion frequently drawn is that, with the proliferation of titles, the quality of the baronets fell.[42] No one, however, has examined the later recipients. Certainly those baronets in 1611 were eminent country gentlemen: 39 had been sheriffs, 33 Members of Parliament. But of the later appointments, of which there were 112 up to the year 1625, 26 had been sheriffs and 14 Members of Parliament before their appointment; 27 would be sheriffs and 34 would be Members of Parliament after their appointment. Of the 112 only 23 held no county position.[43] In other words 80 percent

[40] "Proto-Corruption in Early Stuart England," in James C. Scott, *Comparative Political Corruption* (Englewood Cliffs, N. J., 1972), pp. 12, 54.

[41] See Conrad Russell, "Parliamentary History in Perspective, 1604-1629," pp. 1-27; Arnold Heidenheimer, ed., *Political Corruption* (New York, 1970), p. 5.

[42] See Stone, *Crisis*, p. 93, and Katherine S. Van Eerde, "The Jacobean Baronets," *The Journal of Modern History*, 33 (1961), 144-45. Van Eerde cites John Burgh, writing in the next reign: "many men of base birth and weak estate . . . had this honour conferred on them, to the disgrace of the first institution" (p. 144). Similar complaints, however, were made of the first recipients, who, as Van Eerde points out, were "men of good birth and real substance" (p. 142).

[43] I am grateful to Conrad Russell for suggesting the baronets as a test case of Court and Country patronage links. The analysis here of the Jacobean baronets is drawn from G. E. C[ockayne], *The Complete Baronetage*, vol. I (Exeter, 1900); *DNB*; and local histories.

of those created baronets were not only country gentlemen but county officeholders. Of particular interest is the small number of titles conferred on courtiers. A handful of officials were created baronets, including Francis Cottington and Adam Newton as well as a couple of lawyers and a merchant. They stand out by their oddity. In short, the title of baronet was created and distributed throughout James's reign to reward and link country leaders and gentry with the Court.

These are the overall figures, but if we examine one county in detail the findings are the same: in Norfolk four of the five later creations were members of old county families. For instance, Sir Richard Berney's mother was a Gawdy, and his grandfather served as a justice of the Court of Common Pleas and as high sheriff of the county. One of his brothers married the daughter of Sir Edward Coke and another was sheriff of Norfolk, as Sir Richard was himself two years after his creation.[44] Sir Edward Barkham alone was a new man and an outsider who bought land and established his estate in Norfolk. Yet he too was politically important. Barkham was made a baronet the year he served as Lord Mayor of London. His funeral monument symbolizes that hardy British tradition of merchants becoming landed gentry; for it shows him wearing his Lord Mayor's gown over knightly armor.[45] This is not to suggest that all recipients of the baronetage were of equal quality or that the distribution of these titles did not create real dissension amidst the ranks of the gentry and prompt questions in the House of Commons. But it is of some interest that Sir Francis Barrington, the well-known Puritan gentleman with political links and kinship ties to most of those critical of the Court in the 1620s, had three sons-in-law who were made baronets in the 1620s.[46] Even for the Puritan and county leaders the status the title conferred overcame distaste for payment. In short, the pressure of numbers, not the ill-breeding of the recipients, drove the price down.

This distortion of the patronage system was reflected in the position of the patron. While normally that position was inherently superior to that of the client, the Jacobean patron found himself as much acted upon as acting, whether at Court or in the localities.

[44] Francis Blomefield, *An Essay towards a topographical history of The County of Norfolk* (London, 1810), XI, 123-28.

[45] Blomefield, *Essay*, VI, 82-83.

[46] Gilbert Gerrard in 1620, William Masham in 1621, and Sir Richard Everard in 1629.

Hassell Smith has described the feverish competition for local office among Norfolk gentry after 1572.[47] Factionalization among those identifying themselves with the interests of Court or Country, rapid turnover of office, and heightened interest in county elections marked Norfolk politics. The result was that, in this case, the country gentry were acting on the Court as much as vice versa. While the Court patron might now have a greater opportunity to stir in local affairs because of such local competition, the increasing scramble for reward created anxiety on his part as to whether or not he would be able to fulfill his part of the patronage contract, delivering a slice of a pie that was constantly shrinking. The patron continuously canvassed his position at Court, his relation to the favorite, and his peers.

This heating up of the patronage process did not begin with James's accession; it has been traced to the 1590s and the narrowing of the channels of Court patronage to two: Essex and Cecil. In their fight to the death, every favor was taken to reveal their standing on the wheel of fortune. Yet this process became exacerbated under James. Northampton provides a case in point. Having created a patronage network spanning the Court and countryside, he found himself caught like a fly in a web of his own making. His letters to the favorite show increasing anxiety even as his influence increased. Over the matter of a knighthood he spoke of "failing," "quailling," "staggered," "disgraceful," and "desperate."[48] Northampton recognized the minor nature of the reward but emphasized the major consequences of failure. In one case concerning an office in the Duchy of Lancaster, he counseled the favorite, Carr, to assert his influence even though the office and the candidates were minor:

> For my part, I know neither of the competitors, but finding that the world expected grace to one of them from you which is a kind of engagement and that the matter in your absence is laid in sleep, I presume to tell your Lordship . . . to stir in it again. . . . But this to yourself alone whose beams I would not have to be eclipsed.[49]

Jacobean patronage was not only organized on the one-to-one re-

[47] A. Hassell Smith, *Country and Court: Government and Politics in Norfolk, 1558-1603* (Oxford, 1974).

[48] British Library, Cotton MS. Titus C VI, fol. 93ᵛ (February 1614); fols. 107-107ᵛ (after 21 February 1614).

[49] British Library, Cotton MS. Titus C VI, fol. 88-88ᵛ (1612-13).

lationship between patron and client; it also included the indirect and more amorphous relations of friends of friends and enemies of enemies. As head of a faction the patron might find himself granting favor to those he knew little of. When at times he was more acted upon than actor, the patron's favor mirrored the expectation of his peers as much as his own inclinations.

Yet another structural difficulty may have been not the bloated administration of the state, but the fact that its efficient parts were too small. Derek Hirst has raised the question as to whether the Crown had the resources to oversee its policies.[50] One can find cases such as the Plantation of Ulster where the Privy Council tried time and again to force its projectors to comply with guidelines. With the outbreak of war in the 1620s, the Council was no longer able to oversee internal policy with vigilance. In some sense, then, the expansion of the bureaucracy in the Restoration period was a reflection, at least in part, of governmental need.

These structural problems—inelasticity of reward, growth in the size of the political elite, lack of governmental capacity—all of which had begun to show up in the 1590s, were brought to the breaking point during the Jacobean period because patronage became the preserve of the King's favorites. The previous competition for favor within the Council among men of different views, each with his own clientele, ensured that favor would be distributed across a fairly broad range of the politically preeminent. Now competition gave way to a single channel—first Carr, then Buckingham. Efforts by Jacobean officials to use their patronage to name competent men to office, to develop policy, and to maintain links with the country came to nought. Attempts to reform administration foundered on the entrenched interests of lower officials and of the royal favorites. The dysfunctional patronage system alienated those local elites it was designed to conciliate.

The Jacobean dilemma of how to manage both patronage and policy simultaneously was brought about by structural difficulties. It was not possible to satisfy all those who hungered for Court reward. Policy required the distribution of patronage to conciliate the politically preeminent; lack of resources prevented its realization. Giving favor often interfered with policy. And some policies, such as raising money through indirect means because parliamen-

[50] Derek Hirst, "The Privy Council and Problems of Enforcement in the 1620s," *Journal of British Studies*, 18 (Fall, 1978), 46-66.

tary subsidies were inadequate, conflicted with the interests of local elites who were the Court's clients. Calling Parliament into session then might hamper projects to increase royal revenues; this became a familiar Jacobean dilemma.

In addition to these problems, a different dilemma confronted Jacobean officials. After working long and hard on commissions to reform government departments, they were faced with a monarch who would not hold his officials to account. Menna Prestwich has contrasted the failure of the English with the successful efforts of Sully, Richelieu, and Colbert to reestablish the resources and power of the Bourbon monarchy in France. The chief difference, she suggests, lay in French monarchs who, unlike the Stuarts, understood the importance of maintaining the wealth of the Crown, valued the services of able advisors, and were willing to punish corrupt officials.[51] When in 1621 James announced to Parliament that the Court had learned that "every day was not to be a Christmas," it was clear that the separation of patronage from policy began at the top.[52] Thus, while it is necessary to reassess the Jacobean court and see its positive accomplishments, it is equally necessary to admit that James's role remains a mystery. As King of Scotland, James had skillfully balanced factions at Court. Yet he never brought the English patronage system under his control. He was content to allow his officials to flounder in the wake of his favorites. Asking why James did not act may be akin to what Sherlock Holmes referred to as " 'the curious incident of the dog in the night-time.' 'But, the dog did nothing in the night-time.' 'That was the curious incident,' said Holmes."[53] That may be the most curious—and the most important—case of all.

[51] Prestwich, *Cranfield*, pp. 223-26.
[52] Robert Zaller, *The Parliament of 1621* (Berkeley and Los Angeles, 1971), p. 35.
[53] Arthur Conan Doyle, "Silver Blaze."

THREE

Corruption and the Moral Boundaries of Patronage in the Renaissance

ROBERT HARDING

MANY historians and social scientists have pointed out that our modern conception of corruption tends to foreclose discussion of the subject in early modern European states. This is because we define corruption as subversion of the public interest or of the principles of conduct implicit in the idea of public office. In early modern states the present notion of public office did not exist, and the public domain was not clearly distinguished from private interests. The confusion of public and private interests inherent in feudalism was perpetuated through the early modern period by the existence of venality and patronage. This confusion raises the problem of just exactly what people meant when they spoke of corruption in the Renaissance. Is it possible to define corruption in a way that is valid for the Renaissance? There are two general approaches to this problem, and neither is wholly satisfactory.

One approach is simply to sidestep the problem of moral relativity by defining certain practices as corrupt regardless of contemporary norms. Historians often use the word corruption in this value-free way. They group together phenomena like bribery, extortion, nepotism, string-pulling, squeeze, and protection under the label corruption, perfectly aware that in early modern societies either these practices were legitimate or else their moral status was confused. A variant of this value-free approach is the market-oriented definition commonly used now by social scientists and economic his-

torians.[1] In pre-bureaucratic governments, officeholders often treated their offices as business enterprises and sought to maximize their personal incomes from them. Corruption is simply defined as any activity in which officials seem to be operating in a free market, exchanging services and resources for cash. The amounts that businessmen and farmers had to pay for bribes or extortions can, therefore, be thought of as business costs, and official corruption can be conceived as a sector of the economy.

However fruitful this value-free approach may be for the sake of simplification or for understanding the difficulties of economic development, it obviously sheds no light on political morality. The most detailed and sophisticated effort to deal with early modern standards of political propriety has been made by Joel Hurstfield in a series of articles on Tudor-Stuart England and later the Continent.[2] Briefly stated, Hurstfield's point is that the public interest was the standard for political propriety, just as it is today, but that this standard was more loosely applied because of primitive methods of administration and of assessing merit.[3] Patronage was the best available system for assessing merit. In their control of patronage, Burghley, Salisbury, and the *mignons* of Henri III of France were corrupt, but only because they generally promoted clients who were second-rate; this amounted to sacrificing the public to the private interest, the need for a first-rate body of public servants to the interests of a leader of a faction.[4] Similarly, the inadequacies of the tax system meant that officials had to be paid very low

[1] For some examples, see five articles conveniently anthologized in Arnold J. Heidenheimer, ed., *Political Corruption* (New York, 1970): J. van Klaveren, "The Concept of Corruption," pp. 38-40; van Klaveren, "Corruption as a Historical Phenomenon," pp. 67-75; B. Hozelitz, "Performance Levels and Bureaucratic Structure," pp. 76-81; R. Tilman, "Black-Market Bureaucracy," pp. 62-64; N. Leff, "Economic Development through Bureaucratic Corruption," pp. 510-20.

[2] See the three articles by Joel Hurstfield reprinted in his *Freedom, Corruption and Government in Elizabethan England* (Cambridge, Mass., 1973): "Political Corruption in Modern England: The Historian's Problem," pp. 137-62; "Corruption and Reform under Edward VI and Mary: The Example of Wardship," pp. 163-82; "The Political Morality of Early Stuart Statesmen," pp. 183-96. Hurstfield's "Social Structure, Officeholding and Politics, Chiefly in Western Europe," in *The New Cambridge Modern History*, ed. Richard Bruce Wernham (Cambridge, 1968), III, 126-48, is reprinted in revised form in *Freedom, Corruption and Government* under the title "Officeholding and Government Mainly in England and France," pp. 294-325.

[3] Hurstfield, *Freedom, Corruption and Government*, pp. 141, 149-50; Hurstfield, "Social Structure," pp. 133-34, 144.

[4] Hurstfield, *Freedom, Corruption and Government*, pp. 152-53, 193.

salaries. They were therefore expected to accept gifts, favors, and perquisites, and these payments were not considered corrupt unless they were intended to gain preferential treatment. Hurstfield compares such payments and services to tips.[5] In his view, the mounting complaints about corruption in the Renaissance were not the result of a tightening-up of the standards of political conduct, but a response to the very real tendency in governments to sacrifice the public interest in making appointments and awards and in extracting larger incomes from office holding.[6]

The number of scholars concerned with passing moral judgment on Renaissance statesmen has been declining for a long time, but there is no question about the importance of what Hurstfield is trying to do. A grasp of the boundary between legitimate conduct and corruption is essential to understanding the political and institutional history of the period. Disinterest in moralizing and a value-free approach to history can lead to as much distortion as the older penchant for anachronistic censoriousness.

This essay is limited to France in the sixteenth and seventeenth centuries. It is a certainty, rather than a probability, that norms of political conduct varied substantially across national frontiers in the Renaissance. The prevailing assumptions in France were, for example, antithetical to the views of Leonardo Bruni and others of his circle in Florence, who articulated the theory that access to public honors should be based on natural talents, honesty, and commitment to serve the commonwealth, without attention to status, family, and connections. Hans Baron has described the aversion and incomprehension with which these ideas were received north of the Alps.[7] Equally alien was the conception of Machiavelli and Guicciardini that corruption and virtue operated in dialectical tension with one another, forming a cyclical history of decay and regeneration. The tendency to think of corruption primarily as the invasion of the public domain by private interests was clearly emerging in Florentine thought.[8]

[5] Hurstfield, *Freedom, Corruption and Government*, p. 152; Hurstfield, "Social Structure," p. 144.

[6] Hurstfield, *Freedom, Corruption and Government*, p. 153; Hurstfield, "Social Structure," p. 141.

[7] Hans Baron, *The Crisis of the Early Italian Renaissance*, rev. ed. (Princeton, 1966), pp. 418-29. See especially the long note on pp. 421-23.

[8] For discussions of these themes see Felix Gilbert, *Machiavelli and Guicciardini* (Princeton, 1965), p. 176; and J.G.A. Pocock, *The Machiavellian Moment* (Princeton, 1975), pp. 93, 203-4, 258-63, and *passim*.

This essay is also limited to the morality of patronage; this limitation presents some difficulty because perversions of patronage were sometimes viewed as the ultimate cause of other kinds of corruption, such as financial peculation and subversions of justice. As will become apparent, however, some of the normative expectations imposed on patronage were irrelevant to financial and judicial administration, so the morality of patronage does form a distinct subject.

Patronage was a method and set of criteria for appointment to public offices and ecclesiastical benefices, and for the award of titles, honors, certain privileges, fiscal exemptions, money gifts, lands, and pensions. The alternative that French commentators had in mind when they wrote on patronage was not a modern system of recruitment and reward decided by examinations, level of training, and other objective standards of expertise. The alternative that came to mind was venality. Patronage always involved a broader range of awards, but as more and more offices were put up for sale in the sixteenth century, as commissioned charges like governorships and titles of nobility started to be bought and sold, the two alternatives drew into direct competition.[9] The specter of venality haunted discussions of patronage, which was generally viewed as the morally superior method of appointment and award.

This conflict came to a head in the early seventeenth century. In 1602, the royal superintendent of finances, Sully, brought forth a plan to institutionalize venality of office holding by guaranteeing hereditary ownership of offices in exchange for an annual tax payment from each officer; this payment came to be called the *paulette*. Henri IV backed this plan, and it was finally enacted in December 1604. Undoubtedly, it was a financial expedient.[10] However, its consequences were so significant that ever since the seventeenth century the belief has persisted that the *paulette* was also deliber-

[9] Between 1515 and 1665 the number of royal offices in France (not including commissioned charges such as governorships) increased from about 4,041 to 46,047. Taking account of population change, this translates into an increase from about one officer for every 4,700 inhabitants in 1515 to about one officer for every 380 inhabitants in 1665. Correspondingly, the increase was from one officer for every 115 km^2 to one for every 10 km^2. See Roland Mousnier et al., *Le Conseil du Roi de Louis XII à la révolution* (Paris, 1970), pp. 17-20.

[10] On the intense pressure the King was mounting to raise revenue in 1604, see Sully's *Sages et Royales Economies d'Estat*, in Michaud and Poujoulat, eds., Nouvelle collection des mémoires relatifs à l'histoire de France, no. 16 (Paris, 1881), pp. 555-59, 619-21. This work will henceforth be cited as Sully, *Economies royales*.

ately intended to undermine and partly supplant the system of pa-
tronage and patron-client loyalties for political and social reasons.
Hereditary transfer sharply curtailed the influence of the *noblesse
d'épée* over royal administration and over the *noblesse de robe* who
held offices. Since 1946 it has been forcefully argued that although
these political and social consequences were widely appreciated by
the time of the Estates General of 1614, no one seems to have
foreseen them at the time of the debate over the *paulette* in 1602-
4.[11] This argument—that the new plan was simply a fiscal inno-
vation—has not been universally received, and a new attempt has
been made to revive the theory of an attack on patronage that
depends primarily on a single important piece of evidence—Jacques-
Auguste de Thou's summary of Sully's argument in defense of the
paulette.[12] Sully was put on the defensive by critics, led by the
chancellor Bellièvre, who cogently predicted the range of corruption
that hereditary transfer of offices would lead to:

> Rosny [Sully] responded to these arguments that honors, dig-
> nities and offices were no longer the *bienfaits* of the Prince;
> that all these things had become the fruit of intrigues and the
> prey of avaricious *courtisans* who gave them away to bind
> clients or sold them to meet their expenses; . . . that instead
> of letting money run into the coffers of individuals, it was
> much more reasonable to channel its course into the public
> treasury.[13]

What were Sully's intentions in making this argument? There are
good reasons to doubt that he was making a political or social
critique of the system of patronage and aristocratic clientage. He

[11] Roland Mousnier, *La vénalité des offices sous Henri IV et Louis XIII*, 2nd ed.
(Paris, 1971), pp. 594-605; Raymond Kierstead, *Pomponne de Bellièvre* (Evanston,
1968), pp. 130-34.

[12] J. R. Major, "Henry IV and Guyenne: A Study Concerning the Origins of Royal
Absolutism," *French Historical Studies*, 4 (1966), 365-67; J. R. Major, "Bellièvre,
Sully, and the Assembly of Notables of 1596," *Transactions of the American Phil-
osophical Society*, N.S. 64 (1974), pt. 2, 29-30.

[13] Jacques-Auguste de Thou, *Histoire universelle depuis 1543 jusqu'en 1607* (Lon-
don, 1734), XIV, 325; my translation. The two key sources for Bellièvre's arguments
against the *paulette* are a 29 November 1602 letter from him to Villeroy and a 1602
memoir by him. These documents are in Bibliothèque Nationale, FF [fonds français]
15894, fols. 544, 450-54 respectively. The memoir and part of the letter are reprinted
in E. Fages, ed. "Contre la Paulette. Mémoire du chancelier Bellièvre," *Revue Henri
IV*, 2nd ed., I (1912), 182-88.

was probably making an implicit ethical distinction and indicting only certain operations of patronage that he thought transgressed the acceptable limits. Both in theory and in practice, Sully was a well-known proponent of the interests of the *noblesse d'épée* and of their role in monarchical government.[14] It is unlikely that he would intentionally undermine the influence of his own class. Neither he nor his king was completely disillusioned with the political value and legitimacy of clientage. The other side of their attitude toward the system emerges from the King's advice to his superintendent when he received the governorships of Poitou and adjacent regions in 1603:

> Governing these provinces and especially over their Huguenots, you will [act] with prudence, following the instructions I give you, and pass through your mediation all the gratifications they will get from me. You will receive all the credit and diminish that of the Bouillons and malcontents, above all making them know that my intentions are good. . . . Maintain constantly an equality of affections, of favors and of *bienfaits*, always guarding the proportions due to the rank, capacities and services of each.[15]

When Sully visited his provinces in the summer of 1604, he faithfully propagandized this view of the operation of royal patronage and claimed that it placated the provincial nobility.[16]

It appears, therefore, that the attitude of Sully and the King toward patronage was not so unconventional as de Thou's report suggests. When it ran the way it should, patronage was a vortex that drew the nobility and other elites into royal service and preserved social harmony. Unfortunately, the system was corrupted. De Thou's report proves that the issue of patronage was on the

[14] Major, "Bellièvre," p. 29. David Buisseret, *Sully* (London, 1968), pp. 175-77. Roland Mousnier, "Sully et le Conseil d'Etat et des Finances," *Revue historique*, 192 (1941), 82-83. Kierstead, *Pomponne de Bellièvre*, pp. 128-29.

[15] Sully, *Economies royales*, XVI, 521-22. I have altered punctuation to break up sentences for the sake of coherence. Bouillon was a Protestant leader in Poitou who was implicated in the revolt of the marshal Biron which resulted in Biron's execution in the summer of 1602. The untranslated phrase is *"Bouillons et brouillons"*—a pun.

[16] Sully, *Economies royales*, XVI, 585-86. Sully informed the nobles that the King intended "to preserve an equality with just proportions in the distribution of his *bien-veillance*, favors, honors, charges, dignities and gratifications" and to reward them "by gratifications proportional to their services and loyalty."

minds of royal councilors in the debate over the *paulette*, but it was the corruptions of patronage, not the system itself, that had a bearing on their decision. Sully's argument was, in effect, that hereditary transmission of offices was no worse ethically than the way offices, resignations, and *survivances* were dispensed by courtiers. Criticisms like those of Sully had been commonly heard since the 1570s when the Court and its munificence sank into a sort of moral crisis, an erosion of confidence and public respect. It was precisely the *noblesse d'épée* that felt most victimized by the "avaricious *courtisans*" Sully alluded to. It had become very difficult to believe that patronage was proof against the sort of "corruptions" Bellièvre feared from the *paulette*.

Henri IV's remark about "the proportions due to rank, capacities and services" was a platitude that summarized the conventions of patronage in Renaissance France. These norms are treated in varying detail in formal treatises of the period, of which I have found the most useful to be the famous works of Charles Loyseau and Jean Bodin, Emeric Crucé's *Le nouveau cynée* of 1623, Cardin Le Bret's *Traité de la souveraineté du roi* of 1632, and Philippe de Béthune's *Le conseiller du roi* of 1633.[17] These five formal treatments can be supplemented by fragmentary remarks on patronage that crop up constantly in speeches, *cahiers*, correspondence, and other sources from the Renaissance period. The danger with formal treatises is, of course, that the opinions may be idiosyncratic. There is a reassuring banality, however, in the sections on patronage in these five works and a repetition of themes that recur through the political rhetoric of the period. All of these commentators wanted to keep patronage corralled within ethical boundaries, but these boundaries were variable, logically unrelated, and often conflicting in their dictates.

All five treatises advocated a criterion for appointments and awards that resembles the modern conception of merit, except that it was conceived much more in terms of innate talents rather than talents acquired by training and education. Charles Loyseau wrote that external honors should be distributed in proportion to indi-

[17] C. Loyseau, *Les Oeuvres*, ed. C. Joly (Paris, 1616). Jean Bodin, *Six livres de la République* (Paris, 1579). Emeric Crucé, *Le nouveau cynée* (Paris, 1623; reprint, T. Balch, ed., Philadelphia, 1909). Cardin Le Bret, *Traité de la souveraineté du roi* (Paris, 1632). Philippe de Béthune, *Le conseiller d'Estat* (Paris, 1665).

vidual merit, which he called "internal honor" or "virtue."[18] Philippe de Béthune had the same idea in mind when he urged recognition of the "natural capacities" or "humors" of candidates in making appointments. Military charges should go to valiant men, judicial offices to judicious men.[19] Emeric Crucé in *Le nouveau cynée* described the art of matching offices and charges to the "habits" of candidates: "If he is prudent and politic, one will make him a Councillor of State. . . . One will grant him management of finances if he is exempt from avarice."[20]

Such formulas give a modern ring to Renaissance commentaries on patronage. However, none of these critics considered merit to be the only criterion for patronage. The imperatives of personal loyalty and respect for ascribed status were also recurrent themes. Given the prevailing assumption that the social hierarchy was sanctioned by natural and divine laws, it was difficult to escape the conclusion that privilege and rank provided their own justification for awards. This is presumably what Secretary of State Villeroy had in mind when he wrote that the King should not give to social inferiors what "nature and ancient laws and constitutions assigned to *les grands*."[21] In its general *cahier* of 1614 the second estate informed the monarch that "nature, religion and duty" obliged him to regulate pensions and confine them to "gentlemen of merit."[22]

While all of the formal commentators allowed for the claims of privilege, they distinguished themselves from one another in their generosity toward the claims of the hereditary nobility, especially the *noblesse d'épée*. Loyseau was parsimonious in preserving his insistence that all offices and charges be distributed by merit; he allowed the nobility only an automatic monopoly of military positions by his claim that the nobility possessed, by definition, only

[18] Loyseau, "Cinq livres des offices," in *Les Oeuvres*, pp. 14, 63-64; Loyseau, "Traite des ordres et simples dignités," in *Les Oeuvres*, p. 79.

[19] Béthune, *Le conseiller*, pp. 139-40. See also pp. 178-83, 362-70.

[20] Crucé, *Le nouveau cynée*, p. 137. For other contemporary formulations of this theory, see Le Bret, *Traité*, pp. 209-10; Bodin, *Six livres*, pp. 508-22; Anon., *Avis à Messieurs des estats sur la reformation et le retrenchment des abus & criminels de l'Estat* (n.p., 1588), pp. 9-10 (Bibliothèque Nationale Imprimés Lb[34] 525); *Recueil des cahiers généraux des trois ordres aux Etats-généraux*, ed. Lalourcé and Duval (Paris, 1789), II, 283, article 262, 1576, 3rd estate.

[21] N. de Villeroy, *Mémoires*, ed. Michaud and Poujoulat, Nouvelle collection des mémoires pour servir à l'histoire de France, no. 11 (Paris, 1838), p. 108.

[22] Lalourcé and Duval, eds., *Recueil des cahiers*, IV, 175, 1614, 2nd estate.

one form of merit—the virtue of military valor.[23] Emeric Cru , a monk who became a law professor, was the most extreme of the commentators in downplaying the significance of status and family background, but he did not dispense with it. "The nobility of race merits also some consideration," he wrote, "and it is to be presumed that the son of a good father will bear himself heir of his virtues, and will dread blame, if he has any sentiment. Therefore he must be preferred to him whose ancestors are unknown, in case they are both equal in capacity and worth."[24] The natural emulation of fathers and the need to live up to the family name ("dread blame") were common justifications for nepotism, which was unquestionably an accepted norm in appointments and awards, even if it was excoriated in other administrative procedures. Bellièvre is a good example of someone who could crusade against nepotistic connections between judges and litigants while never losing confidence that great robe families like his own should be a hereditary elite.[25]

Cruc seemed to give priority to merit over privilege, postulating that rank and family background should come into play only after a pool of applicants had been formed on the basis of merit.[26] Elsewhere, however, he seemed to take it as a foregone conclusion that even merit would be secondary to the need for recompensing services.[27] Commentators were at pains to distinguish recompenses or liberalities from payments.[28] Patronage awards of all sorts were

[23] Loyseau, "Cinq livres," in *Les Oeuvres*, p. 83.

[24] Cruc , *Le nouveau cyn e*, p. 135. Béthune's statement on the claims of privilege is in *Le conseiller*, pp. 179-80, 182, 256.

[25] Edmund H. Dickerman, *Bellièvre and Villeroy* (Providence, 1971), p. 124; Kierstead, *Pomponne de Bellièvre*, pp. 107, 132.

[26] This priority is confirmed by the passage immediately following the preceding quotation: "But virtue must always have the upper hand in matters of honor and recompense: otherwise affairs will never move smoothly. And although it seems difficult for a monarch to show the door to a brother or a mother who presents to him someone to be provided with some post or benefice, nevertheless such recommendations must not take place, unless they are based on the merit of the person who is presented" (Cruc , *Le nouveau cyn e*, p. 136).

[27] "Recompense incites men to do well. It is due to those who have done some good deed for the Prince or the public. It is very reasonable that they should be recognized, and it would be ingratitude to do otherwise. But also the men of virtue and industry must not be forgotten, since they have qualities that raise them above the vulgar and make them capable of executing great things" (Cruc , *Le nouveau cyn e*, p. 131). Béthune's dictum, "avant les mérites les services doivent marcher," is more emphatic (*Le conseiller*, p. 363).

[28] Béthune, *Le conseiller*, pp. 254, 367. Bodin, *Six livres*, pp. 70-76.

supposed to stimulate gratitude and rededication to loyal service, as well as provide compensation in proportion to the services already received. The principle of reciprocity decided the legitimacy of awards, but it applied within an ongoing relation of loyalty, whether a strictly personal patron-client relationship or a more generalized protection relation such as that between a governor and the corporate institutions in his province.

The continued respect for these relations of "*fidélité*" goes some distance toward clearing up the difficult Renaissance distinction between "corrupt gifts" (*dons corrompables*) and legitimate ones. Examples of corrupt gifts included bribes to judges to subvert justice and gifts to officials from foreign sovereigns or ambassadors.[29] Bodin, Béthune, and Crucé all wrote that it was a virtue in a ruler to offer corrupt gifts to foreigners but a great vice in foreigners to accept them.[30] Gifts intended to lure people from prior loyalties and obligations might be considered corrupt, although often with an element of subjectivity.[31] On the other hand, many apparent bribes or kickbacks that were clearly meant to elicit preferential treatment were considered legitimate because they occurred within the context of an ongoing relation of protection and loyalty. It was no vice for a provincial governor to accept large money gifts from town councils and other corporations in exchange for favors; nor was it considered illicit for a lawyer to serve an aristocratic family for years in the expectation of eventual help in securing a royal office.[32]

The formal treatments of patronage display a striking reluctance to attach priority or relative importance to the acceptable standards for awards. Even Crucé was vague and somewhat inconsistent on

[29] For examples see François Isambert et al., eds., *Recueil général des anciennes lois françaises* (Paris, 1822-1833), IX, 249, edict of April 1453, article 118; Edmond Huguet, *Dictionnaire de la langue française du seizième siècle* (Paris, 1925-1966), under "corrompable," "corrupteur," etc.

[30] Bodin, *Six livres*, p. 242. Béthune, *Le conseiller*, p. 365. Crucé, *Le nouveau cynée*, p. 93. See also Lalourcé and Duval, eds., *Recueil des cahiers*, II, 146, 1576, 2nd estate; and IV, 273, 1614, 3rd estate.

[31] Le Bret, *Traité*, pp. 179-80. Béthune, *Le conseiller*, pp. 365-66. Huguet, *Dictionnaire*, under "corrompable," etc.

[32] For numerous examples, see Robert Harding, *Anatomy of a Power Elite: The Provincial Governors of Early Modern France* (New Haven and London, 1978), pp. 135-37, 182-89.

this point.[33] Good statesmanship was viewed as an ability to balance the dictates of all the criteria, rather than as consistency in the application of a single rule. This Renaissance plurality of norms was related to a tendency to view corruption as a systemic evil rather than as individual malfeasance. Accusations of financial peculation, for example, made little sense unless they could be pinned on an individual. Accusations about patronage most often referred to the systematic neglect of merit, status, or services in making appointments and awards. This way of looking at the subject lent itself to organic analogies, which abound in the literature on patronage. Corruption was an imbalance in the humors of the body politic, an ulcer, or a disease. It is often ambiguous whether the term referred to political impropriety or to natural decay.

Another theme of the literature was the familiar Renaissance tendency to view the old ways as best and to believe that all evil was recent. Criticisms of patronage policy frequently ended with appeals to return to the way things were back in some golden age. In the late sixteenth century, the reign of François I was the main model to be emulated.[34] In the seventeenth, it was the reign of Henri IV.[35]

[33] Crucé seems to put rank and merit on an equal footing as criteria in discussing ecclesiastical benefices, and he allows exceptions to the primacy of merit for persons the King personally favors (*Le nouveau cynée*, pp. 136, 148). It should be apparent that in discussing only merit, rank (or privilege), and services (or loyalty), I have isolated three norms for appointments and awards that, in my judgment, were the most important and generally acknowledged. Some political moralists added other criteria that seem to be either minor or refinements of the three principal ones. Most notably, Béthune (*Le conseiller*, pp. 363-67) added four more reasons for monarchical liberality toward individuals. Two of these have to do with initiating a relationship of personal loyalty—to win foreigners from the service of enemies and to attract new servants. The other two reasons were to gain a reputation for liberality and to display "good will." Béthune did not specify how important he thought these reasons were, but judging from the whole body of literature on patronage, they seem minor. Certainly most writers would never have thought it justifiable for the government to neglect merit, rank, and services simply to exhibit liberality and good will.

[34] Bodin, *Six livres*, pp. 518, 630.

[35] Jean Bourgoin actually said that "the ancient golden age" had been restored by Henri IV only to be swiftly debased under his widow (*La chasse aux larrons* [Paris, 1618], p. 1 [Bibliothèque Nationale Imprimés Lf[76] 50]). See also Lalourcé and Duval, eds., *Recueil des cahiers*, IV, 93, 175, 196, 1614, 1st and 2nd estates; and A. Arnaud, *Propositions au roy sur la Reformation de l'Estat* (Paris, 1617), pp. 1-14 (Bibliothèque Nationale Imprimés Lb[36] 1067).

Looking back over their many decades in high public offices, both Villeroy and de Thou attached great significance to the year 1574 for the origin of the corruption of their own time. They viewed the accession of Henri III as a very abrupt change in patronage policy, a "strange revolution," to use de Thou's phrase.[36] De Thou's explanation was simply that Henri III changed the "method and rules" of appointments and awards for the benefit of those who had the most *crédit* at Court.[37] Villeroy, who was a secretary of state at the time, had a more detailed and technical explanation. He said that the new King altered the procedure of awards so that the secretaries of state no longer screened requests to make sure of their legality. The secretaries were converted into simple scribes who expedited any request from a suitor with a petition signed by the King. Before he fully realized his new role, Villeroy found himself in hot water for resisting a request from the seigneur d'Escars for a privilege to tax the tenants on his estates for the upkeep of troops in his chateau, a practice prohibited by royal edicts.[38]

The crisis of the patronage system was fundamentally one of brokerage, or the mediation of appointments and awards. Villeroy's explanation was clearly a minor aspect of the problem, since royal legislation did not begin to comprehend or define all the corruptions of patronage.[39] Nor was the simple existence of brokers the basic problem. Admittedly this was an area of some disagreement, since political commentators sometimes enjoined monarchs to make all appointments and awards themselves.[40] Such a naively idealistic position was never accepted in real politics. De Thou and Villeroy both closely identified legitimate brokerage roles with social status. To de Thou it was "the *grands* and those whose services were known" who should have the ear of the King.[41] To Villeroy, it was "the princes and seigneurs of quality."[42] Radiating out through the

[36] De Thou, *Histoire universelle*, VII, 134.

[37] De Thou, *Histoire universelle*, IX, 72.

[38] Villeroy, *Mémoires*, p. 108.

[39] The most patently illegal abuse of patronage was alienation of the royal domain, an ongoing process in the Renaissance but a violation of fundamental law. On alienations see especially Le Bret, *Traité*, pp. 322-26.

[40] Bodin, *Six livres*, pp. 435, 516-17. Béthune, *Le conseiller*, pp. 139, 369. Lalourcé and Duval, eds., *Recueil des cahiers*, IV, 192, 1614, 2nd estate.

[41] De Thou, *Histoire universelle* (1574), VII, 134.

[42] Villeroy, *Mémoires*, p. 108. Crucé proposed a specialized secretary to keep tabs on the worthiness of candidates for appointments and use of the royal council to screen requests (*Le nouveau cynée*, pp. 133, 151-52).

provinces, the system of governors and their lieutenants was a continuation of the legitimate brokerage system and a way of partitioning influence geographically. The role Henri IV envisioned for Sully in Poitou in 1603 had long been uniformly instituted throughout the country.

The problem under Henri III (1574-1589) was that the brokers at Court were the *mignons*, "new men" from lesser noble families, who had neither merit nor an accumulation of worthy services, only "the most infamous services."[43] The *mignons* became notorious for selling offices and hitherto non-venal commissioned charges, such as governorships and military commands, which subverted all the conventions for their award.[44] The result was a dramatic widening of the psychological and moral cleavage between the Court and the *noblesse d'épée*. Most of the *grands* lost their brokerage influence, and most of the lesser nobles followed their lead in returning to the provinces. "The court was at first very numerous," de Thou remarked, "but became quickly deserted."[45] To be sure, some of the abuses antedated 1574. One obvious case was the corruption of the knightly Order of St. Michel, still the subject of lamentation under Henri III. Originally these knighthoods were restricted to a few dozen of the most worthy great nobles, but after the 1560s many hundreds of titles were handed out to persons of lowly status and no discernible merit or record of services.[46]

Somewhat paradoxically, the Court acquired notoriety for "prodigality" at the same time that it was alienating the *noblesse d'épée*. Pasquier thought his country's Court displayed "a liberality never seen in any other Republic."[47] Bodin also marveled at the fact that royal revenue in France maintained 2,000 pensioners, not including

[43] De Thou, *Histoire universelle*, VII, 134; VIII, 550. See VII, 729-30 for a petition from the estates of Burgundy making the same points. See also Villeroy, *Mémoires*, p. 108.

[44] Lalourcé and Duval, eds., *Recueil des cahiers*, III, 53, 139, 1588, 1st and 2nd estates. De Thou, *Histoire universelle*, VII, 134, 729; X, 674-76. Harding, *Anatomy*, pp. 124-25.

[45] De Thou, *Histoire universelle*, VII, 134-35. For other passages on the alienation of the nobility, see VIII, 550; X, 674-76.

[46] Bodin, *Six livres*, pp. 512-14. De Thou, *Histoire universelle*, VI, 424. Michel de Montaigne, *Essais*, ed. M. Rat (Paris, 1962), I, 418-20. Harding, *Anatomy*, pp. 81-82.

[47] Etienne Pasquier, *Oeuvres* (Paris, 1723), II, 338-39 (Pasquier to Sainte Marthe, n.d. [1588]).

foreigners.[48] We do not have to rely on these impressions to know that the financial component in the French patronage system was a mammoth operation by comparison with, say, England, even if we allow for the fact that France's population was about four times larger. Queen Elizabeth kept the costs of pensions and fees for her government under £30,000 per year.[49] This amounted to less than one-tenth of what the French crown paid in pensions alone, even in the mid-1570s in the thick of the civil wars—over 2.5 million *livres*.[50]

Throughout his career Villeroy recommended a policy of satiating the great nobility with large gifts and pensions, and Bellièvre was in general agreement. The reasons are best revealed in the private memos Villeroy addressed to Marie de Medici toward the end of his career. Royal liberality would encourage the great aristocrats to "comport themselves with more gratitude and stability," and the money would trickle down and eventually ameliorate "the misery of those who have mismanaged their houses."[51] Villeroy presumed that because the lesser nobility was still grouped in the clienteles of the *grands*, in their households, military companies, and local government positions, the huge sums paid to the *grands* would be well spent.

Many commentators, including Sully, advocated greater restraint than Villeroy's advice suggests. Nonetheless, the distinction between the great virtue of liberality and the great vice of prodigality was more a matter of where the money went and how it was used than a matter of sheer amounts. Everyone could agree on the prodigality of the *mignons* because there was no justification for it in the traditional terms of recompensing services and sustaining the military

[48] Bodin, *Six livres*, pp. 606-7. See also pp. 519-21; Lalourcé and Duval, eds., *Recueil des cahiers*, II, 296-97, article 295, and pp. 318-19, 1576, 3rd estate; III, 164, article 244, 1588, 2nd estate.

[49] Lawrence Stone, *The Crisis of the Aristocracy* (Oxford, 1965), p. 419.

[50] Bibliothèque Nationale Dupuy 852, fols. 30-99, "Estat des pensionnaires du Roy . . . ," shows pensions on the Epargne totaled 1,853,835 l.; pensions on the *recettes générales* came to 392,764 l., and 311,438 l. on the *caisses* of the *trésoriers de l'extraordinaire des guerres* (1576).

[51] Cited by Joseph Nouaillac, *Villeroy secrétaire d'état et ministre* (Paris, 1909), p. 524, from an *avis* of 1611. See also Joseph Nouaillac, ed., "Avis de Villeroy à la reine Marie de Médicis (10 mars 1614)," *Revue Henri IV*, II (1907-8), p. 83. For the similarly generous views of Villeroy and Bellièvre in the 1580s, see Dickerman, *Bellièvre*, p. 120 and n. 4.

nobility. From the 1570s on, many schemes appeared to regulate the payment of gifts and pensions, enforce controls by the *chambre des comptes*, and require recipients of monetary awards to divulge publicly what they had received.[52]

Viewing the commentary on patronage as a whole, one sees that the notion of the public interest was most commonly evoked in urging restraint on prodigality. Everyone knew that gorging a courtier meant "taking the bread out of the hands [of poor people]."[53] As an ethical constraint on patronage, *le bien publique* denoted the welfare of the populace as a whole, especially the economic welfare of ordinary subjects. There was no sense of the primacy of this ethic over all others; it coexisted with criteria for appointments and awards that required respect for privileged interests and for *fidélité*.

As the image of the royal Court blackened through the last quarter of the sixteenth century, it became an easy target for public indignation over the failings of other institutions, failings that were only partly a consequence of patronage policies. One sees this tendency in the sermons and tracts of the preachers of the League who constantly criticized the corruption of the Church. They traced the blame for pluralism, non-residency, and other ancient abuses to the wheeling and dealing in benefices that went on at Court.[54] Royal favorites were blamed for the subversion of justice because of the practice of "evocations," which amounted to a sort of legal privilege. Courtiers had the lawsuits and criminal proceedings of their relatives and protégés evoked out of lower courts for trial in the Grand Conseil or another royal jurisdiction, where, it was assumed,

[52] Bibliothèque Nationale FF 17287, fol. 161 ff.; Anon., "Mémoire de l'ordre et règlement proposé peu auparavant le décès du feu roy Charles IX . . ."; Bodin, *Six livres*, pp. 629-31; Lalourcé and Duval, eds. *Recueil des cahiers*, II, 320, articles 354-55, 1576, 3rd estate; III, article 247, 1588, 3rd estate; Crucé, *Le nouveau cynée*, pp. 152-53; Le Bret, *Traité*, p. 422.

[53] Lalourcé and Duval, eds., *Recueil des cahiers*, II, 319, 1576, 3rd estate. To be sure, whatever the government did to promote manufactures, religion, education, and art was understood to be in the public interest. However, commentators kept "liberality toward the public" and "liberality toward individuals" in separate compartments (as in Béthune, *Le conseiller*, pp. 360-70). Insofar as the "public interest" entered discussions of patronage or liberality toward individuals, it generally functioned as a negative injunction, a sort of ethical out-of-bounds marker.

[54] Three excellent examples of this are: J. Porthaise, *De la vraie et faulse astrologie* (Paris, 1578), dedication; S. Vigor, *Sermons catholiques pour tous les jours*, ed. J. Christi (Paris, 1588), fols. 66; Anon., *Apologetic d'un prestre de Rennes contre les heretiques & politiques dudict lieu* (Poitiers, 1590), pp. 15-16.

they would be given biased treatment.[55] As in many other periods of history, the sense of pervasive corruption engendered a conspiracy mentality that reduced the cause of the problem to a small clique near the center of power. From a royalist perspective, like that of Jacques de La Guesle, *procureur du roi* in the parlement of Paris, the real corruption was the ingratitude of the beneficiaries of the *bienfaits du roi*. He claimed that "*graces* and *faveurs*" were taken for granted "like the rays of the sun." "All is corrupted," he wrote, "as in the body there are ulcers."[56] But this was a very idiosyncratic view alongside the multitude of pamphlets, popular poems, and broadsides that ridiculed the great favorites who profiteered from patronage. To the end of the wars of religion, the royal Court was the moral sink of France in the view of Protestants and Catholic Leaguers alike.

There had been improvements in the patronage system by the time of the decision in favor of hereditary transfer of venal offices. The financial restraints maintained under Henri IV are well known. Among Sully's papers, there survives a volume entitled "Dons du Roi, 1589-1596," proving that Sully was doing something reformers had recommended for decades—keeping careful tabs on money gifts by compiling a register of extracts from the *chambre des comptes* of Paris.[57] However, as Sully himself pointed out, his tightfistedness produced new abuses, because the difficulty courtiers encountered in acquiring direct awards led them to press the King for grants of monopolies and indirect tax revenues—very much the same consequence that attended Elizabeth's parsimony at the same time in

[55] One defense of evocations was that they could be used to remedy corruptions like alliances between judges and litigants; see Biraque's speech to the Estates General of 1576 (Bibliothèque Nationale FF 17287, fols. 129-34). For contemporary complaints about evocations, see Lalourcé and Duval, eds., *Recueil des cahiers*, I, 56, article 139, 329, article 114, 1560, 1st and 3rd estates; II, 73, article 212, 149, article 104, 284, article 263, 1576, 2nd and 3rd estates; III, 145, article 179, 1588, 2nd estate; IV, 118, 311, 324, 1614, 1st and 3rd estates. For more details, see Mousnier, *La vénalité*, pp. 602, 649; Kierstead, *Pomponne de Bellièvre*, p. 109; Auguste Poirson, *Histoire du règne de Henri IV* (Paris, 1862-1865), III, 61-62.

[56] Jacques de La Guesle, *Les remonstrances de messire Jacques de La Guesle* (Paris, 1611), pp. 3-4. Quotation is from the first remonstrance (27 May 1588). La Guesle returns to the same theme on pp. 35-36, 308-9, 580 (remonstrances of 1588, 1594, 1598).

[57] Archives Nationales 120 AP 12, "Dons du Roi, 1589-1596."

England.[58] Sully's vendetta with Soissons resulted from his opposition to a new tariff on imports and exports granted to Soissons in 1603.[59] Sully mentioned "twenty or twenty-five" similar grants up for consideration at the same time.[60] The sale of offices and commissioned charges continued unabated,[61] and Sully's *Economies royales* are packed with invectives against the ingratitudes and patronage abuses of courtiers.[62] It is clear that the old war horse never completely lost his suspicion and contempt for the Court.

The evidence suggests, therefore, that the supporters of the *paulette* viewed it as a threat, not to patronage and patron-client networks, but to the corruptions of patronage. Sully was making an ethical distinction that was common in the political rhetoric of the period, and he was articulating views shared by the *noblesse d'épée* in general. His intention was to neutralize the ethical issue and leave the financial benefits to the monarchy as the only basis for decision on the *paulette*, not strike a blow at legitimate patronage that served the interests of the nobility and sustained their clienteles. For the distinction between legitimacy and corruption, in the consensus of articulate contemporaries, did not coincide with the line between public interests and private ones. Hurstfield's conception of corruption is too reductionist and too modern to be applied to Renaissance France. Prevailing values had not yet clearly subordinated personal loyalty and privilege beneath devotion to public authority and the common good.

It is possible that modern ideas of political morality developed more slowly in France than in England. The nobility retained its

[58] J. E. Neale, "The Elizabethan Political Scene," in *Essays in Elizabethan History* (New York, 1958), pp. 59-84. Stone, *Crisis*, pp. 424-49. Perez Zagorin, *The Court and the Country* (New York, 1970), ch. 3 and passim. J. E. Neale, *Elizabeth I and her Parliaments* (New York, 1966), II, 325-56, 376-88. Lawrence Stone, *Family and Fortune* (Oxford, 1973), pp. 55-58.

[59] Sully, *Economies royales*, XVI, 511-14.

[60] Sully, *Economies royales*, XVI, 513.

[61] Mousnier, *La vénalité*, pp. 337-38. See especially J. Leschassier, "La maladie de la France" (1602) in *Oeuvres* (Paris, 1649).

[62] For the period 1594-1603, there are comments on financial fraud and patronage abuses at Court in Sully, *Economies royales*, XVI, 189-93, 244, 250-51, 285, 298, 303-306, 354-55, 381-82, 511-14, 520-21. As many historians have pointed out, Sully never mentioned the *paulette* in his *Economies royales*—a possible sign of embarrassment over its consequences by the time he was writing his great work after 1611.

importance in military service and in local government in France; the monarchy was reluctant to break down the system of clienteles; the appropriation of offices was far more institutionalized. Not until fundamental social and institutional changes had taken place could a modern public service ethic take hold in government.

FOUR

Religion and the Lay Patron in Reformation England[1]

GUY FITCH LYTLE

ECCLESIASTICAL patronage was both a cherished legal right of many men of property and a major enigma facing religious reformers during the later Middle Ages and Reformation. In one sense, the *advowson* (the right to name the next incumbent to a vacant Church living) was an unspectacular type of Renaissance patronage. But because of its sheer quantity and its integration into the structure of both society and Church, this form of ecclesiastical patronage represented a significant exercise of power (with much potential for influence or abuse) and a real and symbolic hurdle to any attempts at comprehensive reform of Church organization. At its most basic level, ecclesiastical patronage determined jobs and promotions for a hard-pressed clergy. As such it was one of the routine social and religious roles that the propertied classes had inherited from the feudal past. It overlapped with the political alliances forged by the Crown, nobility, and gentry. It overlapped as well with the endowment of education and Church architecture, with commissions of new music and art, and with the encouragement and protection of religious authors.

Without ignoring these grander themes, my concern here is to

[1] I am grateful to the American Council of Learned Societies, the American Philosophical Society, the National Endowment for the Humanities (through the Folger Shakespeare Library), and the University of Texas at Austin for their support of my work. I would like to thank M.G.A. Vale, Mordechai Feingold, and Joel Lipkin for many useful conversations about Renaissance patronage. I also thank John Andrews and Stephen Orgel, without whom neither the conference nor this book would have been possible. The impetus for this study came from numerous discussions with Lawrence Stone, Christopher Hill, Lord Dacre (H. R. Trevor-Roper), and Francis Haskell. I remain in their debt, despite anticipating their various disagreements with some of my attempts to "re-theologize" the subject.

examine rival conceptions of lay patronage itself. I would like to deflect attention briefly from the focus of many recent sociological analyses of the state of the clergy or of activities in specific locales or of prominent individuals to consider what might be called the "theology" of lay patronage.[2] From contemporary expressions of ideals, frustrations, and justifications, one can learn much about both patronage and religion in a society that was trying to graft new concerns about souls and morals and new definitions of laymen and priests onto an old tree of social and ecclesiastical procedures rooted deeply in attitudes of deference and holiness. By concentrating on questions of patronage, one can also fathom much about relationships and conflicts between the clergy and the laity.

Patronage in the sixteenth century was an inherited muster of laws, properties, obligations, social ligatures, ambitions, religious activities, and personal decisions that kept a complex society work-

[2] Among the many studies that deal at least in part with the facts of patronage, and sometimes with the theories behind it, see especially the following books: J. E. Christopher Hill, *Economic Problems of the Church from Archbishop Whitgift to the Long Parliament* (Oxford: 1956; corr. ed., 1963); M. Bowker, *The Secular Clergy in the Diocese of Lincoln 1495-1520* (Cambridge, 1968); P. Heath, *The English Parish Clergy on the Eve of the Reformation* (London, 1969); K. L. Wood-Legh, *Perpetual Chantries in Britain* (Cambridge, 1965); A. Kreider, *English Chantries: The Road to Dissolution* (Cambridge, Mass., 1979); R. O'Day, *The English Clergy: The Emergence and Consolidation of a Profession 1558-1642* (Leicester, 1979); W. K. Jordan, *Philanthropy in England, 1480-1660* (London, 1959); P. S. Seaver, *The Puritan Lectureships: The Politics of Religious Dissent, 1560-1662* (Stanford, 1970); C. Cross, *The Puritan Earl: The Life of Henry Hastings, Third Earl of Huntington, 1536-1595* (London, 1966); R. C. Richardson, *Puritanism in North-west England: A Regional Study of the Diocese of Chester to 1642* (Manchester, 1972); J. Bossy, *The English Catholic Community, 1570-1850* (London, 1975), and the various works of Hugh Aveling on Catholic patronage. Among many articles, see especially: R. O'Day, "The Law of Patronage in Early Modern England," *Journal of Ecclesiastical History*, 26 (1975), 247-60; "The Ecclesiastical Patronage of the Lord Keeper, 1558-1642," *Transactions of the Royal Historical Society*, 5th Ser., 23 (1973), 89-107; and "Ecclesiastical Patronage: Who Controlled the Church?" in *Church and Society in England: Henry VIII to James I*, ed. F. Healy and R. O'Day (London, 1977), pp. 137-55; M. C. Cross, "Noble Patronage in the Elizabethan Church," *Hist. J.*, 3 (1960), 1-16; M. Feingold, "Jordan Revisited: Patterns of Charitable Giving in Sixteenth and Seventeenth Century England," *Hist. of Ed.*, 8 (1970), 257-73. Among many important and as yet unpublished doctoral theses, see the list in Healy and O'Day, eds., *Church and Society*, pp. 186-87. To begin any study of the theologies of patronage, one should consult Peter Milward, *Religious Controversies of the Elizabethan Age* (Lincoln, Neb. and London, 1977) and *Religious Controversies of the Jacobean Age* (Lincoln, Neb. and London, 1978); and F. B. Williams, Jr., *Index of Dedications and Commendatory Verses in English Books before 1641* (London, 1962).

ing. The institutional Church was an integral part of that society, but it had its own internal tensions. Relations had almost never been easy between the Christian laity and the Christian clergy. Their respective roles were ambiguously defined by Scripture and by historical evolution. For those in holy orders, laymen were both patrons and clients, protectors and supplicants, masters and servants to the servants of God. Prominent laymen sought access to, and even control of, the sacred—both as their natural right and as a means to assure the salvation of their souls. And theology, for well over a millennium, stressed the path of good works as the usual way to such lay access to holiness. In the intensely practical society of feudal Europe, the logic was inescapable that rewards required prior contributions. When these took the form of gifts and endowments of land, buildings, or tithes to the Church, both laymen and clerics—and God's work—appeared to benefit.

Although perspicacious individuals called attention to the possibilities for conflicts of interest inherent in this scheme, the earthly needs of the Church and the spiritual ambitions of the more prosperous laity overwhelmed opposition. Visible temples arose on foundation stones hewn from rival quarries. And since these monuments were both valuable properties and perpetual sanctuaries, disputes over their control, while often base and avaricious on either side, could also become imbroglios about the power and status of layman and priest in the eyes of the law and in the sight of God. Relationships could become even more complicated when religious and social interests had to compete for the same limited resources or when circumstances allowed one group to try to impose its sense of morality or its definition of the nature of the "true Church" on the other.[3]

The physical survival and continued use of medieval church buildings during the Reformation stood as reminders that a particular person or family had founded the place of worship in each parish. In Buddhism, endowment of a temple was the single most meritorious act a layman could perform (the second being the provision of half an endowment).[4] Although Christianity never went this far, the law, practice, and theology of the medieval Church did reward

[3] I am now at work on several studies of medieval religious patronage, and lay-clerical conflicts and full citations of secondary literature will be given there. Also see reference in note 32 below.

[4] S. J. Tambiah, *Buddhism and the Spirit Cults in North-East Thailand* (Cambridge, 1970), pp. 146-47; compare J. T. Rosenthal, *The Purchase of Paradise: Gift Giving and the Aristocracy, 1307-1485* (London, 1972).

its special benefactors (and their heirs) with spiritual benefits and earthly privileges. Among the latter, the right to nominate the parish priest was perhaps the most significant.

Left unfettered, such a privilege presented a threat to the ecclesiastical conception of the Church. The Church therefore attempted to control lay privileges. The growth of papal power after the investiture controversy and the development of the science of canon law combined to reduce the *Eigenkirche* claims of the early patrons to a *ius patronatus*, which preserved lay rights to nominate parish priests but reserved to the bishop the responsibility of approving the candidate and installing him.[5] Meanwhile, the Church actively promoted the model of the pious, even militantly orthodox, layman: the protector and respecter of Church rights, property, and authority. Charters, coronation oaths, mirror-of-princes treatises, sermons, chronicles, and iconography stressed this ideal. As Joinville wrote about St. Louis: "When any benefice of Holy Church fell into his gift, the king always consulted clerics and other worthy people on whose goodness he could rely before bestowing it; and after consultation with them he would make such appointments loyally, conscientiously, and as if in the sight of God."[6]

The potential for conflict between lay patrons and the Church was nowhere greater than in England. There the new developments in canon law had been only partially received. From the *Assize of darrein presentment* and the *Constitutions of Clarendon* in the twelfth century to the laws against *mortmain* and the statutes of *provisors* in various fourteenth-century parliaments, English common law asserted the rights of patrons against encroachments from Rome.[7] Advowsons were property, if of a somewhat ambiguous

[5] See the recent, excellent account by P. Landau, *Ius Patronatus: Studien zur Entwicklung des Patronats im Dekretalenrecht und der Kanonistile des 12. and 13. Jahrhunderts* (Cologne and Vienna, 1975); and note 7 below.

[6] Joinville, "The Life of St. Louis," in Joinville and Villehardouin, *Chronicles of the Crusades*, tr. M.R.B. Shaw (Baltimore, 1963), p. 337; compare L. K. Little, "St. Louis' Involvement with the Friars," *Church History*, 33 (1964), 125-48.

[7] Some more modern studies, which incorporate references to a large and important older literature, are J. W. Gray, "The *Jus praesentandi* in England from the Constitutions of Clarendon to Bracton," *English Historical Review*, 67 (1952), 481-509; F. Cheyette, "Kings, Courts, Cures, and Sinecures: The Statute of Provisors and the Common Law," *Traditio*, 19 (1963), 295-349; S. Raban, "Mortmain in Medieval England," *Past and Present*, 62 (1974), 3-27; G.W.O. Addleshaw, *Rectors, Vicars and Patrons in Twelfth and Early Thirteenth Century Canon Law* (York, 1956); W. A. Pantin, *The English Church in the Fourteenth Century* (Cambridge, 1955).

sort, and as such could be sold, bequeathed, or given away (potentially another pious act if they were given, say, to a monastery). Patronage could not, except under very unusual circumstances, be lost or taken away. In his fifteenth-century compilation of ecclesiastical laws affecting England, Lyndwood did note a few disabilities. Heretics were banned from exercising the right of patronage, for example; but unless all their goods and estates were confiscated, they retained ownership of the advowson. In another situation, Lyndwood noted that "if patrons . . . presume to kill or maim a rector, vicar, or clerk of that church either by themselves or by others, then the patrons wholly lose their patronage . . . to the fourth generation . . . and we will often have this announced in churches." Simoniacs were barred, but neither Church nor state could interfere with the rights of proper heirs, legitimate or illegitimate (even minors and women), or of any other owners or possessors of the patronage. In fact, according to Lyndwood, the Church excommunicated anyone who "in the vocation of any church . . . put forth maliciously the question or doubt of patronage . . . that so they might defraud the true patron of the collation and gift of that church." If there was a dispute about patronage, "the king's court [claimed] cognizance to belong to itself." English churchmen accepted these circumstances in practice, whether or not they conceded their validity in principle.[8]

Whatever the legalities, many critics saw corruption in the late medieval English clergy that imperiled the spiritual life of the nation. For some, lay patronage was at the heart of these abuses; for others, it offered the key to reform. All agreed that lay patronage was an important issue facing both Church and society.

Lay patrons were frequently indicted for lack of concern about spiritual qualifications in their nominees. While it is true that exaggerations abounded and that many of the critics were themselves frustrated seekers after preferment, it is equally clear that certain charges were made too frequently not to carry some conviction. It was said that university graduates, for example, were overlooked:

> Worthy clerks famous
> In Oxford and Cambridge also
> Stand unadvanced. Whereas the vicious
> Favel hath churches and prebends more
> Than God is pleased with.

[8] William Lyndwood, *Provinciale* (Oxford, 1679), pp. 215ff.

All too frequently, a vacant benefice would go to "a fool, to a clerk of a kitchen or of the chancery."[9] Comfortable companions rather than dedicated priests were promoted. Many priests thus ran "amiss by the means of temporal men: for if a priest can flatter smoothly, if he will keep you company at banqueting, dicing, and carding, run with you hunting and hawking, which things draw after them all kind of vices, he will be called a good fellow, and on such ye will bestow your benefices."[10] The Dominican John Bromyard told a parable about a fool who set a cat to guard his food against the ravages of mice, and then drew the moral: "The same can be said of fatuous patrons and prelates, who hand over souls to be guarded from demons into the care of wicked incumbents, who make worse destruction of them than the demons themselves: for the latter would not . . . give so many bad examples as they do."[11] In an age of upward social mobility, some patrons sold their appointments on a thriving open market: "No better merchandise is now-a-days than to procure advowsons of patrons for benefices, for prebends, for other spiritual livelihood, whether it be by suit, request, by letters, by money. . . . These advowsons are abroad here in this city . . . in the shops, in the streets, a common merchandise."[12] But whatever the corruption or irresponsibility of some patrons, or the questionable morals of some priests, we must remember, in our broader considerations of patronage and society, that most of the lay patrons had enormous obligations to retainers and servants of all sorts, obligations that had to be met with a limited income. What ecclesiastical reformers saw as abuses, lay patrons saw as a legal and proper use of their resources, and no affront to either God or Church.

Many ecclesiastical reformers blamed the clergy themselves for all abuses, since to the pre-Reformation mentality laymen could hardly be expected to be models of virtue. According to John Myrc, "far more priests have gained promotion in the church by adulation and simony than by uprightness of conduct and learning. Since

[9] *The Poems of John Audelay*, ed. E. K. Whiting (London, 1931), p. 30; *Pierce the Plowman's Crede*, ed. W. W. Skeat (London, 1867), pp. 28-29.

[10] William Chedsey and Cuthbert Scott, *Two notable sermons lately preached at Paul's crosse* (London, 1545), sig. Gv.ᵛ

[11] G. R. Owst, *Literature and Pulpit in Medieval England*, 2nd ed. (Oxford, 1961), pp. 256-57.

[12] John Longlande, *A Sermonde made before the Kynge, his maiestye at Grenewiche* . . . (London, 1538), sig. Fiii.ʳ

scarcely anyone at all is promoted without bribe of hand or tongue or sycophancy, either he gives bribes . . . or flattering words . . . or else fawns by performing some toilsome office. He who enters his benefice with sin, must of necessity live . . . in sins."[13] John Longlande, Bishop of Lincoln, was even harsher in summoning the "heavy hand of God upon simoniacs. . . . Until such simoniacs be weeded out, . . . Christian souls shall perish. For such be . . . more regarding the fruits and profits than the souls that Christ so deeply bought with the price of his most precious blood." He did not exempt his fellow bishops from similar charges.[14]

On the other hand, John Wyclif, while condemning the "heresy of simony" and giving as an example of the sin of "inordinate love" the priest who loved his patron because of his promotion, considered the lay patron a proper agent to reform a corrupt church.[15] Since the original patrons had endowed churches for pious uses, Wyclif argued, it was their right and obligation to assure that no priestly fraud detracted from these uses: "It pertains to the king or patron in default of spiritual superior to withdraw alms proportionately to the crime from the . . . cleric habitually abusing the goods of the church or patron." Wyclif justified his views by reference both to pre-Gregorian canon law decrees and to English common law. He concluded that the King, as "paramount and immediate patron of all the clergy," bore the ultimate responsibility for religious reform.[16]

Still another reforming tradition stressed the roles of the Pope and the bishops in controlling patronage. In an anonymous Oxford theological disputation (ca. 1467), a monk tried to refute the Wyclifite position. All provisions belonged to the Pope, he said, notwithstanding any claims of lay patronage. Patronage had been allowed to temporal lords by the Pope simply to induce them to favor the Church with gifts and protection. But endowment *per se* gave no right of patronage, since (paraphrasing Leviticus xxvii.28-29) all things consecrated to the Lord would be put to death and were thus completely "dead" to the world and to the previous owner.

[13] Owst, *Literature and Pulpit*, pp. 276-78.

[14] Longlande, *A Sermonde*, sig. Fiii.ʳ

[15] *Tractatus de Mandatis Divinis*, ed. J. Loserth and F. D. Matthew (London, 1922), p. 331; *Tractatus de Simonia*, ed. M. H. Dziewicki (London, 1898), *passim*.

[16] *Opera Minora*, ed. J. Loserth (London, 1913), p. 45; for the best current introduction to Wyclif's views on lay patronage, see William Farr, *John Wyclif as Legal Reformer* (Leiden, 1974), pp. 95ff., 119-38, 154-55.

The fact that previous popes had allowed some rights of patronage to laymen did not mean that current or future popes might not revoke these grants.[17] Robert Grosseteste, the influential thirteenth-century Bishop of Lincoln, had acknowledged this claim of the Pope to dispose of all ecclesiastical livings, but had reserved the right of approval and installation to the local bishop.[18]

These themes and tensions were certainly not muted by the English Reformation. They would echo in the polemics and exhortations of every subsequent generation. But the Reformation did make a difference. It changed some of the rules of the game and significantly increased the stakes with which and for which the laity now played. What were some of these important changes?

First, the proportion of direct ecclesiastical patronage, of advowsons, in lay hands rose significantly. While more quantitative work is required to determine the exact nature of this realignment, we now know generally how the extensive holdings of land, patronage, and impropriations by the possessioned religious orders were swept away in the 1530s, first into the control of the Crown and then by gift and purchase into the assets of the nobility and gentry.[19] The ownership of property thus reinforced acceptance of the new religion. The actual uses of that property, however, illustrated a genuine continuity with the parish structure, church buildings, and procedures of ecclesiastical patronage inherited from the medieval *ecclesia anglicana*.

Second, new theologies and new economic conditions combined to undermine some of the incentives for traditional patronage and some of the strictures against its abuse. The sixteenth century witnessed the decline of Purgatory and the rise of avarice (or at least of the argument of economic necessity). Redefinitions of the role of good works struck at the root of much medieval piety and patronage. With the decline in the necessary role of the sacraments,

[17] British Library MS. Royal 8.E.VII, fol. 78-81ᵛ.

[18] See W. A. Pantin, "Grosseteste's Relations with the Papacy and the Crown," in *Robert Grosseteste: Scholar and Bishop*, ed. D. A. Callus (Oxford, 1955), pp. 178-215.

[19] In addition to the important current quantitative work of Margaret Bowker, Joel Lipkin has put into computer-readable form much data from the early sixteenth-century bishops' registers. I am now trying to do similar work on the late-medieval registers. We hope soon to publish the raw data for general use and complete several studies based on it. See Dr. Lipkin's thesis, "Pluralism in Pre-Reformation England: A Quantitative Analysis of Ecclesiastical Incumbency, c. 1490-1539," Ph.D. dissertation, Catholic University of America, 1979.

and thus of the holy status of the clergy, patrons were less inhibited both in their exploitations and in their demands for control. And one can even see in the iconoclasm of some of the new theologies a more than merely symbolic attack on the results of earlier religious patronage.

The third major change was the emergence of a post-Reformation morality, derived both from Protestantism and from the severely puritanical, self-critical, pre-Reformation Christian humanist tradition, which was now intended to be applied to the laity as well as to the clergy. This attempt to judge and control the practices and attitudes of a "bastard feudal" society by new canons of religious ethics produced confusion, intense individual self-examination, aggrieved self-justification, and some genuine reform.

Fourth, despite the fact that neither the concept of the "priesthood of all believers" nor violent anti-clericalism developed as rapidly or as extensively in England as they did on the Continent, the clergy and laity did struggle over money and authority. The contest was exacerbated by the bitter conflict among different factions of the clergy over the nature of the "true Church," as well as over the practical concerns of getting and holding ecclesiastical positions.

Finally, among the ideologists of all camps, new forms of Scriptural, historical, and pragmatic arguments were tried and countered as attempts were made to abolish or reform Church patronage. But the laity had continuity and a strong ally—the common law—on their side, so many churchmen sought to convert patrons to their views and convince them to use their patronage for the furtherance of one of the rival "just causes."

With the increased proportion of patronage in lay hands after the Reformation, the cases of, or at least the potential for, abuse multiplied. At the same time, the quickening of the pulse of reform among clerics, whether essentially Erasmian or more distinctly Protestant, resulted in a generation of more vigilant and articulate preachers proclaiming a new public morality. In many ways their ecclesiastical broadsides must be seen as mirror images of the anti-clerical writings of the preceding period. New attention was now directed at the religious role of the upper laity in society. As the clergy's grasp on the keys to the kingdom of Heaven loosened, so too did some of their tongues and pens. The laity, of whom little had been realistically expected in the later Middle Ages, could—indeed must—now be reminded to do their duty and were castigated when they failed.

The most common accusation against lay patrons continued to be greed. In 1549 Latimer preached: "Patrons be charged to see the office done, and not to seek a lucre and a gain by their patronship." He went on to tell the story of how an aspiring cleric had assured himself of a benefice by offering the patron thirty apples all filled with gold pieces. Get yourself a graft from that tree, Latimer added,

> and I warrant you it will stand you in better stead than all of St. Paul's learning. Well, let patrons take heed: for they shall answer for all the souls that perish through their default. . . . There be a great many in England that say there is no soul, that believe not in the immortality of man's soul. . . . I perceive . . . [that] these sellers of offices show that they believe that there is neither hell nor heaven; it is taken for a laughing matter.[20]

Jewel castigated the lay impropriator who took the tithes of his churches for his own use:

> parsonages and vicarages, . . . the castles and towers of . . . the Lord's temple . . . seldom pass now-a-days from the patron . . . but either for the lease or for present money. Such merchants are broken into the church of God, a great deal more intolerable than were they whom Christ chased . . . out of the temple. They should be careful of God's church, that should be patrons, to provide for the consciences of the people, and to place among them a learned minister. . . . [Patrons] serve not Jesus Christ, but their belly . . . throughout England. A gentleman cannot keep his house unless he have a parsonage or two in farm for his provision.[21]

By failing to protect earlier religious patronage, contemporaries were iconoclasts and robbers, destroying the gifts and ignoring the intentions of pious (if sometimes misguided) medieval donors. As Henry Bedel preached: "Look what . . . our fathers as fools did lay forth . . . upon shameless friars . . . and fat bellied monks. . . . Where is the plenty of gold that garnished the erroneous church? . . . It is true men then gave out of fear and to avoid harsh penalties,

[20] *Sermons and Remains of Hugh Latimer*, ed. G. E. Corrie (Cambridge, 1845), I, 186-87.

[21] *The Works of John Jewel*, ed. J. Ayre (Cambridge, 1847), II, 1011-13; also pp. 999ff.

but none the less they gave. Should fear move men more than the true Gospel?"[22] Henry Burton counted simony as "the mother of all mischiefs in the church. For simony doth usually poison and corrupt two Well-heads, whence the streams of good life do generally flow unto all the people . . . the Parson and the Patron. These be, as the two great lights in the firmament of the church, from whom the sublunary and subordinate people receive direction and conduct of their life."[23] Burton quoted Coke and echoed Latimer's view that corruption of the Commonwealth, especially "lay simony in buying and selling all sorts of [political] offices, great and small, of public justice and private service," drew its inspiration and justification from the example of ecclesiastical simony.[24]

But such sermons, however eloquent, were apparently puny weapons with which to attack the citadel of patronage. In his description of St. Paul's during Elizabeth's reign, James Pilkington found "the south alley for usury and popery, the north for simony." In the north nave, all types of clerics advertised their availability by the "*Si quis*" door. And all this was as "well known to all men as the beggar knows his dish."[25]

Greed and simony, though certainly the main charges, were not the only reasons given by contemporaries to explain why England was cursed with a parish clergy wholly inadequate to its new tasks. Since the upper classes still faced many of the same social demands and now had less ready money available for salaries, patrons continued the late medieval practice of using advowsons to bestow . . . benefices on their bakers, butlers, cooks, archers, falconers, horsekeepers, and the like in lieu of salaries or pensions for their long and faithful service.[26] Even when proper ministers were given the positions, this social environment kept them from doing their duty and further subordinated the clergy to the laity. Anthony Anderson complained that "the holy Ministry is holden in contempt . . . their patrons . . . deprive the preacher's portion to serve their own provision: it is enough for the priest to have ten pounds . . .

[22] *A Sermon exhorting to pity the poore* (London, 1572), sig. B iii.ᵛ

[23] *A Censure of Simonie* (London, 1624), pp. 93-99.

[24] Ibid., p. 97.

[25] *Works*, ed. J. Scholefield (Cambridge, 1842), pp. 540-41; *Puritan Manifestoes*, ed. W. H. Frere and C. E. Douglas (London, 1954), p. 31.

[26] For many references to such occurrences, see J. W. Blench, *Preaching in England in the late Fifteenth and Sixteenth Centuries* (Oxford, 1964), especially pp. 238ff.; and H. C. White, *Social Criticism in the Popular Religious Literature of the Sixteenth Century* (New York, 1944), pp. 101ff., 183ff., and *passim*.

and for this too he shall . . . carry a dish to his master's table, or else stand at the dresser orderly to set out the mess of meat and supply the clerk of the kitchen's place; his service and homilies he must cut short, and measure them by the cook's readiness." If he keeps his auditors too long at their religion, such a minister will be called, by "master and men, Sir John-burn-Goose."[27]

In addition to fulfilling social obligations with minimal expenditure, these traditional practices also gave the patron a comforting, if temporary, benefit. Bernard Gilpin noted that

> patrons see that none do their duty, they think as good to put in asses as men. . . . If he never opened the Bible, so much the meeter for their purpose, as he is not able to speak against their abuses, but will suffer them to sleep in their sin. . . . What preposterous judgment they use. For all worthy offices they search meet . . . men; only Christian souls so dearly bought are committed without respect to men not worthy to keep sheep. . . . Let them not abuse God's patience, for if they do not shortly repent and bestow livings better, both master and man shall burn in hell fire.[28]

Protestants and Catholics alike censured the great majority of the chaplains serving in noble households: "Few confessors of great men went to heaven, because by their base flattery they became guilty of soul-murder and for want of telling them their faults, destroyed both their own and their patron's souls."[29] Before this ultimate price was exacted, however, such control by the patron over a minister's tongue could have other sinister effects. As Robert Burton said: "If the patron be precise, so must his chaplain be; if he be papistical, his clerk must be so too, or else [be] turned out."[30] In an age that feared breaches of official orthodoxy, this last concern would provoke sporadic attempts at state limitations on patrons' actions. But the fact that patronage was a property right, with the bulwark of the common law as its fortification, left patrons relatively free to perform by their own lights.

The lack of an adequate pool of qualified clerical aspirants was

[27] *The Shield of our Safetie* . . . (London, 1581), sigs. T iv.ᵛ-vi.ʳ

[28] *A Sermon Preached in the Court at Greenwitch* . . . *1552* (London, 1630), pp. 18-20.

[29] Edmund Calamy, *A Patterne for all, especially for Noble and Honourable Persons* . . . (London, 1658), p. 33 and quotations cited there.

[30] *The Anatomy of Melancholy*, ed. A. R. Shilleto (London, 1904), I, 322.

blamed on lay patrons who failed to support the universities and refused to promote outstanding students to vacant benefices. During Elizabeth's reign, Bartimaeus Andrewes preached that "many blind dolts of the country, ploughmen, and artificers, through simony and corruption, steal into the livings of the church [so] that the learned and meet persons in the university which should be called forth are fain to be without place. Which happeneth . . . by default of patrons which make not conscience of the Lord's people . . . [and] the poor souls of the people are in extreme hazard thereby."[31] The frustration of worthy students by bad patrons had been a commonplace since at least the fourteenth century. Whether the prospects for university graduates really were getting worse remains to be determined, but the theme was seldom absent from Reformation catalogues of patronage abuse.[32] As one critic noted, "This buying and selling in the Church of God will make barren and like desolate and forsaken widows, the two universities." If simony was the only way to advance, what wise parent would invest money in a superfluous education for his sons?[33]

It was generally agreed among ecclesiastical critics that the bulk of the blame could be heaped on the lay patrons. Yet because patronage was a reciprocal relationship, and because many patrons were clearly quite passive, it was hard to restrict guilt to them alone. The clergy (from lowly curates to the most exalted bishops) were also quite often accused of culpability as they sought advancement wherever they could find it: "Birds of the same feather are covetous patrons, . . . parsons, vicars, readers, parish priests, stipendaries, and riding chaplains that under the authority of their masters spoil their flocks of the food of their souls. Such seek not the Lord Jesus, but their own bellies."[34] The influential radical, Thomas Brightman, summarized the current practices and problems. The clergy, he said, are

> men bowing themselves to the ground for a piece of silver,
> . . . craving to be put into one of the priest's offices. . . . What

[31] *Certaine verie godly and profitable Sermons* . . . (London, 1583), p. 121.

[32] For a fuller discussion of this, see my "Patronage Patterns and Oxford Colleges, c. 1300-c. 1530," in *The University in Society*, ed. Lawrence Stone (Princeton, 1974), I, 111-49, and my forthcoming book *University Scholars and English Society, 1300-1550.*

[33] John Howson, *A Sermon Preached at Paul's Cross the 4. of December 1597* . . . (London, 1597), pp. 30-35.

[34] *Puritan Manifestoes*, ed. Frere and Douglas, p. 32.

running up and down is there among them, what bribery, what
. . . begging, what flattering offers do they make of all their
obeisance . . . that they may come by these ecclesiastical pro-
motions? . . . [Is this] an honest way to get a church-living?
. . . Is it any whit a less filthy thing to come to a rectory . . .
by favor than by money? . . . It is all one fault to creep in,
whether it be by bribing and simony, or by fawning and flat-
tery. [Others] are diligent in attending the common sort of
patrons, whose thresholds they lie watching at, whose wives
they . . . court as if they were their mistresses, whose children
they cogge with, whose servants they allure with fair words
and promises. . . . Nay are the bishops themselves clear of this
base beggary? What meaneth then that continued haunting of
the Court, and hanging upon the nobles?[35]

Attacks on the bishops took several forms after the Reformation.
In an anonymous Puritan document of 1584, the author refused to
absolve bishops from responsibility for allowing unfit men into
church positions.[36] How could a bishop find fault with a patron
for presenting an unqualified man when the bishop himself had
ordained him? "If unwise bishops did not make unlearned ministers,
covetous patrons could never present [them]."[37] And many lay-
men were inclined to agree with the Commons' "Supplication
against the Ordinaries" (1532), which argued that

spiritual persons, being presented as well by your Highness as
by other patrons within this your realm to divers benefices,
. . . the said ordinaries . . . do not only take of them for their
letters of institution . . . large sums of money, . . . but also do
long delay them without reasonable cause . . . because they
will have the profits of the benefice during vacation, unless

[35] *A Revolation of the Revolation that Is* (Amsterdam, 1615), pp. 143-45.

[36] The author agreed that simony was rampant among lay patrons and that bishops
faced serious legal impediments from the common law if they refused a lay patron's
nominee. He even admitted that bishops had "diligently exhorted patrons . . . to
consider the necessities of the churches and to have before their eyes the last days,
the judgment . . . of God, that therefore they prefer no man to any ecclesiastical
living but him which doctrine, judgment, godliness, honesty, and innocency of life
is able to bear so heavy a burden." But when all this had been conceded, who had
in fact "made this evil . . . or unlearned men, presented by a covetous patron, a
minister? Did the covetous patron? No, he is a layman, he may give no orders." *An
Abstract, of Certain Acts of parliament* . . . (London, 1584).

[37] Ibid.

they will . . . covenant with them . . . that the ordinaries should have part of the profits of the said benefice after their institution. . . . Also the said spiritual ordinaries do daily confer and give sundry benefices unto certain young folks, calling them their nephews or kinsfolk, being in their minority . . . apt nor able to serve the cure of any such benefice; whereby the said ordinaries do keep . . . the profits of the same benefices in their own hands . . . and the poor silly souls of your people and subjects . . . for lack of good curates do perish without good example, doctrine or any good teaching.[38]

As contemporary moralists saw things, there was sufficient cause to blame the whole lot. According to William Walker, England was plagued with lay patrons who "turn their patronage into pillage," simoniacal ministers whose bribes caused "their gentle patrons . . . to betray the souls of them that should not die," and unconcerned bishops who allowed these abuses to go uncorrected: "If Magus come with money enough, Judas will sell, and Balaam will bless; but woe be to the commonwealth where Judas is patron of a benefice, Magus the minister, and Balaam the bishop: there Christ himself will be sold, the Holy Ghost bought, and both dispensed withal."[39]

But it was clearly not enough just to identify the problems and exhort Christians (both laymen and priests) to stop sinning in these sacred transactions. Whether it was to be new regulations or a total reorganization of the Church (and, implicitly, of English law and society, too), something more had to be done. The search for a solution produced a major religious debate.

Thomas Becon, concerned that "unprofitable clods" and "blind curates should have the oversight of Christ's congregation," suggested one solution in a dialogue between would-be reformers. While one imputed fault "unto the bishops, which admitted such unlearned asses into the priesthood," another responded that the "patrons of the benefices are not altogether blameless for giving the livings to such ignorant men, whether it be for affection or for rewards; neither shall their punishment, I fear, be small at the day of judgment. For . . . what shall we . . . say of them which are the

[38] C. H. Williams, ed., *English Historical Documents, V, 1485-1558* (London, 1967), p. 735.

[39] *A Sermon preached at the Funerals of the Right Honourable, William, Lord Russell* . . . (London, 1614), pp. 14-15.

occasion that the blind guide with his blind flock fall into the ditch, into everlasting damnation? Shall not the blood of them that perish be required at the patrons' hands in the dreadful day of judgment?" But Becon concluded with optimism when the first complainant answered: "Let these things pass; for doubt ye not the king's highness with his most honorable council will most graciously provide for the redress of such abuses."[40]

The monarchs, whom Hooker called "the highest patrons which the church of Christ hath on earth,"[41] possessed the largest amount of patronage. They or their agents nominated clerics to jobs at every level, from Archbishoprics to private chaplaincies. Crown promotions could be used to build or to link patronage networks, to advance worthy graduates, or to reward Court favorites and their minions. But as well as being the greatest patrons, the monarchs, along with Parliament, were the lawgivers. Thus it was natural for many clerics to look to them directly for positions and, with differing motives, to hope that they would expand their control over the laws, as well as the exercise, of ecclesiastical patronage.

The hopes for effective government intervention (i.e., lay control) can be seen in a variety of complaints and supplications made to the Crown and Parliament. We have already cited several Tudor court sermons on this theme. In 1570, Edward Dering boldly urged Queen Elizabeth both to set a model for her subjects and to devise new laws:

> I would lead you first to your [own] benefices . . . some are defiled with impropriations. . . . Look . . . upon your patrons . . . [who] are selling their benefices . . . some keep them for their children, some give them to boys, some to servingmen. . . . And yet you, in the meanwhile that all these whoredoms are committed, you at whose hands God will require it, you sit still and are careless. . . . The Lord increase the gifts of his Holy Spirit in you . . . till . . . you be zealous as good King David to work his will. . . . To reform evil patrons, your Majesty must strengthen your laws, that they may rule as well high as low.[42]

[40] "The Jewel of Joy," in *The Catechism of Thomas Becon*, ed. J. Ayre (Cambridge, 1844), pp. 423-34.

[41] Richard Hooker, *Of the Laws of Ecclesiastical Polity* (New York, 1877), bk. VIII, ch. 7, no. 7.

[42] L. J. Trinterud, ed., *Elizabethan Puritanism* (New York, 1971), pp. 159-60.

Philip Stubbs believed that because of "abuses infinite," if "the patronages were taken away from them that now enjoy them, nay, that make havoc of them . . . either to rest in the right of the Prince, as they ought, or else in the right of churches, who will not be corrupted, it were a great deal better than now they be."[43]

The Anglican Richard Cosin saw inadequacies in the common law that needed to be addressed before bishops could do their duty. Why should a bishop invite great trouble and expense, he said, by refusing to appoint some unqualified nominee "whom he is sure the law of the land will repute sufficient" to be instituted?[44]

The new patronage laws passed by Parliament after the Reformation focused on three matters: the continuation, even the strengthening, of lay patronage, especially the traditional property-right attributes of advowsons; the proscription of simony; and the problem of religious heterodoxy in patrons. The exact specifications of these laws have been frequently discussed,[45] so here I shall consider only the religious debates surrounding them.

Throughout Christian history, few heretics, apostates, and nonconformists could have even survived, much less flourished, without the protection of powerful patrons; and the role of devout lay patrons as protectors was essential to the fortunes of Puritanism and Catholicism in Tudor and Stuart England.[46] But by the early seventeenth century, there were statutes that severely limited the ecclesiastical patronage of Catholic laymen and made it a felony to provide maintenance for a Catholic priest.[47] In 1604, when some lay Catholics asked the King to allow partial toleration for Catholicism in England, they promised that the number of priests in the country would be limited to those required by the nobility and

[43] *The Second Part of the Anatomy of Abuse*, ed. F. J. Furnivall (London, 1882), II, 82. See also A. Peel, ed., *A Seconde Parte of a Register* (Cambridge, 1915), II, 186; and Hill, *Economic Problems*, p. 71.

[44] Cosin, *An Answer to the two first and principall Treatises of a certaine factious libell* . . . (London, 1584), pp. 176ff.

[45] See, for example, J. Doddridge, *A Compleat Parson or A Description of Advowsons* (London, 1630); Wm. Hughes, Esq., *Parsons Law: or, a view of advowsons* . . . 3rd. ed. (London, 1673); and note 2 above.

[46] See the studies listed in note 2; also compare, for example, J. M. Klassen, *The Nobility and the Making of the Hussite Revolution* (Boulder, Colo. and New York, 1978); P.R.L. Brown, *Religion and Society in the Age of Saint Augustine* (London, 1972), pp. 183-226.

[47] *The Tudor Constitution*, ed. G. R. Elton (Cambridge, 1965), pp. 424ff.; *Statutes of the Realm* (London, 1810), IV, 1077.

gentry and that every patron who kept a priest would take absolute civil responsibility for his behavior.[48] Arguing against such toleration, Matthew Sutcliffe expressed confidence that although the Pope "pretendeth right . . . to dispose of the livings of the church, . . . no state will give this power to strangers, and enemies, that has liberty to refuse it." Sutcliffe aimed a further argument directly at the recusant patrons themselves:

> The popes and masspriests make merchandise of men's souls, and make little conscience to buy and sell churches, . . . heaven, grace, and all spiritual things. They . . . make havoc of Christian men's estates. . . . [Lay patrons] show themselves devoid of reason, that admit masspriests into their houses, that like owls fly the light and sight of the magistrate, that entertain intelligence with foreign enemies, that devour their substance, that like impure lechers abuse the wives, daughters, and maids . . . and pretending to make them Catholic do indeed make them Cuckholdic.[49]

Henry Burton wanted even "more careful care of this cursed cankered sin" whereby some secret Catholic sympathizers still functioned as patrons. He wanted an act to force all those who did not wish to be "deprived and dispossessed of all presentative power whatsoever in disposing of any church-living . . . [to] take [an] oath, not only of Allegiance but of Supremacy, this being the . . . touchstone to discern a true Christian from a counterfeit Catholic, and a good Patron from a crafty Roman Latron. For can the flock be in safety when the dog is of the wolf's providing."[50]

An Anglican, probably Richard Bancroft, cited similar abuses by lay Puritan patrons. Puritan clerics

> do practice daily how they may . . . creep into noble and gentlemen's bosoms . . . [and] thrust themselves forward by all the power of their friends. . . . Very many gentlemen . . . have joined themselves in this faction, and are become great favorers . . . thereof. . . . If any do resist their seditious dealings, . . . either in common speech or by preaching obedience, he

[48] *A Petition Apologeticall, presented to the Kinges most excellent Maiestie by the lay Catholikes of England* . . . (Douai[?], 1604), pp. 33-35; Bossy, *English Catholic Community*, pp. 38-39.

[49] *The Petition Apologeticall of Lay Papists . . . contradicted, examined . . . and refuted* (London, 1606), pp. 41-42, 51.

[50] *A Censure of Simonie*, pp. 113-14.

is forthwith most shamefully defaced for a madman, . . . a papist, or . . . a neuter . . . [or hauled] before . . . Assizes for preaching . . . that doctrine no honest nor learned man in England was able to reprove, tending only to the maintenance of laws and reprehension of such as be both disobedient and seditious. . . . [We] must not touch . . . the gross sins of [the Puritan clergy's] good Masters, either the oppression of the poor, enhancing of rents, enclosing of common grounds, sacrilege, simony, pride, contempt of magistrates, of laws, of ceremonies and order ecclesiastical, nor any such horrible sins wherewith all the most of our precise gentlemen are infected.[51]

Lay patronage presented a danger to the unity of the state religion and even of the nation itself. In the successful prosecution of the Puritan Feoffees for Impropriations in 1633, the patrons were convicted of virtual simony. But also according to one of the judging barons, "here is their supreme Patronage, thus they go about to make themselves a National Vestry and to make Orders after their own minds . . . they would provide Doctrines for their lecturers."[52] As the ultimate lay patron, the state had to protect itself against the public consequences of individual or collective patronage of private heterodox opinions and worship.

Sometimes a patron would intervene to uphold conformity. In a trial concerning the lawfulness of the 1584 deprivation of Eusebius Paget from his church living, his lawyer claimed that the "minister was promised by both Ordinary [i.e., the bishop] and patron that he would not be required to use such ceremonies as troubled his conscience. . . . [Later] his Ordinary . . . commanded him to use the book in every point, but no proper book was provided, so he behaved as before. At this both Ordinary *and patron* were enraged, and the *latter* secured his presentment [to the High Commission] by means of churchwardens and sidesmen nominated by himself, and not properly elected" (my italics).[53] But in most cases it would be up to the government and the bishops. In 1604, Matthew Hutton, Archbishop of York, acknowledged some government instructions: "I have received letters from . . . his Majesties . . . Privy Council,

[51] A. Peel, ed., *Tracts ascribed to Richard Bancroft* (Cambridge, 1953), pp. 57, 71-72.

[52] I. M. Calder, ed., *Activities of the Puritan Faction of the Church of England 1625-33* (London, 1957), especially pp. 111-22.

[53] Peel, ed., *A Seconde Part of a Register*, I, 176; Trinterud, ed., *Elizabethan Puritanism*, pp. 380-81.

containing two points. First, that the Puritans be proceeded against according to law, except they conform themselves. Secondly, that good care be had unto greedy Patrons, that none be admitted in their places, but such as are conformable, and otherwise worthy for their virture and learning." Hutton hoped that soon "a like order were given . . . to proceed against Papists and Recusants."[54]

Although less of an ultimate threat, simony was a far more common abuse. The oft-cited statute of 31 Elizabeth, c. 6, required anyone accepting an ecclesiastical position to swear that no simoniacal transaction had taken place, and many reformers desired a new law to prescribe a corresponding oath for the patron as well. In 1610, Bancroft and a bishops' commission petitioned the House of Lords to force such an oath, along with the penalty that lay patrons should "forfeit their patronage forever to the king when it . . . be proved that they have committed simony upon any such presentation; . . . [and] that it may be held simony to sell advowsons as well as presentations."[55] It was still being debated in the Commons in May 1621, when Sir Benjamin Rudyard rose to demand

> that some course may be taken for the bridling of covetous, presumptuous Patrons who dare sell . . . to God which was his own before. . . . Now the minister is fettered by an oath . . . and the patron is left at large to make his market. I know there are . . . many Religious Conscionable Patrons who are a law to themselves. But laws were invented for the bad not the good. Many a poor, honest, sufficient minister sits shut up in his study . . . smothering . . . his Calling, because he can find no way out but by offending his conscience. The bold, worthless, ignorant minister . . . buys a benefice as one would buy a farm. . . . This often . . . exposes the church to the brokerage of servants and women, and sometimes of the worse sort. . . . How can such a patron ever be edified by such a pastor, whom he knows to have made shipwreck of his conscience by breaking his oath. . . . My humble motion is that this honorable House . . . appoint a committee to consider a reciprocal oath on behalf of the patron for the . . . preventing this . . . damnable mischief.

[54] S. R. Babbage, *Puritanism and Richard Bancroft* (London, 1962), pp. 113-14.
[55] Bodleian Library, Certe MS. 77, esp. fol. 17v; Babbage, *Puritanism*, pp. 113-14.

We are told that this speech was "very well approved by the House."[56]

Complaints throughout most of the seventeenth century, however, show that patrons were ingenious enough to circumvent the laws and that clerics were too numerous and too ambitious to be tracked down by those who would close the simony market. Philip Stubbes saw how they "shift to defeat the law. . . . For though they give . . . three hundred pounds for a benefice, yet shall it be done so closely, as no dogs shall bark at it; . . . to avoid . . . perjury, . . . the pastors themselves will not give any money, but their friends shall do it for them; and then they may swear, with as good a conscience as ever Judas betrayed Christ, that they . . . came by it freely."[57] But Thomas Brightman added that although

> some men will say all this is not a corruption of laws, but the corruptness of men, nay surely, as long as that manner of conferring ecclesiastical charges [i.e., patronage] takes place . . . there is no remedy. . . . In the late Parliament, laws were enacted severely against it; but what came of that? Nothing truly, but that it made men deal more . . . cunningly to cosen the law. We must not think to do any good with our laws where Christ's laws are not obeyed.[58]

This leads us to the last and most contentious of the questions: whether the traditional mode of patronage through advowson rights should continue at all, and, if so, how it could be justified. In post-Reformation England, the debate about patronage was being forced beyond questions of procedure and abuses. Now it was seen as impinging on fundamental aspects of church organization and doctrine itself. Most Puritans and Presbyterians, virtually all Congregationalists, many Catholics, and even quite a few Anglicans found the current situation intolerable both to conscience and to belief. For many, the abolition of lay patronage in its established format was essential, although they differed considerably about what

[56] W. Notestein et al., eds., *Commons Debates 1621* (New Haven, 1935), IV, 343-45.

[57] Furnivall, ed., *The Second Part of the Anatomy of Abuse*, II, 81-82. And William Walker watched "priests find backways and by ways into [the Church] through their patrons' houses, which stand too near the churches, tho the doors be sealed with the . . . most wholesome laws . . . to prevent simony." See *A Sermon at the Funerals of Lord Russell*, pp. 15-16.

[58] *A Revolation*, p. 144.

should replace it and what role, if any, the laity should continue to play in the naming of pastors. Lay patronage offended their morals; but more importantly, it went counter to their various conceptions of God's "true church."

For the Puritans and Congregationalists, the basic objection was really quite simple. As the moderate Puritan Josias Nichols wrote in 1602, "if they read the tract of the primitive ages, they may trace a good many years before that ever these advowsons . . . were once heard of in the church of Christ."[59] The same position was more forcefully stated in many a Congregationalist manifesto: the choice of pastors "belongeth not to the civil-magistrates, as such, or diocesan-bishops, or patrons: for of these or any such like, the Scripture is wholly silent, as having any power therein."[60] The Separatist Henry Barrow argued that "concerning the office of these patrons . . . we find no mention thereof in the Testament of Christ (where all the offices of his church are perfectly described). . . . Christ has appointed that every particular church, all members thereof . . . as well learned as other, with one accord should make choice of their ministry."[61]

But while the lack of Scriptural precedent was the central objection, it was by no means the only one. To quote Barrow again, the proper

> choice can not be made or order kept when one man (were he never so wise) takes away the power and duty of the whole church to make the choice, how much less when the patron that owns the advowson is many times a stranger both to the priest and people, ignorant and unable to discern or judge the gifts, fitness, life of the person chosen and presented, the patron many times being a child, a woman, . . . a profane or wicked person, a papist, an atheist, a heretic, etc., which choice the miserable people rue that are subject to these woeful orders,

[59] *The Plea of the Innocent* (London, 1602), pp. 215-16.

[60] See, for example, W. Walker, ed., *The Creeds and Platforms of Congregationalism* (Boston, 1960), esp. pp. 214-15; John Owen, *The True Nature of a Gospel Church and its Government*, ed. J. Hustable (London, 1947), pp. 53-61; M. Tolmie, *The Triumph of the Saints* (Cambridge, 1977); and references to Canne, Cartwright, etc., below.

[61] *The Writings of Henry Barrow 1587-1590*, ed. L. H. Carlson (London, 1962), pp. 236-37.

and must endure whatsoever these lords their patron and ordinary do, be the priest never so bad.[62]

Philip Stubbes would have forbidden "any private or singular man of what degree soever to have the patronage . . . of any ecclesiastical living." He would have vested this right in the individual churches, "because one man may easily be corrupted, and drawn to bestow his benefice either for favor, affection, or money upon such as be unworthy; the whole church will not so."[63] John Canne suggested the following analogy to those who defended the hereditary rights of the patron:

If someone in a parish had entailed to him, and to his heirs forever, the power of appointing husbands and wives to all the people therein, the slavery were insufferable, although in a matter of a civil nature. But how much more . . . insufferably great is their sin which lose a spiritual freedom.[64]

In another treatise, Canne denounced the tyranny which forced priests onto congregations "though they consent not unto it, nay . . . be wholly against it and have good reason . . . yet if the Patron (whether popish, profane, or religious, *all is one*) and the Bishop do accord in the business, they must necessarily put their necks under the yoke of the wicked usurper" (my italics).[65] But if the problems and their perpetrators—lay patrons and the episcopacy— were both obvious to factions at one end of the Protestant spectrum, any agreement soon splintered when righteous complaint gave way to prescriptions for the proper replacement.

There was considerable debate about the nature and degree of the laity's proper role in the congregational selection of new ministers. In the 1630s John Paget thought that the best way to understand a fellow's religious persuasion was to quiz him as to "whether a particular congregation hath power to call a minister, without the approbation of the *classis* under which it stands."[66] For some, no limitations were acceptable. Others were chary of total independence. In *An Admonition to the Parliament* (1572), Thomas

[62] Ibid., p. 237.

[63] Furnivall, ed. *The Second Part of the Anatomy of Abuse*, II, 79-82.

[64] *A Second Voyce from the Temple to the High Powers* (London, 1653), pp. 23-24.

[65] *A Necessitie of Separation from the Church of England, proved by Non-Conformists Principles* (London[?], 1634), p. 17.

[66] K. L. Sprunger, *The Learned Doctor William Ames* (Urbana, Ill., 1972), p. 223.

Cartwright had written that "the way . . . to reform these deformities is this: Your wisdoms have to remove advowsons, patronages, impropriations, and bishops' authorities, claiming to themselves thereby right to ordain ministers, and . . . bring in that old and true election, which was accustomed to be made by the congregation."[67] In *A Second Admonition*, he urged "Her majesty, and other that have had the gift of benefices . . . to depart with it that . . . the choice of the minister may be free."[68] But to the charge that he would therefore "have the ministers to be called, allowed, and placed by the people," Cartwright replied, "This . . . is utterly false. . . . The election was made by the Elders with the common consent of the whole church." As for his views on the continued existence of lay patronage, "is it to be thought that any reasonable man would stand for these, as though it were an absurdity to say they ought to be taken away; why not a Cardinal at Canterbury, . . . as an advowsonage at any place?"[69]

Others worried about such thoroughgoing lay control, even by the duly-elected elders. Cartwright's contemporary, William Fulke, thought that since "the election of pastors is a great and weighty matter which ought not to be permitted to the judgment of any one man, but pertaineth to the church whereunto they should be chosen, it is convenient that it be done by judgment of the particular *synod*, both for better advice in choosing a meet man and for authority in causing him to accept their election." After citing several Biblical references against any single individual having the authority either to ordain ministers or to impose them on specific churches, Fulke concluded that

> the assembly of [lay] elders, consisting of grave, wise and godly men, ought to inquire when the pastor's place is void, where they may find a man meet . . . and therein to desire the aid of the synod. The man by such godly advice so chosen ought to be presented to the congregation and of them to be . . . received, if no man can show any reasonable cause to the contrary. This is the right election and ordaining of pastors, grounded upon the word of God and practiced by the primitive church. . . . By this we may plainly see that our presentation of patrons is both profane and prejudicial.[70]

[67] *Puritan Manifestoes*, ed. Frere and Douglas, p. 12.
[68] Ibid., p. 132.
[69] Ibid., pp. 137-40.
[70] Trinterud, ed., *Elizabethan Puritanism*, pp. 291-92.

In 1588, John Udall added that "the manner in . . . elections that according to God's word we desire" is "as Calvin taketh it upon Acts 16: they [congregations] might not elect alone, without the direction of some grave and good minister."[71] But whatever their differences, all agreed that present customs were wrong and that the corrective lay in a proper understanding of the practices of the primitive Church as recorded in Scripture.

If necessary, they could also produce non-Biblical arguments in support of congregational consent. To quote Udall again: "That which pertaineth to all ought to be approved by all the congregation; . . . election by common consent is most effectual to bring the people to obedience, when they themselves have chosen. . . . Therefore election by the people is the best and all others be unlawful." They could also cite authorities from patristic writings, early councils, and modern Protestants. But they felt safer relying on the New Testament.[72]

On the question of patronage, as on a number of other issues, Anglicans were thrown onto the defensive by their intensely self-righteous, fundamentalist opponents. The weight of tradition, long association with the established social hierarchy, and a commitment to gradual reforms without radical change left Anglicans vulnerable to assaults from exponents of the new morality. Anglican writers attempted to refute Puritan and Congregationalist contentions wherever they could; to inspire fear at the likely results (especially for propertied laymen) of the extremists' programs; to justify the past and present need for good works of patronage and to emphasize the propriety of earthly and spiritual rewards for such donors; and to make modest proposals for reforms, usually through strengthening the role of the bishops. Anglicans also showed a consistent awareness of the legal, administrative, and religious practicalities of ecclesiastical patronage.

Like most of the Anglican apologists, John Whitgift acknowledged the existence of patronage abuses. But this was not the sole problem: "I confess that the covetousness of some of them in one way, and the contentiousness of some of you [i.e. the Puritans] in another way, hath done much harm in the church and brought no small hinderance to the Gospel. . . . Every man . . . [should] espy his own deformity, and be thereof ashamed."[73]

For Anglicans, the history of the primitive Church, like Scripture

[71] *A Demonstration of Discipline*, ed. E. Arber (London, 1880), p. 34.

[72] Ibid., pp. 29ff.

[73] *The Works of John Whitgift, D.D.*, ed. J. Ayre (Cambridge, 1853), III, 456-57.

itself, required contextual interpretation, not merely slavish imitation of the chimera of original truth. In a tract, probably compiled by Bancroft though drawn largely from the writings of Whitgift, the author wrote: "The first prerogative they challenge to the Presbyteries is the election by the peoples' consent of all . . . ministers, facing us down most impudently, without authority, that so it was ordained in the Apostles' time, so it was commanded to be always continued; whereas . . . I am persuaded the Apostles themselves of purpose would not use always one order therein, lest any should think, as these men do, the same to be necessary in all time and places."[74] In the early days, the number of Christians was small, so all could know each other and choose the fittest to be the pastor. Moreover, there was then no formal church, whereas "now there are Christian magistrates and a church established and subject to rules." The early Christians were blessed with a special gift of judgment that had now "ceased, and most be ignorant and without judgment." Then the congregations were devoid of idolators, superstitious persons, etc., while now the church was filled with drunkards, "Papists, Atheists, and such like." What strange ministers they would pick if they were allowed free elections.[75] The Puritans denied that the latter types were "of the church, but without . . . and therefore are not to meddle in any holy action; but if the people should choose an unmeet man, the eldership . . . is to reform them."[76] Anglicans were happier when the latter authority rested with the bishops.

Anglican writers also denied the historical veracity of the Protestant tracts and said that they overlooked a very troublesome consequence of popular elections, even of the modified Puritan sort. John Bridges accused William Fulke of misrepresenting the historical evidence, which "was rather . . . about the choosing of their bishops, than of all pastors in every particular congregation." During the first two centuries, Bridges noted, congregations lost even this right "by abusing the same, through their factions, immoderate, and tumultuous contentions, oftentimes ended with bloodshed."[77]

[74] Peel, ed., *Tracts ascribed to Bancroft*, p. 101. He added "Diversity of times, of manners, and of people requireth . . . divers manner, kind, form of government . . . for although the order might be commendable in the Apostles' time, yet could it not . . . be very hurtful and inconvenient for the present state of the Church of England?"

[75] Ibid., pp. 109-10.

[76] Udall, *A Demonstration of Discipline*, p. 34.

[77] *A Defence of the Government Established in the Church of England . . .* (London, 1587), p. 1253.

Matthew Sutcliffe found no examples in Scripture or "in all antiquity" of "consistorial elections, no not of the consistories themselves"; and he, too, worried that "the election by consistories is subject to faction and division, undiscreet and partial choice, slow proceeding. The same is prejudicial to the laws of the realm, to the patron's right, prince's prerogative, and all good course of government."[78]

In answer to the radicals' claim that the traditional process of lay patronage might convey the choice of a parish vicar to "a woman, an infant, an idiot, [who might] have . . . forty benefices . . . in all parts of the land, such as he hath never seen, . . . yet doth he present, and the people must accept,"[79] Bancroft replied that a more serious problem was that Puritans gave "to themselves and to the people of their own parishes all interest and authority in elections; . . . considering the sinister affections of the people, and how easily they are divided and rent asunder, there must needs ensue very great debate and contention."[80] Sutcliffe was even more emphatic: if the people should choose their own ministers, then it logically followed that "not only householders, as . . . Cartwright says, but women and servants and young men, and all that are the people of God should have a voice in the election, for all these have like interest in their pastor with householders. . . . In every church there are in the external society of it more called than chosen, and more temporizers and cold professors than true Gospellers; . . . these will overrule all causes by plurality of voices." Since the Puritans could not allow either the social equality of the first of these conclusions or the religious consequences of the second, Sutcliffe maintained that their call for election by the people was absurd. He concluded with a question: is it "a matter tolerable and beseeming wise governors that clowns and men of occupation should determine matters of religion, or that idiots should . . . govern all matters ecclesiastical; and by what rule of divinity . . . may [it] be surmised that an ignorant man, being chosen an Elder, should suddenly be endowed with new graces . . . and become a new man? "[81]

To this threat of social upheaval, the Anglicans added further fears by invoking the specter of clerical tyranny. John Bridges wrote:

[78] *A Treatise of Ecclesiastical Discipline* (London, 1590), p. 36.

[79] *The Writings of John Greenwood, 1587-1590*, ed. L. H. Carlson (London, 1962), p. 250.

[80] Peel, ed., *Tracts ascribed to Bancroft*, p. 83.

[81] *Ecclesiastical Discipline*, pp. 31-32; Sutcliffe, *An Answer to a Certain Libel* (London, 1592), p. 188.

I defend not . . . the corrupt dealings of any patrons, but rather heartily lament . . . the manifold abuses. . . . But they may be remedied by far better means than for the wrongs done by some to overthrow the right due to all, neither to spare gentleman, nobleman, bishops, . . . prince, . . . but turn all loose to the peoples' election. And yet . . . to take it cunningly away from the people, too, and to give the patronage . . . to an assembly of a few, . . . to summon synods and assemble pastors and elders of every parish . . . in the shire to intermeddle themselves in this matter, which are . . . most of them as much strangers, if not more, unto that parish . . . [than] perhaps is the patron. . . . If our presentation of patrons be profane and prejudicial, verily this election . . . by their elders and synods is far more dangerous unto all the state, and manifest injurious unto many.[82]

Whitgift also stressed the religious consequences of extreme "clerical" Protestantism:

Take from bishops their . . . authority, let every parish elect their own minister, . . . exempt from all controlment of bishops, magistrates, and prince, you shall have as many kinds of religion as there are parishes . . . and a church miserably torn in pieces with mutability and diversity of opinions. Do you not see what they shoot at? . . . Do they not in effect say with the anabaptists, "Christians may have no other magistrates but ministers of the word"? . . . The pope . . . did never more earnestly seek to be exempted from . . . jurisdiction . . . both . . . ecclesiastical and civil. Princes, nobles, and magistrates were never brought into greater servitude and bondage than these men seek to lay upon them.[83]

Archbishop Parker combined all of these concerns: those who advocate popular election, he said, put on the "color . . . [of] sincerity, under the countenance of simplicity, but in . . . truth they are ambitious spirits, and can abide no superiority." Even though "their fancies are favored [by] some of great calling who seek to gain by other men's losses . . . surely if this fond faction be applauded

[82] *A Defence of the Government*, pp. 1254-55.
[83] *Whitgift Works*, ed. Ayre, III, 9-10.

... or borne with, it will fall out to a popularity, and as wise men think, it will be the overthrow of all the nobility."[84]

Puritans had demanded that, at the very least, the parishioners participate in the selection and give their free consent to the man chosen. Cosin replied that this "is neither required by God's nor man's law"; the procedure would be a sham in any case, he said, since there was no doubt that the people would "give a very free consent to ... him whom their patron liketh for his gain's sake, and whom they dare not mislike for fear of the patron's displeasure."[85] In a mid-seventeenth-century defense, John Brinsley offered an interesting analogy that borrowed the language of the common law: "As for our election, if a popular vote be ... needful, ... many of us can ... plead a *Fore-consent*, most of us ... an *After-consent*. ... What was it that made Leah Jacob's wife? She was not so the first night he bedded with her. [But] there came an After-consent, a *Ratihibition* as the lawyers call it, which made the marriage valid. And such a consent, I presume, most ... [of] the godly ministers in the kingdom have."[86] In reality, many patrons did allow the active participation of parishioners in the selection of their pastors, but that aspect of the subject lies outside the focus of my theoretical and theological concerns.

Anglicans did not remain always on the defensive. If their ecclesiology was to work, they had to offer convincing remedies for the evils in the contemporary Church and articulate positive reasons for their practices.

Reform was, of course, devoutly to be wished. For the Anglicans it was to come from more, not less, episcopal oversight: vigilance against simony; greater concern for the quality of those ordained; fearless rejection of the unfit nominees of lay patrons; and continued exhortations.[87] In a sermon before Convocation in 1511, John Colet had preached: "Let the laws be rehearsed that command that benefices ... be given to those that are worthy, and that promotions

[84] *Correspondence of Matthew Parker, D.D.*, ed. J. Bruce and T. T. Perowne (Cambridge 1853), pp. 434-37.

[85] Cosin, *An Answer to ... a certeine Factious libell*, p. 183.

[86] *The Araignment of the Present Schism of New Separation in Old England ...* (London, 1646), p. 32.

[87] A complete history of the episcopate under the late Tudors and early Stuarts remains to be written. For the most recent contribution, see P. Collinson, *Archbishop Grindal 1519-1583: The Struggle for a Reformed Church* (London, 1980). A good account of episcopal attempts to reform patronage is in O'Day, *The English Clergy*, chapters 3-6.

be made . . . by the right balances of virtue, not by carnal affection, not by acceptance of persons whereby it happeneth nowadays that boys for old men, fools for wise men, evil for good, do rule and reign."[88] Later Cosin would argue that whatever "the bishops' blame and reprehension, [it] cleareth not the patron's covetousness, his want of zeal, . . . his simony, his abetting and procuring of another man to be perjured for his own lucre."[89] Hooker saw a need for more staunch episcopal resistance to unqualified nominees. He acknowledged that the bishops were hampered by a common law favoring the lay patron, but religious principles also needed to be proclaimed: "It may be that the fear of [the writ of] *Quare impedit* does cause institutions to pass more easily than otherwise would." Perhaps Parliament should repeal this law (which was costing bishops a fortune in legal fees), he said, "yet where law will not suffer men to follow their own judgment, to *show* their judgment they need not be hindered. . . . Conscienceless and wicked patrons, of which sort the swarms are too great in the church of England, are more emboldened to present unto bishops any refuse by finding so easy acceptance thereof." Bishops had to be seen to care about the standards of the clergy and to exercise their own rights of patronage in a responsible way.[90] Thomas Cooper, Bishop of Winchester, wrote that "if there be any bishop that corruptly bestows his livings . . . what[ever] punishment I would have any layman in that case to sustain, I would wish to a bishop double or triple."[91] But Sutcliffe concluded that "the worst bishop doth bestow [patronage] better than many of the best lay patrons. If [the latter] did their duty . . . there would not be . . . so many learned men destitute of living." He also condemned lawyers and others who aided corrupt lay patrons.[92] In 1629, while still Bishop of London, William Laud wrote to the Earl of Mulgrave concerning a chapel that the inhabitants of Hammersmith wished to erect: "I shall be very unwilling to give way to any popular nomination . . . that . . . bring in notorious disturbers of the peace of the church. . . . If they plead that they allow the maintenance, and therefore should have the

[88] Williams, ed., *English Historical Documents*, V, 652ff.

[89] Cosin, *An Answer to . . . a certeine Factious libell*, p. 177.

[90] Ibid., p. 100; Thomas Cooper, *An Admonition to the People of England* (London, 1589), pp. 144ff.; Hooker, *Laws of Ecclesiastical Polity*, bk. VIII, ch. 24, no. 7.

[91] *An Admonition*, p. 144.

[92] Sutcliffe, *An Answer to a Certain Libel*, pp. 134-35.

nomination, I must answer that they give that allowance for their ease, not that they should dispose of the bishop's office." He asked that the new advowson be placed in his own hands.[93]

These reactions demonstrate the ambiguity of Anglican attitudes toward lay patronage. On the one hand, lay patrons tended to be corrupt, self-interested, or religiously lukewarm, and they needed the guidance of the bishops. Yet patrons among the nobility and gentry were a formidable defense against extreme social and religious innovations. On the other hand, endowment of the Church fabric and the clergy had been a necessity in the past, and the need for further generosity would never end. But what tangible reward could the Church offer laymen in return for their patronage of God's work? The need for total episcopal control conflicted with the Anglican Church's historical justification for the evolution of the structure of the Church and the role of its more prominent laity.

Despite his criticisms of certain lay patrons, Hooker thought that for practical reasons the current structure was right:

> In this realm . . . where the tenure of lands is altogether grounded on military laws . . . the building of churches and consequently the assigning of . . . benefices was a thing impossible without consent of such as were principal owners of land; in consideration . . . they which did so far benefit the church had by common consent granted, as great equity and reason was, a right for them and their heirs till the world's end to nominate in those benefices men whose quality the bishop allowing might admit. . . . If any man be desirous to know how patrons came to have such interest, . . . it seemed but reasonable in the eyes of the whole Christian world to pass the right on to them and their successors on whose soil and at whose charge the same were founded. This all men gladly and willingly did, both in honor of so great piety, and for encouragement of many others unto the like, who . . . else would have been . . . slow to erect churches or endow them.[94]

Thomas Bilson expanded these points to refute radical claims for popular election. Under feudalism, every village had a lord, while the other inhabitants "being but his husbandmen and servants, had neither wealth to build nor right to give any part of the fruits and

[93] *The Works of William Laud*, ed. J. Bliss (Oxford, 1860), VII, 26.

[94] *Laws of Ecclesiastical Polity*, bk. V, ch. 80, no. 11 (also compare nos. 12-13 against popular election).

profits of their lord's land; so that either churches must not at all have been built . . . or the lords of each place were to be provoked to the founding. . . . Neither do I see anything in God's law against it; for when you affirm the people should elect their pastor, I trust you do not include in that word children, servants, beggars, or bondsmen, but such as are of discretion to choose and ability to maintain their pastor." Since in earlier times all were bondsmen except lords, the latter had the whole responsibility and thus de-served the full rewards of patronage. The fact that over the centuries the lords had generously manumitted some and made others copy-holders did not eradicate any of their original rights vis-à-vis the Church: "That which hath so many hundred years been settled . . . by the laws of all nations, as the remembrance and inheritance of the first founders . . . shall a few curious heads make the world now believe . . . repugnant to the law of God? By your eager impugning of patronages, without understanding either the intent or effect of them, wise men may soon see what soundness of judg-ment the rest of your discipline is likely to carry."[95] John Canne remade the radicals' case by denying the value of the endowment and thus the necessity for any reward: "When Constantine first began to endow the church with . . . lands and possessions, a voice was heard from heaven, saying . . . 'This day is poison poured into the church.' . . . For thereupon most of the primitive institutions, orders and customs were broken and men began to run mad in ignorant devotion; thinking that true piety stood in works of that nature, [they] made themselves slaves to the priests." For Canne, Julian's confiscations had improved, not hindered, religion. Similar actions were now again necessary to remove all the stains of Ca-tholicism from England.[96]

But the Anglican answer to the question "whether such things as were given for the maintenance of idolatry may . . . be converted to the service of God?" was an emphatic yes: "If men should convert them to their private use, it might be justly thought that in abolishing superstition, private gain is . . . shot at, and not the advancing of God's religion. . . . If such things as were given to the maintenance of Popery may not be converted to the service of God, then pull down church and universities . . . and let Atheism be instead of

[95] *The Perpetual Government of Christ's Church*, ed. R. Eden (Oxford, 1842), pp. 471-72.
[96] *A Second Voyce*, pp. 22-23.

God's religion and Macciavell in the place of the New Testament."[97] More, not fewer, patrons were needed now when the Church lay under the siege of avaricious iconoclasts, "many Atheists and irreligious Julianists."[98]

Turning now to the third principal religious viewpoint, the majority of the Catholic gentry and nobility no doubt worried less about lay patronage *per se* than about the ruinous fines, the legal threats against their religion and property, and the dangers to their own lives and those of their families, chaplains, and servants. They did what they could quietly to advance their cause. But on the clerical side, Robert Persons, S.J., was more ambitious. In his comprehensive plan for the total "reconversion" of England, he wrestled with the problem of patronage and, at times, echoed both Puritan and Anglican answers. Persons was hostile to English common law, both theoretically and because it stood in the way of the return of all former church property to the "true" Church. He argued that, whatever the legalities, restitution should be agreed to by all good Christians, since "these goods belonged first to a third party, which were the . . . givers, and by them taken from their children and kindred and inheritors for a special ecclesiastical use to be applied to God's service and the help of their own souls . . . [and] cannot in any reason or . . . justice be taken . . . from those uses and . . . permitted to be profane." Persons proposed to establish a clerical "Council of Reformation" to decide how best to use those recovered lands and advowsons. The reacquisition of wealth and the renewed patronage would allow "the external reparation of our English Church . . . after so long a tempest . . . and shipwreck . . . [the] repairing, enlarging, and multiplying of churches, hospitals, free schools, seminaries, . . . public lectures in our universities . . . and a thousand . . . necessities . . . for the new setting up of our Catholic Church again." Parliament should review the law of *mortmain*, Persons said, and "seeing [that] all pious works must begin again in England, it were necessary perhaps that this restraint should be removed for a time at least, . . . and men rather animated than prohibited to give that way." But Persons was not willing to reward new donors with any rights of patronage. In fact, he wanted to abolish or severely limit those rights altogether:

[97] Robert Some, *A Godly Treatise . . . touching the Ministerie, Sacraments, and Church* (London, 1588), pp. 14-15.

[98] John Howson, *A Second Sermon Preached at Paul's Crosse . . .* (London, 1598), pp. 26-31.

For the preservation of a good English clergy, . . . the providing
of priests for benefices . . . should be [reserved] to the bishops
and to certain of the chapter or chief-men about him, to be
assigned for that effect; . . . the patrons . . . should be recom-
pensed with some other privilege or honor to be done to them
in their parishes, . . . but not to present the parson, nor give
advowsons; or . . . if all were not to be taken away, the most
should be that they presented some three or four able men
together . . . and that the bishop with his examiners may take
whom of those they judged most worthy.[99]

Persons' ideas are interesting in juxtaposition with the other reli-
gious positions, but they understandably found little support among
propertied Catholics.

As one would expect, these debates focused primarily on matters
of ecclesiastical polity and discipline, the structure of the English
church and its place vis-à-vis English law and society. But occa-
sionally other theological concerns touched on lay patronage. While
many Protestants worried about how independent a function min-
isters could exercise if the control of the patron was too close, some
Catholics approached a new "Donatism" by doubting whether such
subservient priests could effectively absolve communicants of their
sins.[100] The Puritan William Fulke argued the need to change the
basic nature of worship, and especially the role of preaching, as a
prelude to improved discipline in other areas:

While the whole office of a pastor shall be thought to consist
in reading only a prescript number of psalms and chapters of
the Scriptures, with other appointed forms of prayer; and that
he may be allowed as a sufficient pastor which doeth the things
which a child of ten . . . may do as well as he, so long shall
we never lack unlearned pastors, ignorant and ungodly people,
simoniacal and sacrilegious patrons, so long the building of

[99] *The Jesuits Memorial, for the Intended Reformation of England under their
First Popish Prince*, ed. E. Gee (London, 1690), pp. 49-57, 64-69, 107, 132-33; see
also T. H. Clancy, S.J., *Papist Pamphleteers* (Chicago, 1964), pp. 111-22; J. J.
Scarisbrick, "Robert Persons' Plans for the 'True' Reformation of England," in
*Historical Perspectives: Studies in English Thought and Society in Honour of J. H.
Plumb*, ed. N. McKendrick (London, 1974); and Bossy, *English Catholic Com-
munity*, pt. I.
[100] See especially Bossy, *English Catholic Community*, pp. 54-55.

God's church shall go but slowly forward beside other super-
stitious fantasies maintained in the people's hearts.[101]

Of course, practical considerations of various sorts were also
raised. For Whitgift and Bancroft, one of the objections to "Pres-
bytery elections" was that they

> would be the occasion why many churches for too long a
> season should want [a minister] . . . for if unmeet men were
> chosen, and an appeal made to the [nearby] pastors, and from
> them to the next Synod Provincial; and then the parishioners
> that would not yield [were] excommunicated and . . . com-
> plained to the Prince; and then driven to a new election, . . .
> whilst all this were in doing, besides the marvelous schisms,
> contentions, brawlings, and hatred . . . two or three years may
> soon be spent . . . all which time the parishes must be destitute
> of a pastor.[102]

Reformers also had to answer the expediential argument from
priests that since all or most of their competitors were buying their
positions, they must do likewise or find no place to serve God and
fulfill their calling. Some claimed that the Church was in such great
danger that they had to get into positions of power by whatever
means in order to carry out the necessary reforms. Since their mo-
tives were pure, of course, they would not be corrupted by the
process. Henry Burton urged those who made such arguments not
to engage in simony, which would show to all that they were not
"sanctified" in their priesthood, but rather to rely on God to provide
lawful advancement for good priests in time to preserve his
church.[103]

The reformers' real problem, however, was the apparently im-
pervious common law of patronage, which continued in force, vir-
tually unchanged, in the midst of considerable alteration in the
structure of land-ownership, new economic and social conditions,
and religious divisions. The protection the law gave to holders of
this type of property significantly impeded reform efforts. Bishop
Parkhurst wrote to the Earl of Sussex in 1572, in response to the
latter's request that the Bishop make certain that no patronage "be
blotted with the allowing of simony."

[101] Trinterud, ed., *Elizabethan Puritanism*, p. 259.
[102] Peel, ed., *Tracts ascribed to Bancroft*, pp. 86-87.
[103] *A Censure of Simonie*, pp. 60-63, 114-17.

Although I do utterly disallow all such corruption, too commonly used in ecclesiastical matters, . . . yet having . . . conference . . . with such as be Doctors of the Civil Laws and others well-learned, I understand that the old Civil Laws allow not the buying and selling of advowsons, but that taketh no place in this realm . . . [where] controversies about the titles of . . . patronage are ruled and decided [by other laws which] . . . maketh patronage mere temporal and by common use are bought and sold; it is not therefore in my jurisdiction . . . to examine every man's right that presenteth to a benefice.[104]

But as irritating as this situation was, Anglicans and even many Puritans were aware that any fundamental tampering with the rights of patronage was potentially explosive and certain to alienate powerful friends among the laity. Based on his experience in Switzerland, Rodolph Gualter suggested a policy of caution to Bishop Cox in 1573: "Should we seek to deprive them of their rights . . . established by long prescription, what disturbances we should occasion! What danger we should bring upon our churches! It seems to us more advisable that they should enjoy their right" of presentation unless they propose someone completely unacceptable theologically. "We think it better to bear with such things as may be borne . . . without the loss of eternal salvation, but which cannot be altered without peril and disturbance."[105] In 1589, Bishop Cooper opposed the idea of legislation to reform patronage, however useful it might be, because patrons would "never be brought to agree to that purpose, to forgo their patrimony and heritage"; "to attempt the matter by making a law . . . would be occasion of so great troubles and alterations, as would draw with them more inconvenience than would stand with the safe state of this commonweal."[106] As long as the laity had the law on its side, it remained free of clerical control.

In the final analysis, the religious debate failed to resolve the fundamental dichotomy of lay-clerical relationships. Contradictions abounded in all the reform proposals. Anglicans incited lay property holders against the intended "usurpations" of Puritan ministers, yet

[104] Cambridge University Library, Ms. Ee. 2. 34, no. 88e. (I owe my knowledge of this reference to Rosemary O'Day.)

[105] H. Robinson, ed., *The Zurich Letters (2nd Series)* (Cambridge, 1845), pp. 230-31.

[106] *An Admonition*, pp. 86-87.

their own solutions to the problem envisioned an even larger role for the clerical hierarchy. Other writers struggled in vain to resolve the stark dialectic of the lay patron as abuser and reformer. Theologians of quite different doctrinal persuasions and temperaments continued to try to subordinate the laity to clerical guidance or to "sanctify" the laity so that the distinction disappeared; but the majority of churchmen remained frustrated by or resigned to the realities that history had bequeathed them.

Under this barrage of criticism, legislation (proposed and enacted), and attempts at reform, one would suppose that the survival of lay patronage was in question. Yet survive it did. Neither the religious arguments, however cogent, nor the manifold abuses of stewardship by lay patrons, however flagrant, caused the abolition of this traditional right and practice. Even in the 1650s, when England experienced an attempt at *total Reformation*, lay patronage endured in the face of the demise of other feudal tenures.

In 1645, Hugh Peters preached before both houses of Parliament to urge them to recommence the "glorious work" of the Feoffees for Impropriations, and continued: "I know not why the Parliament may not try and examine men, and send them out to preach. . . . If this great work were attended, . . . we should not . . . be quarreling at home; . . . from profane priests and ignorant people, you know the other party have fomented this war."[107] Cromwell and the Members of Parliament (who, of course, were laymen) set up Commissions of Triers and Ejectors to play the parts some had envisioned for bishops or synods. But neither Cromwell, nor the Commissioners, nor the attempts of some members of the Barebones Parliament succeeded in dissolving the power of patrons to present benefices. It is true that many laymen thought some of these actions had gone too far. In the Commons' debate of March 1659, Serjeant Maynard grumbled that "Triers at Whitehall . . . have done more than the Pope or the bishops ever did to take away men's advowsons."[108] But the tribulations were essentially political, and by the later seventeenth century the triumph of the laity over the clergy in the contest for control of the administration of the Church was

[107] *Gods Doing and Mans Duty* (London, 1646), pp. 42-44.

[108] The best general account remains W. A. Shaw, *A History of the English Church during the Civil Wars and under the Commonwealth 1640-1660* (London, 1900), II, 178ff., especially p. 265.

complete.[109] Let me now conclude with a brief consideration of the sentiments of the laity itself and the reactions of the clergy who sought to cope with the new reality of lay control.

It is hard to say how many English laymen, or even clerics, given complete freedom of decision, would have gone along with any of the schemes to abolish lay patronage. Habits of deference die slowly. Many of the clergy, including most of those (whether Anglican, Puritan, or Catholic) in positions of authority, owed their advancement in no small part to lay patrons; and most were ambitious for further promotion. The bulk of the clergy thus either passively acquiesced in or actively manipulated the patronage system. Even though ecclesiastical patronage *per se* (excluding the income from lay impropriations) was only a small feature of the financial and social world of Tudor and Stuart landowners, it was still useful and was protected by a common law that left few, if any, loopholes for religious reformers, let alone total abolitionists. Laymen used it according to their needs and consciences. Some were committed champions of religious reform. Others, secure in the legal safeguards of their property, sloughed off the attacks and challenges with the disdain often shown by the cynical for the impotent. Like the clergy, the laity were anything but monolithic in their opinions about patronage.

Everyone agreed that some good patrons existed. Henry Burton praised

> not a few, both of the truly generous nobility and the truly noble gentry, . . . whose patronages are not tainted with the least touch of simoniacal corruption. . . . Of mine own knowledge . . . many . . . in the vacancy of the benefices within their presentations are not patients, looking to be . . . solicited (a thing which commonly hath no good favor) but themselves are agents, . . . sending to the universities and inquiring after the worthiest men . . . on whom, thus carefully sought, and judiciously found, they freely collate the benefice. . . . Wherein me thinks I see a noble emulation between the laity and the clergy of England . . . in the Apostles' sense, between the

[109] See, most recently, I. H. Green, *The Re-Establishment of the Church of England 1660-1663* (Oxford, 1978); J. H. Pruett, *The Parish Clergy under the Later Stuarts: The Leicestershire Experience* (Urbana, Ill., 1978); R. A. Beddard, "The Restoration Church," in *The Restored Monarchy 1660-1688*, ed. J. R. Jones (London, 1979), pp. 155-75, and the references to his own work and that of other scholars on pp. 202-3.

children and the fathers. You are the gracious sons, the sacred person's patron.[110]

While many lay patrons would have balked at the final analogy, most would have thought they recognized their own image in the mirror of the opening encomium.

A few laymen were as intense in their criticisms of patronage abuses as any cleric would have been. As early as 1535, Sir Francis Bigod wrote: "Is it not a great pity to see a man to have three or four benefices, yea . . . a dozen, . . . but setteth in every one of them a Sir John Lacklatin, that can scarcely read, . . . or else such a ravening wolf as can do nothing but devour the silly sheep with his false doctrine?"[111] Similar sentiments, often with more explicit blame for the sins of the bishops, can be found in other lay writings throughout the Reformation period.[112] Occasionally one can even find examples of lay virtue rising righteously above the approaches of ambitious clerics. In 1623, Sir Simonds D'Ewes received a letter from the rector of Stanstone: "I have been earnestly entreated by a near kinsman of mine, a Master of Arts, to move your worship for your benefice of Stowlanthorne. . . . [If] your worship . . . will . . . pass an advowson upon your good liking of the party who is a general preacher and otherwise very well qualified, your worship shall have two hundred angels to be bestowed as your worship shall think good." To this D'Ewes replied:

Before the receipt of your letters, I was somewhat inclinable for your kinsman, but since that hath bred an utter dislike of me towards him. . . . I am sorry to see a man of your coat make such an offer: the complaint nowadays is against unconscionable patrons, but I think it were more needful against such mercenary ministers who were like to corrupt an honest minded patron by such an offer. . . . I am sure I need not prove to you that this were simony. . . . This is not the way to get preferment from honest men.[113]

Among those laymen who were not so confident of their own virtue, many must have been genuinely puzzled and aggrieved by

[110] *A Censure of Simonie,* "author's conclusion."

[111] *Tudor Treatises,* ed. A. G. Dickens, Rec. Ser. 125 (Wakefield, 1959), p. 53.

[112] See, for example, Thomas Whetenhall, Esq., *A Discourse of the Abuses now in Question in the Churches of Christ* (London, 1606), pp. 106-8, 127ff.

[113] British Library MS. Harleian 385, fols. 74-75.

the intense criticism they heard from certain preachers and even from some other laymen about the performance of their legal, social, and spiritual obligations. Writing to the Earl of Leicester in 1576, Thomas Wood, a Puritan layman, sharply criticized the Earl's failure to further their shared cause sufficiently. Leicester was provoked to a defense:

> No man I know in this realm of one calling or other that hath showed a better mind to the furthering of true religion than I. . . . When times of some trouble hath been among the preachers . . . for matters of ceremonies and such like, . . . who did move for them both at the bishops' hands and at the Prince's? . . . Look of all the bishops . . . that I have commended to that dignity . . . whether they were not men as well thought of as any among the clergy before. Look of all the deans . . . commended by me. Who in England . . . hath more learned chaplains belonging to him, or hath preferred more to the furtherance of the church of learned preachers? . . . I trust there lives not that ever can say I did it for gain. . . . From the beginning I have, as all the world knoweth, been a furtherer . . . of our religion as far as any man hath been, . . . I have always sought to prefer the meetest men and best preachers, . . . there is no cause for any man to . . . report of me as you say.

Leicester was no doubt frustrated and angered further by the unconvinced reply from Wood.[114]

The mentality of the laity was also illustrated in an anonymous tract of the 1580s. A prominent cleric found himself seated near a lay patron and in the ensuing conversation

> seemed to lay the whole fault of . . . having so bad men in the ministry upon such patrons. . . . The gentleman, . . . galled . . . and knowing him to be a plurality-man and a non-resident, . . . made this demand of him: "Sir, . . . is it not as lawful for me, a poor gentleman in the country, having the patronage of a benefice, to bestow the same upon some honest poor man, conditionally, to let me have the profits thereof at a reasonable price, allowing him a reasonable stipend for his services, . . . tho he cannot preach, as it were for me to give the same benefice to you, an Oxenford man and a great scholar and able to

[114] *Letters of Thomas Wood, Puritan, 1566-1577*, ed. P. Collinson, spec. suppl. 5 (London: 1960), pp. 10ff., especially 13-15.

preach, and yet will not . . . preach?" Had . . . this man suddenly been stricken dumb and dead as a door nail, you should as well have heard his reply.[115]

But unfavorable comparison was not the only line of defense. If we can believe those who tried to refute them, some patrons argued that simony on their part was not a sin because Simon Magus offered to *buy*, not to *sell*, the Spirit of God.[116] Another gambit was for the patron to claim that he had a "good intent to convert such money" after he received it "to some charitable use, as to bestow it in alms." Many also thought that since simony had been rampant for so long without God's punishment, that was evidence that He did not disapprove.[117] Some claimed personal innocence of any wrongdoing; but as Henry Burton pointed out, it is not "sufficient that you shake your own hands from simony, but see your family, your wife, your son or daughter or servant be free from it. . . . When you bestow a benefice at the earnest suit of any of yours, when you cannot be ignorant of some base corruption, you give your consent to the betraying of the lambs of Christ into the wolf's power."[118]

Such specific excuses and rebuttals, however, pale in comparison with the comprehensive defense by William Prynne, Esquire, in 1654. Reacting both to his fears of what the current government might do and to the dual religious threats of John Canne and William Lilburne on the one hand and Robert Persons on the other, Prynne compiled a substantial legal brief against the earlier attempts to abrogate lay patronage and even suggested that patronage should be expanded. He wrote that behind the attack on "our church ministers, religion, nation in general, and disinheriting all patrons of their ancient, just, and legal inheritances, and advowsons . . . I

[115] *An Abstract, of Certain Acts of parliament*, pp. 101-3.

[116] Howson, *A Sermon . . . 1597*, pp. 42ff.; C. D(owning), *A Discourse on the State Ecclesiastical of this Kingdom in relation to the Civill* (London, 1634), pp. 101-2.

[117] Ibid., pp. 101-2; Burton, *A Censure of Simonie*, p. 65; Howson, *A Sermon . . . 1597*, pp. 46-47.

[118] Or, Burton continued, you "will say you bought the perpetual presentation . . . at a great rate; or, if not yourself your father or predecessors. If . . . (they) left it freely to you, you may the more freely bestow it. If you bought it . . . not for the glory of God, and the good of his church, but to make a gain, . . . your sin is so much the greater. . . . The living is God's, not yours. You keep it but in trust." See *A Censure of Simonie*, p. 116. Compare, for example, anon., *A Treatise of Tithes* (London, 1653), pp. 3-5.

conceive the power, animosity, activity, hopes of the jesuitical and anabaptistical contrivers" that, if unchecked, "may by like violence and injustice seize upon . . . [our] manors, lands, as well as upon . . . advowsons." He then reviewed all of the civil, common, and canon laws concerning patronage from classical times to the present and eloquently restated the argument that the perpetual right of patronage was the minimum reward owed to the original donors and their heirs for their generosity and piety. Prynne went on to say that founders had initially had the privilege of investiture as well. Gradually the Roman church had eroded this claim; but now, he said, "popes' and prelates' . . . canons, depriving patrons of their ancient right of investiture, being . . . abolished, it is both reasonable, just, and equitable that this right now be fully restored . . . and they [be] freely permitted to give full possession to their . . . churches . . . without any further ceremony . . . by any other stranger's hands." Prynne also thought that the "right of patronage, being thus *warranted, established, by all laws of God and men*, cannot be justly lost, forfeited or taken from them . . . without the highest injustice" (my italics). In the event of attainder for treason or felony, the advowson was forfeited along with other possessions; but in cases of simony, recusancy, outlawry, or negligence, the patronage was voided only for the duration of the crime.[119]

Prynne agreed that there should be "a vigilant care of governors and presbyteries, to admit none but able, godly, orthodox persons into the ministry," but he rejected popular election, which led to contention and delays. Rather, he said, one should rely on lay patrons who were

> commonly of good quality and better able to judge and make choice of fitting ministers than the people. . . . The generality of the parishioners . . . throughout England are so ignorant, vicious, irreligious, injudicious, profane, neglectful of God's public ordinances, and enemies to all soul-searching, soul-saving ministers, who would seriously reprove and withdraw them from their sins and evil courses, that we may sooner find a hundred conscientious, religious, godly patrons, careful to present, protect and encourage such ministers, than one such par-

[119] *Jus Patronatus* (London, 1654), pp. 1ff., 10-12, 15ff.

ish wherein the generality and swaying part of the people are so well-affected and qualified as such patrons.[120]

Prynne concluded by claiming that he was just continuing the work of the parliaments of Charles I's times, parliaments which had opposed any infringements on the fundamental laws and rights of Englishmen: "The Lord grant that these new projectors' and pamphletors' endeavored changes . . . of our fundamental, ancient . . . laws, privileges, customs, government . . . [of] our church and realm, may not bring such present confusion upon the whole state . . . of both, and destroy this only security . . . of this nation, peoples' lands, liberties, privileges, lives, . . . and all our patronages, churches, . . . and religion too, which too many public enemies hope for and design."[121]

Whatever the impact of Prynne's treatise, the power of the propertied classes made their case almost unassailable. Most clergymen realized this and knew that they had to appeal to the patrons themselves to effect reforms. As William Covell wrote in 1604: "Howsoever good laws have been made to avoid the corruption of patrons . . . yet the covetous desires of such . . . are able to find means to escape the danger. . . . For human laws (how virtuous or religious soever) where the *uprightness of conscience is wanting*, serveth . . . not to make the sin less common, but the sinner . . . to be more secret" (my italics).[122] Suits to conscience, contrasting models of ideal and abominable patrons, and an occasional denunciation or exhortation were about the only arrows in a reformer's quiver.

In 1550, Hugh Latimer had sketched the qualities of ideal patrons and found them sadly lacking in reality. He tried to show patrons

upon what manner of man they should bestow their benefices: upon a true man, a teacher. . . . But what do you do, patrons? Sell your benefices, or give them to your servants . . . for keeping of hounds or hawks, for making of your gardens. These patrons regard no souls, neither their own nor other

[120] Ibid., pp. 10-11, 27-28. Another layman, Francis Quarles, had a similar opinion at least on this: "It is very requisite for a prince to have an eye that the clergy be elected and come in either by collation from him, or particular patrons, and not by the people"; see *Enchyridion* (London, 1641), first century, no. 54; Hill, *Economic Problems*, p. 50.

[121] *Jus Patronatus*, pp. 30-37, 40-47.

[122] *A Modest and Reasonable Examination* . . . (London, 1604), pp. 140-41.

men's . . . so [long as] they have money. . . . [But] the office
of a patron is to have . . . a vigilant eye for souls' health, and
to provide for his churches . . . that they may be taught in
God's word. . . . Many now . . . go to the law [over] who
should be patron. And what strive they for? . . . Even which
of them shall go to the devil first. . . . I would ask no more
diligence to this . . . than men are wont to bestow upon their
worldly pleasures . . . nay . . . half the labor.

Christ prayed all night before he sent the apostles forth, "ere he
would put them in this preaching office"; should not patrons do
as much?[123] Patrons should always "beware such fellows which
seek for benefices," since they will fail their flocks. It was

a great burden before God to be a patron. For every patron
when he doth not diligently endeavor . . . to place a . . . godly
man in his benefice . . . or else is covetous and . . . hire [one]
. . . which shall say service so that the people shall be nothing
edified, . . . that patron shall make answer before God, for not
doing of his duty. . . . How many soever perish in that parish
because of lack of teaching, the patron is guilty of them. . . .
Therefore it appeareth most manifestly that patrons may not
follow friendships or other affections; but they must see that
God's honor be promoted, that they place such men as may
be able to teach and instruct the people.[124]

Thomas Fuller further urged "the good patron, when he hath freely
bestowed a living, . . . [to] make no boast of it. To do this were a
kind of spiritual simony, . . . as if the commonness of faulting herein
made . . . the rarity of giving things freely merit . . . a general
commendation. He expects nothing from the clerk he presented but
his prayers to God for him, respectful carriage towards him, and
painfulness in his calling."[125]

A number of Renaissance and Reformation manuals of behavior,
funeral sermons, and dedicatory epistles offered heaven above and
honor below to a Christian aristocracy that fulfilled its obligations.
In discussing the nature and duties of nobility, Lawrence Humphrey
said: "This is peculiar to Noble men, to relieve the cause of the

[123] Corrie, ed., *Sermons of Hugh Latimer*, I, 290-92.

[124] Ibid., II, 28-29.

[125] *The Holy State, the Profane State* (London, 1841), pp. 78ff. I am grateful to
William Barr for this reference and for note 128 below.

gospel fainting, to strengthen with their aid impoverished religion, to shield it forsaken with their patronage. . . . [They] who excel in authority, whose power . . . God useth in redeeming and defending religion . . . they be in [a] manner the pastors of the people and the guardians of . . . piety."[126] John Bridges stressed that "the person descending of that line" of the original "noble or gentle" founders should "hold by that right to be ever . . . the patron of that pastorship, that is, to be not only the donor of his living, but the defender of him both in the exercise of his office, and in the liberties, rights and privileges of his church."[127] In 1658, Edmund Calamy's eulogy for Robert, Earl of Warwick, praised "his faithfulness to the trust committed to him . . . especially in disposing of his church-livings. Herein he was very eminent, and very exemplary, being always exactly careful to prefer able, godly, and painful ministers to them. And I doubt not but there are thousands blessing God in heaven for the good they have got by the ministers put in by this noble Earl. . . . He was a great patron and Maecenas to the pious and religious ministry."[128] Other funeral sermons compared their subjects to great patrons of the past. Richard Vines in 1646 lamented the premature death of Robert, Earl of Sussex: "How it amazeth the faith of God's people when the star that led them . . . goes out of sight before it hath brought them to their journey's end. That youngling world of Reformation in Luther's time had a sore temptation when it must see the fall . . . of the Elector of Saxony and others that were pillars of hope. Moses must live no longer than to bring Israel into the plains of Moab. . . . God . . . takes off such Instruments that he may show that he doth not need, is not tied, to any tool."[129] Still others were more personal. William

[126] *The nobles or of nobilitye* . . . (London, 1563), bk. II, sig. M.7, O.8-P.6.

[127] *A Defence of the Government*, p. 1254.

[128] *A Patterne for all*, pp. 6-7. After offering similar praise for the life of his patron, Sir Augustine Nicholls, Robert Bolton (*Robert Boltons last and learned Worke*, ed. E. Bayshaw, London, 1635) urged those

> that loved him to tread in his steps . . . the rather because your unconscienableness in so high . . . a point for the glory of God, and the good of the church, may not only bring upon your own heads, your house's and posterity the curse of God in the near time, but also a company of poor souls, cast away by reason of your corruption, against you at that last and great day, who will then cry out upon you before the face of God, angels, and men that you for a little . . . gain put upon them an ignorant, idle, dissolute . . . minister . . . whereby they must now perish everlastingly; whereas if you had been honest, . . . they might have lived in the endless joy of heaven (pp. 160-62).

[129] *The Hearse of the Renowned* . . . (London, 1646), p. 15.

Miller extolled his patron's "love . . . to religion and religious men, [which] appeareth by his extraordinary favor and affection to the ministers of the Gospel." While many "have had a full experience of this," Miller wanted to let his "peculiar testimony be a witness of the rest." The patron had encouraged his ministry and his studies, "first, by his countenances; . . . and secondly, by his liberality, in that to his great cost, . . . moved questionless thereunto by the Spirit of God for the advancement of his glory, he . . . procured unto me the . . . use and benefit of . . . [a] well-furnished and costly library of a reverenced and famous doctor late deceased."[130] Finally, countless dedications of religious works flattered the spiritual, as well as the personal, vanity of patrons in return for protection, promotion, and support. John Barthlet, for example, expressed the ideal of Renaissance patronage when he wrote to the Earl of Leicester in 1566 that such dedications were a laudable custom by which writers "not only shield and succor their [own] cause, but also advance their patron's name, with high renown, throughout all posterity . . . especially for that your Lordship is so favorable and zealous a friend of the ministry."[131]

Preachers were not always so gentle. In one piece, Richard Vines began: "An Epistle Dedicatory usually bespeaks a Patron . . . I entreat . . . Patrons no further than the Truth may challenge them *suo jure*. . . . I should rejoice to offend any man for his good, and be afraid to please him for his hurt."[132] In another, he urged great patrons to be humble like Moses, "stooping to the reproofs of the Word of God, brought unto you by the ministers . . . who are . . . earthen vessels like yourselves. . . . Frown not your chaplains into a mealy-mouthed baseness, so they dare no more make a dark . . . reflection upon your darling sins than take a bear by the tooth."[133]

But there was little defense against those patrons who muzzled or intimidated the priests they presented, or those who desired "far more to have their ears tickled than their consciences touched."[134]

[130] *A Sermon preached at the Funerall of the Worshipful, Gilbert Davies, Esq.* . . . (London, 1621), sig. D.₂.

[131] *The Pedegrewe of Heretiques*, epistle dedicatory; E. Rosenberg, *Leicester: Patron of Letters* (New York, 1955), especially p. 211.

[132] *The Impostures of Seducing Teachers Discovered* (London, 1644), epistle dedicatory.

[133] *The Hearse of the Renowned*, pp. 20-21.

[134] *Robert Boltons last . . . Worke*, p. 184.

In 1660 John Barnard thought that now "the minister . . . must conform himself to his patron's humor, either obscene, idle, and misbecoming . . . or else atheistical, profane, Celsian, and Julian, scoffing at the austerity and rigid behavior of Christians."[135] Some twenty years later, several tracts raised the possibility of a still greater immediate danger. While unworthy, ignorant, or simoniacal clergymen, appointed by uncaring patrons, might lead their parishioners astray, even a good cleric, if too much under the control of the patron, could not do his spiritual duty: "How will such a one be able to oppose vice and faction, especially if his patron be criminal? He must be contented to preach such doctrine as will please him; and though embroiling the civil government be the patrons' design, yet the clerk must blow the coals, and preach doctrine suitable, as was too visible in our Civil War; and . . . should the patron be a Roman Catholic, Popery must be quite let alone in his sermons."[136] Bishop Stillingfleet even thought that "if the number of patrons that are against our Established Religion should happen to exceed those that are for it, by the help of . . . bonds of resignation, . . . most of our parochial cures would in a little time fall into the hands of popish priests."[137] Contractual bonds of resignation, in which priests agreed in advance to resign their titles under certain conditions, were considered by reformers to be the latest subterfuge for simony. They were justified by lay patrons as necessary to provide for the promotion of younger sons when they came of age or to allow the dismissal (by the layman) of a cleric who was failing in his duties. There is perhaps no better summary of the social and religious ambiguities of patronage and lay-clerical relationships.

Lay patronage was a permanent feature of English society, more so than in any nation on the Continent. It was grounded in law and property, and no one devised an effective way to be rid of it. Moreover, new patronage continued to be a practical necessity for English religion. On the one hand, an Anglican solicitation in 1677 for funds to complete the rebuilding of St. Paul's appealed to the generosity, piety, and rapidly increasing anti-Roman sentiment of

[135] *Censura Cleri or A Plea against Scandalous Ministers* . . . (London, 1660), pp. 6-8, 13-15.

[136] W. S., *The Unlawfulness of Bonds of Resignations* (London, 1696), pp. 26-27.

[137] Edward (Stillingfleet), Lord Bishop of Worcester, *A Discourse concerning Bonds of Resignation of Benefices in point of Law and Conscience* (London, 1695), p. xi.

Englishmen: "Everyone ought, with more than ordinary zeal, to be concerned for . . . this work, not only for the honor of our nation . . . but also of our reformed religion; that there may be not pretense . . . that error and superstition could make men more zealous of good works than the . . . true religion; and that our adversaries of Rome may be convinced that our piety is as generous . . . as theirs; . . . and that whilst we disclaim the merit, yet we do most steadfastly believe the obligation and necessity of good works."[138] On the other hand, Puritans and Catholics were aware that, however much the divine plan guaranteed the ultimate triumph of their missions, short-term survival depended heavily on committed lay patrons. It is slightly ironic that those Puritan clerics who were most severely critical of patrons' activities were also the most vocal in the expectations they placed on their adherents among the nobility and gentry. But even those laymen who accepted the criticisms and lent their support were more likely to use their patronage for the cause than to relinquish it to the clergy or the congregation. The majority of patrons had a wider field of vision: they looked at religion and the Church with one eye and at economic and political advantage and social obligations with the other. Aspirants for church positions had to be prepared to face a variety of patrons with diverse sets of values. As one handbook on advancement instructed: "Seeing that . . . private patrons are of several dispositions, some more lucrative and covetous; others more charitable and religious, I can give you no other rule of attaining the benefice than this: that your son bring with him the ability of learning, integrity of life, and conformity of behavior . . . and these shall make his way with the good and generous patron. But for the other patron, it makes no matter at all for learning, and a very little for manners, or whether he be . . . conformable or no. Truly, he is indifferent."[139]

Some reformers never gave up the fight, but by the late seventeenth century the tone changed: no more the thunder of Latimer, Cartwright, or Canne. Instead, in 1675, Zachary Cawdrey concluded his history of patronage with "an humble supplication to the pious Nobility and Gentry of England." In it he called for the upper classes both to reassert their control over the process (to take it away from the "rich shoemaker, rope-maker, or ale-draper who hath a son to prefer") and also to institute or allow certain reforms.

[138] J. Lang, *Rebuilding St. Paul's* (London, 1956), pp. 94-95.
[139] Thomas Powell, *The Art of Thriving* (London, 1635), pp. 45-46.

He was sure that the nobility lamented the number of fools and thieves put in by other patrons, since they had been exemplary in the use of their own patronage. He urged: "Go forth, . . . Great Sirs, in this your might and you shall save Israel. . . . For to you it belongs under the King's most sacred majesty . . . to be nursing fathers to God's church, and to deliver the poor starved, neglected souls of thousands ready to perish from . . . the simonists." In his search for a remedy for abuses, he did not wish to be "offensive in . . . pleading the peoples' right of election," yet he believed "that simony will never be kept out . . . till the people have more to do in bringing in their own minister." But even his complicated system of nominations, followed by examinations by local ministers, the congregation, and the universities, still left the final presentation in the hands of the patron.[140]

Much remains to be done before we can fully understand the interaction of lay religious patronage, lay spirituality, and lay-clerical relationships during the late Middle Ages, Renaissance, and Reformation. Patronage of the Church must be analyzed as an aspect of patronage in English society as a whole, both in its practice and in its ideological underpinnings in attitudes of hierarchy, deference, ambition, and property rights. We must compare the situation in England with patronage patterns in Protestant and Catholic lands on the Continent. But we must go beyond patronage in order to understand it properly. Religion remained a very powerful motivating force during this period. The majority of patronage studies have started from this premise and have concentrated on the partisan activities of committed lay patrons for various religio-political causes. This is one important aspect of the subject, but it is not the only one. The treatises, sermons, and other sources cited in this essay place the lay patronage in the context of a wide variety of lay-clerical issues: anticlericalism and clerical sacral elitism, ordination and lay preaching, tithes, direct access to Scriptural meaning, and much more. Historians need to do the same thing. We should go beyond the recent obsession with the strictly sociological history of the Church. We need to treat the religious opinions of all the interested parties—Anglican as well as Puritan, lay as well as ecclesiastical—as seriously as the people themselves did at that time. Despite the work of Tawney, Hill, Thomas, Walzer, Collinson,

[140] Z(achery) C(awdrey), *A Discourse of Patronage* (London, 1675), pp. 27ff.

Lamont, and others,[141] we still lack a full history of the theology of the laity during the English Reformation—either the theologies laymen believed or the religious roles allowed to laymen in the various theologies developed by clerics of the period. The problem of the lay patronage of religion is central to both.[142]

[141] R. H. Tawney, *Religion and the Rise of Capitalism* (London, 1926). Several books by J. E. Christopher Hill, especially *Society and Puritanism in Pre-revolutionary England* (London, 1964), *God's Englishman: Oliver Cromwell and the English Revolution* (New York, 1970), *Milton and the English Revolution* (New York, 1977), and *The World Turned Upside Down: Radical Ideas during the English Revolution* (New York, 1973). K. V. Thomas, *Religion and the Decline of Magic* (New York, 1971). M. Walzer, *The Revolution of the Saints* (Cambridge, Mass., 1965). W. M. Lamont, *Godly Rule* (London, 1969). P. Collinson, *The Elizabethan Puritan Movement* (London, 1967); and "Magistracy and Ministry," in *Reformation Conformity and Dissent: Essays in Honour of Geoffrey Nuttall*, ed. R. B. Knox (London, 1977), pp. 70-91. Among much else, see *Puritans and Revolutionaries: Essays in Seventeenth Century History Presented to Christopher Hill*, ed. D. Pennington and K. Thomas (Oxford, 1978), especially the contribution by B. Manning; and C. Haigh, "Some Aspects of the Recent Historiography of the English Reformation," in *Statburgertum und Adel in der Reformation*, ed. W. J. Mommsen et al. (Stuttgart, 1979), pp. 88-106.

[142] See also the following items which I read after my article had gone to press: M. McGiffert, "Covenant, Crown, and Commons in Elizabethan Puritanism," *Journal of British Studies*, 20 (1980), 32-52; and, especially for the later seventeenth-century situation, D. R. Hirschberg, "The Government and Church Patronage in England, 1660-1760," ibid., 20 (1980), 109-39, and his forthcoming book on this subject.

PART III

Patronage and the Arts

FIVE

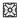

Henry VII and the Origins
of Tudor Patronage

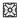

GORDON KIPLING

HENRY VII's avarice, like Richard III's hump, is one of those verities of myth that influence our historical conceptions out of all proportion to the kernel of truth that they may contain. We all know Bacon's Henry VII, that miser-king happy only in his "felicity of full coffers," who carefully examined and signed each page of his treasurer's account book throughout a twenty-four-year reign.[1] He unleashed Empson and Dudley upon his subjects, allowed himself to be bought out of his French war, and reveled in the invention of "Morton's fork." For us, his most fitting elegy remains Lord Mountjoy's famous letter to Erasmus: "The heavens laugh, the earth exults, all things are full of milk, of honey and of nectar. Avarice is expelled the country. Liberality scatters wealth with a bounteous hand."[2] One could hardly think of a less likely patron of art and literature, and so we usually prefer to contrast the miserly Henry with his profligate son. At the court of the former, André, Hawes, and Barclay rivaled one another in the dullness of their verse; at the court of the latter, Wyatt and Surrey, Holbein and Horenbout, More and Erasmus dazzled all Europe.

It may come, therefore, as a surprise to find that Henry VII enjoyed a reputation for liberality among his subjects. When he built a lavish new palace upon the ashes of Sheen and christened it "Richmond," his subjects found that name unusually appropriate. Richmond for them was not just the name of Henry's earldom; rather, they maintained, it meant "Rich Mount," in token of the

[1] *History of the Reign of King Henry the Seventh*, ed. Roger Lockyer (London, 1971), p. 230.

[2] *The Epistles of Erasmus*, trans. Francis M. Nichols (London, 1901), I, 456.

staggering cost of the palace's construction and the richness of its furnishings.[3] Modern scholars who dismiss this merely as an amusing folk etymology miss the point. Henry's subjects turned this pun into a Tudor dynastic symbol. For decades, in poetry, in street pageants, and in masques, jewel-studded mountains appeared as emblematic tributes to Henry Richmond and to his realm, the Rich Mount of England.[4]

If we look carefully at the records of Henry's reign, we shall find that his household stands as the first English court to offer widespread and systematic patronage to artists and men of letters. By emulating the magnificence of the dukes of Burgundy, he transformed the English royal household to include librarians, portrait painters, tapestry weavers, poets, players, glaziers, and the devisers of masques and revels. Thanks to the efforts of the men who filled these newly-created posts, Henry's festivals, tournaments, diplomatic receptions, and ceremonials "were things to marvel at, impressive even to the cynical eyes of Venetian and Milanese ambassadors."[5] From this point of view Henry can claim to be the great innovator of Tudor patronage, the creator of a royal literary and artistic establishment that he passed on to his heirs. His tastes were sometimes unfortunate, it is true; in preferring Burgundian fashions to Italian ones, rhetoricians to poets, propagandists to humanists, he necessarily alienated men like More and Erasmus. But even so, as we shall see, these very preferences often played an important role in the establishment of what we now think of as "Tudor" style.

When he came to the throne in 1485, Henry VII inherited a royal household that had only recently begun reforming itself according to the example of Burgundian magnificence. In 1468 Edward IV had secured an alliance with Burgundy by marrying his sister to Charles the Bold, and he spent a brief exile (1470-71) at that magnificent court during his brief deposition. Impressed by what he saw of his brother-in-law's court in Bruges, Edward commissioned Olivier de la Marche, the Duke's master of ceremonies and the

[3] Arthur H. Thomas and Isobel D. Thornley, eds., *The Great Chronicle of London* (London, 1938), p. 295; British Library MS. Cott. Vit A xvi, fol. 182v; John Leland, *Cygnea Cantio* (London, 1658), p. 5; James Gairdner, ed., *Memorials of King Henry VII* (London, 1858), p. 108; Gordon Kipling, *The Triumph of Honour* (Leiden, 1977), pp. 3-10.

[4] Edward Hall, *The Union of the Two Noble and Illustre Famelies of Lancastre and Yorke* (London, 1550), fol. 12 (Hen. 8); Kipling, *Triumph of Honour*, pp. 96-116.

[5] G. R. Elton, *England Under the Tudors* (London, 1955), p. 43.

greatest authority of his age on court ceremonials and rules, to describe in detail the organization of the Burgundian household. La Marche's *L'État de la Maison du Duc Charles de Bourgongne dict le Hardy* (1473) may well have provided much of the inspiration for the English household reorganization of the late 1470s. Both the famous *Black Book* and the Household Ordinance of 1478, for example, begin with a discussion of the virtue of magnificence as a mean between two vicious extremes, "whereof that one is by excesse and superfluyte, and the other vice by defaute and skarsete." Therefore, the King commands,

> ne willing that oure said household be guyded by prodigalite, which neyther accordeth with honneur, honeste, ne good maner, ne on that other partie, that it be guyded by avarice which is the werse extremite, and a vice moore odiouse and detestable, we have taken ferme purpose to see and ordeyne thadministracion of oure said householde, namely, in costes and expenses, to be grounded and establisshed vpon the forsaid vertue called liberalite.[6]

We recognize here, of course, a quotation from the *Nicomachean Ethics*, but we would probably also be correct in recognizing it as a quotation from Guillaume Fillastre's *La Toison d'Or* (ca. 1470). Fillastre, the chancellor of the Order of the Golden Fleece, uses Aristotle's famous definition in setting magnificence for the first time at the head of the princely virtues, and in his household reorganization Edward IV obviously follows suit.[7] In keeping with this definition, the royal household was divided into two parts. The *Domus Regie Magnificencie* or household "above stairs" consisted of several standing offices—the Great Wardrobe, the Tents, the Works, the Armoury, the Ordinance, and the Mint, each under the control of ·a master or a keeper appointed by patent—and of a variety of personal servants from ushers and grooms to minstrels and chaplains. Under the direction of the Lord Chamberlain these diverse offices and servants were charged with impressing the outside world with ostentatious display. The *Domus Providencie* or household "below stairs," by contrast, consisted of such workaday departments as the kitchen, cellar, bake house, buttery, and chandlery under the direction of the Lord Steward; they made possible

[6] Alec R. Meyers, *The Household of Edward IV* (Manchester, 1959), pp. 3-4, 212.

[7] Kipling, *Triumph of Honour*, pp. 162-63.

the magnificence of the King's upper chamber by means of economy and prudent management.[8]

In accepting this basic organization, Henry vastly elaborated the functions of the household "above stairs" and emphasized the role of formal ceremonial at court. Again and again he adds to and modifies the structure of the *Domus Magnificencie* that he inherited from Edward while leaving the structure of the *Domus Providencie* relatively unchanged. Edward collected books and tapestries; Henry established a royal library as a separate department of the upper chamber, commissioned the designs of whole tapestry sets from Flanders, and added a royal tapestry weaver to his household. Edward provided for the support as necessary of a troupe of minstrels at certain specified times of the year; Henry kept at least two troupes of minstrels at court, added a company of players, encouraged the development of yet a second group of players within his Royal Chapel, and modified the Great Wardrobe so as to make it capable of providing costumes and pageantry for masques and disguisings. Edward's household ordinances are concerned with ascertaining the number and variety of retainers belonging to the *Domus Regie Magnificencie* that could be supported by the *Domus Providencie*. By contrast, Henry's ordinances attempt to define the correct ceremonies that must govern the grooms, ushers, minstrels, and servants in serving the King in royal style. They are, however, correspondingly silent on how the household below stairs is to make possible all this magnificence; somehow the means would be found.[9]

Perhaps the new Tudor approach to royal patronage appears most clearly in the establishment of the first English royal library. Although he obviously agreed with the Burgundian literary tastes of his Yorkist predecessors, Henry VII instinctively institutionalized his patronage of books. Edward IV, by contrast, had been content to remain a noble dilettante. Edward apparently developed a keen interest in illuminated Flemish manuscripts after his alliance with the court of Burgundy in 1468. His sister, the Duchess Margaret, proved an avid patron of the Ghent-Bruges scriptoria, and she undoubtedly supplied Edward with many of his books. So, too, did Louis of Bruges, with whom Edward had stayed during his exile

[8] Meyers, *Household of Edward IV*, pp. 15-16.

[9] "Here begynnyth A Ryalle Book off the Crownacion of the Kinge," in Francis Grose and Thomas Astle, eds., *The Antiquarian Repertory* (London, 1808), I, 296-341.

in 1470-71, earning the earldom of Winchester for his hospitality.[10] Many of Edward's courtiers—Rivers, Tiptoft, and Hastings most prominently—also aspired to that mixture of literature and chivalry characterizing the Burgundian knight, and Edward naturally sought to hold his own with them.[11] Finally, Caxton seems to have enjoyed the King's favor as a supplier of books, having begun his career printing Burgundian texts under the patronage of the Duchess Margaret in Bruges and then moving to England to set up his press at Westminster, near the Court, where his noble clientele could more easily be supplied.[12] Despite all this book-collecting activity, however, Edward's efforts remained typical of a wealthy amateur, somewhat insecure in his tastes, who thought of these splendid illuminated volumes merely as another kind of luxurious furniture. He collected those books that the Duchess Margaret, Louis of Bruges, or Caxton assured him met the highest standards of courtly taste, and then he promptly relegated them to the care of his Keeper of the Great Wardrobe. When Edward moved from palace to palace, the entire collection followed in his baggage train, together with his Flemish tapestries, his gowns, his jewels, and his gold plate.[13] He envisioned no institutional or literary function for this library. Rather, like his tapestries and gold plate, books served him merely as decorative accoutrements, proof of his fashionably noble tastes.

Early in his reign, Henry changed all this by adding the office of Royal Librarian to his household and thereby moving his books completely out of the custody of the wardrobe and centralizing his book patronage. Under the new arrangement, the library now became one of the standing offices of the *Domus Magnificencie* and was presided over by a Keeper who held his office for life by right of royal patent. Like the Keeper of the Great Wardrobe or the Master of the Works, he reported directly to the Lord Chamberlain and received a yearly stipend for his services, in this case £10.

The first holder of this office, Quentin Poulet, received his royal patent just a few months after the death of Caxton. His appointment

[10] See Sir John Sloane Museum, MS. 1, an illuminated Flemish *Josephus* in which the royal arms of England have been painted over Louis of Bruges' own emblem and bombard. See also M. Kekewich, "Edward IV, William Caxton, and Literary Patronage in Yorkist England," *Modern Language Review*, 66 (1971), 482-83.

[11] Kipling, *Triumph of Honour*, pp. 11-16.

[12] Norman F. Blake, *Caxton and His World* (London, 1969), pp. 69-72.

[13] N. H. Nicolas, ed., *Privy Purse Expenses of Elizabeth of York: Wardrobe Accounts of Edward the Fourth* (London, 1830), pp. 125-26, 152.

tells us a great deal about Henry's conception of the nature and function of book patronage at the Tudor court.[14] Poulet was no mere collector and cataloguer of books. He operated, rather, in the manner of such Burgundian atelier managers as David Aubert and Jean Miélot. These men not only commissioned books and employed illuminators, but were writers, translators, and calligraphers in their own right. Indeed, since Poulet was a native of Lille where Miélot operated his atelier, and since Poulet maintained close contacts with these ateliers, we may suspect that he had been trained in Miélot's own workshop, the more so because the famous Burgundian librarian had himself enjoyed excellent relationships with the English court.[15] In any case, we find Poulet operating in England just as Miélot did in Burgundy. A professional calligrapher, he copied a variety of documents for Henry, ranging from the literary to the legal, from such courtly Burgundian romances as *Ymaginacion de la vraye noblesse* (1496) to the formal charters for "the fundacion of the kinges almose houses at Westminster" (1503), and all of them in a distinguished *bâtarde* hand.[16] Many of these he had illuminated by a group of talented Flemish artists whom he may have brought with him when he came to England.[17] From time to time he traveled to Calais "on the King's business," perhaps to buy books or employ illuminators for the Royal Library.[18] Almost from the beginning of his tenure, we find him investing heavily in Antoine Vérard's cunning imitations of Burgundian manuscripts, printed on vellum in a *bâtarde*-typestyle, their woodcuts overpainted by hand to resemble illuminations.[19] Henry, obviously pleased with Poulet, presented him with black velvet gowns, rewards of 100 shillings, and a library especially designed for him when Henry built Richmond palace. When Henry celebrated his son's marriage in 1501

[14] *Calendar of Patent Rolls, Henry VII* (London, n.d.), I, 378, 455-56.

[15] C.A.J. Armstrong, "Verse by Jean Miélot on Edward IV and Richard, Earl of Warwick," *Medium Aevum*, 8 (1939), 193-97.

[16] British Library MSS. Royal 19 C VIII and Additional 59899, fol. 12r.

[17] Kipling, *Triumph of Honour*, pp. 42-49; Erna Auerbach, "Notes on Flemish Miniaturists in England," *Burlington Magazine*, 96 (1954), 51-53 and *Tudor Artists* (London, 1954), pp. 23-25.

[18] Public Records Office E 36/214, p. 65; British Library MS. Additional 46456, fols. 126-27.

[19] See, for example, Vérard's editions of Bonnor's *L'Arbre des batailles* (British Library I. B. 41142) and Suso's *Horologium aeternae sapientiae* (British Library I. B. 41151). Poulet's own signature occurs in a copy of Vérard's edition of *Le Pélerinage de l'âme* (British Library I. B. 41186).

at the new palace, Poulet and his library were among the important features of that "lantirne spectacle and bewtyouse exemplare of all propir lodgynges" that the King pointed out with particular pride.[20] By the end of the reign, so successful were Poulet's efforts that foreign ambassadors like Claude de Seyssel were presenting Henry with illuminated manuscripts (in this case his own French translation of Xenophon's *Anabasis*) with the avowed wish that they might find a place in Henry's splendid library.[21]

When Poulet left the royal service about 1507, Henry continued to appoint Franco-Flemish successors who shared Poulet's tastes, interests, and methods.[22] The first of these, William Faques, a printer, bookseller, and native of Normandy, was promoted to the library from the newly-created office of King's Printer. When Faques died about 1509, Giles Duwes, another Lowlander, succeeded to the Royal Library. Duwes began his career as the colleague of John Skelton in the household of Prince Henry. While Skelton supervised the Prince's studies, Duwes taught French and played the lute. In addition to his library duties—indeed perhaps as a part of them— we find him writing a French grammar and a book on alchemy, advising Palsgrave on the composition of his *Lesclarcissement de la langue francoyse*, and inspecting the holdings of the Guildhall Library.[23]

Two of Poulet's and Duwes's Flemish countrymen visited Rich-

[20] College of Arms, MS. 1st M. 13, fol. 61ᵛ. Public Records Office E 101/414/8, fol. 20; Public Records Office E 101/414/16, 5 January 1498.

[21] British Library MS. Royal 19 C VI; George F. Warner and Julius P. Gilson, *Catalogue of Western Manuscripts in the Old Royal and King's Collections in the British Museum* (London, 1921), II, 334-35.

[22] Poulet is last recorded at Court on 5 June 1506, when he is given forty shillings to go to Calais "Upon the king's business" (Public Records Office E 36/214, p. 65). A payment of twenty shillings on 7 April 1507 "to hym that kepith yᵉ kinges liberary" suggests that Poulet had left permanently by then, since all previous payments to the Keeper of the Library invariably mention Poulet's name (Public Records Office E 36/214, p. 147).

[23] For references to Duwes in Prince Henry's household see Public Records Office LC 9/50, fol. 73ᵛ; Public Records Office E 101/415/7, fol. 67; for various references to "Giles luter" see Public Records Office E 101/415/3 and British Library Additional 59899. For references to Duwes as royal librarian and teacher of French see *Letters and Papers, Foreign and Domestic, of the Reign of Henry VIII*, ed. John S. Brewer, James Gairdner, and Robert H. Brodie (1862-1910), I, 96, 537; X, 776 and also John Stow, *A Survey of London*, ed. Charles Lethbridge Kingsford (London, 1918), I, 282; John Palsgrave, *Lesclarcissement de la langue francoyse* (London, 1530), fol. 23ᵛ. For his literary works, see Warner and Gilson, *Catalogue*, I, xiii.

mond and inventoried the library in 1535, the year of Duwes's retirement and death. The catalogue they drew up represents a unique record of Tudor literary taste, and from it we can judge the nature and direction of forty years of Tudor patronage. Surprisingly, the library contains few English or Latin books. A predominantly French vernacular collection, it is filled with Froissart, Alain Chartier, Christine de Pisan, French translations of classical texts, and French prose romances like David Aubert's version of *Perceforest*.[24] There is little here that would gladden the hearts of More or Erasmus, and much that would have fed Ascham's disgust of romances full of "bold bawdry and open manslaughter." Although obviously a selective catalogue—it does not mention several of Vérard's printed editions we know to have been there—it is almost certainly a representative one.

The entire collection is obviously without humanistic direction. Gibbon's oft-quoted comment on Caxton's neglect of the classics would be equally true of Henry's library, and for exactly the same reason. This list shows the Tudor court heavily committed to the Burgundian tradition of "learned chivalry." Poulet and his successors provided the Tudors with that mixture of histories, romances, and poetry—heavily chivalric in emphasis and composed in copious, aureate prose—that was so popular at the French and Burgundian courts in the late-fifteenth and early-sixteenth centuries. In a seminal essay on literacy in the northern Renaissance, J. H. Hexter has described the motives leading to the establishment of noble libraries like Henry's. The Burgundian knight was obliged to become learned so that he might serve his prince in council, in embassies, and in governing the commonwealth.[25] By reading Cicero, he became eloquent; by reading Caesar, he mastered strategy. For the first time, virtue and learning were linked with chivalry, and we find John Tiptoft, for example, an English knight very much in the Burgundian mold, remarking that knights "utterly ignorant of good letters rarely excel in arms."[26] Though these sentiments share some similarities with those of humanism, the differences are nearly as startling. There is very little interest in Latin or Greek *per se*, for example; the Burgundian dukes in fact employed numerous secretaries to

[24] H. Ormont, "Les Manuscrits français des rois d'angleterre au Chateau de Richmond," *Études romaines dediées à Gaston Paris* (Paris, 1891), pp. 1-13.

[25] "The Education of the Aristocracy in the Renaissance," *Journal of Modern History* 22 (1950), 1-20.

[26] Rosamond J. Mitchell, *John Tiptoft, 1427-1470* (London, 1938), p. 100.

turn classical texts into French prose. Little distinction was made between history and romance; if anything, the latter was accepted as the former, and both were valued insofar as they provided examples of stirring, chivalric deeds and touching, noble sentiments. Hence, we have the origin of the chivalric man of letters in England—Tiptoft, Earl Rivers, or Lord Berners—men of real scholarly accomplishments who translate Cicero, Buonaccorso, or Marcus Aurelius, write romances, and then dash enthusiastically off to seek glory on the tilting field. More than one writer has thought of these men as "humanists" and wondered how they could sustain their interests in chivalry alongside their literary pursuits.[27] But they are in fact members of quite a different intellectual tradition. These learned knights pursued letters as a way of supporting their chivalric duties and thirst for glory. Orthodox humanists, by contrast, were likely to inquire with Petrarch, "where do we read that Cicero or Scipio jousted?"[28] In England we see both intellectual traditions at the same time. The Burgundian tradition of learned chivalry leads directly to Henry VIII, Sidney, and Spenser. The purer humanistic strain runs through Erasmus, More, and Ascham.

The establishment of the Royal Library directly affected royal patronage in other areas, and was symptomatic of Henry's literary patronage as a whole. The King's patronage, through Poulet, of the great French printer Antoine Vérard, for example, probably eclipsed Wynkyn de Worde, driving him from Westminster to the City, where he began to print books more for the popular than for the courtly taste.[29] Beginning in the mid-1490s, shortly after the death of Caxton, Vérard apparently enjoyed exclusive rights to the sale of literary printed books to the Royal Library, much as a modern purveyor of goods may win the right to sell his wares "by appointment to His Majesty the King." As we shall see, the royal tapissiers already enjoyed such exclusive royal patronage, and the pattern of Vérard's sales to the Library suggests that he enjoyed the same privilege. For more than a decade, almost all of the literary printed books added to the Library took the form of Vérard's printed-on-vellum editions, many illuminated with the English royal arms. In 1502 Vérard himself appeared at the English court where he sold

[27] Arthur B. Ferguson, *The Indian Summer of English Chivalry* (Durham, N.C., 1960), pp. 198-99.

[28] Johan Huizinga, *The Waning of the Middle Ages*, trans. Frederik J. Hopman (London, 1924), p. 71.

[29] Blake, *Caxton*, p. 81; Kipling, *Triumph of Honour*, pp. 38-39.

Henry his two-volume edition of *Le Jardin de santé* for the astonishing sum of £6.[30] As this sale alone shows, such an exclusive commercial privilege was far more important to a printer than it first appears. By selling a special presentation copy of a book to the Royal Library for three or four pounds, a printer might well recoup much of the investment required to print and stock the entire edition of several hundred copies, which could be sold profitably in the usual paper editions at a price of about three shillings each.

With Vérard enjoying his commercial monopoly on the sale of printed books to the Royal Library, London printers concentrated on winning Court commissions for official publications, and Poulet apparently controlled this road to Henry's patronage as well. For such important official commissions as parliamentary laws, the program for the reception of Katharine of Aragon, and the *Sarum Missal*, the royal patronage overlooked de Worde and favored two Norman Frenchmen resident in London, William Faques, who dabbled in printing, and Richard Pynson, a fine, professional printer.[31] The obvious next step in the development of Henry's press patronage lay in the creation of the office of King's Printer to serve the household as a kind of official publications office. Henry did this about 1504, granting William Faques that title. Faques's relative inexperience as a printer, however, suggests that he may have been a close friend of Poulet, since his merits as a printer would not seem sufficient to recommend him to the royal service. This suspicion receives strong support from the fact of Faques's subsequent appointment as royal librarian in succession to Poulet only three years after becoming King's Printer. In turn, Pynson succeeded Faques as royal printer—receiving a patent this time—and continued in that role into the next reign.[32] Thus, before his death in 1509, Henry had created two household agencies for patronizing books: literary books were manufactured, commissioned, and collected in the Library, while official publications emerged from the office of King's

[30] Public Records Office E 101/415/3, 18 June 1502; John Macfarlane, *Antoine Vérard* (London, 1900), p. 70; Kipling, *Triumph of Honour*, pp. 38-39.

[31] Public Records Office E 36/214, p. 325; British Library MS. Additional 59899, fols. 37ʳ, 61ʳ; Henry R. Plomer, "Bibliographical Notes from the Privy Purse Expenses of King Henry VII," *The Library*, 3rd Ser. 4 (1913), 291-305.

[32] For references to Faques as "keeper of the king's library," see Brewer, Gairdner, and Brodie, eds., *Letters and Papers of . . . Henry VIII*, I, 14. For references to him as King's Printer, see E. Gordon Duff, *A Century of the English Book Trade* (London, 1905); and as bookseller and importer of books, see Public Records Office E 122/80/2.

Printer. At least initially, as we have seen, Henry's Franco-Flemish librarian probably directed both operations.

Henry's establishment of a royal library probably also led to the founding of a school of Flemish illuminators at the English court. Poulet may well have brought some manuscript painters with him from Miélot's workshop in Lille when he entered the royal service in 1492. Between 1496 and 1500, for example, we find two exceptionally fine Flemish artists at the Tudor court illuminating some five texts for the Royal Library, including the poems of Charles d'Orleans, Bernard André's *Grace entiere sur le fait du gouvernement dun prince*, and *Ymaginacion de la vraie noblesse*.[33] The last of these alone, a Burgundian didactic work copied in Poulet's own hand, may have cost Henry as much as £23 for the illuminations and nearly £7 more for the calligraphy, vellum, and binding.[34] A glance at the work of these Flemish artists demonstrates at once that their work—including the famous view of London Bridge and the Tower (Figure 5.1)—compares favorably with the finest of contemporary manuscript painting in the Ghent-Bruges school. Indeed, judging from Claude de Seyssel's *Anabasis* illuminated in the best Parisian ateliers, Henry VII could command better manuscript paintings than even the King of France.[35] Together with other Flemish expatriates, these artists set about the transformation of Tudor illumination. Thus in the 1490s, as Erna Auerbach points out, an unprecedented originality of ornamental design suddenly appeared in the illuminated documents of the Tudor court. Legal documents began to flaunt floral patterns, scrolls, grotesques, and full-blown illuminations. Older and cruder manuscripts in the Royal Library were reworked by the newly-arrived Flemish masters.[36] Even as we move away from the Court, we find a number of other Flemish artists of varying abilities executing commissions for Caxton, the Beauchamp family, the College of Heralds, and John Colet.[37]

This school of Ghent-Bruges illuminators apparently entered the

[33] British Library MSS. Royal 19 C VIII and Royal 16 F II.

[34] Kipling, *Triumph of Honour*, p. 43, n. 10.

[35] See British Library MS. Royal 19 C VI.

[36] Auerbach, *Tudor Artists*, pp. 24-25. Fitzwilliam Museum, Cambridge, MS. 57 is an extensively modified book of hours reworked for Henry VII. British Library MS. Royal 15 D IV, one of Edward IV's books, has had Tudor emblems added to the margins.

[37] K. L. Scott, *The Caxton Master and his Patrons*, Cambridge Bibliographical Society Monograph no. 8 (Cambridge, 1976). British Library MS. Cotton Julius E. IV ("The Beauchamp Pageants"). British Library MSS. Royal 1 E. V and 1 E. III.

royal household by degrees. Under Poulet's tenure none of them was paid by the Treasurer directly; instead, the librarian seems to have commissioned individual artists to paint individual works, and they were paid for their labors through Poulet as he presented his reckonings to the Treasurer. In this sense they were not part of the household *per se*, although the royal patronage, controlled by a Flemish librarian, probably had much to do with encouraging them to come to England in the first place. But the success of this first group of Ghent-Bruges artists undoubtedly led to the migration of still more renowned manuscript painters to the Tudor court, and Giles Duwes at last completed the process that his predecessor had begun by finding them salaried positions in the royal household. Under Duwes's stewardship, the entire Horenbout family of miniaturists entered the royal service—the patriarch Gerard, his daughter Susanna, and his son Lucas—where they received generous annuities ranging from £20 to 100 marks, salaries greater than Holbein was able to command. Indeed, the elder Horenbout left a prestigious position as Court painter to Margaret of Austria, Regent of the Netherlands, to join the Tudor household: this is a sign of the artistic prestige of the Tudor court. The painter of the *Grimani Breviary* and the *Sforza Hours* had become a Tudor servant. We find this remarkable family working in the Tudor household from the mid-1520s, painting pictures and illuminating such manuscripts as a gospel-lectionary and an epistolary for Cardinal Wolsey.[38] Just before Duwes's death in 1535, Lucas Horenbout was promoted to the post of King's Painter, the final step in the assimilation of the Flemish artists into the Tudor household. But even before the arrival of these particular masters, we find John Skelton paying tribute to the Ghent-Bruges painters already working at Court in his *Garland of Laurel*. As the Queen of Fame opens her book of remembrance, Skelton lovingly describes the illuminations that could only have been painted by Flemish artists:

> With that, of the book loosened were the clasps
> The margent was illuminated all with golden rails
> And byse, empictured with gressops and wasps,
> With butterflies and fresh peacock tails,
> Enflored with flowers and slimy snails;
> Envived pictures well touched and quickly.

[38] Auerbach, *Tudor Artists*, pp. 187-88. Oxford, Christ Church MS. 101; Oxford, Magdalen College MS. 233.

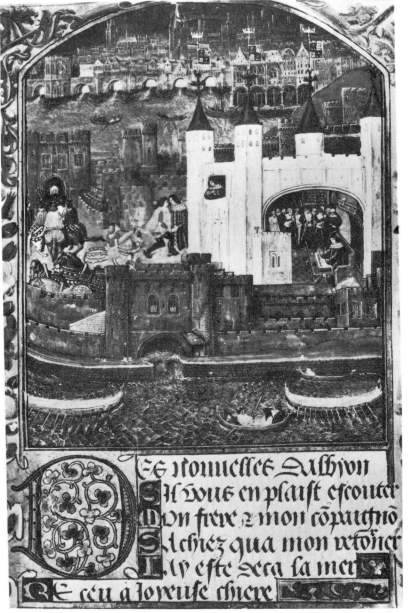

5.1. Unknown Flemish illuminator. *Charles d'Orleans in the Tower of London*. Illumination from a manuscript of the poems of Charles d'Orleans.

· ·

> With balasses and carbuncles the borders did shine;
> With *aurum musaicum* every other line
> Was written.
>
> (1156-68)

Skelton need not have traveled to the Lowlands to see the flowered *trompe-l'oeil* borders full of insects, snails, and gems that are the trademark of the Master of Mary of Burgundy and his Ghent-Bruges followers. Thanks to Henry VII's patronage, the school of the Master of Mary of Burgundy had become a Tudor school.

The King who collected these books and patronized these printers and illuminators, of course, did not do so merely to satisfy his private tastes. His library both set and reflected a Court literary style. He was obviously influenced by the tastes of his courtiers, and in turn his considerable patronage reflected his own tastes and did much to create an early Tudor poetic style. As an index to the literary tastes that Henry's patronage did much to form, we can find no better source than John Palsgrave's *Lesclaircissement de la langue francoyse*. By virtue of his associations with the Tudor literary establishment, Palsgrave could claim to be an authority on Tudor court taste. He was a friend of the royal librarian, Giles Duwes, he taught French to Princess Mary just before her marriage to Louis XII in 1514, and he published his book at the press of Richard Pynson, the King's Printer. Hence, *Lesclaircissement* is no mere grammar; instead, it aims to provide, by means of frequent allusions and generous quotations, a critical guide to such authors as Palsgrave esteemed "to be most excellent in the French tongue."[39] It is, in short, the nearest thing we shall find to an official statement of the poets with whom a Tudor courtier was expected to become conversant. Not surprisingly, the *Roman de la Rose* (now "turned into the new French tongue," however) still holds its popularity. But for the most part, Palsgrave's allusions and quotations demonstrate the high popularity of the Franco-Flemish rhetoricians at the Tudor court. The poet mentioned most frequently is Jean Lemaire de Belges, the disciple of Molinet.[40] Octavien de Saint-Gelais, another popular Flemish rhetorician, ranks second, and he is followed in turn by three other poets who were either fostered by the court of Burgundy or honored there: Alain Chartier, Jean Froissart, and Jean Meschinot. Palsgrave fails to mention either Villon or

[39] (London, 1530), fol. 21ᵛ.

[40] Lemaire is quoted three times as often as the *Roman de la Rose*.

Charles d'Orleans, however. The omission of these two poets speaks eloquently of the high favor in which the Franco-Flemish rhetoricians were held, particularly since Charles d'Orleans' fashionable love lyrics, written in the Tower of London, had been so closely linked to the English court in the fifteenth century.

Only against the background of the predominant Franco-Flemish tastes of the early Tudor court can Henry VII's patronage of poets and scholars—the so-called laureates of Henry's household—be properly understood.[41] For Bernard André, the blind poet of Toulouse, Henry created the position of Court Chronicler, another significant expansion of the royal household, and one modeled upon a Burgundian court office. George Chastellain, Jean Molinet, and Jean Lemaire de Belges filled this office with distinction under the Burgundian dukes, and like these writers, André conceived history to be a species of encomium. Thus André's early work—a series of Latin poems celebrating such events of the reign as Bosworth Field, the coronation, the birth of Prince Arthur, and the murder of the Earl of Northumberland—could later be brought together with appropriate prose linkages into his *Vita Henrici VII* (1500).[42] By any objective standard it makes a poor biography, but it conforms exactly to the style and genre of such eulogistic occasional pieces as Molinet's *Le Trosne d'Honneur*. Part prose, part verse, these effusions were the staple of the Burgundian chroniclers. Similarly, André's *Les Douze triomphes de Henry VII* (1497), full of the aureate French style and mythological conceits of the rhetoricians, celebrates the completion of Henry's first twelve years by comparing them to the labors of Hercules. From the year 1500 to the end of his life, André's chief occupation was the composition of a yearly *Annal* of the reign in the same style. Henry evidently placed great importance upon the contribution of this office to his household's magnificence; he provided André an annuity of £24 and rewarded him with 100 shillings each New Year's Day upon the presentation of each new *Annal*. Not even the King's Glazier, whom Henry paid an exorbitant salary, earned as much.[43]

In addition to instituting this special post for André, Henry found

[41] The best discussion of the Tudor Laureates remains William Nelson, *John Skelton Laureate* (New York, 1939). See also Kipling, *Triumph of Honour*, pp. 11-30.

[42] Gairdner, *Memorials*, pp. 9-75.

[43] Kipling, *Triumph of Honour*, p. 20, n. 28. For Flower's unusually large salary, see Howard M. Colvin, ed., *The History of the King's Works* (London, 1977), III, 25 and n. 4.

places in his household for several other laureates: Pietro Carmeliano and Giovanni Gigli served as Henry's Latin secretaries; Skelton tutored Prince Henry; and Hawes served as one of the grooms of the King's chamber. Indeed, in most of these cases, one strongly suspects that literary qualifications were primary, that Henry deliberately found a place in his household to support a poet whose pen might amplify the magnificence of his court. No previous English king had been so acutely aware of the political advantages of surrounding himself with literary servants. Thus, in addition to the formal duties of their several offices, they all were expected, as the occasion demanded, to join André in composing verse for the King—Carmeliano and Gigli in Latin, Skelton and Hawes in English.[44] With André, they celebrate the birth of Arthur and his creation as Prince of Wales, lament the murder of Northumberland, describe the betrothal of the Princess Mary to the Prince of Castile, hurl defiance to the Scots, and repay the French humanist, Robert Gaugin, for an insult he had offered to their royal master.[45]

In most of these activities Henry's laureates present themselves as orators rather than poets (at least in our sense); they seek to present Tudor policy in as forceful and impressive a manner as possible and, in so doing, to portray the Tudor court as a place of intellectual substance. In keeping with the reputation for letters that he cultivated, Henry was as quick to reward foreign poets and orators when they appeared in embassies at his court as he was generous in rewarding his own.[46] In this respect, the efforts of André and of Skelton as scholars and tutors are relevant. The Tudor princes, like several generations of Burgundian nobles before them, were made to cultivate their own oratorical powers so that they could speak well in council and in negotiations. André, for example, composed *Grace entiere sur le fait du gouvernement dun prince* for his royal charge, while Skelton translated Quintin Poulet's lavish Burgundian manuscript, *Imaginacion de la vraye noblesse*, into English as his *Dialogues of Imaginacion*.[47]

The English members of this group of court laureates, therefore, lived in daily contact with Franco-Burgundian men of letters like

[44] Gairdner, *Memorials*, pp. vi-xiv.

[45] Nelson, *Skelton*, pp. 11-14, 23-31.

[46] For example: "Item to an Italian a poete xx li" (Public Records Office E 101/414/6, fol. 30r).

[47] H.L.R. Edwards, *Skelton: The Life and Times of an Early Tudor Poet* (London, 1949), p. 58.

André, Duwes, and Poulet. Not surprisingly, both Skelton and Hawes write English poetry very much in the tradition of the Burgundian rhetoricians, although with differing skill and originality. We find Skelton, for example, composing poems on exactly the same political subjects as André, translating works from Poulet's royal library, and assisting Duwes in the education of Prince Henry. In the *Garland of Laurel*, Skelton's journey to the Palace of Fame takes a distinctively Burgundian rather than Chaucerian path. Instead of Chaucer's Lady Fame, who distributes her rewards capriciously, Skelton finds himself admitted to a palace of true glory because of his catalogue of worthy poems, just as the worthy Burgundian heroes of Molinet, Saint-Gelais, and Lemaire de Belges earn the right to enter similar palaces because of their lives of virtue and achievement.[48] So, too, such poems as "Speke Parrot" and "Philip Sparrow" seem to borrow much from Lemaire de Belges' *Épistres de l'Amant Vert*. Still more revealingly, Skelton's extant morality play, *Magnyfycence*, examines the Tudor kingship from the point of view of the most central of Burgundian virtues and does so in a way reminiscent of the discussion of magnificence in Fillastre's *La Toison d'Or*, which may have been printed for the first time just before Skelton wrote his play. Even his most original technique, the "Skeltonic," shares with the rhetoricians their love of frequent-rhyme devices; indeed, the works of Chastellain, Molinet, and Lemaire de Belges offer some interesting technical analogues to Skelton's prosody.[49]

While Skelton's work uses these rhetoricians' techniques with originality and independence, Hawes's work rarely escapes the conventions of the Franco-Burgundian tradition. Both the *Example of Virtue* and the *Pastime of Pleasure* belong to the genre of allegorical romance so popular in France and the Lowlands. Indeed, Hawes's characters with their French names, like Graunde Amoure and La Bell Pucell, and his plots, characterized by their peculiar combinations of chivalric romance and scholastic allegory, derive far more clearly from Burgundian romances and tournaments—*Florimont*, *Le Chevalier Délibéré*, the *Pas de l'Arbre d'Or*, and the *Pas de la*

[48] Jean Molinet, *Le Trosne d'Honneur*; Octavien de Saint-Gelais, *Le Sejour d'Honneur*; Jean Lemaire de Belges, *Temple d'Honneur et de Vertus*; Gawin Douglas, *Palice of Honour*; Alexander Barclay, *Eclogue IV*.

[49] Gordon L. Kipling, "John Skelton and Burgundian Letters," in *Ten Studies in Anglo-Dutch Relations*, ed. Jan A. van Dorsten (Leiden and London, 1974), pp. 1-29.

Belle Pelerine—than they do from the works of Chaucer or even those of Lydgate. In a curiously Burgundian way, Hawes's hero, Graunde Amoure, must become worthy of his lady in two ways; first he must defeat a series of knights and monsters as proof of his chivalric prowess, and then he must master the seven liberal arts as proof of his intellectual prowess. He is, in short, a knight very much like Henry VIII, who enjoyed displaying his academic learning even as he delighted in riding onto the tournament field in the persona of Cueur Loyal. Hawes may be a very bad poet, but his works nevertheless represent a kind of distillation of the qualities that early Tudor patronage sought to cultivate: a mixture of learning, chivalry, and moral allegory suggestive of the Burgundian magnificence that Henry VII sought to emulate. The failure of men like More and Erasmus to meet these standards suggests why they failed to achieve patronage while their intellectual inferiors, André and Hawes, found comfortable positions in the royal household.

The same desire to increase the household's magnificence appears in Henry's experimental appointment of a royal portrait artist as King's Painter. Previously, this artisan had been closely connected with the heraldic establishment. As a patent artisan, he was called upon to paint heraldic banners for royal funerals and weddings and to decorate the King's palaces, barges, and carriages with armorial escutcheons as the occasion demanded. He reported directly to the chamberlain, earned a daily wage of one shilling for his labor, and an appropriate price for each item completed, plus expenses. On occasion, if his work especially pleased the King, he might receive whatever additional reward that it might move the King to bestow upon him. If more than one painter joined him to work on a given task, the King's Painter directed the work as a whole and the other artists received a lower daily wage than his, usually eight pence. Henry inherited his first King's Painter, John Serle, from the household of Edward IV, and he appears regularly in the accounts of Henry's reign, preparing heraldic work for all of the major state weddings and funerals. He painted the eleven great armorial banners (including the arms of Cadwalader and Brute) that were grouped around Prince Arthur's hearse in 1502, for example, and after thirty years in office he is last seen painting heraldic trumpet banners and heralds' tabards and decorating the royal carriage for Princess Margaret's marriage to James IV of Scotland in 1503.[50]

[50] Auerbach, *Tudor Artists*, p. 185; Public Records Office, LC 9/50, fol. 30ᵛ;

To judge from the many surviving records of his output, however, he never painted anything but armorial work in all those years.

But even as Serle was ending his long career in the King's service, Henry was appointing a portrait painter to the household for the first time. The position was probably made necessary by the royal marriages of 1501 and 1503. At this period, portraits played an essential part in international negotiations, and artists often accompanied ambassadors to take the measure of foreign princes. Portraits of Archduke Philip and the Duchess Joanna, for example, apparently accompanied the Burgundian ambassadors when they came to negotiate the *Magnus Intercursus* in 1496, and Margaret of Austria sent Michael Sittow to paint Henry VII's portrait when he was attempting to negotiate a marriage with her in 1505. Indeed, late in his reign we find Henry instructing his ambassadors to "inquire for some cunning painter" who could "draw a picture of the visage and semblance" of one of his prospective brides.[51] It is in this context that we must view the arrival of the painter Maynard Wewyck, probably a Lowlander, into Henry's service.[52] As "Mynour the Inglis payntour" he first appears bringing to the Scots court portraits of "the King, Quene, and Prince of England, and of our Quene" (Margaret Tudor) in advance of the Anglo-Scots marriage of 1503.[53] As an artist-ambassador, Maynard's portraits of the English royal family may therefore have been important in sealing the match between James and Margaret. When he returned to England a year later, perhaps bringing portraits of James IV (see the Abbotsford James IV, Figure 5.2, a very similar composition to the standard portrait series discussed below), he apparently succeeded Serle as King's Painter, although without patent.[54]

Accounts of the Lord High Treasurer of Scotland, 1500-1504 (London, n.d.), II, 438-41. *Calendar of Patent Rolls, Henry VII*, I, 48.

[51] G. Gluck, "The Henry VII in the National Portrait Gallery," *Burlington Magazine*, 77 (1933), 105-6; Roy C. Strong, *Tudor and Jacobean Portraits* (London, 1969), p. 149; Kipling, *Triumph of Honour*, p. 52; Gairdner, *Memorials*, p. 236.

[52] Maynard is called "inglis" in Scottish records (immediately below) and declared to be a "franchmen" by the executors of Lady Margaret Beaufort (R. F. Scott in *Archaeologia*, 66 [1914-15], 371). He signed his own name, however, as Meynnart Wewych (R. F. Scott, *Archaeologia*, 66 [1914-15], 371). The Scots probably regarded him as English because he was employed by Henry VII, while Lady Margaret's executors regarded him as French because of his native tongue. Taken together, the evidence seems to suggest that he was a Walloon.

[53] J. B. Paul, ed., *Compota thesaurariorum regum Scotorum* (Edinburgh, 1877), II, 341.

[54] Maynard's entry into the royal service can probably be traced through the

Even if Henry VII at first employed Maynard as a royal artisan paid at the usual daily wage of one shilling as necessary, Maynard eventually became a household retainer paid at an annual salary of £10, a change marking the transformation of his job into a position similar to that of the Royal Librarian or the Royal Lute Player. He thus stands as the first of a long line of Tudor portrait artists, including Holbein and the Horenbouts, whose presence at Court as painters of portraits and pictures was deemed necessary to the magnificence of the chamber above stairs. Maynard first appears in the Court account books as the recipient of the traditional daily wage, together with "rewards" for work that especially pleased. But unlike Serle, he always draws wages for "pictours," never for heraldic work.[55] In the reign of Henry VIII, however, Maynard completed his transition from artisan to retainer. As late as 1526, when he was described as "olde Maynard Wewoke peynter," he was drawing an annuity larger than that of Lucas Horenbout, who had recently joined Maynard as a portrait painter in the royal household.[56]

As Henry's royal portrait artist, Maynard almost certainly painted the originals of the so-called "standard" portrait series. These portraits of Henry, Elizabeth of York, Prince Arthur, Prince Henry, and Lady Margaret Beaufort (Figures 5.3-5.6)—most of them painted at the turn of the century as Maynard was just entering the royal service—coincide with the royal marriages of 1501 and 1503, when for the first time we hear of portraits being painted at the Tudor court. The new great hall of Richmond Palace, for example, contained a large wall portrait of Henry VII, and portraits of the royal house were evidently sent to Ferdinand and Isabella when the Spanish wedding guests returned home.[57] The almost identical poses of the standard portraits—three-quarter bust, soft hats, heraldic chains, right hand turned upward, left hand turned downward—also suggest the same date, since they were apparently based upon the Flemish portraits of the Archduke Philip and his

account books as follows: British Library Additional MS. 59899: 1 February 1504, "Item to hugh denes for the kinges paintor" (fol. 46ʳ); 8 March 1504, "Item to the kinges paynter upon a Rekenyng" (fol. 48ᵛ); 15 March 1505, "Item to Maynard the King's Painter" (fol. 80ᵛ). Many of Henry's artisans served without patent during the reign; see Colvin, *History of the King's Works*, III, 25.

[55] Kipling, *Triumph of Honour*, p. 52, n. 20.

[56] British Library MS. Egerton 2604, fol. 6.

[57] College of Arms, MS. 1st M. 13, fol. 62ᵛ, 65ᵛ.

Duchess Joanna that were given to Henry in 1496.[58] In the next reign, Maynard continued to paint important portrait commissions. He drew up the full-sized patterns for Torrigiano's tomb effigies of Henry VII and Lady Margaret Beaufort, for instance, and from the latter of these he probably painted the full-sized portrait of the Lady Margaret (1512) that still hangs in the library of Christ's College Cambridge (Figure 5.7).[59] The last work that can be assigned to him with any confidence is a portrait of Henry VIII painted according to the "standard" formula about 1520.[60] Although as a portrait artist he certainly cannot be compared to the Flemish masters whose style he imitates, his best work nevertheless shows him to be an artist of genuine skill and a worthy pioneer in the office later filled by Horenbout and Van Dyck.

Henry's innovative addition of a portrait painter to his royal household symbolizes his attitude toward the arts of visual display in general. He was particularly anxious to build a fine tapestry collection and to have his royal palaces glazed in the best available Flemish stained glass. Throughout his reign Henry was particularly aware of the importance of tapestries to his statecraft. Wherever we look, his festivals, embassies, and celebrations are staged against a background of the finest and most expensive Flemish tapestries. He shipped them to Calais in 1500 for his meeting with the Archduke of Burgundy; he lavished them upon the great hall of his newly-built Richmond Palace; he sent them north to Scotland with Princess Margaret to maintain the magnificence of her estate when she married James IV; and he literally surrounded himself with tapestry wherever he went.[61]

Because of his emphasis upon tapestry, Henry was no longer willing simply to entrust his arras to the Keeper of the Great Wardrobe as Edward IV had done. Instead, he added yet another patent artisan to the royal household, a "royal arras maker" who reported to the Keeper of the Great Wardrobe and drew the customary

[58] Kipling, *Triumph of Honour*, pp. 56-58.

[59] Strong, *Portraits*, I, 20; Scott, *Archaeologia*, 66 (1914-15), 370-71; P. Tudor-Craig, *Richard III* (exhibition catalogue, National Portrait Gallery, London, 1973), p. 91.

[60] Strong, *Portraits*, I, 158; II, Plate 302.

[61] Calais, 1500: British Library MS. Arundel 26, fol. 33ᵛ; J. G. Nichols, ed., *Chronicle of Calais* (London, 1846), p. 50; Public Records Office E 101/415/3, fol. 24ʳ. Richmond: College of Arms, MS. 1st M. 13, fol. 62ᵛ. Princess Margaret's journey to Scotland: Public Records Office E 101/415/7, fols. 90, 98, 111; Paul, ed., *Compota . . . regum Scotorum*, p. 441.

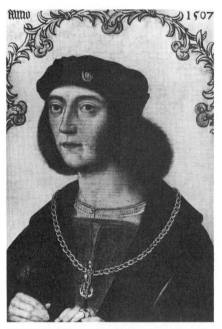

5.2. Unknown sixteenth-century artist. *James IV*.

5.3. Unknown artist. *Henry VII*. Late sixteenth-century copy of an original from about 1500.

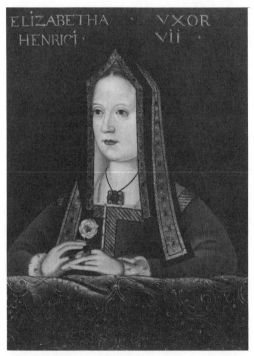

5.4. Unknown artist. *Elizabeth of York*. Late sixteenth-century copy of an original from about 1500.

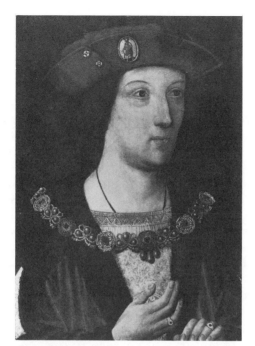

5.5. Maynard Wewyck (?). *Arthur Prince of Wales*. From about 1500.

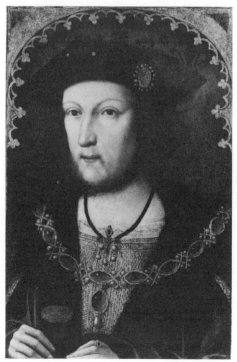

5.6. Maynard Wewyck (?). *Henry VIII*. From about 1520.

artisan's wage of a shilling a day whenever his services might be required. Although Henry did not yet create a separate standing department of the upper chamber for his tapestries as he did for his books, nevertheless this organizational refinement within the Great Wardrobe effectively increased the importance of the tapestry collection to the household. As might be expected, most of the Tudor arras makers throughout the century were Lowlanders trained in prestigious Flemish workshops. Since these patent artisans were free to pursue their craft independent of the Court whenever their labors were not required by the Great Wardrobe, most were probably proprietors of London tapestry workshops.[62]

The records of Henry VII's second patent arras maker, Cornelius van de Strete (appointed 1502, reconfirmed 1510, died 1529) give an especially good idea of the duties of this important office. In one record, he is purchasing tapestries in Bruges and arranging their carriage to London; in another, he is lining some seventy-four "fflemmyshe stikkes of Arras" with canvas for the marriage of Princess Margaret to James IV. In still another, he is both mending nine pieces of tapestry and weaving red roses and portculluses— Tudor royal badges—into their borders.[63] But perhaps the most eloquent testimony to the effectiveness of Van de Strete's collecting and conserving efforts appears in the praise that the foreign ambassadors lavished upon Henry's tapestry hangings at the Field of the Cloth of Gold (1520). According to one Italian witness, the hangings in the English pavilion were the finest in Europe, for they seemed "si belle et si singuliere, que l'on n'en a point veu de pareille." By all accounts, the vivid and life-like designs of the King's tapestries could not possibly be bettered, even in a painting, for "veramente, le figure pareano vive." Even Martin Du Bellay was forced to admit that the English pavilion, because of these hangings, must be judged "un des beaux bastimes du monde."[64] In comments like these, we see the exact political effect that Henry VII's patronage policies were intended to produce.

[62] Public Records Office E 404/83, 8 February 1503; Cornelius van de Strete was succeeded in 1529 by John Musting of Enghein, who was succeeded in turn by John Bukk and Nicholas Morrent; all were Lowlanders. See *Letters of Denization and Acts of Naturalization for Aliens in England 1509-1603*, Huguenot Society of London Publications (London, 1893), p. 1.

[63] Public Records Office E 101/415/7, fols. 90, 98.

[64] Sydney Anglo, *Spectacle, Pageantry, and Early Tudor Policy* (Oxford, 1969), p. 143.

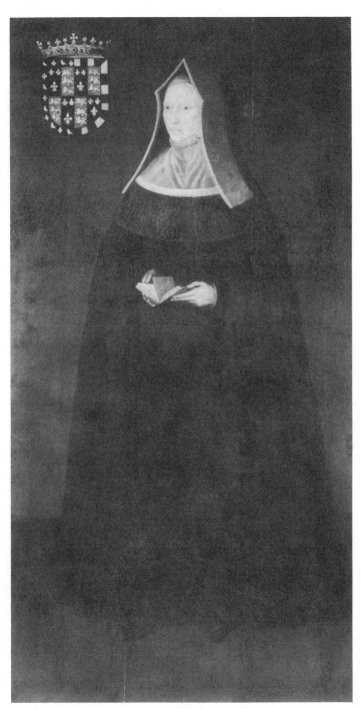

5.7. Maynard Wewyck. *Lady Margaret Beaufort.*

Although Van de Strete, like all of his Flemish successors in office, was obviously a skilled weaver, as his reweaving of tapestries to add Tudor royal badges shows, he never appears to have woven whole sets of tapestries for the royal collection. Instead, Henry bought his tapestries from a second "royal arras maker," a prestigious weaver-merchant in the Lowlands to whom he granted exclusive trade advantages in return for his services. In this way, the royal weaver stood in approximately the same relationship to the royal household that the printer Vérard stood to the Royal Library. Indeed, within a year of his accession, Henry VII had already appointed the first of these merchant-tapissiers, Pasquier Grenier of Tournai, weaver to the court of Burgundy and the greatest tapissier of his time.[65] In September 1486 Henry issued remarkably comprehensive letters of protection to Grenier and his son, allowing them the right to import their wares freely into England. Two years later Henry was purchasing from them the centerpiece of his collection, one of Grenier's superb *Destruction of Troy* sets, a design originally woven for Charles the Bold in 1472 (Figure 5.8). By the turn of the century Henry is to be found sitting in estate among several of Grenier's designs.[66] When Grenier died in 1496, Henry moved quickly to extend his patronage to the looms of Piers Enghein (Pieter Van Aelst of Enghein), who wove many of his tapestries to the designs of Bernard van Orley.[67]

Henry's relationship with Enghein, a Brussels weaver, seems to have been particularly close. In late 1500, for example, Henry gave Enghein nearly £800 in payments for tapestries and loans. In this large sum we may well detect Henry not only purchasing previously designed tapestries from his royal tapissier, but also commissioning an entirely new design, a Tudor history cycle. We know that such a cycle did exist and that it contained panels depicting, among other events, the marriage of Prince Arthur and Henry's Bosworth Field victory: "Item, one pece of Arras of the comyng into Englonde of

[65] For Grenier, see W. G. Thomson, *History of Tapestry* (London, 1930), pp. 110, 146, 151-52, and Madeleine Jarry, *World Tapestry* (New York, 1969), p. 58.

[66] William Campbell, ed., *Materials for a History of the Reign of Henry VII* (London, 1873-77), II, 281; Thomson, *History of Tapestry*, p. 110. College of Arms, MS. 1st M. 13, fol. 62ᵛ. Henry owned the following sets of Grenier tapestries: *The Destruction of Troy, The Siege of Jerusalem, The History of Alexander, The Passion*, and (probably) *The Siege of Mount Alba*: see Kipling, *Triumph of Honour*, p. 61 and n. 31.

[67] For the association of Enghein and Van Orley, see Thomson, *History of Tapestry*, pp. 192-94, 216.

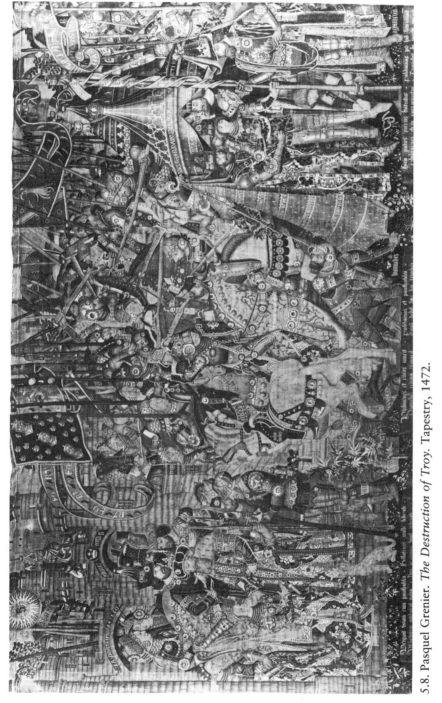

5.8. Pasquel Grenier. *The Destruction of Troy*. Tapestry, 1472.

king henryc the vij^(th) takinge with thone hand the crowne from king Richard the thurde vsurper of the same, & with thother hand holding a roose crowned." The purported surviving panels of this series, the *Betrothal of Prince Arthur* at Magdalen College, Oxford (Figures 5.9 and 5.10), which are Brussels tapestries woven about 1500, might well have come from Enghein's workshop.[68] Certainly these mediocre designs cannot pretend to compare with the Grenier *Destruction of Troy* set, although they probably were intended to do so. Rather, they must be seen in the context—and as the visual equivalents—of André's *Vita* and *Annals*. They reflect the Tudor attempt to depict their dynastic history as a Burgundian chivalric romance, however unromantic much of that history may have been.

Henry VII's attempt to imitate the magnificence of the court of Burgundy by surrounding himself with the Burgundian arts of visual display shows nowhere more clearly than in the transformation of the office of King's Glazier. When Henry came to the throne, the King's Glazier, one of the six patent artisans attached to the Office of the Works at a daily wage of one shilling, was charged with "keeping . . . the kinges manours & castelles in Reparacion with glasse."[69] His service, like that of the royal arras-mender, was largely limited to repair and conservation of existing glasswork. His artistic abilities in designing new stained glass windows were of secondary importance, and much of his job was probably devoted to setting up and taking down removable glass windows in their frames. But with the launching of an ambitious new building program in the 1490s, Henry found himself with a growing need for newly designed stained glass windows to adorn his works at Greenwich, Richmond, the new chapel at Westminster, the Savoy Hospital, and King's College Chapel, Cambridge. And not satisfied merely with adding glass to new buildings, Henry fitted out his existing London palaces with new glass for such major court festivals as the marriage of

[68] For Enghein see Public Records Office E 101/415/3, fols. 26^(v), 37^(r), 58^(r); Public Records Office E 404/83, 7 February 1502; Brewer, Gairdner, Brodie, eds. *Letters and Papers, Foreign and Domestic, of the Reign of Henry VIII*, I, 163, n. 11. For the Tudor history cycle, see Thomson, *History of Tapestry*, pp. 149-50, and Horace Walpole, *Anecdotes of Painting* (London, 1849), I, 288. The two panels now preserved in Founders' Tower, Magdalen College, Oxford recall Walpole's description of the *Marriage of Prince Arthur*, which featured Henry VII and King Ferdinand "conferring amicably upon a joint throne." For the Bosworth tapestry, see British Library MS. Harley 1419, fol. 217^(r).

[69] Public Records Office E 36/214, p. 52; Colvin, *History of the King's Works*, III, 25.

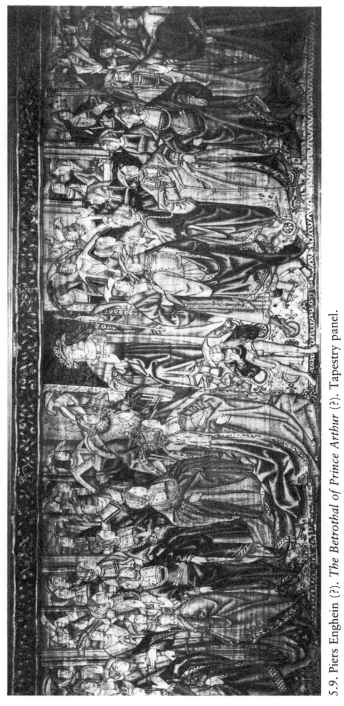

5.9. Piers Enghein (?). *The Betrothal of Prince Arthur* (?). Tapestry panel.

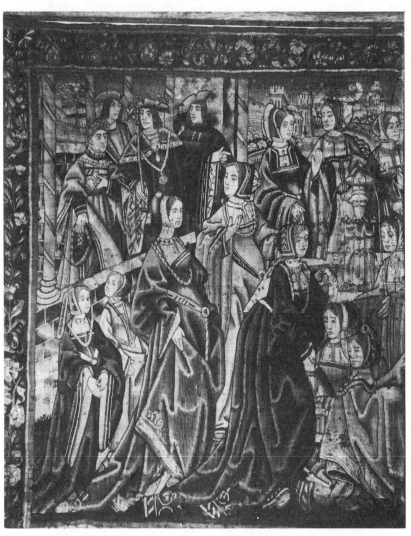

5.10. Piers Enghein (?). *The Betrothal of Prince Arthur* (?). Tapestry panel.

Prince Arthur. No previous English king used glass so extensively as Henry did. All this unprecedented new activity could not help but increase the importance of the King's Glazier to the royal household. For one thing, no one glazier could possibly do all the work alone, hence the King's Glazier would have to become an employer of many other glaziers on behalf of the Office of Works. For another, the high quality of the work demanded for these prestigious buildings necessitated the employment of a particularly skilled artist. Under Henry's auspices, therefore, the position of King's Glazier was transformed from an artisan's job to an office. No longer paid a daily salary whenever his services might be needed, the glazier now received a large yearly annuity for his repair work, and he contracted separately—at a high price—with the Works office for each new project he might undertake. He now headed, in effect, an independent royal office and was not so much employed by as associated with the Works.

The entrance into the King's service of Barnard Flower, the most considerable visual artist to serve at the court of Henry VII, fully reflects this change of status. An "Almain" craftsman, according to his patent of denization, Flower was executing lucrative commissions at the Tudor court by 1496.[70] Within four years, he had already become the most important artisan in the employ of the Clerk of the King's Works; in preparation for Prince Arthur's marriage, Flower was given the lion's share of the glazing work at St. Paul's, the Bishop of London's Palace, the Tower, Westminster Hall, Greenwich, and Eltham in preference to his English colleagues.[71] In 1503 his dominance at the Tudor court was confirmed by his completion of the most important commission that Henry could offer, the glazing of the great hall and chapel at Richmond Palace. That same year appropriately marks the beginning of Flower's tenure as King's Glazier, not, as we have seen, as a mere artisan, but as the head of a standing household department paid an annual salary of £24.[72]

The character of his earliest recorded work, limited as it was to

[70] Brewer, Gairdner, Brodie, eds. *Letters and Papers, Foreign and Domestic, of the Reign of Henry VIII*, I, 2964, no. 11; Public Records Office 101/414/6, fol. 45ᵛ.

[71] British Library MS. Egerton 2358, fols. 8ᵛ, 18ᵛ-19ʳ, 33ʳ, 47ʳ, 51ʳ. His fellow glaziers in 1500 were Adrian Andrew, William Asshe, Mathew Arnold, Thomas Shutleworth, John Cole, and Gherard Plye.

[72] British Library MS. 59899, fols. 23ᵛ (for "glassing att Richmount") and 48ʳ (first payment of half-yearly stipend of £12).

heraldic decoration, was obviously dominated by Henry's desire to lend status and magnificence to his dynasty. As early as 1494, for example, Henry was instructing his glaziers to depict images of the Tudors together with those of various saints for the Grey Friars Church at Greenwich. These figures are conceived conventionally and heraldically rather than realistically, leaving little scope, one would imagine, for the plastic and realistic style for which Flower was to become famous. Henry VII himself was to be depicted in these windows "but halff body to the waste lyke a yong kyng in his Roobis of Astate & Apparell lyke a kyng crowned" with a sceptre in his left hand and an orb in his right. Beneath this depiction the King's arms hung on the branch of a tree to identify him.[73] The accounts of the Clerk of the King's Works consequently show Flower executing just such heraldic designs in his early years: stained-glass roundels depicting red roses, portculluses, dragons, leopards, and the Tudor royal arms. Not surprisingly, he was assisted in some of this work by John Brown, one of Henry's heraldic artists.[74]

Flower's ability to transcend the artistic limitations of such projects, however, probably recommended him for his new office; in particular, his ability to transform conventionalized, flat pattern designs according to the more realistic and intricate Flemish and German styles undoubtedly accounts for his preeminence at Court, not to mention the high prices his services commanded there. Thus, in the Magnificat Window of Great Malvern Priory, which was glazed just as Flower was achieving his early ascendancy at Court, traditional English design has been superseded by the new Continental style. Although still conceived heraldically as in the Greenwich windows, the figures are well modeled; conventional English seraph-style angels have given way to realistic young women with curly hair and dressed in long, white gowns.[75] With Flower at the head of the King's glass works, the new style completely takes over in England during the last decade of Henry VII's reign, whether in major projects like the Savoy Hospital or relatively minor ones, as at the Vine.

Flower's appointment as King's Glazier thus marked the beginning of the long preeminence of the Southwark school of glaziers

[73] British Library MS. Egerton 2341A.

[74] British Library MS. Egerton 2358, fol. 51ʳ.

[75] Margaret Rickert, *Painting in Britain: The Middle Ages* (London, 1954), pp. 210-11.

at the English court, so called because Flower and his successors mainly resided there. This remarkable school of artists, under the patronage both of Henry VII and Bishop Fox, in whose diocese they settled, largely accounts for the "invasion of the foreign style" that transformed English art in the early sixteenth century.[76] Although many of their major works have not survived—the Savoy Hospital and Westminster glass, for example—their primary achievement, the glazing of King's College Chapel, Cambridge, still testifies to the intensity of Henry VII's commitment to artistic patronage. Flower began the project in 1506, and it was completed after his death under the direction of his successor, the Dutchman Gaylon Hone. Perhaps Flower was responsible for commissioning Dirick Vellert, ranked by his contemporaries with Michelangelo, to prepare designs for the religious theme set by Bishop Fox, "The Old Law and the New."[77] That these windows, the acknowledged masterwork of Renaissance Flemish glazing, were executed in England entirely under the patronage of Henry VII, testifies eloquently to the liberality and magnificence of a king popularly supposed to be a miser.

Henry's patronage of the drama may well have been crucial in the development of the interlude and masque in England, and yet it has been consistently undervalued and misunderstood. Much of this lack of appreciation can be traced to Sir Francis Bacon, who observed that Henry was far too "given to his affairs" to take much interest in such "toys"; consequently, Henry appeared "rather a princely and gentle spectator" of such shows than a prince who "seemed much to be delighted" by them.[78] But this influential evaluation of Henry's attitude toward the drama suffers from polemical distortions and historical misconceptions. Bacon wished to depict Henry as a politic and serious prince whose lack of interest in masques, when compared with the Stuart fascination for such "toys," seemed refreshingly laudable. Bacon assumed that the disguising as Henry VII knew it was essentially similar to the Stuart masque. Since Henry VII did not perform in his own court dis-

[76] Kenneth Harrison, *The Windows of King's College Chapel, Cambridge* (Cambridge, 1952), p. 21.

[77] Public Records Office E 36/214, p. 72 (first payment of £30 to Flower "upon an indenture towardes the glasing of the Chauncell of the kinges college at Cambridge"). For Vellert and the designs of the windows, see Hilary Wayment, *The Windows of King's College Chapel, Cambridge* (Cambridge, 1972), pp. 2, 18-22.

[78] Bacon, *Henry VII*, p. 234; *Essays*, XXXVII.

guisings, while Henry VIII—not to mention Elizabeth and Charles—did perform in theirs, Bacon understandably concluded once more that Henry VII was not very interested in such entertainments. In fact, however, the disguising as Henry knew it was an entertainment for the King and his courtiers; it was not customarily performed by them. The fashion of the King dancing with his courtiers in an English masque was an innovation of Henry VIII's.[79]

If we put aside these misconceptions, however, Henry VII emerges as a genuinely innovative and generous patron of the drama. He was the first English king to patronize troupes of players, and his patronage of these players was a good deal more important, as we shall see, than has been acknowledged.[80] Similarly, his interest in

[79] Kipling, *Triumph of Honour*, pp. 96-115.

[80] A persistent misreading of "histrionibus" as "actors" in the various records has bedeviled our histories. E. K. Chambers, for example, attaches special significance to the replacement of *ministralli* with *histriones* in the accounts of Shrewsbury Corporation (*Medieval Stage* [Oxford, 1903], II, 251), and Wickham would locate a company of six actors in the households of both Richard III and Henry VII on the basis of a similar misreading (*Early English Stages* [London, 1959], I, 267). But as Giles E. Dawson has shown, "minstrels, *mimi*, and *histriones* are synonymous terms" on the one hand, while "players, *lusores*, *ludatores*, and *homines ludentes*" are likewise to be equated on the other. Hence, in a study of Kent records, he shows that *histriones* are always to be seen as minstrels, and that actors' companies can only be identified with certainty when they are referred to as players, *ludatores*, or the like (*Records of Plays and Players in Kent, 1450-1642*, Malone Society Collections, no. 7 [Oxford, 1965] pp. x-xii). In addition to his impressive linguistic evidence, I would myself call attention to the biographical context of the payment of 6s. 8d. to "histrionibus domini Regis recept' per Petrum Casenowe" in 1487-88 by the Canterbury Corporation. Since Peter Cassanova was marshall of the King's Trumpeters (Public Records Office E 101/415/7, fol. 110), his troupe of "histrionibus" was obviously a group of instrumental musicians. Almost certainly, this is the group that Wickham mistakenly refers to as "players" at the beginning of Henry VII's reign. It is also possible to show that the same minstrel-"histriones" of the Kent records are traveling to Yorkshire in the records Wickham cites. Thus the troupe of six royal *histrioni* which Wickham finds operating in the 1480s are more likely to have been minstrels than actors. Henry VII's actors numbered only four from 1493, when they first appear, until 1508, when they expanded to five (see the lists of King's Players in the funeral accounts of Elizabeth of York and Henry VII [Public Records Office LC 2/1] and records cited by Chambers, *Medieval Stage*, II, 240-58). For these reasons, Chambers' identification of a troupe of players in the household of the Duke of Gloucester (Richard III) must be doubtful at best. In all the extant records—whether the Yorkshire accounts printed by Wickham or the Kent archives which Dawson has mined—they are *histrionibus, mimi*, or minstrels. Only in the Howard accounts are they once referred to as "iiij pleyers of my lord of Gloucestres," and this exceptional description begs the question whether "players" in this case is not being used in the sense of "instrumentalists" (*Medieval Stage*, II, 256).

the disguising and the tournament led to crucial developments in these forms. The disguising, by adopting Burgundian-style pageant cars manufactured in the Great Wardrobe, became a spectacular drama fully anticipating the Stuart masque as Ben Jonson and Inigo Jones knew it. The tournament, by adopting the same Burgundian pageant cars along with the romantic scenarios of Burgundian tournaments, was transformed from a martial contest to a spectacular drama such as the Elizabethan Accession Day jousts of Sidney and Sir Henry Lee. All these developments were encouraged by means of major revisions in the Great Wardrobe and Chapel that Henry himself seems to have initiated and that led, ultimately, to the formation of the Office of the Revels.

Although the Yorkist household had employed minstrels who had performed plays upon occasion, it had never supported a troupe of players *per se*. Henry's patronage, not just of one, but of three troupes of actors—two in his own household and one in that of the Prince of Wales—in addition to two minstrel companies, must therefore seem all the more innovative.[81] Of these, the King's Players, the first actors' troupe ever to enter the service of an English king, first appears in the Court records of the early 1490s. Under the mastership of John English, they performed regularly at the King's Christmas revels from Epiphany 1493-94 on, perhaps earlier, and for such special occasions as royal marriages and diplomatic negotiations. For their services this group of four actors received livery, an annual stipend of twenty marks, and a reward ranging from one mark to two pounds for their performances.[82] Late in the reign yet another group of players joined English's troupe in the royal patronage. "The Players of the King's Chapel" consisted of four Gentlemen of the Chapel Royal, including William Cornish and John Kite. From 1505 on, this "Chapel" troupe appeared at each of the King's Christmas revels to draw a reward of about twenty marks for their performances.[83]

The two companies were therefore exactly the same size, enjoyed approximately the same financial support, and performed upon the

[81] For the Yorkist minstrel troupes, see Myers, *Household of Edward IV*, pp. 131-32, 247. For the Prince of Wales's company, see Sydney Anglo, "The Court Festivals of Henry VII," *Bulletin of the John Rylands Library*, 43 (1960-61), 44.

[82] Chambers, *Medieval Stage*, II, 187; Public Records Office E 36/131; Public Records Office E 101/414/6, 8 January 1496; British Library MS. Additional 59899, fols. 10ʳ, 75ʳ; British Library MS. Stowe 146, fol. 5ᵛ.

[83] British Library MS. Additional 59899, fol. 75ʳ and payments transcribed in Anglo, "Court Festivals," on 10 January 1506, 7 January 1507, 7 January and 25 December 1508, and 7 January 1509.

same occasions. Nevertheless, they are usually contrasted in our histories. On the one hand, the Chapel troupe is generally conceived of as an amateur company, the forerunner of the various children's, academic, and Court troupes of the "elite" tradition. On the other hand, the King's Players, composed of yeomen rather than Gentlemen of the Chapel, are usually considered a troupe of professional actors organized along the lines of a strolling minstrel troupe who spent most of their time touring the provinces while appearing at Court once or twice a year to earn their livery. As E. K. Chambers puts it, "when their services were not required at court, they took to the road, just as did the minstrels, *ioculator*, and *ursarius* of the royal establishment."[84] Hence they must be understood in the context of the "popular" dramatic tradition.[85]

A study of the personnel of these two troupes, however, suggests a different picture. Neither John English nor Richard Gibson, the two chief members of the King's Players, for example, was a professional actor; both were employed in the Great Wardrobe, English as an artisan, Gibson as a bureaucrat. English, a joiner, was employed by the Wardrobe to build pageants for disguisings in 1501-02, 1508-09, and perhaps on other occasions. In 1503, he assisted Gibson in making the funeral effigy of Elizabeth of York. In yet another capacity, he was one of the small army of servants employed by the Wardrobe to buy silks for the coronation of Henry VII in 1485.[86] Gibson, meanwhile, pursued a career in the service of the upper chamber of the household, rising from yeoman tailor (1501) and porter (1504) in the Great Wardrobe, then transferring to the Tents as Yeoman (1513) and Sergeant (1518). An essential link between his actor's vocation and his household service appears in the series of account books that he kept for the King's Revels from 1509 onwards. As servants of the Wardrobe, both men seem to have been fixtures at the court of Henry VII. Their stints as traveling actors, consequently, must have been brief, at least in the early years. A search of the records of early traveling players' companies fully confirms these insights. While players wearing the liveries of the Earls of Oxford, Arundel, and Essex appear frequently in var-

[84] Chambers, *Medieval Stage*, II, 187.

[85] For the characteristics of the "popular" dramatic tradition contrasted with those of the "elite" tradition, see David M. Bevington, *From Mankind to Marlowe* (Cambridge, Mass., 1962).

[86] Campbell, *Materials*. Public Records Office L. C. 9/50, fol. 150r. Public Records Office LC 2/1, fol. 46v; Public Records Office E 101/415/3, 31 August, 8 September, and 3 November 1501.

ious places throughout the realm in the late-fifteenth century (from 1477 on for the Earl of Arundel's players), the King's Players scarcely travel at all during the reign, except as members of a royal entourage.[87]

Indeed, their inclusion in Princess Margaret's retinue (1503) shows the difficulties the King's Players must have had in mounting an extensive tour away from the Court under Henry VII's patronage. When Margaret went north to marry James IV of Scotland, Henry sent his players along in her retinue. At the Scots court, "John Inglish and hys compangons" performed twice, once specifically acting in "sum moralite."[88] James IV rewarded these actors handsomely, but as his account books show, only three of the company traveled to Scotland, not four, a circumstance that must have made the performance of their "morality" somewhat difficult.[89] Most probably, Richard Gibson's duties as yeoman tailor in the Wardrobe prevented him from accompanying his three fellow actors. And if Gibson could not be freed for such an important state occasion as this, surely it must have been still more difficult to mount a casual tour. In fact, Gibson's increasing responsibilities in the Great Wardrobe after 1504 may explain why the company expanded from four to five actors at the end of the reign. Only by such an expansion could the company be assured of four actors so that it might undertake a tour. At the same time, however, Gibson's increasing importance to the Wardrobe, although at times inconvenient to the company, made him ever more useful to the players. By the end of the reign, Gibson may even have become the dominant member of the King's Players, for he, not John English, now began to draw the annual stipend of twenty marks on behalf of the company, even as he was drawing his own wage as porter of the Great Wardrobe.[90]

[87] For Gibson's career: Chambers, *Elizabethan Stage* (Oxford, 1923), I, 72, and Public Records Office E 36/217 (Revels Accounts). I have been able to find the King's Players performing away from Court on only four occasions during the reign of Henry VII: twice at Dover (1502-3 and 1503-4), once at Sandwich (1508-9), and once at the court of Scotland as part of Margaret Tudor's entourage (1503). The other companies under noble patronage, meanwhile, appear in these and many other places, including the Court. For references, see Dawson, *Records*, Appendix A, and Anglo, "Court Festivals," pp. 44-45.

[88] College of Arms, MS. 1st M. 13, fols. 114-15.

[89] *Compota . . . regum Scotorum*, II, 13-14 August 1503.

[90] The King's Players begin to appear regularly in Kent only after 1517, for example (Dawson, *Records*, Appendix A). For Gibson's receipt of wages, see British Library MS. Stowe 146, fol. 5ᵛ.

These circumstances suggest, therefore, that the King's Players, like the Chapel players, were formed from within the household by servants who spent most of their lives pursuing other livelihoods. Most, like their master, English, were artisans; even as late as 1529, George Muller, one of the King's Players, was pursuing a glazier's profession and having difficulties keeping his apprentice contented. Like the Chapel players, who emerged from the Chapel Royal each Christmas only to return to their choristers' duties, the King's Players must have led only an intermittent existence apart from the Christmas revels and other state festivals. In this respect, we should recall that the earliest extant record of the troupe (1494) describes them as "Lusoribus Regis, alias in lingua Anglicana, les pleyars of the kyngs enterludes," a title that might be paraphrased more accurately as "the performers of plays for the King" than as "the group of traveling players sponsored by the King."[91] There is very little about them to confirm the romantic image of "four men and a boy" trudging through the provinces, bearing the slings and arrows of outrageous fortune and philistine village mayors, all for the sake of the dramatic muse. Rather, the troupe may well have been created by members of the Wardrobe itself to perform the kind of plays that traveling troupes could not mount nearly so well. As we shall see in examining the Court disguisings of Henry VII's reign, the King demanded increasingly sophisticated spectacle in his Court revels. Small peripatetic companies, however, found expensive costumes, scenery, and pageantry a burden to be avoided. But a company formed by members of the royal household specifically for the purpose of adding to the splendor of the King's festivals could draw directly upon the resources of the Wardrobe without considering the necessary economies of traveling. Indeed, on the one well-documented occasion when the King's Players do travel extensively, they can rely upon Princess Margaret's baggage train to carry whatever props, costumes, and scenery they might desire. That the master of this troupe pursued a joiner's trade, built pageantry for Court disguisings, and purchased robes for the coronation tends to confirm this view and suggests a troupe whose strong suit was spectacle.

Most probably, therefore, the King's Players performed plays in the "courtly" rather than in the "popular" tradition, more along the lines of Medwall's *Nature* and *Fulgens and Lucrece* than those of *Mankind*. By creating such a troupe of royal interluders Henry invested the early drama with a stature it had heretofore lacked.

[91] Chambers, *Medieval Stage*, II, 187-88, n. 3.

No longer just a popular or a didactic entertainment, it became a courtly art in Henry's reign, thereby preparing the way for Heywood and Lyly, Jonson and Jones. If the thought of yeomen artisans banding together to produce such courtly drama sounds too much like Bottom the Weaver, Snug the Joiner, and a company of rude mechanicals putting on a tedious brief interlude before Duke Theseus at Athens, then we must grant that Shakespeare knew something of the history as well as of the practice of his craft.

In the staging of his Court disguisings, Henry's taste for spectacle led to the collaboration of the Wardrobe and Chapel Royal in producing these spectacular revels, the Great Wardrobe executing the costumes and pageantry while the Chapel provided the actors. Late in the year, usually in September, Henry would appoint a "master of the revels" and charge him "to make a disguysing for a moryce daunce" for Christmastime.[92] In consultation with the King, he would decide on the theme of the disguising and would be given a budget. Then he would draw a part of that budget in the form of a "prest" or advance and begin work, hiring artisans and buying materials as needed. As the work on the costumes and pageantry progressed, he might draw further amounts against his actual costs, and he would present his final reckonings in January or February after the materials had been disassembled, removed from the disguising hall, and stored in the Great Wardrobe.[93] Contrary to what Bacon says about Henry VII's lack of interest in these productions, the King seems to have exercised a great deal of control over the work as it progressed. So that Henry might examine and approve his work in progress, for example, Harry Wentworth, master of the revels in 1508-9, was obliged to pack it all up, ship it from London to Richmond "to thentent he [the King] myght se the disguising stuff," then ship it back from Richmond to London so that the work could be completed.[94]

As these activities suggest, the responsibilities of the "master of

[92] For John Holt's account of the origin of his office, circa Henry VII, which he wrote later in the century, see E. K. Chambers, *Notes on the History of the Revels Office Under the Tudors* (London, 1906), where it is reprinted in full. Holt's contention that these "seasonal" masters of the revels were actually called by that title is borne out in Gibson's Revels Accounts, where Harry Wentworth, one of Henry VII's revels masters, is customarily given the title "Master of the Revels" as early as 1509 (Public Records Office E 36/217, fols. 5ʳ, 11ʳ, 12ʳ, 25ʳ, 37ʳ).

[93] Kipling, *Triumph of Honour*, pp. 175-77. In Public Records Office LC 9/50, fol. 152ᵛ, Harry Wentworth asks allowance for charges of 8d per day for his costs while "Lying at London for the delyuerey of the stuff of disguising."

[94] Public Records Office LC 9/50, fol. 152ᵛ.

the revels" extended only to the construction of costumes and pageantry. For this reason, he was invariably drawn from the Great Wardrobe during Henry VII's reign. He was never a playwright or a poet, but rather a man like Walter Alwyn, Jacques Hault, William Pawne, John Atkinson, or Harry Wentworth. In most respects, they are the Calibans, not the Ariels, of Henry's court. They can also be found in other contexts serving in various standing offices of the King's upper chamber: they buy silks, timber, and parchment; mend roads; construct forts; find housing for visiting dignitaries; deliver messages; and keep the books in the Ordinance. However "unpoetical" these men may seem, however, we must remember that they only created the pageantry and costumes for the revels; they never had anything to do with the scenarios and speeches. The one surviving Revels Account Book for the entire reign, for example, details the activities of Master Harry Wentworth in completing the pageants and costumes for a disguising in 1508-9. He engages painters, joiners, embroiderers, tailors, and basketmakers; he oversees the construction of the disguising; and he provides his artisans with a supper "at Richemount the nyght of disguysing" to celebrate the completion of their labors. But he has nothing to do with poets or actors.[95] In Jonson's terms, he manufactures only the "body" of the masque, not the "soul."

For the "soul" of the masque we must turn to the Chapel Royal, which provided much of the acting for Henry's disguisings, and perhaps the poetry as well. For a disguising enacted on Twelfth Night 1494, for example, Walter Alwyn, the master of the revels, had constructed a pageant in the form of "a terryble & huge Rede dragun, The which in Sundry placys of the halle as he passed spytt ffyre at hys mowth." But it was William Cornish and his fellow Gentlemen of the Chapel Royal who turned this marvelous dragon to dramatic purpose; indeed Cornish, a poet, musician, and dramatist, may well have written this show. While the King's Players were in the midst of performing an interlude before the King, Queen, and various ambassadors, suddenly there "Cam In Ridyng oon of the kyngys Chapell namyd Cornysh apparaylid afftyr the ffygure of Seynt George, and aftir ffolwid a ffayer vyrgyn attyrid lyke unto a kyngys dowgthyr," who was leading the dragon by a silken lace. After Cornish spoke "a certayn spech made In balad Royall," he began to sing a Saint George anthem, which was then picked up

[95] Public Records Office LC 9/50.

and continued by the Gentlemen of the Chapel "which stood ffast by." As the Gentlemen continued to sing out "all the hool antempn [anthem] with lusty corage," Cornish discreetly "avoyded wyth þe dragon, and the vyrgyn was ladd unto the Quenys stondyng." At this point, twelve gentlemen entered leading twelve ladies by "ker-chyffys of plesance" and danced an intricately choreographed dance to the tune of "a smal Tabret & a subtyle ffedyll."[96] An even closer collaboration between the Chapel and the Wardrobe appears in 1501 when Cornish's name appears in the Treasurer's account as the architect of several pageants for the four disguisings held to celebrate the marriage of Prince Arthur. Upon the same occasion, the Children of the Chapel were drafted to perform. In one pageant, a large castle, "a litill childe appearellid like a mayden" stood in each of the four turrets of the structure and sang "full swettly and ermenosly in all the commyng of the lengeth of the hall till they came bifore the Kinges mageste." In another, "a Chyld of the Cha-pell" was concealed in each of four pageant mermaids attached to a glittering two-story throne, and again they sang "ryght suetly and with crost armoney" as the pageant entered the hall.[97]

In each of these cases, the collaboration of the Chapel and the Wardrobe leads to the same end: the creation of a spectacular and musical setting for a costumed dance. The pageantry, singing, speeches, and dramatic scenario are staged quite separately from the well-choreographed dancing of sixteen or twenty-four men and women. The pageants may in fact bring the dancers into the hall, but when the dramatic prologue has been completed, the pageantry and actors withdraw as the dancers begin their performance. The two halves of the entertainment, however, are closely related; after St. George and the King's Daughter enter leading a dragon by a silken lace, the dancers enter, the men leading their ladies by "ker-chiefs of pleasance," mirroring the dramatic emblem from the pro-logue. The jars of a symbolic courtship, portrayed as the storming of the Castle of Ladies by the Knights of the Mount of Love, are resolved in the matrimonial harmony of the dance. The unrequited faithful lovers who enter the hall in pageants designed to represent Lydgate's *Temple of Glass* and the arbor setting of the *Complaint of the Black Knight* find their lovers' rewards as they couple with one another in dancing while their pageants leave the hall. We

[96] Thomas and Thornley, eds., *The Great Chronicle of London*, pp. 251-52.
[97] College of Arms, MS. 1st M. 13, fols. 53r, 64v.

unfortunately do not know who the dancers were who performed against the background of these spectacular dramatic settings.[98] Since they are never named, however, even in quite detailed accounts where the "estates" are carefully identified, we must suspect that they, too, were household retainers rather than noble dilettantes.[99]

Both interlude and disguising, therefore, remained entertainments performed by the household for the courtiers throughout Henry VII's reign; wherever we look, the boundaries between courtier and entertainer remain firmly in place. Only after the disguising has finished do the courtiers themselves begin to dance with one another. Not until "the disguysers rehersid . . . avoydid and evanyshid ought of the sight and presens" of the Court do the Lord Prince and the Lady Cecil dance two baas dances; then follow the princess and one of her ladies; and "third and last cam doun the Duke of York, havyng with him the Lady Margaret his sister on his hond, and dauncyd two baas daunces. And aftirward he, perceyvyng himself to be accombred with his clothis, sodenly cast of his gowne and daunced in his jaket with the said Lady Margaret in so goodly and pleasaunt maner that hit was to the Kyng and Quene right great and singler pleasure."[100] And here in the future Henry VIII's obvious love of dancing, displayed with enthusiasm and *sprezzatura*, we may perhaps see the seeds of that breaking of the barriers which was to characterize the English masque.

In its concentration upon the devising of these spectacular dramatic prologues during the reign of Henry VII, the Chapel Royal, through its disguisings, became a major force in the creation of courtly drama, and much of its success was achieved through the adoption of Continental pageant cars as an essential medium of dramatic production. Such pageant cars had long been familiar in the Franco-Burgundian *entremet*, but had yet to make much of an impression upon English entertainments. Walter Alwyn's fire-spitting dragon of 1493-94 illustrates the impressive and ingenious devices the Wardrobe was capable of producing, but even so it represented little more than an especially elaborate costume for one

[98] Kipling, *Triumph of Honour*, pp. 96-115.

[99] College of Arms, MS. 1st M. 13 is usually careful to identify all the "estates," but it identifies none of the actors or dancers in the disguisings, except for the Children of the Chapel. The only actor ever mentioned in a disguising of Henry VII's reign is William Cornish in the 1494 disguising discussed above.

[100] College of Arms, MS. 1st M. 13, fol. 53ᵛ.

or two men who played a reptillian antagonist to Cornish's romantic St. George. In 1501 the first recorded pageant cars appear at Court—large pageants in the shape of ships, arbors, lanterns, castles, mountains, and two-story thrones—capable of bearing not only a few actors to perform a skit, but also eight, twelve, or even twenty-four dancers. After this development, the masque's future as an essentially spectacular entertainment was assured. From this festival on, pageants were used increasingly in the disguising hall, often in multiples: a castle, ship, and mount to allegorize a courtship; a castle, tree, and mount to symbolize an alliance; and so on. Since the enlargement and multiplication of pageantry made these shows ever more expensive, they could not have been performed at all without the active encouragement of the King, whose wishes must therefore have been central to the development of the form. Certainly this is the implication of the King's demanding to see the "disguising stuff" while the show was still under construction, even if it meant shipping it from London to Richmond and back again. By the end of Henry VII's reign, in any case, these sophisticated scenic devices had transformed the disguising into a danced and enacted emblem, and it was this tradition that Inigo Jones and Ben Jonson inherited. From this point of view, Jones and not Jonson was correct in their famous quarrel.[101] It was indeed truer to say that painting, not poetry, was the soul of the masque—thanks to the patronage of Henry VII.

Even as the royal household was transforming the disguising from a mimed dance to a spectacular, enacted emblem, so it was also transforming the tournament from a martial contest into a romantic drama. In doing so, it took as its model the romantic Burgundian tournament of the mid-fifteenth century. The Grand Bastard of Burgundy had devised just such a tournament, the *Pas de l'Arbre d'Or*, to celebrate the marriage of Margaret of York to his brother, Duke Charles the Bold, in 1468. By means of pageant cars, scenery, fantastic costumes, and supporting actors, he took upon himself the persona of Florimont and enacted the famous episode from the *Roman de Florimont* where the Dame de l'Ile Celée requires the hero to undertake a great tournament for her sake in which he will

[101] Ben Jonson, *Works*, ed. Charles Herford and Percy and E. Simpson (Oxford, 1925-52), VIII, 404.

decorate a golden tree with the arms of the illustrious knights who
answer his challenge.[102]

The English court's first essays in this form derive, in fact, directly
from the Anglo-Burgundian negotiations that dominated the first
decade of the sixteenth century. When Henry VII and his courtiers
met the Archduke Philip and his knights—including Florimont him-
self, the Grand Bastard of Burgundy—at Calais in 1500, two groups
of English knights challenged the Archduke's courtiers to a tour-
nament designed to match the romantic tournament style, still un-
familiar in England, for which the Burgundians were famous.[103] In
1506, when the Archduke in turn spent an enforced stay of several
months in England, Henry VII's knights fought still more romantic
tournaments, carrying the development of the form even further in
the direction of the drama. In both cases, Henry's own tastes for
spectacular Court celebrations, combined with his desire to achieve,
at whatever cost, an authentically Burgundian scale of magnificence,
seem to have proved crucial in the development of the form. Thus
the two tournament challenges of 1500 make elaborate provisions
for trees of chivalry to be erected in the lists. Just as in the Grand
Bastard's famous *Pas de l'Arbre d'Or*, answerers to the challenge
were to hang their shields ceremonially from the trees according to
prescribed rituals. In the tiltyard over which these trees presided,
English knights made their entrances for the first time aboard elab-
orate Burgundian pageant cars: on one day, for example, the Mar-
quis of Dorset, adopting the persona of a hermit knight, entered
the lists in a pageant hermitage preceded by thirty beadsmen dressed
in black; on the same day, the Earl of Devonshire entered within
a red dragon pageant car that was led at the end of a green and

[102] For the *Pas de l'Arbre d'Or*, see Olivier de la Marche, *Mémoires*, ed. Henri
Baune and Jules d'Arbaumont (Paris, 1883-88), III, 123-33. For Florimont, see C. C.
Willard, "A Fifteenth-Century Burgundian Version of the Roman de Florimont,"
Medievalia et Humanistica, N. S. 2 (1971), 21-46. For the discussion of the use of
Florimont in the *Pas de l'Arbre d'Or*, see Kipling, *Triumph of Honour*, pp. 117,
119-22.

[103] For the two English challenges, delivered at Calais in 1501, see British Library
MS. Additional 46455, fols. 4-10. A later English version of the Duke of Buck-
ingham's challenge is found in College of Arms, MS. M. 3, fols. 24ʳ-26ʳ. My dis-
cussion of the dating of this latter challenge, and consequently much of my discussion
of the "modifications" of the Tree of Chivalry device based upon that dating (in
Kipling, *Triumph of Honour*, pp. 120-21 and n. 11), must now be seen as incorrect
since the newly-discovered French version of the challenge was proclaimed at Calais
with the Dorset challenge in 1500.

white leash by a giant wildman. On another day, an entire team of knights "sailed" onto the lists aboard a full-rigged ship "with all manner of tacklings and [with] mariners in her," its guns booming out volleys at the waiting defenders.[104] In some of the individual "acts" of this long tournament, the knights clearly made their martial sport subservient to the "literary" demands of a romantic scenario. On one day, for example, the Marquis of Dorset and his companions entered the lists as henchmen to a triumphal chariot in which rode "a fair young lady." After circling the field, they stopped before the royal box, bowed to their lady, and helped her to a seat among the Court party. They then fought their day's tournament against the background of the shield-bearing tree, collected their lady again after having defended her beauty against all comers, and rode off as they came. As readers of the *Arcadia* can vouch, this romantic episode so closely anticipates Artesia's tournament in that work that Sidney might fairly be accused of "realism."[105]

The tournaments of 1506 and 1507 fully completed the transformation of this martial sport into a spectacular drama by providing a comprehensive allegory to govern the entire tournament. A 1506 May tournament, inspired by the visit of the Archduke Philip to England that year, thus boasts the first extant "literary" tournament challenge in England, albeit a somewhat pallid example of that familiar Burgundian genre. Taking the form of a letter sent by the "Lady May" to the Princess Mary, the challenge establishes an allegorical situation for the proposed tournament: the Lady May, hearing of a joust held in February that had honored her "great enemy," Winter, calls upon her servants to defend her honor "in exercise of chivalry."[106] Save for the fact that this letter may have been declaimed by an actor from the deck of a flower-bedecked ship at Greenwich, however, the dramatic effects of the challenge must have been minimal; there was no playacting on the part of the knights, no pageantry. But in the following year another such allegorical challenge, combined with the pageantry first introduced for the 1501 jousts, completes the transformation. Princess Mary now plays the Queen of May, the challenger-knights adopt various

[104] College of Arms, MS. 1st M. 13, fols. 52, 56ᵛ-57ʳ.

[105] Kipling, *Triumph of Honour*, pp. 129-31. College of Arms, MS. 1st M. 13, fols. 57ᵛ-58ʳ.

[106] British Library MS. Harley 69, fols. 2ᵛ-3ʳ; for dating, see Kipling, *Triumph of Honour*, p. 132, n. 37.

allegorical personas of her servants, they hang their shields from a flower-decked hawthorn tree, and they fight a tournament judged by "an Officer of Arms called April."[107] All the elements of the tournament are now subservient to a single, overriding dramatic fable. As if to symbolize the occasion, an anonymous versifier described the event in a two-hundred-line poem, *The Justes of the Moneth of Maye*, which attempts to recreate the romance of this chivalric drama after the manner of a *chanson de geste*.[108] In this way, the tournament had become literature in fact, and we are but a short step from Sidney's *Lady of May* and the Accession Day jousts.

The construction of pageantry and scenery for these first English dramatic tournaments necessitated a significant modification in the household machinery responsible for staging such shows. There can be little doubt that the King himself, with his expensive tastes in spectacle, was central to this development as well. Previously the Armoury and Works departments of the household were primarily responsible for tournaments, the former providing weapons and armor, the latter constructing the lists and scaffolding.[109] For the 1501 tournament, however, we find the Wardrobe for the first time playing a major part in the tournament. John Atkinson, the same Wardrobe official who presided over the construction of pageantry for the disguisings, takes responsibility for the tournament pageantry. Indeed, in some cases pageantry from the disguisings does double duty in the lists; the same team of heraldic animals draws a pageant car into the disguising hall and a chariot onto the tournament field. The ship that brought ambassadors to the Castle of Ladies from the Knights of the Mount of Love probably also ferried the Marquis of Dorset's knights into the lists to assault the Duke of Buckingham and his companions.[110] Henry's Master of the Revels has thus, for the first time, been given responsibility for both the tournament and the disguising, and his use of the same pageants

[107] College of Arms, MS. S.M.L. 29, fol. 21; Kipling, *Triumph of Honour*, p. 133.

[108] (London, 1507), printed in William C. Hazlitt, ed., *Remains of the Early Popular Poetry of England* (London, 1866), II, 109-30.

[109] For example, British Library MS. Harley 69, fol. 10ᵛ: "And for justs, tourneys, and other ceremonies, they be remitted to the said Mr. Comptroller, serjeant of the Kinges armoury, and as for provision of the scaffolds, and all other things belonging to the said justs, Mr. Comptroller and Worley have taken upon them the charge." Worley was Master of the Works, and his accounts of the erection of scaffolds for the lists appears in British Library MS. Egerton 2358, fol. 12.

[110] College of Arms, MS. 1st M. 13, fols. 52ᵛ-53ʳ, 56ᵛ-57ᵛ.

for both events shows that the Court now sees both forms as "revels." In the future this experiment will become orthodox practice, and the English Master of the Revels will take increasing responsibility for all forms of courtly entertainment: masques, revels, disguisings, and interludes. From Henry's adoption of Burgundian pageantry in the lists and disguising halls of 1501, therefore, dates the parallel development of both forms as spectacular revels: the masque becomes a spectacular drama designed about a dance, while the tournament becomes a spectacular drama designed about a joust. Both are designed by the same artisans in the same workshops.

Inevitably, as more and more responsibility devolved upon the Master of the Revels in this way, the creation of a permanent and independent revels office became necessary. For one thing, with the revels he provided increasing in variety and frequency, the Master gradually became a permanent rather than a seasonal officer. For another, the revels literally outgrew the Wardrobe. Henry's practice of drawing his Christmas revels masters from the Wardrobe derived from the early years of the reign when disguisings demanded fanciful costumes more than pageantry. But with an increasing demand for scenery and pageantry, as well in the lists, on stage, and in the disguising hall, the Revels found a more logical home in the Tents Office, which was traditionally charged with the construction of such large structural units. Hence, early in Henry VIII's reign, the Sergeant of the Tents became in addition the Yeoman of the Revels. Although these developments were not completed until shortly after Henry VII's death, nevertheless the Revels Office derives directly from his own organizational experiments and from his decision to adapt the pageant car to his revels upon a large scale. The revels office, therefore, stands as a monument to Henry VII's genius for institutional patronage in the drama. As if to symbolize these connections, Richard Gibson, a founding member of the King's Players and a Wardrobe official under Henry VII, transferred from the Wardrobe to the Tents early in the next reign, taking up his offices as Sergeant of the Tents and Yeoman of the Revels by 1518.[111] But the sense of change implied by all these various titles and offices is belied by Gibson's unbroken series of revels accounts covering these very years.[112] Henry VII's revels organization apparently remained unchanged, its continuity insured by Gibson's continued

[111] Chambers, *Elizabethan Stage*, II, 72.
[112] Public Records Office E 36/217.

services. Rather the transfer from Wardrobe to Tents and the various titles merely ensured the increased ability of the revels to supply ever more impressive pageantry for the King's celebrations. By 1520 Gibson and his revels office were thus able to organize the Field of the Cloth of Gold across the Channel in Calais, even as they continued to provide Court festivals at Westminster with their usual efficiency. And with that splendid diplomatic festival, the patronage policies of Henry VII find their logical culmination.

If we are to understand Henry VII's court patronage, then, we must see it in its proper context. Henry indulged lavishly in literature, the visual arts, and the drama, but his indulgences were characteristically of the institutional rather than the philanthropic variety. Artists in his service became servants in his household, and just as his ushers, guardsmen, and grooms enhanced his estate through their liveried and ceremonial attendances, so his artists were expected to enhance his estate through their poetry, pageantry, and painting. For these reasons, Henry's patronage always moved in the direction of magnificent visual display and political eulogy. Its consummate expression lay in the political festivals to which all household departments alike contributed, magnifying the royal estate. Although Henry was undeniably lucky in some of the artists he employed—John Skelton, Barnard Flower, and William Cornish, for example—his major contribution to the arts rested in the impressive organizations he created rather than in the sponsorship of individual works of art. Within these limits, then, Henry must be seen as an innovative, indeed a generous, patron; he willingly spent enormous sums to surround himself with the ostentatious magnificence reminiscent of the Burgundian court, and in so doing he transformed the royal household into a major influence upon the development of the fine arts in England. By the same means, he set a standard of courtly patronage and established a distinctive royal style for his descendants. Ultimately, Henry's patronage of the arts, rather than his neglect of the muses, may have had much to do with his posthumous reputation for avarice. We have seen how Henry greatly expanded his household organization to make his patronage policies possible, and how he expended vast sums on these artistic projects. But all these new departments and projects had to be paid for somehow. Ironically, then, Henry's expensive patronage may have played a major part in the invention of "Morton's fork" and the exactions of Empson and Dudley.

SIX

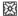

The Political Failure of
Stuart Cultural Patronage

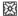

MALCOLM SMUTS

CHARLES I of England ranks among the leading patrons of art and literature of the early seventeenth century.[1] He amassed one of the two greatest collections of painting in Europe, lured foreign artists to London, and helped support men responsible for innovations that decisively influenced the course of English architecture, poetry, music, and portraiture until well into the eighteenth century.[2] Ben Jonson, Inigo Jones, and Van Dyck worked at his court; Rubens and Bernini accepted his commissions. Their work enhanced the majesty of Charles's life, creating a magnificent setting for acts of state and conveying a carefully wrought image of the benefits his reign purportedly bestowed.[3] Yet in one crucial respect, the culture of the early Stuart court proved inadequate. Its cosmopolitanism and baroque styles aroused little sympathy within a realm still suspicious of French and Italian culture on religious grounds, where a taste for Renaissance art had scarcely penetrated beyond the Court. Indeed, Court culture sometimes antagonized important segments of the public. The liturgical splendor of the Chapel Royal, the religious art patronized by the Queen, and Inigo Jones's restoration of St. Paul's Cathedral aroused passions con-

[1] The author wishes to thank his colleague, David Sacks, for helpful comments on an earlier version of this paper.

[2] No one, I take it, would deny the long-term influence of Inigo Jones upon English architecture and Van Dyck upon portraiture. Jonson, Waller, Carew, and Suckling exercised a comparable influence over Restoration and Augustan poetry. Probably none of the composers of Charles's court approached greatness; but collectively they assimilated the operatic and early baroque styles of Italy, thereby paving the way for Purcell.

[3] For a general treatment see Roy Strong, *Splendor at Court: Renaissance Spectacle and the Theatre of Power* (Boston, 1973).

165

cerning popish idolatry. The Court's love for plays and masques and the acting of the Queen defied deeply held prejudices. Prynne's famous note, "women actors notorious whores," may represent the response of an irascible extremist; but even the old courtier John Chamberlain was bemused by "this strange sight, to see a Queen act in a play."[4] A culture brilliantly successful in its own right only reinforced the suspicion of many Englishmen that the Court had become a center of immorality and Roman Catholic influences.

The profusion of loyal ballads, sonnets, pageants, and sermons Elizabeth had inspired further emphasized this shortcoming. The cult of the Virgin Queen made her into a living symbol of England's destiny as a nation chosen by God to fight His battles.[5] It both expressed and reinforced the bonds of political loyalty and religious fervor uniting Gloriana to her people. When this cult was replaced by a courtly civilization with few native roots, the Crown lost an invaluable prop to its authority.

The damaging political repercussions of Stuart cultural patronage have often provoked comment. One writer has gone so far as to blame the Court for a "breakdown of the national culture."[6] Others have listed lavish expenditure on art and Court masques among the causes of the Crown's financial difficulties and the fury of the English taxpayers. Stephen Orgel has commented on the ways in which Caroline masques contributed to an illusion of royal power and social harmony obstructing Charles's view of political realities.[7] Nevertheless, very little is really known about Stuart cultural patronage and its relationship to political concerns. No one has determined how much the Court spent supporting cultural activities, nor whether any coherent policy guided its efforts. The administrative procedures governing Court culture have received only spo-

[4] John Chamberlain to Sir Dudley Carleton, 4 December 1624, in *Letters of John Chamberlain*, ed. Norman E. McClure (Philadelphia, 1939), II, 588. On Prynne's polemic and the reactions of the Court to it, see Stephen Orgel and Roy Strong, *Inigo Jones: The Theatre of the Stuart Court* (London, 1973), pp. 50ff.

[5] See especially Elkin C. Wilson, *England's Eliza* (Cambridge, Mass., 1939), and "Elizabeth I as Astraea" and "Elizabethan Chivalry" in Frances Yates, *Astraea: The Imperial Theme in the Sixteenth Century* (London, 1975).

[6] Peter W. Thomas, "Two Cultures? Court and Country under Charles I," in *The Origins of the English Civil War*, ed. Conrad Russell (London, 1973), p. 184.

[7] Yates, *Astraea*; Stephen Orgel, *The Illusion of Power: Political Theater in the English Renaissance* (Berkeley and Los Angeles, 1975); Stephen Orgel, *The Jonsonian Masque* (Cambridge, Mass., 1965); Orgel and Strong, *Inigo Jones*; Roy Strong, *Charles I on Horseback* (New York, 1972).

radic attention, and the ways in which art and literature fit into a broader pattern of elegant display, virtually none at all.

Consequently, although we can now trace the development of cultural styles, themes, and symbols in some detail, it remains unclear why such a marked transformation of the culture and pageantry of kingship should have occurred in the first place. Did the Stuarts plan the change, as part of a systematic, if ill-fated, effort to alter public perceptions of the monarchy? Or did it take place without conscious guidance? If the latter is the case, through what sort of process did the change occur? Answers to these questions should affect both our understanding of Court culture and our perceptions of the goals and methods of Caroline government.

Attitudes Toward the Political Role of Culture

Neither Charles nor his principal ministers have left us a clear statement of the purposes they sought to achieve by patronizing artists, musicians, and poets. We have to guess their intentions from their actions and the pronouncements of lesser figures. The reign coincided, however, with the first great period of baroque civilization in Italy and Flanders, involving the careers of Rubens, Guercino, Bernini, and Monteverdi. It was this essentially Catholic culture, with its heavy emphasis upon the sensuous and theatrical didacticism of art and spectacle, that Charles learned to appreciate as an adolescent and tried to transplant into English soil as king. His collection of paintings, his participation in masques, and his support for Laud's "beauty of holiness" unfolded against the backdrop of a European environment in which aesthetic splendor routinely served the needs of religious and secular propagandists.

Several artists and poets of the Court certainly believed that their work contributed substantially to social or political goals. Jonson once described poetry as an art disposing men "to all Civil Offices of Society . . . the absolute Mistress of manners . . . which leads on and guides us by the hand to action with a ravishing delight and incredible Sweetness."[8] Inigo Jones was equally sanguine about the usefulness of architecture. He argued, for example, that the Romans erected Stonehenge so that its ordered proportions would civilize

[8] C. H. Herford and Percy Simpson, eds., [*Works of*] *Ben Jonson*, vol. VIII (Oxford, 1947), 638.

their rude British subjects.[9] His masque designs frequently show classical buildings as emblems for social and political harmony.

Caroline masques and panegyrics carry these ideas further, presenting Charles as a ruler civilizing the manners of his subjects through both cultural and political acts. In *Britannia Triumphans* (1637), the muses arrive in England after war has chased them through Europe, settle in the peaceful environment Charles has created, and turn the realm into a pattern of civility comparable to classical Greece. The foreign policy of the Crown and royal support for the arts and literature fuse into a vision of England's progress toward high civilization, under a virtuous and enlightened monarch. Similarly, Waller, in his panegyric on Charles's restoration of St. Paul's, moves easily from a discussion on architectural and musical harmony into a tribute to royal government:

> These antique minstrels sure were Charles-like kings,
> Cities their lutes, and subjects' hearts their strings.[10]

Skillful government and aesthetic beauty derive from the same quest for order and proportion. It would be easy to multiply examples. The iconographic traditions of Whitehall in the 1630s treat cultural progress and good government as twin manifestations of royal efforts to order society and refine the manners of England.

None of these ideas concerning the bond between royal government and the arts and letters was original. They derived, ultimately, from classical sources: in particular, panegyrics praising the supposed golden age of cultural brilliance and social harmony ushered in by Augustus Caesar. By the seventeenth century the hope of Silver Age poets, that a strong ruler would bring the arts to perfection, had become a commonplace, as had the related idea that progress in poetry and art would refine the customs of society, making it more amenable to political control.[11] Yet, commonplace or not, these ideas provided a ready justification for efforts to employ literature and the arts to buttress the state. From the Florence of Lorenzo the Magnificent to the eighteenth century, court academies and princely patronage rested on similar intellectual foundations. Charles's entourage clearly shared attitudes that prompted other

[9] This is the drift of the discussion in *Stonehenge Restored* (London, 1653), a book compiled from Jones's notes by his assistant, John Webb.

[10] "Upon his Majesty's Repairing St. Paul's" in *Poems* (New York, 1968), p. 16.

[11] For a discussion of the influence of the cult of Augustus upon Renaissance courts see Yates, *Astraea*.

absolutist rulers to launch very ambitious programs to patronize and regulate culture.

Administrative Arrangements and Finance

In light of this background, it comes as something of a surprise that the Stuarts took virtually no steps to develop more effective supervision of court culture. Nothing like the Continental academies, with their attempts to develop uniform canons of taste and to exert systematic control over a broad range of cultural disciplines, ever grew up in England. In fact, whatever formal control the royal household exercised over culture depended upon procedures set up before 1603. The organization of the King's musicians, for example, followed arrangements of Henry VIII's court that grouped the players into several orchestras and ensembles, each with well-defined responsibilities and a head musician.[12] The Caroline period was one of stylistic innovation, as the Elizabethan styles of Byrd, Dowland, and the madrigalists gave way to experiments in recitative and baroque composition. The change took place, however, only because Charles replaced the older musicians as they died off with men schooled in Italian styles.

This institutional conservatism appears even more clearly with respect to Court architecture. Inigo Jones probably had more to do with the evolution of Stuart court culture than any other individual. He developed a classicist style of architecture, advised both aristocratic and royal collectors on purchases of paintings, helped to recruit foreign artists, and designed the scenery for nearly all the Stuart masques. Yet his only major office remained the medieval one of Surveyor of the King's Works. The staff of artisans employed by this department had not changed, in numbers or in nominal responsibilities, since the Tudor period.[13] Jones did what he could to recruit and train men capable of working in the new styles he had developed. The masons and carpenters of the King's Works probably helped to spread his innovations, by accepting private commissions and executing them in a Jonesian manner. The Crown never attempted, however, to expand and reorganize Jones's staff or officially redefine his responsibilities.

[12] For a general treatment see Walter L. Woodfill, *Musicians in English Society from Elizabeth I to Charles I* (Princeton, 1953).
[13] H. M. Colvin, D. R. Ransome, and Sir John Summerson, *History of the King's Works* (London, 1975), III, pt. 1, ch. 7.

Where Jones's activities took him beyond the traditional functions of Surveyor, the Crown enhanced his authority through various makeshifts. To give him some leverage over London building, he was appointed to a royal commission charged with licensing all new construction within the city and its suburbs.[14] During his work on St. Paul's Cathedral he joined another, ecclesiastical commission; when he designed chapels for the Queen, she appointed him as her Surveyor.[15] Every time Jones designed a masque he apparently received a new commission. These arrangements are a perfect example of what G. R. Elton has described as personal government, operating through the energy of a single individual close to the King and employing *ad hoc* methods rather than creating new institutions.

In areas where the Tudors had not constructed any bureaucratic controls over Court culture, Stuart organization always remained rudimentary and haphazard. The masques, for instance, had long since developed to the point where the ancient Office of Revels, nominally in charge of Court spectacles, could not adequately supervise them. For a time in James's reign there was talk of making Ben Jonson Master of Revels, thus giving him a post from which he could formally oversee the literary, artistic, musical, and social elements that had to mesh in each performance. The plan fell through, however, with the result that Revels continued to arrange admission and seating for the masque audience while Jones worked with a series of poets and composers to plan the actual masque. Responsibilities remained so fluid that we cannot always know for certain who decided on the themes and symbols used in these spectacles: Jones alone, a team including Jones and others, or even the King himself.

The same conclusion applies even more forcefully to painters, sculptors, and poets. Charles and his wife collected all three: the number of talents attached to their court grew steadily throughout the reign. In each case, however, the Crown made separate arrangements. In 1618 Mytens arrived to occupy the traditional post of painter to the King. When Van Dyck settled in London fifteen years later, this office was simply duplicated until Mytens vacated his post by retiring to the Netherlands. The casual way in which this transition took place is indicated by the fact that we do not know

[14] Sir John Summerson, *Inigo Jones* (Harmondsworth, 1966), pp. 83-96.

[15] Summerson, *Inigo Jones*, pp. 97-106; Colvin et al., *King's Works*, p. 139.

when he left England. In 1625 the Florentine painter Gentileschi arrived in the train of Buckingham, after the Duke's embassy in France. For the next several years he served Charles as a painter and artistic counselor: when the Papal envoy wanted to know what paintings the King would like to receive from Rome he turned to Gentileschi.[16] Yet this Florentine artist did not have a post within the royal household: technically, he served the Duke rather than the King. Finally, in the early 1630s Buckingham's widow grew tired of housing and feeding him and Charles had to create a new post, "painter of historical and mythological subjects," to accommodate his confidant. Other artists were picked up by English diplomats traveling abroad and inserted wherever a place could be found for them. Arundel, for example, found the engraver Wenceslaus Hollar during an embassy to Vienna and brought him back to London, where Charles appointed him drawing master in the newly established household of the royal children.

The Court retained poets in even more haphazard ways. Carew became a member of Charles's privy chamber. Sir William Davenant held a position in the household of a royal favorite, Endymion Porter, before rising to the household of the Queen and, in 1637, succeeding Jonson as laureate. Suckling made his way as a courtier, popular for his witty conversation and skill at verbal repartee. Others attached themselves to a Court aristocrat. The poetaster, Tobie Mathew, for instance, gained the nickname of "Lady Carlisle's dog" from his constant attendance upon that famous Court beauty.

In spite of the absence of any attempt at a centralized system of control and the lack of effort to organize Court culture as part of an overarching government policy, the King and his Court sometimes used culture to make political statements. Charles's keen appreciation for art probably led him to take a close personal interest in the symbology of kingship. Orgel has argued that the King helped plan the masques,[17] a view that gains support from a letter of the Tuscan ambassador, Salvetti. In 1636 Jones requested a book illustrating Medici intermezzi, which he intended to use as a source of ideas for his masque sets. Salvetti expressed certainty that the King would also want to see it.[18] We can perhaps imagine Charles

[16] Panzani dispatch of 1 July 1635, Public Records Office Roman Transcripts.

[17] Summerson, *Inigo Jones*, p. 52.

[18] Salvetti dispatch of 24 March 1634, Public Records Office Roman Transcripts.

and his Surveyor sitting down together with the volume to select the scenes they wished to imitate.

On a few occasions, the Crown tried to use cultural works as propaganda beyond the Court. Either the King or his advisers grew especially fond of erecting bronze statues of the monarchs in public places throughout the realm. Laud put up statues of the King and Queen at his new college, St. John's, Oxford. Effigies of both James I and Charles were inserted into the screen of Winchester Cathedral and installed above Jones's great Corinthian portico at St. Paul's, London. The equestrian statue now in Leicester Square originally stood in a public thoroughfare through the main court of Whitehall Palace. According to a petition of 1639, Covent Garden should have contained a great bronze statue of the King.[19] Here, at least, we find a clear example of an artistic cult of the monarch, employed in public places. Yet these statues represent a more or less isolated instance. To treat them as an English counterpart to, say, the cult of Louis XIV would be to attribute far too clear-headed and ambitious a program to Charles's government.

The impression that the Crown did not employ culture very extensively or systematically to mold public opinion gains support if we glance at the history of public royal pageantry under the first two Stuarts. In this period, the major Continental monarchies participated in lavish spectacles, involving displays of fireworks, immense equestrian ballets, processions of hundreds of horsemen riding through triumphal arches, and fountains flowing with wine. At her departure from Paris, for example, Henrietta Maria received an escort consisting, according to the *Mercure François*, of three companies of archers, royal guards, mounted officers of the city in their robes, and 500 trumpeters.[20] At the gate of the city the great of the Court turned out in such numbers of carriages as to remind one observer of ants swarming over their nest. Journeying through Amiens, the Queen passed under triumphal arches as the sound of tambourines and trumpets emanated "from all quarters of the city," to a greeting by 5,000 mounted bourgeois, drawn up in military formation.[21] To take another example, in Madrid the death of Gustavus Adolphus touched off days of public celebrations, with bonfires set through the streets and candles in the windows of all large

[19] Public Records Office State Papers, Charles I, Vol. 402, fol. 75.

[20] *Mercure François*, XI (Paris, 1626), 367.

[21] *Mercure François*, XI (1626), 368ff.

houses. A comedy celebrating Gustavus' death ran for twelve days before packed audiences.[22]

The Stuarts arranged such public spectacles, but for the most part grudgingly, infrequently, and on the smallest acceptable scale. Despite the forty-odd courtiers who turned out in their coaches to greet her in Dover, Henrietta Maria's arrival in England proved a dismal flop. Her French servants complained bitterly of the lack of proper accommodations, the antiquated furnishings of royal residences, and the lack of splendor. "Everything was melancholy," one of them wrote back about London, adding that the English ambassadors had lied about the wealth of their country.[23] The Venetian ambassador confirmed the assessment: "Penury appeared in all directions, at table, in coaches, wagons and horses."[24] Two years later, an Englishman commented on the lack of pageantry at the annual procession of knights of the Order of the Garter.[25] Even at his coronation, Charles canceled the traditional triumphal ride through London, to the frustration of city livery companies that had already invested in triumphal arches.[26] In his entire reign, Charles participated in a large civic pageant only once—in Edinburgh, during his coronation there in 1633. Only once did he take the Court on a great progress in the Elizabethan style: again on the journey to Edinburgh. The public pageantry of kingship declined noticeably under both Stuarts, a fact which may help to explain the erosion in popular enthusiasm for the monarch, especially in London, that became so evident and so damaging during the early months of the Long Parliament.

In short, we confront something of a paradox. An art-loving king attuned to the values of early baroque culture, with its emphasis upon the didactic functions of art and literature, nevertheless failed to launch a program of cultural propaganda and ceremonial display remotely comparable to those of several Continental courts. How can we explain this fact?

The relatively modest scale of Caroline efforts to use culture and pageantry stemmed, at least in part, from the straitened circum-

[22] *Mercure François*, XIX (1633), 741-43.

[23] Tanneguy Leveneur, Comte de Tillieres, *Memoires inédit . . . sur la cour de Charles Ier* (Paris, 1862), p. 92.

[24] Contarini (?) report in *Calendar of the State Papers* (Venetian), XIX, 606.

[25] Letter to Joseph Mead dated 27 April 1627 in Thomas Birch, *Court and Times of Charles I* (London, 1848), I, 220.

[26] Henry Perrinchief, *The Royal Martyr* (London, 1676), p. 21.

stances of the Exchequer. Charles did not have the money to erect a palace on anything like the scale of Versailles—though designs by Jones still survive to show he dreamed of doing so.[27] He would have had great difficulty in pensioning all the significant poets and authors of his realm, as Louis XIV tried to do, or in financing the great public spectacles so common on the Continent. Much has been made of the cost of Court masques, at about £1,500 each. Yet the public spectacles of the Continent must have cost far more, even if we allow for the contributions made by city governments and guilds. For all its brilliance, Caroline court culture always remained essentially restricted within the palace walls and confined to relatively inexpensive forms. Architectural projects were comparatively small in scale: neither the Queen's house, nor the new chapels at St. James and Somerset House, nor even the Banqueting House rivaled the greater private residences of the age in scale or opulence, to say nothing of the palaces of European kings, such as Philip IV's Buen Retiro.[28] In the seventeenth century, paintings and antiquities fetched a far lower price than at present, even allowing for inflation. Van Dyck charged around £50 a canvas; masterpieces by Titian or Leonardo might bring in a few hundred; Rubens, then the most expensive painter in Europe, charged £3,000 for the Banqueting House ceiling, consisting of nine monumental paintings. These were not trivial sums; but neither were they sufficiently large to place a noticeable strain on the King's income, especially in view of the fact that Charles often delayed payment for years. A single Court pension could gobble up enough each year to buy a room full of great art or to pay for a very elaborate masque.[29] The £18,000 Charles borrowed to purchase the Mantuan collection in the late 1620s appears to have been exceptional; the Declared Accounts for the reign list nothing approaching this amount in payments for art during the rest of the reign.[30] As I hope to show at greater length

[27] Summerson, *Inigo Jones*, pp. 127-34.

[28] Lawrence Stone established the cost of Hatfield House, for example, at roughly £40,000, nearly twice that of the Banqueting House, the largest and probably the most expensive early Stuart architectural project. Stone, *Family and Fortune* (Oxford, 1973), p. 41.

[29] The total cost of pensions was running between £75,000 and £100,000 a year in the late 1630s (Frederich C. Dietz, *Receipts and Issues of the Exchequer* [Northampton, Mass., 1928]). Individual pensions are listed in the original receipts; some of the great peers of the Court, such as the Duke of Hamilton, received over £1,000 a year.

[30] Public Records Office E 405/281-85.

elsewhere, Caroline court culture bears several marks of shoestring financing. Accounts of royal extravagance common in works on the period exaggerate to the point of distortion.

Yet Charles's shortage of funds cannot explain his failure to organize more effectively the artists and poets he did patronize. To explain why he did not do so, we have to realize that for both him and Henrietta Maria, patronage was always an avocation, rather than an act of state. "In painting he had so excellent a fancy," an early biographer wrote in 1676, "that he would supply the defect of art in the workman, and suddenly draw those lines, give those airs, which experience had not taught the painter.... He delighted to talk with all kinds of artists and with . . . great facility did apprehend the mysteries of their profession."[31] The image this description conjures up, of Charles snatching brushes to touch up the work of Court artists, may or may not be authentic; but the pleasure the King derived from both paintings and painters is well documented. Just as Charles enjoyed the company of artists, so his wife enjoyed conversing with witty poets, among them Waller, Davenant, and Suckling. Even the masques served as a form of recreation as well as a vehicle for political philosophy: diplomatic dispatches afford glimpses of the King happily absorbed in daily rehearsals, dropping more serious items of business for the pleasures of these grand spectacles.[32]

The point may seem obvious, but it made a crucial difference. The court academies of Europe were headed by professionals, such as Vasari and Ronsard, who built their careers by making art, literature, and music serve the needs of kings. They were administrators as well as artists or poets, organizing the output of lesser men to contribute to the glory of their princes. By contrast, Charles showed no taste for administrative work even when attending to the tasks of government. He had little sense of how to fulfill his belief in a strong royal state through workable programs, involving efforts to restructure or improve the machinery of government. This fact appears nowhere so clearly as in his approach to cultural patronage. Charles did not need to initiate administrative changes to provide for his own cultural recreations: he knew his artists, poets, and musicians well enough to supervise them directly. He did not organize patronage to influence cultural trends beyond the Court

[31] Perrinchief, *The Royal Martyr*, p. 253.

[32] For example, Salvetti's dispatch of 15 January 1637, Public Records Office Roman Transcripts.

because the administrative work and political calculation such a task would have demanded were alien to him.

Social Influence upon Court Culture and Pageantry

To this point, we have focused on the role of the King and his household in shaping Court culture and pageantry. In doing so we have presented a one-sided picture of Court patronage and its relationship to political concerns. For the structure of the English court would never have permitted the King to dominate completely its cultural and ceremonial life, even if he had shown more diligence and administrative talent than Charles did. In this respect, Whitehall differed fundamentally from Versailles and other, late seventeenth-century courts modeled after it. Louis XIV reorganized the ceremonial and cultural life of his court only after his government suppressed the Fronde and erected an efficient bureaucracy to collect taxes and govern the realm. As a result, his household for the first time possessed the wealth and power to dominate the lives of all who attended upon the King. The residential patterns of the Court show this clearly. Before the 1670s many great French nobles maintained their own houses in Paris while attending the King in the Louvre. Thereafter they moved into the massive structure of Versailles, located just far enough from Paris so that no alternative centers of social or cultural life could distract them from their attendance upon the Roi Soleil. The Court became a world unto itself, ordered in a strictly hierarchical pattern to reflect the glory of the Crown.

Nothing like this ever happened in England, where the Court remained a cluster of households with the King's at its center and those of great lords grouped around it. Even relatively minor figures lived outside the royal palace and maintained a more or less independent social life. Van Dyck, for example, entertained several lords at his house in Blackfriars, even receiving visits from the King.[33] Several of these private residences functioned as centers of cultural activity. Buckingham produced his own masques and retained his own architect and painters, reproducing the royal cultural establishment on a smaller scale. The Earl of Arundel was an influential collector and patron of art, and even a mere gentleman

[33] Giovane Bellori, *Le Vite de Pittori, Scrittori et Architetti Moderni* (Rome, 1672), p. 259. Bellori's information came from Sir Kenelm Digby, a friend of Van Dyck.

like Endymion Porter could gather a circle of poets around himself. Beyond the houses of the great courtiers lay the city of London with its theatres and lively intellectual life, in which courtiers freely participated. Thus, the royal household was only the largest of several sources of patronage influencing the development of Court culture.

In fact, the cultural brilliance of Whitehall would have been impossible had courtiers not supplemented the patronage of the Crown. Of the artists and poets drawing royal pensions, only Inigo Jones appears to have served the monarchs alone, and he did so only after about 1620. Van Dyck was more typical. During his seven years in England the Crown paid him some £1,700 for paintings plus whatever he could collect of his pension of £200 a year.[34] These sums would have provided him with a gentleman's income, had they not come in sporadically and, for the most part, after 1636. In the same period, however, he turned out probably hundreds of portraits for courtiers, country peers, and gentry visiting London. We cannot calculate his profits, but they probably amounted to several times the sums Charles paid him. In much the same way, Jonson wrote for the stage years after he became royal laureate and angled for gifts from the fourth Earl of Pembroke, Sir Kenelm Digby, Richard Weston, the Earl of Newcastle, and many other Court aristocrats.

Consequently, Court art and poetry developed to meet the demands not only of the Crown, but of the entire society gathered in the vicinity of Whitehall to hold or seek office. Most of the stylistic innovations underlying Caroline court culture, in fact, originated well outside the royal household. Jonson's classicist poetry derived from a fusion of the antiquarianism of Camden with the vigorous literary traditions of the playwrights and satirists of Jacobean London. The vogue for foreign art first took hold through the efforts of such Court aristocrats as Arundel, Pembroke, and Buckingham. In the role of cultural patron Charles was always *primus inter pares* more than absolute ruler. The civilization of his Court grew from the initiative and investments of many individuals, including some who arguably had a greater impact than the King.

In fact, no English monarch ever succeeded in regulating the entire panoply of art, literature, music, and pageantry woven

[34] This statement is based on the Declared Accounts of the Exchequer, which list purchases of paintings separately. Public Records Office E 405/281-85.

through his public life. As an example we can take an aspect of Court ceremony that seems, at first glance, to have involved rigid control: the rules of etiquette governing behavior within the royal household. In England these derived mainly from the Yorkist and early Tudor period. The influence of nearby Burgundy and the insecurity of both Edward IV and Henry VII combined to make them elaborate and formal. A hundred years later, in Charles's reign, Whitehall preserved a reputation as one of the most ceremonious courts in Europe. "The English are excessively punctillious," as a Venetian ambassador put it, "and stand upon their King's honor more, perhaps, than any nation in the world."[35] Still, etiquette and decorum altered subtly to suit the personality of each successive monarch and the changing ambience of the Court. Elizabeth used the rules as instruments of her inimitable royal style, enforcing their full rigor or dispensing with them according to the needs of the moment.[36] Under James decorum slackened as courtiers pressed in on their all-too-affable sovereign, responding to his earthy humor and pressing for the grants of money, honor, and office he gave so readily. Everything at Court from sexual morality to social manners coarsened, often sufficiently to cause scandal.[37]

Charles, with his cold, haughty manner and exalted sense of royal dignity, revived the regulations with a vengeance, adding some touches of his own. "The nobles do not enter his apartments in confusion, as heretofore," an observer noted in 1625, "but each rank has its appointed place. . . . The King has also drawn up rules for himself, dividing the day from his very early rising, for prayers, exercizes, audiences, business, eating and sleeping. It is said he will appoint a day for audience and he does not wish anyone to be introduced unless sent for."[38] New household ordinances stipulated everything from the order in which Court lords should enter the Chapel Royal to the select group of people who might watch while the King removed his boots.[39] All this amplified the style of a monarch famous for his gravity, who once spoiled a dinner given by his

[35] Pasaro dispatch of 25 May 1625 in CSPV, XIX, 60.

[36] See, especially, Sir John Neale, *Essays in Elizabethan History* (London, 1938), p. 93.

[37] As shown, for example, in Sir John Harington's well-known account of the drunken entertainment given the King of Denmark during his visit to the English court. See D. H. Willson, *James VI and I* (New York, 1956), pp. 193-94.

[38] Pasaro dispatch of 25 August 1625, CSPV, XIX, 21.

[39] Public Records Office State Papers Charles I, CLXXXII, fol. 31.

wife because his sobriety stifled laughter and conversation.[40] This cold and stiff ambience, very reminiscent of the Spanish court, derived from Charles's temperament more than from anything in the English tradition.

In short, Court decorum developed around a core of ancient rules that the household might strengthen or alter from time to time. But the tone of Court life and the way people behaved in the royal presence depended equally upon an intangible personal chemistry between a ruler and his courtiers. At best, a monarch as shrewd as Elizabeth could manage the manners of the Court through an artful blend of formal commands and informal influence. Often, however, the process through which decorum changed remained mysterious even to those most directly concerned. James, for example, never understood why Court etiquette collapsed so disastrously during his reign and expressed helplessness before the undignified groups of petitioners besieging him. "You will never let me alone," he once shouted in exasperation at one of them, "I would to God you had first my doublet and then my shirt and when I were naked I think you would give me leave to be quiet."[41]

The iconography of kingship and styles in cultural and ceremonial display evolved through a similar interplay of traditional elements, royal supervision, and independent initiative from men serving the King. Court pageantry developed around a skeleton of inherited forms and customs, such as the feast day of the Order of the Garter, or the ancient habit of celebrating Christmas by dances and allegorical shows, from which the masques developed. Yet even the most ancient ceremonies and cultural events often depended, in large part, upon the independent contributions of courtiers. A shift in fashions or social habits could make a critical difference to their success. Tudor jousts and processions of the Order of the Garter, for example, owed much of their opulence to the retinues of mounted gentlemen attending the lords of the Court. When the custom of keeping those retinues died out after 1600, chivalric pageantry suffered enormously. This fact undoubtedly helps to explain the movement away from neomedieval styles in art and literature no less than in pageantry that took place in the early seventeenth century.

The most significant contributions of courtiers to the cultural and

[40] Dumoulin dispatch of 2 May 1627, Public Records Office Paris Transcripts.
[41] Quoted by Willson, *James VI and I*, p. 195.

ceremonial glorification of the monarchs derived from their daily efforts to compliment and entertain. By its nature Court life fostered wit and artifice, which in turn often led to the creation of novel ceremonial, literary, and artistic formulas.[42] Throughout the Renaissance, for example, courtiers devised ingenious ways of expressing the idea that monarchs deserve worship, as "little gods set upon an earthly throne." The variations on the theme were endless, shifting according to literary conventions, individual taste, and the prevailing climate at Court. When men worshiped Elizabeth, they paid attention to her predilection for intricate conceits, built from recondite fragments of classical mythology, and constructed pagan cults to the royal Diana, Astrea, or Cynthia. "I was wont to behold her . . . hunting like Diana," Ralegh once wrote, in a passage typical of this adulation, "walking like Venus, the gentle wind blowing her fair hair about her pure cheeks like a nymph, sometime sitting in the shade like an angel, sometime playing like Orpheus." Forty years later, the adulation came in a more somber key, often influenced by the theology of divine right. Thus, Wentworth once asked the King for advice on Irish politics with the phrase: "I do humbly beseech your Majesty's quickening Spirit may move upon these waters that we may from your directions receive Life, and from your Wisdom borrow Light to guide us along the Way we are to take." The contrast between the playful eroticism of the first passage and the heavy formality of the second encapsulates a profound change in relations between courtiers and monarch. If we were to place a madrigal by Campion next to a panegyric by Waller, the same contrast would appear.

In much the same way, cultural works grew out of the elements of stylized play inherent in Court life—the elaborate flirtations, the dances, mummings, and disguisings through which a leisured elite passed its time.[43] The innumerable poems praising the beauty of Elizabeth or pleading with her for her love provide a striking example. Courtiers elevated the sexual deference she demanded into a literary form, in the process writing some minor masterpieces of neo-Petrarchan verse. Needless to say, there could be no question of anyone formally regulating this output: again a personal chem-

[42] For an interesting recent treatment of the effect of courtly artifice on the development of English poetry see Daniel Javitch, *Poetry and Courtliness in Renaissance England* (Princeton, 1978).

[43] Letter to Charles I of 22 January 1633 in *The Earle of Strafforde's Letters and Dispatches*, ed. William Knowles (London, 1739), I, 183.

istry between the Queen and such servants as Ralegh, Sidney, and Drayton determined its flavor. Forty years later Henrietta Maria inspired a comparable flood of poetic devotion, though in a very different style, which her personality and literary taste helped to create. Charles's Queen grew up in a Parisian culture where women expected to be entertained by fluent conversation and lively wit. The urbanity, the lightness of touch, and the fine sense of tact characterizing the poetry of Lovelace, Waller, and the other Cavaliers must owe something to this French taste.

This dependence of the Crown upon independent and more or less spontaneous contributions to the cult of royalty appears even with respect to such great rituals as coronations, royal marriages, and funerals. These always involved a core of traditional and carefully regulated ceremonies, but with few exceptions they also spilled over into public festivities or periods of mourning, not only within the Court but in the streets of London and the countryside. Court ceremony served to initiate and orchestrate public displays of sympathy with the royal family. "We had here great triumph and rejoycing for the good forwardness of the French match," John Chamberlain reported during negotiations over the marriage between Charles and Henrietta Maria; "the organs in Pauls played on their loudest pipes and so began to the bells, the bells to the bonfires, the bonfires to the great peal of ordinance at the Tower; God grant it may prove worth all this noise."[44] In theory, the populace and the livery companies would then join in, illuminating windows, cheering or dancing in the streets, and perhaps erecting arches or statues paying tribute to the event.

In practice, of course, the response would depend both on the temper of the populace and on their feelings toward the reigning monarch. When Charles returned from Madrid without a Spanish bride in 1624, the bonfires exceeded anything Chamberlain had ever seen. Middleton's *Game at Chess*, which ridiculed the Spaniards, enjoyed a nine-day run before diplomatic pressure closed it down. So, too, the death of Prince Henry touched off a great display of mourning, including elegies written by almost every major poet in the realm. The Londoners, the universities, and various provincial towns all seem to have had their own taste in this kind of display, and their own feelings as to when it was appropriate. Strong has

[44] Chamberlain to Carleton, 4 December 1624, *Letters of Chamberlain*, ed. McClure, p. 588.

shown, for example, how Puritan districts turned Elizabeth's accession day into a pretext for fasting and praying, whereas other areas were content with bonfires.[45] Some of the arches erected for James I in 1603 by London livery companies may reflect a city tradition of symbolic imagery that may have been as elaborate as that of the Court.

Yet if the royal family or its policies grew unpopular, the public could register its discontent by refusing entirely to honor the Court's cues. The breakdown of ceremonial bonds between the royal household and the realm appears, with particular force, in the late 1620s. In 1627 London failed to honor the King's birthday only two days after it had rung its bells and lit bonfires to observe the anniversary of Elizabeth's accession.[46] The next year Rous observed a picture at Bartholomew Fair, "to which [there was] much running," cruelly parodying the traditional allegorical tributes to military victory. It showed "a naked young woman, and beside her or before her, one riding on the back of an ugly old woman, and written under it: 'All you that will go with me, I'll carry you to the naked Isle of Rhee.' "[47] After Buckingham's assassination, feelings ran so high that the funeral had to be conducted in the middle of the night, for fear of a disturbance. In 1630 the capital failed to celebrate the conclusion of peace with Spain, and when a Prince of Wales was born a few months later reports came in of "Puritans" who openly refused to join in the celebration, saying God had already provided for the succession in the family of the Elector Palatine, the German Calvinist married to Charles's sister.

How did the Culture and Pageantry of the Court Change?

We have reached rather negative conclusions concerning the scope of royal efforts to alter views of the monarchy through the use of culture and ceremony. Charles I certainly took an interest in Court masques and paintings, and the artists and poets of his court believed their work possessed considerable social and political significance. Yet the royal household never took effective steps to organize cultural activities to serve political ends, as, for example,

[45] Roy Strong, "The Popular Celebration of the Accession Day of Queen Elizabeth" in *Journal of the Warburg and Courtauld Institutes*, 21 (1958), 86ff.

[46] Public Records Office State Papers, Charles I, CCLVIII, fol. 29.

[47] *Diary of John Rous . . .* , ed. Mary A. E. Green (London, 1856), p. 22.

Louis XIV did later in the century. Indeed, under the circumstances prevailing in England it is hard to see how the Crown could have achieved strict control over the ceremonial and cultural trappings of kingship, let alone the high culture of England.

Nevertheless, Court pageantry and culture changed fundamentally between 1603 and 1642, in ways that reflect political conditions. To appreciate this fact we need only place a royal portrait by Hilliard next to one by Van Dyck. The contrast between the bright colors and two-dimensionality of the former and the baroque elegance of the latter is symptomatic of a much broader change of tone within the Court. Elizabethan culture and pageantry were saturated in romantic memories of medieval traditions and informed by an essentially northern and medieval love for flamboyant spectacle. By contrast, Charles's court displayed at every turn its cosmopolitan taste for baroque art and classicist poetry and architecture. It developed a culture of monarchy rooted in the literature of Augustan Rome and the international courtly civilization emerging under the auspices of absolutist rulers throughout Europe. Behind the shift in styles, we can sense a reorientation of outlook, away from indigenous, half-medieval traditions and toward the assumptions of a cosmopolitan but socially restricted milieu of courtiers and diplomats. This transition, in turn, reflects that taking place in the political sphere as the relatively isolated but internally united England of the 1590s grew into Stuart Britain, with its close diplomatic ties to France, Italy, and Spain and its clashes between King and Parliament. If the Stuarts did not systematically plan these cultural changes, as a projection of their political aspirations, then why did the transformations occur?

The space remaining permits only a sketch of an answer; but several key points stand out clearly. First, Elizabeth worked far more skillfully than her successors to exploit the kind of independent contributions to a royal cult, by courtiers and others, that we have just described. She spent very little on culture: less than the Stuarts and the contemporary Valois; but less also than her father. Pensions granted to Court musicians and the budget of the Office of Works failed to keep pace with inflation; major royal architectural projects ceased entirely, and the Crown never tried, in her reign, to recruit and hold important foreign artists. But in compensation, she exacted or inspired a vast amount of devotion, expressed through many different kinds of ceremony and culture, from her servants and her people. Courtiers naturally bore the

heaviest burden, erecting fabulously expensive prodigy houses, sponsoring pageants, jousts, and masques, gracing the Court with their retinues, and composing or commissioning poems to Eliza. Several of the greater courtiers also distributed patronage widely to scholars, poets, and, from the 1580s, playwrights. Leicester's remarkable affinity for literary men—dozens of figures in all—has received the most attention from scholars. But Burghley, Essex, Ralegh, and others also distributed their money widely among the learned and witty.

Even beyond this sprawling network, country lords and borough corporations often found themselves pulled into the work of adoring Gloriana. The progresses, especially, inflicted the duty of entertaining the Queen and her Court on many a reluctant peer and provincial city. The fêtes produced by these provincial hosts sometimes involved dozens or even hundreds of participants, and from time to time they made a major contribution to the royal cult.[48] Even the Accession Day jousts, perhaps the most significant of all Elizabethan Court pageants, originated during a visit of the Queen to the house of Sir Henry Lee on a progress in 1575.[49] Needless to say, Elizabeth displayed a genius for playing to the audience on these public occasions. "Some she pitied, some she commended, some she thanked," one observer noted after watching her in public: "at others she pleasantly and wittily jested . . . distributing her smiles, looks and graces so artificially, that hereupon the people redoubled the testimony of their joys."[50] These progresses probably did more than anything else to make her a living presence in the lives of ordinary Englishmen.

The entire system reflects quite closely the networks of political patronage Neale and MacCaffrey have discovered in the same period.[51] In each case privy councilors and royal favorites were the pivotal figures. They gained substantial incomes through office and by exploiting various types of royal favor; but in return they had to construct personal followings upon which the Queen could draw. Essentially the same arrangements provided her with soldiers, pol-

[48] The fullest narrative is John Nichols, *Progresses of Queen Elizabeth* (London, 1823).

[49] Yates, "Elizabethan Chivalry," *Astrea*, pp. 94-102.

[50] John Hayward quoted by Neale, *Essays*, p. 92.

[51] Neale, "The Elizabethan Political Scene," *Essays*, pp. 59-84; Wallace T. MacCaffrey, "Place and Patronage in Elizabethan Politics," in *Elizabethan Government and Society*, ed. S. T. Bindoff et al. (London, 1961), pp. 95-126.

iticians, and poets: in each case courtiers discovered and paid men with the requisite talents, and in each case Elizabeth also enforced their principle that all Englishmen were ultimately her servants, whether or not they received compensation from the Court. This kind of decentralization allowed for a maximum of flexibility and communication and encouraged constructive initiatives from men not directly connected to the royal household. Most of the styles, motifs, and genres that went into the Elizabethan cult originated from one of her many audiences: the courtiers grouped around her on a day-to-day basis, the country lords obliged to treat her to an occasional spectacle, the boroughs and livery companies responsible for civic pageants. We can speak of a ceremonial and cultural dialogue taking place between the Court and the realm, a tradition of royalist culture growing out of the continual interplay between the royal entourage and communities throughout England.

After 1603 the whole system broke down for at least three reasons. First, the political and financial problems of the 1590s and the early seventeenth century, together with the end of a threat from Spain, undermined the unity that had made the Elizabethan cult viable. As early as the 1590s, Essex used Elizabethan chivalry to stir the military instincts of the realm at a time when the Cecils and the Queen were trying to conclude peace. A decade or more later, Prince Henry revived the same imagery to encourage opposition to the pacific policies of his father.[52] By 1620 the Protestant mythology of national election, as developed by Foxe and his successors, became the vehicle for opposition to James's Hispanophile policies. A cult as loosely structured as that of Elizabeth, as dependent upon the efforts of courtiers and others, inevitably raised the danger that the Crown might lose control of its own cultural and ceremonial props. From the late 1590s this began to happen; groups within the Court and a few outsiders, who disliked the drift of royal policy, turned the traditions of Elizabethan monarchy against the Stuarts.

At the same time, James failed to continue the kind of broadly-based pageantry characteristic of the previous reign. He disliked crowds and avoided them whenever possible, with disastrous results. Even more important, he failed to maintain the principle that the nobility as a whole should foot the bill for Court spectacle. The

[52] Roy Strong, "Inigo Jones and the Revival of Chivalry," in *Apollo*, 86 (1967), 102ff.

great progresses withered and died, the Accession Day tournaments declined. Had James possessed the revenues of a Louis XIV this might not have mattered; but given the limited resources of the Crown, the inevitable result was a constriction of ceremonial display. James probably made matters still worse by failing to cut back on the expenditures of the household itself. The Court became more extravagant than ever, with the King paying out more than twice as much for pensions and food allowances as Elizabeth. Under Charles things became still worse. Yet less of this ostentation took a form the public could understand or enjoy. The money went for private banquets and masques from which all but a few were excluded, rather than for public cavalcades, jousts, and progresses. The Stuarts consequently were blamed for extravagance while they provided less and less in the way of visible magnificence for those beyond the Court.

In addition, the growth of a new culture within Court circles, oriented toward the aesthetic values of Catholic Europe, eventually created a grave psychological barrier to communication. The conclusion of peace in 1603 and the renewal of diplomatic contacts with the Continent greatly facilitated foreign travel and the interchange of cultural values between the English court and its European counterparts. Some Englishmen had always traveled abroad and returned with foreign ideas and manners; but the scale of this intercourse increased dramatically under the Stuarts and eventually changed the mentality and social habits of the Court in decisive ways. Figures like Endymion Porter, who spent his adolescence in Madrid, or the Earl of Arundel, who continually traveled abroad and sent agents to Italy in search of art, had more in common with Italian and Spanish courtiers than with most English gentlemen.[53] Charles reached maturity as the impact of these trends became decisive. He was the first English king to grow up in a society familiar with Shakespeare and Jonson, Titian, Rubens, and Palladio—one anchored in London and more detached from rural society than any that had previously existed in England. To a country squire struggling to live up to his station from the profits of a modest but carefully managed estate and immersed in a county society of quarter sessions, fairs, and horse races, the King's world must have seemed very remote indeed.

[53] Gervase Huxley, *Endymion Porter, the Life of a Courtier, 1587-1649* (London, 1959); Marie F. S. Hervey, *The Life, Correspondence and Collections of Thomas Howard, Earl of Arundel* (Cambridge, 1921).

If my analysis is correct, the Stuart cult of monarchy did not develop out of an absolutist program, comparable to the ceremonial and cultural reforms of Louis XIV. Yet it may reflect something even more important. Our findings suggest that the early seventeenth century witnessed a weakening of cultural bonds uniting the monarch with the political nation and the largely illiterate populace. The Crown came to be associated with a narrow elite within the aristocracy, developing an urban high culture whose long-term influence would be enormous, but whose short-term impact was politically disastrous. Political disputes dovetailed into a far more fundamental, if still vaguely defined, cultural schism. For the uncommitted and informed minorities on either side, the Civil War developed into a struggle between two visions of society and two ways of life. The King came to stand for the theatre, for cosmopolitan tastes, and for the sophistication of the Cavaliers as much as for prerogative government. Despite the neutrality pacts, the local loyalties, and the reluctance to take sides characteristic of the whole contest, the realm plunged into a struggle between rival cultural ideologies. For the next century, this cleavage influenced the course of both political and cultural history.

Literature

SEVEN

Literary Patronage in Elizabethan England: The Early Phase

JAN VAN DORSTEN

"IF only we had the Maecenases," Martial complained in his Epigram VIII, lvi, "there would be no shortage of Virgils."[1] The early Elizabethan period appears to bear out his remark: there was certainly no Virgil, and literary patronage too had reached a low point—or so it seems. "The immense output of literary work during the [later] Elizabethan age," Phoebe Sheavyn wrote in 1909, "was fostered very little by any enlightened encouragement";[2] and when at 101 years of age she read the proofs of the revised edition (1967) of her work, her somewhat Edwardian ideas were still being echoed by most literary historians.[3] Eleanor Rosenberg, author of *Leicester Patron of Letters*, however, finds all this a "misconception," a "ghost," a "fallacy."[4] And indeed, if one widens (as she does) both the terms "literary" and "patronage" and if one redefines the period's intellectual and artistic needs and purposes, literary patronage ceases to be nonexistent—although it still does not yield a Virgil.

The first enlightened patron of some significance, without any doubt, was Sidney. Moreover, he at least did have an interest in belles-lettres—writing of a kind that both Martial and most other people associate with a Maecenas in spite of Eleanor Rosenberg's objections. Yet even Sidney is best described (in Fulke Greville's phrase) as "a general Maecenas of Learning"; and to study him as a literary patron in the usual sense of the word is to look the wrong

[1] "Sint Maecenates, non derunt, Flacce, Marones."

[2] *The Literary Profession in the Elizabethan Age* (Manchester, 1909), p. 7.

[3] *The Literary Profession in the Elizabethan Age*, rev. John Whiteside Saunders (Manchester, 1967).

[4] *Leicester, Patron of Letters* (New York, 1955), pp. 12-13.

way and for the wrong thing, as John Buxton explains in *Sir Philip Sidney and the English Renaissance.*[5]

The main object of patronage in the first three decades of Elizabeth's reign was indeed not belles-lettres.[6] Authors dedicated books in order to gain support for a cause or to draw attention to their loyalty and personal expertise in an attempt to improve their own social position through "preferment." Both the works themselves and their dedicatory pages almost invariably stressed political, religious, or educational usefulness to Queen and country. Writers therefore tried to approach influential political figures with their dedications—the Earl of Leicester, for instance, or even the Queen herself—rather than enlightened connoisseurs, if they existed. Books tended to be purposely propagandistic. No true humanist would raise an objection to this, for what use are the *bonae litterae* if they fail to serve the interests of the *res publica*?

Yet among these countless useful books, pamphlets, manuscript notes, and what not, items sometimes occur, even early in the reign of Elizabeth, that by any definition must be called literature, or attempts at literature. Often they serve a cause, but occasionally their principal service is to give pleasure to their dedicatees—their patrons, if that is the correct word. To appreciate them the way they were intended to be appreciated one needs to bear in mind that they were generally written to suit a particular occasion and a known taste. The Elizabethans, in Buxton's phrase, wrote "as often as not, for someone with whom they had dined a few days ago."[7] As a result, many of these literary by-products remained in manuscript or were printed long after the event. In such cases the poet-patron relationship was extremely informal, at least on paper, and the nature of the literary work was largely determined by the patron's taste. If he liked Latin, a poem would be in Latin. If his tastes were conservative—they usually were—nothing avant-garde was called for. In all these cases, patronage appears particularly informal and personal to us because it cannot be associated with great prosperous courts and cities (as in sixteenth-century Italy), but only with some few individuals and their houses either in London or deep in the country.

As a result it is often difficult to use terms like patron, client, or dedication in the accepted sense of the word. Much depends on the

[5] *Sir Philip Sidney and the English Renaissance* (London, 1954), ch. 1.

[6] Rosenberg, *Leicester*, pp. 15-17.

[7] Buxton, *Sidney*, p. 22.

occasion and circumstances. To give one example, in 1584-85 the influential Dutch politician, Jonkheer Jan van der Does, was in England as one of the leaders of a delegation to negotiate English intervention in the Netherlands after the death of William of Orange.[8] Being one of the most prominent poets of his country, he also wrote, as Janus Dousa, a great deal of Latin verse during his English sojourn, most of it addressed to important English political figures, all of it in the interest of what in modern terms would be called public relations, and eventually printed it in a volume, *Odarum Britannicarum liber*, dedicated to Queen Elizabeth. This is straightforward enough. But in the same months he also gave a copy, still in the Hatfield House library,[9] of his 1584 *Epodon ex puris iambis libri II* to William Cecil, Lord Burghley with an elaborate autograph dedication. Is it a dedication? After all, the volume also includes a printed dedication to someone else. Does it make Burghley Dousa's patron? According to Dousa it did, for he signed his inscription: your "cultor ac cliens." But at home, Dousa was looked upon as a patron rather than somebody's client. Indeed, in the cosmopolitan *res publica litterarum* with its powerful religio-political overtones, poet-patron relationships are very much a matter of circumstance. The term patronage can be used, of course, but not without certain readjustments.

Although there is a marked difference between literary patronage and the patronage of painting in the sixteenth century—for one thing, because the former could exist without abundant financial resources, whereas the latter remained the prerogative of the rich— their predicament was not entirely dissimilar. In early Elizabethan England

> painting and allied arts . . . struggled for survival. Their withered state was not helped by the total collapse of a settled court culture and, with it, that of active royal patronage. Henry VIII was the only Tudor with pronounced, if derivative, artistic tastes and during his reign every effort was made to keep abreast of the latest fashions in architecture, painting, and the decorative arts. Edward, Mary, Elizabeth, James, who suc-

[8] Roy C. Strong and Jan A. van Dorsten, *Leicester's Triumph* (Leiden and London, 1964), chs. 1-2; Van Dorsten, *Poets, Patrons, and Professors* (Leiden and London, 1962), pt. 2, ch. 1.

[9] Hatfield House Library, Shelfmark Br. 11972.0.1.

ceeded him, all failed to engage in active artistic patronage. After Henry's death in 1547 no new palaces were built, no major additions were made to those that already stood, no important commissions from the Crown were given for furniture, tapestries, paintings or any other art form apart from those which were dictated by necessity such as the advent of an embassy, or by renewal on account of decay.[10]

The same could be said of poetry: court patronage or munificent, poetry-loving noblemen were not in evidence. But because the writer's social and intellectual prestige was generally higher than that of a painter, men of letters were not entirely deprived of encouragement.

They at least had access to a few literary rendezvous comparable to those that existed across the Channel. One should not imagine the existence of literary circles consisting of a rich patron surrounded by competing *clientes*. Rather, one should think of those important centers of informal patronage that characterize sixteenth-century northwestern European humanism: the great printing houses, and the dinner tables of leading humanists where, almost regardless of differences in social status, men of letters were encouraged to exchange ideas as fellow-literati. Regrettably, Elizabethan England produced no publishers in the tradition of Froben or Oporinus. No English Plantin or Estienne *officina* could act as a clearinghouse for writers, merchants, and patrons. But Sir Thomas More's household was remembered by the next generation of humanist-statesmen, and William Cecil in particular tried to emulate his example.[11]

Somehow one does not often think of Mr. Secretary Cecil as a man of letters, even though in the early reign of Elizabeth he was one of the three most prominent dedicatees of printed books— Elizabeth and Leicester being the other two. Yet, unlike his competitors, he at least was actively interested in the pursuit of letters. "Though his head be never so full of most weightie affaires of the Realme, yet, at diner time he doth seeme to lay them alwaies aside: and findeth ever fitte occasion to taulke pleasantlie of other matters, but most gladlie of some matter of learning: wherein, he will cur-

[10] Roy Strong, *The English Icon* (London and New York, 1969), p. 1.

[11] Jan A. van Dorsten, "Mr. Secretary Cecil, Patron of Letters," *English Studies*, 50 (1969), 1-9; *The Radical Arts*, 2nd ed. (Leiden and London, 1973), pp. 62-63 and *passim*. The next few paragraphs necessarily repeat some of my earlier remarks.

teslie heare the mind of the meanest at his Table," said Ascham in the "Praeface" to his *Scholemaster* (dedicated in 1570 to Cecil by the author's widow). Mr. Secretary's wife Mildred was, moreover, a Greek scholar of some repute, being the second of Sir Anthony Cooke's learned daughters of whom George Buchanan had said, "Cucides Aonidae mihi erunt, pater alter Apollo."[12] It was a matter of course that the Cecils would ensure the best tuition for their children; and in their house classical studies, philosophy and science, and certain kinds of poetry and music were cultivated. Although Conyers Read believes that Cecil cannot "justly be regarded as a patron of the arts, except architecture," Cecil House was England's nearest equivalent to a humanist *salon* in the days after More, and possibly the only one in early Elizabethan England.[13]

There are two sides to Cecil's patronage: one public, the other private. The first can to some extent be measured by counting the number of printed books dedicated to him by a succession of English authors and translators. Some of them are still remembered in the footnotes to English literary history. In 1566 Thomas Drant, whose rules for classical meters are constantly mentioned in the important, puzzling Spenser-Harvey *Letters* of 1580, dedicated his *Medicinable Morall . . . Horace his Satyres* to the Cooke sisters, Lady Bacon and Lady Cecil, "favourers of learning and vertue," though his other publications were not addressed to a Cecil.[14] Arthur Golding, however, who two decades later finished and revised[15] Sidney's rendering of Duplessis-Mornay's *De la vérité de la religion Chrestienne*, appears to have been a client in the proper sense of the word; for at the time when he dedicated some of his translations to Cecil, he was living in his patron's house attending upon Cecil's ward, the Earl of Oxford, Ann Cecil's future husband.[16] The not very talented Barnaby Googe dedicated two books to Cecil, the

[12] "Cooke's daughters were, to me, the Muses, their other father Apollo": *Opera Omnia* (Leiden, 1725), II, 95.

[13] *Mr. Secretary Cecil and Queen Elizabeth*, Bedford Historical Series, no. XVII (London, 1962), p. 11.

[14] An interesting example of multiple patronage is the British Library copy of his *Praesul* (1576). The book was dedicated to Thomas Grindall; in it, Leicester is referred to as Drant's patron; and this particular volume is the author's presentation copy to the Queen, to whom he dedicates the book in an eighteen-line poem, "Lady, and life of this thine English land. . . ."

[15] *Miscellaneous Prose of Sir Philip Sidney*, ed. Katherine Duncan-Jones and Jan van Dorsten (Oxford, 1973), preface.

[16] *Short Title Catalogue*, 3933, 4335.

printer Richard Grafton one. Grafton had also been the printer of Thomas Wilson's *Vita . . . duorum fratrum Suffolciensium* (1551), which includes two Latin poems by Cecil himself.[17] Wilson in 1570 dedicated his translation of three orations of Demosthenes to Mr. Secretary, but the relationship between Cecil and the future Secretary of State was one of near-equals, as is clear also from the tone of Wilson's verses to Cecil on the latter's illness in 1568 (in which Wilson laments the fact that England is full of vice while the one great man is ill).[18] Finally, there is Ralph Robinson, who in 1551 offered his translation of More's *Utopia* to William Cecil, recalling in his Epistle "that old acquayntaunce, that was betwene you and me in the time of our childhode, being then scolefellowes together," and who for many years continued to appeal to his old schoolmate, without any apparent success. Such, then, was the "public" side of Cecil's literary patronage.

More important, and more difficult to define, is Cecil's private patronage. Perhaps one should now abandon the word patronage and instead think in terms of hospitality and accessibility. Records of Cecil House as a center of letters and learning are to be found in abundance, though they are not readily available. One comes across them (when one is not really looking for them) in all sorts of books and manuscripts: poems and letters among the state papers, incidental references in the correspondence of Continental scholars, complimentary verses in long-forgotten collections of neo-Latin poetry, the odd entry in an *album amicorum* of some visitor to England, but rarely in a formal dedication. Pieced together, they suggest a setting not unlike many others in sixteenth-century Europe. One is reminded of the various Continental scholar-statesmen to whom Sidney was introduced by Languet in the 1570s, some of whom were soon to reverse the roles by dedicating their books to their former visitor. Cecil's hospitality to men of letters followed the familiar pattern of humanist dinner-table conviviality: informal symposia where the *bonae litterae* were a standard subject. By tracing the persons and topics involved, one can sometimes catch a

[17] Read, *Cecil*, pp. 353-54, quotes, "about the only surviving poem from his pen," a New Year poem to his daughter Ann. Another (in memory of Thomas Chaloner) occurs in Chaloner's *De rep. Anglorum instauranda libri decem* (London, 1579), sig.** ij. A 1571 *Carmen in adventu reginae*, which I have not seen, has also been attributed to Cecil. The Cambridge MS. I.i.5.37 (Bartholo Silva, *Hortus*, presentation copy to Leicester—not in Rosenberg) includes some Greek poetry by Mildred Cecil.

[18] State Papers foreign, 12/47, f. 52.

glimpse of the tastes and interests of these gatherings; and in some cases one may be able to explain how certain books came to be written or why certain people, years later, could talk or correspond like old friends when nonliterary reasons—politics, more often than not—made it useful to revive the acquaintance. Throughout the sixteenth century many an influential man, like Cecil, was particularly accessible if one could display philological or literary skill. Thus, when the Dutch envoy Dousa first approached him in 1572, he brought him a letter from one of his earlier Dutch *clientes* praising the envoy's fame as a Latin poet.[19] It is perhaps no exaggeration to claim that whatever the outcome of such meetings at Cecil House (or any comparable rendezvous) was—preferment, political aid, or nothing at all—it often began with poetry.

Apart from their personal interests, the Cecils had another reason for entertaining men of letters. They were trying to educate their eldest daughter, Ann (born 1556), and the two younger children, Robert (born 1563) and Elizabeth (born 1564), plus a large number of wards, according to the most advanced mid-century Protestant-humanist principles. In addition to strictly observed religious devotions, solid philological studies kept the children busy. Some of England's leading pedagogues were among Cecil's closest associates. Thus, to go back one decade, two of King Edward's tutors had been John Cheke, Cecil's Cambridge tutor and brother of his first wife, and Sir Anthony Cooke, his present wife's father. A third was Roger Ascham, a fellow of St. John's in Cecil's time and future tutor to Queen Elizabeth. More humanist acquaintances with educational interests could be added. As the Cecil House ménage grew to ever larger proportions because of Cecil's numerous wards with their servants and tutors, and as the Cecil children themselves required more advanced tuition, men of letters became most welcome visitors to that "great resort hotel."[20] The Cecils believed strongly in education, including the education of women. It was an essential aspect of their patronage.

In all fairness it should be added, merely as an aside, that we do not know very much about the education of women in mid-sixteenth-century Britain, although a fair amount has been written about educated women and more is likely to follow. A classical training for women as well as men had, of course, been advocated

[19] Van Dorsten, *Poets*, p. 25.
[20] Pearl Hogrefe, *Women of Action in Tudor England* (Ames, Iowa, 1977), p. 15.

by various early humanists, Sir Thomas More in particular, and the new phenomenon of educated ruling queens—Elizabeth and the two Maries—certainly did no harm to the emancipatory trend. The reason why the actual training of women in early Elizabethan England is imperfectly documented may be that it did not differ significantly from that of the men and, more importantly, that it had nothing to do as yet with preparing women for a professional career. At best it helped them to obtain "an equality in communication with their *husbands'* guests."[21] Lastly, it concerned very few women, a small intellectual (and not necessarily aristocratic) élite. The very fact that Mildred Cecil and her well-trained daughters were much commented upon by humanist writers indicates how exceptional they were.

The Cecils, then, had various good reasons for encouraging men of learning to visit their home. They could not complain of lack of response—Mr. Secretary had become a very influential man. If he himself was only present at dinner time, his wife, supremely able manager of a very large household, would have supervised the activities of wards, tutors, and visiting scholars during the day. Her house began to look more and more like a humanist college where many of the principal gentlemen of the realm sent their sons to be educated. As a meeting place for the learned it had no parallel in early Elizabethan England.

In many respects it did resemble one other household of the same period: that of Jean Morel in Paris, whose wife could compare with Mildred as a philologist and who also had several daughters to educate.[22] The general pattern is the same. In the late fifties and sixties their house was a leading and very cosmopolitan meeting place for scholars and poets. Yet there are two crucial differences between the two centers of learning (apart from the fact that the Morels were Catholics and that Jean Morel never became an influential statesman like Cecil). One is quality. England in the 1560s could not compete with Paris, which at the time was the most advanced artistic and intellectual center in northwestern Europe. We encounter all the great names among Morel's regular guests. The second difference is that belles-lettres did play an important role in Morel's "sacra Musarum aedes," which was frequented, among others, by the poets of the Pléiade. When in 1559 Du Bellay

[21] Hogrefe, *Women of Action*, p. xx. (Italics mine.)
[22] See van Dorsten, *Radical Arts*, app. II.

published his *Epithalame sur le marriage de . . . Philibert Emanuel, duc de Savoye, et . . . Marguérite de France*, his address to the reader even records the fact that Mme. Morel and her three daughters had actually sung the epithalamion.

Three points need to be made. The first is that in Morel's case, too, the term patronage cannot be used in the conventional sense. The second is that there is sufficient evidence to prove that the Cecils were fully familiar with what went on in that much more remarkable rendezvous across the Channel, for quite a few *literati* visited both houses. The activities of two such go-betweens are well documented: Daniel Rogers and the Dutchman Charles Utenhove, both scholars, politicians, and *poetae minores* whose chief contribution to literary history is (as in this case) the importance of the contacts they established.[23] The third, and most crucial, point is that in spite of all these opportunities, Mr. Secretary failed to emulate the Frenchman's example. Not that he suffered from xenophobia; he simply continued a solidly conservative English humanist tradition; and he certainly never encouraged any new literary trends.

One suggestive detail must be added. Cecil House was young Philip Sidney's first encounter with a private center of learning.[24] He often stayed with the Cecils, and after the 1568-69 Christmas holidays, which "my darling master Philip"—Cecil's phrase—spent at their house, no less than a marriage settlement between Cecil's favorite daughter, Ann, and Philip himself was agreed upon by Sir Henry Sidney and Ann's father. The match never materialized; but Sidney's experiences at Cecil House at an impressionable age must have influenced him, as an example and occasionally as a warning, when he himself became a patron one decade later.

It is tempting to continue by enumerating the activities of all those writers and scholars, and especially the foreign clients, whose presence at Cecil House or some other hospitable place is on record. Unfortunately, it would add nothing significant to the topic of this essay. In the development of English literature and the emerging of a spectacularly new literature, all this is of marginal importance. What is important? A student of literature is naturally interested in the mysterious early years that were to produce the first, "silver" generation of Elizabethan nondramatic poets. Is he to conclude that

[23] Van Dorsten, *Radical Arts*; van Dorsten, *Poets*, pt. I.

[24] Van Dorsten, "Cecil, Patron of Letters," p. 9; James M. Osborn, *Young Philip Sidney 1572-1577* (New Haven and London, 1972), p. 16.

it all happened in spite of the fact that patronage of belles-lettres was no great concern of Cecil and his contemporaries? The greatest patron of the period was the Earl of Leicester, among whose clients one finds two literary figures: Spenser and, to a rather lesser degree, Gabriel Harvey. But not even the most tortuous argument can demonstrate any active encouragement on the part of their employer.[25]

No matter how hard one tries to look for alternatives, the new poetry had only one patron: Sidney. Against all odds and almost single-handedly, he provided the ambience and the inspiration that was to initiate one of the greatest periods in European literary history. He himself did not live to see the result. (Indeed, one wonders whether he would have approved of Marlowe and Shakespeare and their successors, who were to offend against his neoclassical rules—although one likes to think that he would have appreciated almost everything else, μίμησις, *energia*, and all.) What he did see, before his death in 1586, was infinitely more tentative and exclusive. Yet the importance of his role in these formative years was acknowledged by many of his contemporaries, and is again recognized by present-day scholars.

Sidney's activities as a Maecenas of learning have been traced and described in considerable detail.[26] Rather less is known about his personal involvement as a patron of belles-lettres, although Spenser scholars have necessarily tried to define the extent of his contribution. The greatest puzzle, still unsolved, concerns the years before *The Shepheardes Calender* (1579) came to be dedicated to "the noble and vertuous Gentleman most worthy of all titles both of learning and chevalrie M. Philip Sidney." Admittedly, the evidence is inconclusive and therefore rather offputting; but one cannot afford to ignore it. Sidney's presence can be felt everywhere, and there was no one else.

From a domestic point of view the young Philip Sidney had neither the power nor the money to act as a patron of any significance, and the Queen's efforts to minimize his political influence should have made him even less eligible. In terms of international hopes and expectations, however, he was the most promising patron England possessed. As a result, his role was cast largely by Continental (or Continent-oriented) forces; and it should be studied in that light. The facts are well known. His Continental education began in 1572.

[25] Rosenberg, *Leicester*, ch. ix.

[26] Especially B. Siebeck, *Das Bild Sir Philip Sidneys in der Englischen Renaissance* (Weimar, 1939); Buxton, *Sidney*; Van Dorsten, *Poets*; Osborn, *Young Sidney*.

The original reason for his Grand Tour had been to attain "the knowledge of foreign tongues," but he returned with rather more.[27] His charisma, as some would call it today, coupled with the wealth and political importance he was likely to inherit, drew the attention of scholars and politicians, and especially of the Protestant League organizers who were anxious to involve the great Protestant power, England. Presumed to be the heir to the Earls of Warwick and Leicester (and perhaps of Sussex and Huntingdon as well) and styled "son of the Viceroy of Ireland," Sidney's prestige abroad in the late seventies was truly astonishing. His tutor Hubert Languet and other supporters of the League, including the omnipresent English envoy Daniel Rogers, made every effort to establish the young Englishman as the embodiment of virtue and perfection. Sidney himself certainly tried to live up to his image—one sometimes wonders whether the Queen's determined attempts to reduce him to political inactivity did not in fact compel him to persist in that role.

Unlike some prominent contemporaries of his, Sidney's interest in learning and letters was genuine. It encouraged some of the finest Protestant humanists of the time to adopt the part of *clientes*, and there is reason to believe that this is how he acquired much of his up-to-date humanist learning.[28] The Protestant League circle, however, is not remarkable for its poets in the vernacular. At most, his Continental acquaintances could have been the channel through which he received copies of literary works in French or Italian. But what he must have learned from the northern humanists, most of whom had been profoundly influenced by the mid-century Parisian literary scene, was how poetry too should be made a guiding instrument in times of conflict.[29] There is enough in Sidney's literary remains, private though they may be, to suggest that he took these ideas to heart when, forced to be idle, he became actively involved in poetry—his own poetry and that of others, particularly Spenser.

Posterity knows Spenser as the author of *The Faerie Queene*, the *Hymnes,* the *Prothalamion,* and *Epithalamion*; and one is inclined to assume that Sidney must have recognized Spenser's potential well before these works came to be written, and therefore encouraged him to produce them. This may be true. The two men certainly

[27] Arthur Collins, *Sidney Papers* (London, 1784), I, 98.

[28] See Jan A. van Dorsten, "Sidney and Franciscus Junius the Elder," *Huntington Library Quarterly*, 41 (1978), 1-13.

[29] Van Dorsten, *Poets*, pt. I; A. C. Hamilton, *Sir Philip Sidney* (Cambridge, 1977), pp. 13-15.

were in touch for a while, and there is some evidence that the dedicatee of *The Shepheardes Calender* did encourage his client to do even better. But one should add that the poet who came his way in 1579, or probably earlier, had for many years been inspired by ideas and examples comparable to those in which Sidney himself had become interested rather more recently.[30]

How they first met we do not know. It would fit the pattern of Sidneian patronage if it was because of Spenser's employment by a known supporter of English involvement in the League: Sidney's uncle, the Earl of Leicester. But nothing is certain. Most of Spenser's early work is lost—the *Dreames,* the *Dying Pellicane,* the *Epithalamion Thamesis*—and no one, so far as we know, had shown any interest in his literary aspirations. When *The Shepheardes Calender* appeared, the English reader must have noted how different it was from what he was accustomed to. The same could be said of Spenser's only surviving *juvenilia,* the poems of the 1569 *Theatre for Worldlings.* It is a typically mid-century work in the French manner which anticipates both the humanistic experiments in the vernacular of the late seventies and Spenser's later attitudes toward the function of poetry.[31] Sidney alludes to the *Calender* in his *Defence*; but there is no proof that he knew Spenser's *Theatre.* Yet both the *Theatre* and (if one may interpret a title) the *Dreames* were derived directly from the same French literary scene about which Sidney's Continental friends and teachers continued to talk and write; and it is likely, therefore, that the young patron understood what his client was trying to do, no matter how much they differed. Sidney never wrote quite like Spenser, and vice versa, but their theory of literature was the same. Spenser's *The English Poet* does not survive, and we do not know whether it was as close to the *Defence of Poetry* as the October Eclogue or certain passages in the Letter to Ralegh; but his practice in *The Faerie Queene* certainly agrees with the principles outlined in the *Defence.*[32] For in spite of all the differences—tone and manner, personal prestige, perhaps also talent—

[30] The *terminus post quem* is autumn 1579 (but see Duncan-Jones and van Dorsten, eds., *Miscellaneous Prose,* p. 60). Internal evidence (see below) suggests that something must have passed before then.

[31] The most recent study is Carl J. Rasmussen, " 'The Bondes of Mans Nature': Spenser's Vision Poems," Ph.D. dissertation, University of Wisconsin-Madison, 1978. See also van Dorsten, *Radical Arts,* pp. 75-85.

[32] In this article Sidney's essay on poetry is referred to as *A Defence of Poetry.* Duncan-Jones and van Dorsten, eds., *Miscellaneous Prose,* pp. 69-70, explain why this title is to be preferred.

the two men shared a literary ideology that each of them appears to have independently acquired from abroad. It seems irrelevant to speculate about who could have taught whom.

When they first met, say in 1578, Spenser had had nine years of practice as a "new poet." Sidney must have had some, too. *The Lady of May* was perhaps written in 1578;[33] the *Arcadia* may have been begun in August-December 1577;[34] his earliest experiments with quantitative verse (of which he had "already greate practise" in 1579[35]) must have been made before April 1578;[36] but no known text can reasonably be dated earlier than these years.[37] Of course, this does not mean that he had never written any verse before;[38] such a critical and self-conscious person may well have destroyed his *puerilia* as his literary abilities improved. During his Grand Tour in the early seventies, he had always been "with the Muses sporting," as his servant Lodowick Bryskett said in 1587—and why not?[39] Similarly, when his friend Paulus Melissus addressed him in May 1577 as "Sidnee Musarum inclite cultibus," the obvious conclusion is that the German poet was talking to someone who had had at least some literary experience.[40] A long Latin poem of 14 January 1579 praises Sidney's linguistic and literary skills.[41] Its author, Daniel Rogers (who is always accurate), presents his compliment in a manner that seems to imply that these skills were not entirely new. He certainly indicates their connection with Sidney's interest in law, theology, and moral philosophy, plus the fact that Dyer and Greville (who later were to inherit Sidney's library) were also involved. Whether we like it or not, the long-disputed Areopagus theme of the Spenser-Harvey *Letters* is reintroduced.[42]

[33] Duncan-Jones and van Dorsten, eds., *Miscellaneous Prose*, p. 13.

[34] Sidney, *The Countess of Pembroke's Arcadia*, ed. Jean Robertson (Oxford, 1973), pp. xv-xvi.

[35] Spenser to Harvey, 5 October 1579, in *Two Other Very Commendable Letters* (London, 1580). *Prose Works*, ed. Rudolf Gottfried (Baltimore, 1949), p. 6.

[36] Sidney, *The Poems*, ed. William A. Ringler, Jr. (Oxford, 1962), p. xxxiv.

[37] See Ringler, ed., *The Poems*, pp. 517-19.

[38] In my experience many literary phenomena of the sixteenth century have earlier beginnings than one assumes.

[39] *A Pastorall Aeglogue*, quoted in Ringler, ed., *The Poems*, p. xxiii.

[40] Van Dorsten, "Sidney and Junius," pp. 6-7; van Dorsten, *Poets*, pp. 50-51, 173-74.

[41] Van Dorsten, *Poets*, pp. 61-67, 175-79.

[42] See James E. Phillips, "Daniel Rogers: A Neo-Latin Link Between the Pléiade and Sidney's 'Areopagus,'" in *Neo-Latin Poetry of the Sixteenth and Seventeenth Centuries* (Los Angeles, 1965), pp. 5-28.

Areopagus or no, it is clear that during his period of political inactivity between his important visit to the Continental Protestant leaders in 1577 and the year 1579 at least Sidney was looked upon as the patron and leader of a group of intellectuals—Spenser, Harvey, Dyer, Greville, Rogers—who sought to establish a new poetry based upon a new approach to the *humaniora*. Again, these are the lost years. We do not know how often the young patron and members of his group met or what exactly they did and read and talked about. All we have are the five *Letters* printed in 1580, the Rogers poem, and a few scattered remarks. As far as poetry is concerned, the most telling documents are the final version of the old *Arcadia* and the *Defence of Poetry* in which "they that delight in poesy . . . seek to know what they do, and how they do"; these works can only be read as a summary of Sidney's findings at the end of the early years.[43] Together the evidence suggests that these literary-minded areopagites (who, incidentally, all had Protestant League affiliations) met in an attempt to acquire "those skills that most serve to bring forth" the architectonic "knowledge of a man's self, in the ethic and politic consideration, with the end of well-doing and not of well-knowing only."[44] Sidney's inspiration to stimulate and guide these discussions presumably came from the example of his Continental friends and teachers. Not surprisingly, his informal little seminars remind one of the idealistic preoccupations of that much more prestigious circle of scholars and politicians in Paris in the sixties, of which Rogers (like Melissus) had firsthand experience.[45] Even the English circle's concern with quantitative verse—the only topic that is properly documented—recalls the French academicians' efforts in earlier years.[46]

In such a context, belles-lettres were only a by-product. At the same time they became increasingly important as the delightful medium carrying the useful message. The *Defence* is quite unambiguous about the relationship between *dulce* and *utile*. Unfortunately, the group's earliest experiments with the new medium do not survive, apart from a few hints in the *Letters* and some pieces

[43] Duncan-Jones and van Dorsten, eds., *Miscellaneous Prose*, p. 111.

[44] Duncan-Jones and van Dorsten, eds., *Miscellaneous Prose*, pp. 82-83.

[45] Phillips, "Daniel Rogers," *passim*; van Dorsten, *Poets*, pt. 1. See Anne Lake Prescott, *French Poets and the English Renaissance* (New Haven and London, 1978), chs. 2-3.

[46] Frances A. Yates, *The French Academies of the Sixteenth Century* (London, 1947); Phillips, "Daniel Rogers."

in the *Arcadia* that may be early. Sidney was a profound believer in teaching by example; and it seems perfectly natural that it was his effort to improve the poetic medium that "made the rest audacious," as Daniel puts it.[47] But how did it happen? We all know Sidney's sophisticated verse; but there was no English precedent (other than Surrey), and all things have a beginning.

We can catch a glimpse of these lost beginnings, I think, in Spenser's *Complaints*, published five years after Sidney's death, of which the first part, *The Ruines of Time*, commemorates "the Patron of . . . [his] young *Muses*." In any memorial one attempts to evoke the past. So did Spenser. As a result, his poem must have sounded distinctly archaic even in 1591.[48] Evidently he was trying to recapture a very distant past for the benefit of those few who could recall it, especially Sidney's sister to whom the *Ruines* were dedicated. His first move was to adopt the Chaucerian stanza. Sidney's only surviving poem in this verse form is the so-called Ister Bank poem of about 1579, his most autobiographical piece.[49] In it he also looks back, in more ways than one, upon the years 1573-79. It cannot be a coincidence that Sidney, too, used Chaucerian stanzas for retrospection, and that on this one occasion he wrote a "Spenserian" poem in that same "old rustic language" he emphatically rejected in the *Defence*. Toward the end of *The Ruines of Time*, Spenser organized his iambic pentameter stanzas in pairs, to form verse units of fourteen lines. To us, and probably also to the English reader of 1591, they look like quaint, Anglo-Saxon *Ur*-sonnets. (The old *Arcadia* has one such poem.) These fourteen-line stanzas together form two cycles of apocalyptic visions (in the manner of Du Bellay), culminating in an envoy addressed to the "Immortal Spirit of Philisides." Though rhymed, the cycles are identical in tone and manner to the unrhymed sonnets in Spenser's 1569 *Theatre*. There can be only one conclusion: the 1591 *Ruines* recapture the earliest attempts to evolve, within an English tradition, a new, visionary poetry. How many people in 1591, one wonders, can have recognized Spenser's attempt to reconstruct a veiled and intimate record of the first areopagitican experiments?

[47] Quoted in Hamilton, *Sidney*, p. 9.

[48] Problems of dating and composition have sparked off many scholarly hypotheses (see appendixes I and II in *The Works of Spenser*, ed. Edwin Greenlaw et al. [Baltimore, 1947]), VIII, which the present reading does not seem to require.

[49] Jan A. van Dorsten, *Terug naar de Toekomst* (Leiden, 1971).

This is where "modern" English poetry properly begins. From the point of view of patronage it was a one-man affair, a virtuoso performance perhaps, but without Virgils or Maecenases—nothing spectacular. The early phase has left very few traces. Prophetically, Spenser called his visionary flashback "the ruins of time."

EIGHT

John Donne and the Rewards of Patronage[1]

Arthur F. Marotti

IN the Tudor and early Stuart period, patronage affected all aspects of English social, economic, and political life. Hence its influence on literature was inevitable. For most authors, patronage meant much more, however, than the financial support and social protection that allowed them to pursue aesthetic and intellectual enterprises. Often, as Lawrence Stone has noted, it provided "the necessary leverage to thrust them into comfortable jobs in the Church, the universities, and royal administration."[2] Literary patronage was really inseparable from the systems of social and political patronage. Both amateur and professional, courtly and non-courtly writers, those who addressed recognized benefactors and those who communicated their work to an audience of social equals, were involved in the society's system of patronage. Their work either expresses the shared wishes for the rewards patronage could bring or was used, sometimes indirectly, as an instrument to obtain them. The term "literature of patronage" should not be limited to complimentary works or to works provided with complimentary dedications designed to get financial and social favors, for almost all English Renaissance literature is a literature of patronage. The poetry of Daniel, Drayton, and Shakespeare, the courtier verse of Oxford, Dyer, and Ralegh, elaborate productions like Harington's Ariosto translation and Spenser's *The Faerie Queene*, the numerous historical, scientific, and devotional books of the period—work in

[1] The research for this essay was completed on a John Simon Guggenheim Memorial Foundation fellowship in 1975-76.

[2] *The Crisis of the Aristocracy, 1558-1641* (Oxford, 1965), p. 703.

all forms and genres, whether intended for print or manuscript circulation, are related to the structure of patronage in the society.[3]

The case of John Donne provides an interesting and instructive example of some of the ways patronage could affect an English Renaissance author. Although we think of him now primarily as a literary man who wrote first poetry, then sermons, Donne actually treated literature as an avocation rather than a vocation, as part of a style of life and career whose goals were the social prestige and preferment that successful exploitation of the patronage system would win. Though seriously committed to learning, he did not consider himself a professional man of letters, even to the extent a publishing poet like Edmund Spenser did. Rather than printing his verse, he preferred to use it as a medium for social relations with a coterie audience of friends and associates. As a writer, he attempted to maintain the status of a gentleman-amateur while he sought mainly social and political rather than artistic patronage, eager for the kinds of employment that would satisfy ambitions greater than those professional writers generally pursued. We ought not to place him in the category of authors that includes Drayton, Daniel, and Jonson, therefore, for his career was modeled on that of government servants like his friend Sir Henry Wotton, who moved successfully from a secretaryship to the Earl of Essex to positions of responsibility under Robert Cecil and King James.[4]

[3] My approach departs somewhat from that of previous studies of the topic, which tend to isolate artistic patronage from the general patronage system. I am, however, particularly indebted to the following: M. C. Bradbrook, "No Room at the Top: Spenser's Pursuit of Fame," in *Elizabethan Poetry*, ed. John R. Brown. Stratford-upon-Avon Studies, No. 2 (London, 1960), pp. 91-109; John Buxton, *Sir Philip Sidney and the English Renaissance*, 2nd ed. (London and New York, 1964); John Danby, *Poets on Fortune's Hill: Studies in Sidney, Shakespeare, Beaumont and Fletcher* (London, 1952); J. W. Saunders, "The Social Situation of Seventeeth-Century Poetry," in *Metaphysical Poetry*, ed. Malcolm Bradbury and David Palmer, Stratford-upon-Avon Studies, No. 11 (London, 1970), pp. 237-59, and "The Stigma of Print: A Note on the Social Bases of Tudor Poetry," *Essays in Criticism*, 1 (1951), 139-64; Patricia Thomson, "The Literature of Patronage, 1580-1630," *Essays in Criticism*, 2 (1952), 267-84, and "The Patronage of Letters under Elizabeth and James I," *English*, 7 (1949), 278-82.

[4] See J. W. Saunders, "Donne and Daniel," *Essays in Criticism*, 3 (1953), 109-14. Saunders calls Donne a "courtly satellite whose poetry was essential to his private life and thinking, but whose primary ambition was nonliterary and who therefore saw no justification in making poetry public" ("Social Situation of Seventeeth-Century Poetry," p. 250). As a "gentleman-amateur," Patricia Thomson argues, Donne "belonged with his own kind, with Sir Henry Wotton, Sir Henry Goodyer,

While it is true that in the period of his direst need, Donne addressed complimentary verse to noble patronesses like the Countess of Bedford, he scorned the dependency of the artist-client. He wrote in his second satire, for example: "they who write to Lords, rewards to get,/ Are they not like singers at doores for meat?" (21-22).[5] His life from the early 1590s to his ordination in 1615, the time span within which almost all his poetry was composed, shows his steady concern with competition, ambition, and career—in effect, with the realities and rules of patronage. In his verse Donne used a personally and culturally encoded literary idiom that, interpreted in both its biographical and social contexts, reveals his response to a society in which patronage loomed large.

The social, political, and economic hierarchies of Renaissance England imply a functioning system of patronage. Gifts and rewards flowed not only from the monarch, but also from major and minor nobility and gentry, royal favorites, government civilian and military officers, virtually anyone who was positioned advantageously to offer, sell, or bargain over those tangible and intangible benefits ambitious men sought. The prizes of patronage included cash, titles and honors, lands, leases, grants, licenses, monopolies, pensions, educational and ecclesiastical positions, parliament seats, and places in the employ of the nobility, government officials, and the monarch. Young men who passed through the universities and the Inns of Court in the late sixteenth and early seventeenth centuries in record numbers competed heatedly for places, seeking careers and positions in which they could exercise their talents, make use of their training, and improve their social and economic lots. Gentlemen of limited means and those who, as younger brothers, had poor prospects for inherited wealth were especially eager, if not desperate, for success.

Sir Thomas Roe, and his other courtier friends, and had his place in a scheme of social rather than literary patronage" ("Donne and the Poetry of Patronage: *The Verse Letters,*" in *John Donne: Essays in Celebration,* ed. A. J. Smith [London, 1972], p. 310). See my earlier essay, "Donne and 'The Extasie,' " in *The Rhetoric of Renaissance Poetry: From Wyatt to Milton,* ed. Thomas O. Sloan and Raymond Waddington (Berkeley and Los Angeles, 1974), pp. 140-73.

[5] I cite the following texts of Donne's poetry: *The Divine Poems,* ed. Helen Gardner, 2nd ed. (Oxford, 1978); *The Elegies and The Songs and Sonnets,* ed. Helen Gardner (Oxford, 1965); *The Epithalamions, Anniversaries and Epicedes,* ed. W. Milgate (Oxford, 1978); *The Satires, Epigrams, and Verse Letters,* ed. W. Milgate (Oxford, 1967).

One of the effects of the Tudor centralization of power in the monarchy, a process Queen Elizabeth fostered with clear determination, is that the system of royal patronage was strengthened at the expense of the system of aristocratic patronage, making the Court more than ever the focus for men's hopes and ambitions. Wallace MacCaffrey has observed that "the imposing stability of the Elizabethan regime depended upon a number of conditions, among which the successful distribution of patronage must be numbered. Most of the important gentlemen of England became beneficiaries of the Crown, bound to it by the interest of favors received and hoped for."[6] MacCaffrey has estimated that in the latter part of Elizabeth's reign approximately 2,500 men were continually vying for some 1,200 places at the Queen's disposal: "This was a political society of which most of the members knew one another directly or indirectly and were almost all personally known to the leading ministers."[7] In the small competitive world of London the educated and politically or socially active gentlemen knew one another, followed fashions, related gossip, attended major and minor state occasions, pursued their ambitions, and, occasionally, wrote poetry. For such individuals the royal Court was the acknowledged center of the realm, and such environments as the Inns of Court, the universities, London business and professional circles, the country, even the English-occupied areas of the Low Countries and Ireland, were satellites to it, dependent on the decisions of the monarch and her officers.

Although his career was a university one, Gabriel Harvey was concerned with the larger society's rules for success and its arrangements regarding patronage. His comments in his commonplace book on the "Three causes of advancement" indicate that those

[6] "Place and Patronage in Elizabethan Politics," in *Elizabethan Government and Society: Essays Presented to Sir John Neale*, ed. S. T. Bindoff, J. Hurstfield, and C. H. Williams (London, 1961), pp. 124-25. This informative essay deserves careful study. G. R. Elton remarks: "Tudor government depended not only on the activities of rulers both central and local, and in the management of the machinery available, but also on the organization and rivalries of patronage systems constructed around local, familiar, and political foci which everywhere permeated the visible politics of the day" ("Tudor Government: The Points of Contact. I. Parliament," *Trans. of the Royal Historical Soc.*, 5th Ser., 24 [London, 1974], 184). Lawrence Stone (*Crisis*, pp. 250-70) discusses Elizabeth's determined efforts to wrest power from aristocratic magnates and to make the royal patronage system more far-reaching. See his extensive treatment of patronage, especially in chapters 5 and 8, "Power" and "Office and the Court."

[7] MacCaffrey, "Place and Patronage in Elizabethan Politics," p. 99.

outside the Court were well aware of the usual means for getting ahead in the world:

1. Art
2. Industry without art. Experimentes of all fortunes. Great mariages. sum egregious Act.
3. Service in warr, in peace.[8]

The first may be interpreted as skill, ingenuity, or possibly craftiness. The second category is a catch-all one, including plodding determination, adventuring, and advantageous marriage, as well as the timely visible accomplishment. The last assumes participation in the various patron-client relationships of the culture through service to the Queen, her ministers and their deputies, and prominent noblemen. It was especially important to approach powerful individuals for help. In "Certain Precepts for the Well Ordering of A Man's Life" Lord Burghley advised his son: "Be sure ever to keep some great man thy friend, but trouble him not for trifles, compliment him often, present [him] with many yet small gifts and of little charge, and if thou have cause to bestow any great gratuity, let it then be some such thing as may be daily in sight, for otherwise in this ambitious age thou mayest remain like a hop without a pole, live in obscurity, and be made a football for every insulting companion to spurn at."[9] Men could succeed through merit and abilities, especially in the legal profession. But, for the most part, the main requirement for upward social mobility was patronage, a function both of family connections and of those social contacts men were able to establish on their own initiative.

When John Donne left the university for London and the Inns of Court, he entered an environment that was one of opportunity as well as of study and civilized play. With the help of social and political contacts made while in residence, it was possible for a young man to move from the Inns into a career in the government or in an aristocratic household. Not surprisingly, life in the Inns was marked by extraordinary competition, a feature reflected in both the serious and the recreational activities in which the men of the Inns engaged—from the prescribed law exercises, which were in the agonistic mode of much university training, to such intellec-

[8] *Gabriel Harvey's Marginalia*, ed. G. C. Moore Smith (Stratford-upon-Avon, 1913), p. 190.

[9] In *Advice to a Son: Precepts of Lord Burghley, Sir Walter Raleigh, and Francis Osborne*, ed. Louis B. Wright (Ithaca, N.Y., 1962), p. 12.

tual and cultural pursuits as the perennial religious arguments or the composition and circulation of poetry.[10]

The inhabitants of the Inns of Court were naturally preoccupied with or involved in the major institutions of the society. The satires, epigrams, and iconoclastic Ovidian love poetry of men like Marston, Davies, and Donne actually affirmed the cultural centrality of the Court, reflecting not so much an antimaterialistic or socially rebellious withdrawal from the established social system as an intense interest in it, particularly when place, status, and patronage were concerned. Despite the frequent satirization of flatterers, foppish amorists, vain men, and women of fashion, Donne and his colleagues were obviously attracted to the Court, eager to become part of the establishment, to "finde/ What winde/ Serves to 'advance an honest minde" ("Song: Goe and catche a falling starre," 7-9). Although Donne's first, second, and fourth satires[11] all mercilessly criticize the courtly life from the vantage point of a morally innocent speaker whose commitments are to learning and religion, he actually aped some of the manners he satirized. He admitted later in one of his *Sermons*: "We make *Satyres*; and we looke that the world should call that wit; when God knowes, that that is in a great part, self-guiltinesse, and we do reprehend those things which we our selves have done, we cry out upon the illness of the times, and we make the time ill."[12] Like his fellows, Donne cultivated the arts of "civility/ And courtship" ("The Will," 21-22), acquiring the sophistication and refinement necessary to function successfully in the Court-centered cultural world. In this context, ambitions denied were ambitions felt.

As in much amorous verse from the time of the troubadours, in Donne's poetry the metaphorics of love reflect the dynamics of suit, service, and recompense characteristic of a society that tied advancement to patronage. In one of his love elegies, Donne contrasts

[10] For a discussion of the Inns as law schools and social environments, see Philip Finkelpearl, *John Marston of the Middle Temple: An Elizabethan Dramatist in his Social Setting* (Cambridge, Mass., 1969), pp. 3-80 and Wilfred R. Prest, *The Inns of Court under Elizabeth I and the Early Stuarts* (London, 1972). For an account of Donne's life at Lincoln's Inn, see R. C. Bald, *John Donne: A Life* (New York and Oxford, 1970), pp. 53-79. I rely heavily on Bald's superb biography throughout this essay.

[11] These poems are dated 1593, 1594, and 1597 by Milgate, *Epithalamions* (pp. 117, 128, 148), the first two during Donne's residence at Lincoln's Inn, the last after his departure.

[12] *The Sermons of John Donne*, ed. George R. Potter and Evelyn Simpson (Berkeley and Los Angeles, 1953-62), VII, 408.

amorous and political service in a way that suggests their connection:

> Oh, let mee not serve, so, as those men serve
> Whom honours smoakes at once fatten and sterve;
> Poorely enrich't with great mens words or lookes;
> Nor so write my name in thy loving bookes
> As those Idolatrous flatterers, which still
> Their Princes stiles, with many Realmes fulfill
> Whence they no tribute have, and where no sway.
> Such services I offer as shall pay
> Themselves, I hate dead names: Oh then let mee
> Favorite in Ordinary, or no favorite bee.
>
> <div align="right">(VI, 1-10)</div>

In Elizabethan England, courtship and courtiership shared the same social milieu, a fact that underlies the wit of this poem for Donne's coterie audience. In "Loves Diet" Donne suggests that love needs to be mixed with "discretion" (6), comically ascribing some non-amorous causes for a traditional love-symptom: "Above one sigh a day I allowed . . . [Love] not,/ of which my fortunes and my faults had part" (7-8). "Loves Exchange" assumes the relationship of love to other activities at "Court" (3). Even the libertine Ovidian elegies and lyrics set love and sex in an atmosphere of social and economic competition. For example, the female speaker of "Break of Day" complains that "businesse . . . the worst disease of love" (13-14) draws her man away from her. Whether erotic or complimentary, Donne's love lyrics were part of a social world that clearly subordinated amorous to ambitious pursuits, even though it was fashionable in literature to assert the contrary. It is interesting to note that in Hamlet's "To be or not to be" soliloquy, disappointment in love is clearly less important than frustrations of ambition in the list of typical social indignities an aspiring courtier could suffer:

> The oppressor's wrong, the proud man's
> contumely,
> The pangs of dispriz'd love, the law's delay,
> The insolence of office, and the spurns
> That patient merit of the unworthy takes. . . .
>
> <div align="right">(III. i. 71-74)[13]</div>

[13] I cite the text in *The Complete Plays and Poems of William Shakespeare*, ed. William Neilson and Charles Hill (Cambridge, Mass., 1942).

When Donne left Lincoln's Inn in search of opportunity and advancement, he first traveled with friends the familiar route of military service—in this case in the 1596 and 1597 naval expeditions, following the vainglorious Earl of Essex. The love elegy "His Picture" probably marks his departure and the epistles to Christopher Brooke ("The Storme" and "The Calme") record his disillusionment with the adventures.[14] In the last of these poems, Donne confesses a combination of possible ignoble motives for becoming a gentleman-volunteer:

> Whether a rotten state, and hope of gain,
> Or, to disuse me from the queasy pain
> Of being beloved, and loving, or the thirst
> Of honour, or fair death, out pushed me first,
> I lose my end. . . .
>
> ("The Calme," 39-43)

Although he did not enrich himself with spoils nor gain a cheap knighthood as did those who served with Essex earlier in the Low Countries or later in Ireland, Donne did manage, with the help of his friend, the young Thomas Egerton, to obtain the position of secretary to Elizabeth's Lord Keeper. In Sir Thomas Egerton's service, he became both a client of a client of Essex and a royal servant. By the usual standards, then, he succeeded quickly in winning substantial patronage, beginning a promising career of political service that might have led, as it did for others, to a major appointment.[15]

It is interesting to note the difference between Donne's fifth satire, written in 1598, and the first four satires, whose anticourtly sentiments mark them as the work of a social and political outsider. After naming the abuses of the legal system Elizabeth charged Egerton to investigate, Donne addresses both Queen and minister in a way that carefully advertises his own position in the political hierarchy:

> Greatest and fairest Empresse, know you this?
> Alas, no more then Thames calme head doth know
> Whose meades her armes drowne, or whose corne o'rflow:

[14] Bald, *John Donne*, p. 81.

[15] Bald remarks, "Egerton's secretaries could expect promotion either in the service of the state or in the courts of law" (*John Donne*, pp. 97-98). See A.G.R. Smith's study of the prosperous careers of the secretaries who served Lord Burghley and his son, "The Secretariats of the Cecils, circa 1580-1612," *English Historical Review*, 83 (1968), 481-504.

> You Sir, whose righteousness she loves, whom I
> By having leave to serve, am most richly
> For service paid, authoriz'd, now beginne
> To know and weed out this enormous sinne.
>
> (28-34)

Instead of viewing government and the Court, as he did in the previous satire, as a nightmarish, corrupt world, Donne depicts them with their symptomatically exploitative relationships of officers and suitors, as an environment presided over by a benevolent monarch interested in effective reforms. As a sharp observer of the Court with which his daily business brought him in contact, Donne knew better. But he was able, while secure in Egerton's service, to view social and political scrambling with some equanimity and confidence.

Throughout these years of government service, Donne maintained a satiric distance from the Court, at the same time both confessing and boasting of his involvement with it. He wrote, in a 1598 verse letter to Sir Henry Wotton, "I haunt Court or Town" ("Heer's no more newes," 6), playing the role of the gossipy observer who must remain morally as well as politically on guard:

> Suspitious boldnesse to this place belongs,
> And to 'have as many eares as all have tongues;
> Tender to know, tough to acknowledge
> wrongs.
>
> (16-18)

His salutation maintains an anti-courtly attitude: "*At Court*; though *From Court*, were the better stile" (27). He assumes the same stance in a prose letter probably to the same addressee:

> I am no Courtier for without having lived there desirously I cannot have sin'd enough to have deserv'd that reprobate name: I may sometymes come thither & bee no courtier as well as they may sometymes go to chapell & yet are no christians. I am there now where because I must do some evill I envy yr being in ye country not that it is a vice will make any great shew here for they live at a far greter rate & expence of wickednes, but because I will not be utterly out of fashion & unsociable. I gleane such vices as the greater men (whose barnes are full) scatter yet I learne that ye learnedst in vice suffer some misery for when they have reapd flattery or any

other fault long there comes some other new vice in request
wherein they are unpracticed.[16]

His jaunty, satiric pose does not prevent Donne from relating news
about the Queen's public graciousness to Lord Montjoy or the
neglect of Essex. He is more than a little disingenuous in his praise
of the Country (which he despised) and in his pretense that it was
really unaffected by the sociopolitical system centered in the Court.
In treating Court, City, and Country in another epistle to Wotton,
Donne acknowledges their close involvement with one another:

> . . . pride, lust, covetise, being several
> To these three places, yet all are in all,
> And mingled thus, their issue incestuous.
> ("Sir, more then kisses," 31-33)[17]

He himself shared in what he called "court's hot ambitions" (60)
and, like many of his friends from the Inns of Court, did not let
moral scruples prevent him from leading the life of the ambitious
courtier. R. C. Bald remarks: "The years of service under Egerton
were crucial years for Donne, in several respects. In the first place,
they familiarized him with the ways of the court, and taught him
how favours were won and dispensed. In the second place, they
caused him to identify himself with the numerically small class of
gentlemen who were finding a career in the service of the state."[18]

Donne's injudicious marriage to Ann More, the seventeen-year-old
niece to the deceased Lady Egerton, lost him his secretaryship and
spoiled all his future chances for secular preferment. In response
to the angry entreaties of Sir George More, who later regretted his
action, Egerton dismissed Donne from his service, an event noted
by the Middle Temple diarist John Manningham: "Dunne is Un-

[16] In Evelyn M. Simpson, *A Study of the Prose Works of John Donne*, 2nd ed.
(Oxford, 1948), p. 310. Donne probably wrote this letter to Wotton, who had left
the service of the emotionally unstable Essex (confined by Elizabeth to Egerton's
house). The tone of anticourtly disillusionment has much to do with the particular
drama of Essex's fall. See the letters in Simpson, *Prose Works*, pp. 308-9, 311-14.
Bald describes *Metempsychosis*, written about this time, as a "savage satire directed
at court and public life" (*John Donne*, p. 124).

[17] This poem was evidently part of a literary debate concerning the merits of life
in the Court, City, and Country. (See Milgate, *Epithalamions*, pp. 225-26 and H.J.C.
Grierson, "Bacon's Poem 'The World': Its Date and Relation to Certain Other
Poems," *Modern Language Review*, 6 [1911], 145-56.)

[18] *John Donne*, p. 125.

donne; he was lately secretary to the L[ord] Keeper, and cast of because he would match him selfe to a gentlewoman against his Lordes pleasure."[19] For more than simply financial reasons, a careful marriage was essential to prosperity within the Court or the larger society, given the close connections between patronage and familial relationships. One of the soundest, and most conventional, pieces of advice Lord Burghley offered to his son concerns the politic selection of a mate: "When it shall please God to bring thee to man's estate, use great providence and circumspection in the choice of thy wife, for from thence may spring all thy future good or ill; and it is an action like a strategem in war where man can err but once."[20] In the famous letter to his father-in-law announcing his secret marriage, Donne is conscious of the social rules he has broken as he attempts to justify his actions. Acknowledging his own un-worthiness as a husband for More's daughter, he nonetheless de-fends the decision to marry (for which he claims they were both responsible): "I knew my present estate lesse than fitt for her, I knew (yet I knew not why) that I stood not right in your opinion," he explains, careful to state that no one who had "dependence or relation" to More took part in the clandestine wedding ceremony. While affirming his commitment to "her whom I tender much more than my fortunes or lyfe," Donne attempts to assure the older man that his economic, social, and political prospects will improve: "my endeavors and industrie, if it please yow to prosper them, may soone make me somewhat worthyer of her."[21] In effect, Donne defends his violation of the rules of the same social system within which he hopes to succeed both by his own assiduous efforts and by the influence of the very man he has offended.

Instead of assisting Donne, the irascible More tried unsuccessfully to get the marriage annulled and successfully to have his son-in-law dismissed from Egerton's service. In the letter Donne wrote to his employer asking to be restored to his position, he both reviews his career and defines the hopelessness of his condition so long as he is cut off from the Lord Keeper's patronage:

[19] *The Diary of John Manningham of the Middle Temple, 1602-1603*, ed. Robert Parker Sorlien (Hanover, N.H., 1976), p. 150.

[20] In *Advice to a Son*, ed. Wright, p. 9. In the marriage arrangements he made for his own children, Cecil acted shrewdly to cement advantageous familial, political, and social bonds.

[21] In *John Donne: Selected Prose*, chosen by Evelyn Simpson, edited by Helen Gardner and Timothy Healy (Oxford, 1967), p. 113.

How soone my history is dispatched! I was carefully and honestly bred; enjoyd an indifferent fortune; I had (and I had understandinge enough to valew yt) the sweetnes and security of a freedome and independency; without makinge owt to my hopes any place of profitt. I had a desire to be your Lordships servant, by the favor of which your good sonn's love to me obtein'd. I was 4 years your Lordships secretary, not dishonest nor gredy. . . . To seek preferment here with any but your Lordship were a madnes. Every great man to whom I shall address any such suite, wyll silently dispute the case, and say, would my Lord Keeper so disgraciously have imprisond him, and flung him away, if he had not donne some other great fault, of which we hear not. So that to the burden of my true weaknesses, I shall have this addicion of a very prejudiciall suspicion, that I ame worse than I hope your Lordship dothe thinke me, or would that the world should thinke. I have therfore no way before me; but must turn back to your Lordship, who knowes that redemption was no less worke than creation. . . . I know myne own necessity, owt of which I humbly beg that your Lordship wyll so much entender your hart towards me, as to give me leave to come into your presence. Affliction, misery, and destruction are not there; and every wher els wher I ame, they are.[22]

Donne threw himself on the mercy of his patron, but to no avail. Even when his mollified father-in-law pleaded on his behalf, Egerton refused to reverse his decision, explaining to More, in the language of patron-client relationships, that "it was inconsistent with his place and credit, to discharge and readmit servants at the request of passionate petitioners."[23] Over the next dozen or so years Donne learned repeatedly just how disastrous his marriage was to his career. In one of his later letters, for example, he noted that King James turned down one of his suits for preferment because "his Majestie remembred me, by the worst part of my historie, which was my disorderlie proceedings, seaven years since, in my nonage." He called the elopement and secret wedding "that intemperate and hastie act of mine"[24] and, in another letter written after a decade

[22] Simpson, Gardner, and Healy, *Selected Prose*, pp. 119-20. See letter pp. 115-16.

[23] Quoted in Bald, *John Donne*, pp. 138-39.

[24] Quoted in Bald, *John Donne*, p. 161.

of frustration, said "I dyed ten years ago."[25] By flouting the rules that bound marriage to patronage in his society, he literally displaced himself.

At the beginning of the reign of James I, when there were unprecedented opportunities for advancement at Court, Donne was living in social exile in the country, forced to accept for himself and his growing family the charity of his friend, Sir Francis Wooley, in whose house at Pyrford they resided. Without either income or immediate prospects, he enviously watched his close friends take advantage of the change of government and of the King's neurotic generosity: Sir Henry Wotton was appointed ambassador to Venice; John Egerton, Sir Edward Herbert, Thomas Roe, Richard Baker, and Walter Chute got places of varying importance; his closest friend Sir Henry Goodyer became a Gentleman of the Privy Chamber and one of the small circle of retainers who accompanied James on his many hunting holidays. Donne corresponded with those who were closer to the center of political activity; but, because of his social stigma, impecuniousness, and family responsibilities, he felt he could not aggressively resume his activities as a courtier. In 1604 he received a letter from a friend urging him to return to London to pursue his ambitions:

> Your friends are sorry, that you make your self so great a stranger; but you best know your own occasions. Howbeit, if you have any designe towards the Court, it were good you did prevent the losse of any more time. For, Experience and Reason are at odds in this, that the places of Attendance, such as may deserve you, grow dailie dearer, and so are like to do. Notwithstanding that, the King's hand is neither so full, nor so open, as it hath been. You have not a poor friend, that would be gladder of your good fortunes; and out of that conscience, I challenge my self this liberty.[26]

Clearly Donne's misfortunes were compounded by his sense of opportunities missed, especially on such an occasion as the King's visit to Pyrford and More's Loseley estate on his first progress.

[25] Letter to Goodyer in John Donne, *Letters to Severall Persons of Honour*, intro. by M. Thomas Hester (1651; facsimile rpt. Delmar, N.Y., 1977), p. 122.

[26] Quoted in Bald, *John Donne*, p. 144. Sometime later Donne wrote Goodyer: "I owe you what ever Court Friends do for me . . . yea, whatsoever I do for myself, because you almost importune me, to awake and stare the Court in the face" (quoted in Bald, *John Donne*, p. 170).

Courtier poets of the English Renaissance from Wyatt through Gascoigne and Sidney habitually wrote verse in situations of socio-political failure and frustration. Donne followed this tradition. The love poems associated with his relationship with Ann More insistently express thwarted ambition. Overtly proclaiming an aversion to an environment of competitive careerism, they reveal a painful attraction to it. Sophistically arguing that the world is well lost for love, they communicate also the opposite message. As R. C. Bald suggests, there is a real connection between the letter quoted above and a lyric like "The Canonization,"[27] a poem that self-consciously fictionalizes Donne's social exile. In replying angrily in the first stanza to the accusations and advice of a critic-friend, the lyric's speaker mentions the means of advancement that Donne actually regretted he was unable to exploit:

> For Godsake hold your tongue, and let me love,
> Or chide my palsie, or my gout,
> My five gray haires, or ruin'd fortune flout,
> With wealth your state, your minde with Arts improve,
> Take you a course, get you a place,
> Observe his honour, or his grace,
> And the Kings reall, or his stamped face
> Contemplate; what you will, approve,
> So you will let me love.
>
> (1-9)

Interpreted by most modern readers as a spirited defense of love against the crass demands of a materialistic world, this witty lyric was doubtless read by a man like Goodyer or by some of Donne's other friends as an ironic performance. This original coterie audience knew that Donne passionately longed for the worldly advancement he pretends to scorn in his poem, just as Sidney's readers had known how to interpret his disingenuous denial of interest in the national and international events mentioned in the thirtieth sonnet of *Astrophil and Stella*.

Donne apparently loved his wife. But, despite the bold hyperboles of some of the lyrics, their relationship was clearly too small a sphere of activity for him. In the poems of mutual love, the world constantly intrudes on the privacy of the couple. "The Anniver-

[27] Bald, *John Donne*, pp. 146-47; see Edmund Gosse, *The Life and Letters of John Donne* (1899; rpt. Gloucester, Mass., 1959), I, 117.

sarie," for example, calculates the length of a love relationship by
a time-scheme centered in the public realm:

> All Kings, and all their favorites,
> All glory'of honors, beauties, wits,
> The Sun it selfe, which makes times, as they passe,
> Is elder by a yeare, now, then it was
> When thou and I first one another saw. . . .
>
> (1-5)

It is not enough to rationalize that lovers "Prince enough in one
another bee" (14), any more than it is for the speaker of "The
Sunne Rising" to pretend that he and his beloved are self-sufficient:

> She'is all States, and all Princes, I,
> Nothing else is.
> Princes doe but play us; compar'd to this,
> All honor's mimique; All wealth alchimie.
>
> (21-24)

In this poem, the coterie audience would recognize in the line "Goe
tell Court-huntsmen, that the King will ride" (7) an economical
allusion to the game of seeking royal patronage as it was conducted
in a Court that was on the move every time James could flee London
to indulge his passion for hunting. Whatever their function in his
relationship with his wife, such lyrics were poetically brilliant, but
unsuccessful, attempts to justify his marriage and witty, basically
sociable, recreations to relieve the pain of Donne's placeless, hope-
less state.

The prose and verse letters of the first twelve years of his marriage
signal Donne's constant preoccupation with his bad fortune. His
epistle "To Sir Henry Wotton, at his going Ambassador to Venice"
reveals both the good will and envy Donne felt when his friend was
about to assume the prestigious ambassadorship, a post the poet
himself later unsuccessfully tried to obtain. He could not avoid
comparing his situation with his addressee's:

> For me, (if there be such a thing as I)
> Fortune (if there be such a thing as she)
> Spies that I bear so well her tyranny,
> That she thinks nothing else so fit for me.
>
> (33-36)

"Fortune(s)" occurs repeatedly as a term in both the poetry and

prose correspondence of the Pyrford and Mitcham periods, referring ultimately to the relative success or failure in achieving the rewards of patronage. A man of "ruin'd fortune," Donne had to begin the pursuit of preferment afresh, "to urge upward, and his fortune raise" ("To Sir Henry Goodyer," "Who makes the Past," 8).

Donne emerged from his forced retirement when he decided to join Sir Walter Chute on a one-year journey to the Continent, a circumstance that probably occasioned some of his valediction poems.[28] This was his indirect way of re-entering the world from which he had lived apart for some three years. On his return in 1606, he moved his family closer to London, to Mitcham, taking lodgings for himself in the Strand by the early part of 1607 and thus resuming contact with the Court and the satellite courtly environments he knew.[29] In this period (1607-1611) and after his return in 1612 from his Continental sojourn with Sir Robert Drury, he made constant efforts to secure employment: he requested a position in Queen Anne's household, a bureaucratic post in Ireland, a secretarial appointment in the Virginia Company, the clerkship of the Council, and the ambassadorship to Venice. Through Sir Edward Phelips, Master of the Rolls, he got a seat in the 1614 Parliament, but on the whole he lacked advancement. He sought royal patronage by publishing, in *Pseudo-Martyr*, the kind of religious polemic James appreciated, but the whole effort backfired when the King decided to prefer Donne only to an ecclesiastical position.[30] All his attempts

[28] Although the famous "A Valediction: Forbidding Mourning" has traditionally been associated with Donne's trip to the Continent with Drury in 1611, the probable dating of the conjugal love poems early in his marriage suggests that several of the valedictory lyrics were connected with this, Donne's first significant separation from his wife. A poem like "A Valediction: Of Weeping," which conjoins pregnancy, tears, and loving protest against separation, was more appropriate in 1605 than in 1611.

[29] See Bald, *John Donne*, pp. 155-99, and I. A. Shapiro, "The 'Mermaid Club,' " *Modern Language Review*, 45 (1950), 6-17.

[30] See Bald, *John Donne*, pp. 226-27. The epistle dedicatory to *Pseudo-Martyr* casts Donne metaphorically in the role of the gentleman-volunteer in the polemical wars in which James by his "Bookes, is gone in Person out of the Kingdome." In his open appeal for royal patronage, Donne writes: "Of my boldnesse in this address, I most humbly beseech your Maiestie, to admit this excuse that hauing obserued, how much your Maiestie had vouchsafed to descend to a conuersation with your Subiects, by way of your Bookes, I also conceiu'd an ambition, of ascending to your

to get secular preferment between 1607 and his ordination in 1615 finally came to nought.

Meanwhile, through Goodyer, Donne made the acquaintance of Lucy, Countess of Bedford, the influential favorite of Queen Anne and one of the foremost literary patronesses of the day. Although he looked to her more for social and political than for monetary assistance, gaining access through her to some fashionable Jacobean courtly circles, he was ultimately disappointed by their relationship. Lady Bedford was able to obtain for John Florio and Samuel Daniel, professional writers Donne would have considered his social inferiors, positions as grooms of Queen Anne's Privy Chamber, but her support of Donne led to neither major nor minor appointments.[31] He assumed the role of a courtly literary suitor, offering the Countess complimentary poems and letters, but he resented the relationship implied in this kind of patronage, for it signaled to him a decline in his social status. He wrote Goodyer that he wished to be regarded as a man pursuing "a graver course, than of a Poet."[32] Clearly, he set his hopes on political, not artistic patronage.

Unlike such professional poets as Drayton and Daniel, however, both of whom dedicated published work and wrote complimentary poems to Lady Bedford, Donne was involved with the Countess in the socially more respectable activity of exchanging verse. In one of his surviving letters to her, Donne requests a copy of some verses she showed him in the garden of her leased Twickenham estate, referring to other compositions of hers he knew:

Happiest and worthiest Lady,
I do not remember that ever I have seen a petition in verse, I would not therefore be singular, nor adde these to your other papers. I have yet adventured so near as to make a petition for

presence, by the same way, and of participating, by this meanes, their happiness, of whome, that saying of the Queene of *Sheba*, may be usurp'd: Happie are thy men, and happie are those thy Seruants, which stand before thee alwayes, and heare thy wisdome." (*Pseudo-Martyr* [1610; facsimile rpt. New York, 1974], pp. A2ᵛ, A3ʳ-A3ᵛ.) Bald (*John Donne*, p. 222) notes that Donne sent a presentation copy of this book to Prince Henry with a complimentary covering letter.

[31] Donne, of course, wanted something better than the sinecures Daniel and Florio got. Even from a financial viewpoint, he was let down by the Countess, who, as Patricia Thomson points out, was so economically burdened that she found it impossible to be generous to those she patronized ("John Donne and the Countess of Bedford," *Modern Language Review*, 44 [1949], 335-40).

[32] Simpson, Gardner, and Healy, *Selected Prose*, p. 148.

verse, it is for those your Ladiship did me the honour to see in *Twicknam* garden, except you repent your making; and having mended your judgement by thinking worse, that is, better, because juster, of their subject. They must needs be an excellent exercise of your wit, which speake so well of so ill: I humbly beg them of your Ladiship, with two such promises, as to any other of your compositions were threatenings: that I will not shew them, and that I will not beleeve them; and nothing should be so used that comes from your brain and breast. If I should confesse a fault in boldnesse of asking them, or make a fault by doing it in a longer letter, your Ladiship might use your style and old fashion of the Court towards me, and pay me with a Pardon. Here therefore I humbly kisse your Ladiships fair learned hands, and wish you good wishes and speedy grants.

Your Ladiships servant
J. Donne[33]

We know that Lady Bedford wrote the elegy "Death be not proud, thy hand gave not this blow" in response to Donne's elegy on her friend and cousin Cecilia Bulstrode, "Death I recant." Beyond this, they evidently engaged in the courtly social game of responding to one another's poems, much as did the Earl of Oxford and Ann Vavasour or Queen Elizabeth and Sir Walter Ralegh. Within the framework of socially decorous Petrarchism, such pieces may have been love lyrics. Donne's reference to the Countess's verse as products of her "breast" as well as her "brain" and his promise that he "will not beleeve them" strongly suggest this. Part of Lady Bedford's practice of using the "style and old fashion of the Court" might have involved her joining Donne in composing works in the language of courtly amorousness.[34]

Donne's "Twicknam Garden" and "The Funeral" seem to belong

[33] Simpson, Gardner, and Healy, *Selected Prose*, p. 135.

[34] Gardner (*Elegies and Songs and Sonnets*, pp. 248-58) discusses Donne's literary relations with Lady Bedford as well as with Mrs. Herbert. For an excellent discussion of the literary recreations of the social circle surrounding the Countess of Bedford and her friend Cecilia Bulstrode, see *The "Conceited Newes" of Sir Thomas Overbury and his Friends: A Facsimile Reproduction of the Ninth Impression of 1616 of Sir Thomas Overbury His Wife*, ed. James E. Savage (Gainesville, Fla., 1969), pp. xiii-lxii.

to some such literary relationship with the Countess.[35] These lyrics translate the social decorum and the differing hierarchical positions of poet and patroness into the subtleties of the refined Petrarchan mode in which "Affection . . . takes Reverences name" ("The Autumnal," 6). However, Donne's underlying discomfort with this poet-patroness relationship probably accounts for some of the interesting disturbances in these poems that threaten to subvert their conventions, if not the complimentary mode itself. For example, one of the assumptions of such verse is that sexuality and bawdry should not intrude. Although Castiglione's Lord Julian suggests that the sophisticated lady of the court should be able to listen to moderately racy conversation,[36] complimentary love poetry traditionally elevated love above the level of the body and the appetites to discourse about an experience that is spiritual and virtuous, if not angelic. But in "Twicknam Garden," modeled after Petrarch's delicate "Zefiro torna," Donne comically attributes sexual frustration to the suffering lover, characteristically assaulting the conventions he employs. He was temperamentally unable to accept either Neoplatonic or Petrarchan love vocabularies, as he explained in the verse letter to the seventeen-year-old Countess of Huntington, largely because of the subservient position in which they would have placed him. "The Funeral" contains a disturbing, but felicitous, combination of complimentary and aggressive tones. The lover both praises the intelligence of the woman by stating that the bracelet he wears is made from hairs that come from a "better brain" (13) than his and concludes the poem with brash teasing: "since

[35] Both Bald (*John Donne*, pp. 175-76) and Gardner (*Elegies and Songs and Sonnets*, p. 250) discuss "Twicknam Garden." For the association of "The Funeral" with Lady Bedford, see C. M. Armitage, "Donne's Poems in Huntington Manuscript 198: New Light on 'The Funerall,' " *Studies in Philology*, 63 (1966), 697-707.

[36] "This woman ought not therefore (to make her selfe good and honest) be so squeimish and make wise to abhorre both the company and the talke (though somewhat of the wantonest) if she bee present, to get her thence by and by, for a man may lightly gesse that she fained to be so coye to hide that in her selfe which she doubted others might come to the knowledge of: and such nice fashions are alwaies hatefull" (Baldassare Castiglione, *Il Cortegiano*, trans. Sir Thomas Hoby, in *Three Renaissance Classics*, ed. Burton Milligan [New York, 1953], pp. 456-57). The Earl of Northumberland writes that "to talk about modest bawdry . . . is one of a woman's ornaments, well commended everywhere" (Henry Percy, Ninth Earl of Northumberland, *Advice to his Son* [1609], ed. G. B. Harrison [London, 1930], p. 103). In the "News" game played in the Cecilia Bulstrode circle (and in Jonson's "Epigram on the Court Pucell") the three topics of discourse named are "state," "religion," and "bawdry."

you would save none of mee, I bury some of you" (24). Just how much Donne allowed himself to test or violate the decorum of his relationship with the Countess of Bedford in such verse is difficult to determine, but the indications are that the aversion he expressed in his fourth satire to the "tongue, call'd complement" (44) lasted well into his maturity and kept him from committing himself entirely to the codes and conventions of amorous and non-amorous complimentary poetry.

The verse letters to Lady Bedford show clear signs of emotional conflict in their author.[37] Their artistic deadliness is probably a product of Donne's resistance to their social and literary contexts. These poems seem most interesting when they veer away from their complimentary purpose to become the kind of philosophical and satiric verse Donne composed in the epistles to Brooke, Wotton, Goodyer, and Edward Herbert. Such poetry finds its best expression in the two *Anniversaries*, works whose distance from their object of praise afforded the poet the occasion for his most leisurely, but most relentlessly intellectual, poetical ruminations. The Lady Bedford epistles, however, reveal Donne's uneasiness with the very dependency they advertise, a feeling that probably led him to create for himself, by means of ingenious philosophical-satiric lucubrations, an intellectually superior position that would compensate for his socially inferior one. The result is an awkward blending of condescension and flattery. For example, in the poem beginning "T'have written then" Donne breaks off direct compliment after some thirty lines to turn satiric attention to the world in which he and Lady Bedford both live, explaining: "since to you, your praises discords bee,/ Stoop, others ills to meditate with mee" (31-32). After engaging in the kind of speculation elaborated more fully in *The First Anniversarie*, he concludes this fifty-line section, before returning to the renewed praise of his patroness, with the exasperated comment "But these are riddles" (81), acknowledging that intense intellectualizing must be controlled lest it destroy the encomiastic purpose (or pretext) of the poem in which it is set. Furthermore, since Donne well knew that Lady Bedford was deeply involved in the corrupt world of the Jacobean court from which

[37] Referring mainly to the verse letters to patronesses, Patricia Thomson writes: "The results of the system of patronage on Donne's spirit were almost wholly bad. He was forever in search of favours from the great. Neurotic and undignified, even some of his best poetry shows signs of unsteadiness and frustration arising from the basic lack of peace of mind" ("The Literature of Patronage, 1580-1630," p. 282).

he pretended to isolate her morally, there were obvious restraints on his satiric digressions. Donne's ability to conceal his distaste for the arts of courtly flattery as he attempted to win and keep the favor of a prominent aristocratic woman like the Countess of Bedford was quite limited.

Donne used the religious poems he wrote in the period before his ordination to good advantage in his social life. He sent *"Holy Hymns* and *Sonnets"* to Magdalen Herbert, including the *La Corona* sequence to which he prefaced a dedicatory poem, the same complimentary gesture he made in giving six of the "Holy Sonnets" to the extravagant new Earl of Dorset.[38] In "A Litanie" Donne seems to confess not only some of his own worldly ambitions— "From thinking, that great courts immure/ All, or no happiness ... Good Lord deliver us" (130-31, 135)—but also a less than purely pious motive in his devotional writing: "When wee are mov'd to seeme religious/ Only to vent wit, Lord deliver us" (188-89). In "Goodfriday 1613. Riding Westward" he admits that "pleasure" and "businesse" (7) are mixed with his piety. The religious melancholy of the "Holy Sonnets" reflects Donne's depression over his lack of worldly success. In his prose correspondence with Goodyer, he repeatedly juxtaposes religious thoughts and comments on his failed aspirations. Donne tried hard in the *Essays in Divinity* to find religious benefits in his misfortunes, creating the kind of scheme for his life that Isaac Walton later elaborated hagiographically: "Thou hast delivered me, O God, from the Egypt of confidence and presumption, by interrupting my fortunes, and intercepting my hopes; And from the Egypt of despair by contemplation of thine abundant treasures, and my portion therein."[39]

The philosophical and religious themes of the complimentary and devotional poetry not only express Donne's genuine intellectual interests but also signal his frustrated ambition. From the time of Henry VIII and that of the midcentury authors represented in the miscellany *The Paradise of Dainty Devises* up through the later Elizabethan period, writers conventionally used philosophical and religious (as well as pastoral) material to cope with political and

[38] See "To E. of D. with six holy Sonnets" (in Gardner, *Divine Poems*, pp. 5-6), which presents Donne's poems as a supposed response to the Earl's own compositions. Richard Sackville succeeded his father as Earl of Dorset in 1609. This free-spending peer (see Stone, *Crisis*, pp. 582-83) was a friend of Sir Edward Herbert and the husband of Lady Anne Clifford, another of Donne's friends.

[39] *Essays in Divinity*, ed. Evelyn Simpson (Oxford, 1952), p. 75.

social defeat. When a courtier or gentleman fared badly, he could always claim stoically "My mind to me a kingdom is"[40] or make a show of stepping outside the arena of competition: "Like to a hermit poor in place obscure/ I mean to spend my dayes of endless doubt."[41] Morally critical or Christian *contemptus mundi* attitudes toward the world and its selfish practices were probably more a question of emotional necessity than of keen ethical and religious sensibilities. Familiar notes are sounded by Lear's "Come let's away to prison" speech and Rowland Whyte's comment on the disgrace of the Earl of Essex: "This is the greatest downfall I have seen in my daies, which makes me see the vanity of the world."[42]

Donne's own meditation on the vanity of the world in his two *Anniversaries* is related to his social, economic, and political failures. Significantly, these poems were written for a patron whose own efforts in seeking prestigious employment had been unrewarded and who might, therefore, have responded to them not only as a bereaved father but also as a disappointed courtier.[43] These poems, I believe, expressed for Donne a sense of deep loss having less to do with religious longing or the death of a girl he never met than with his having been excluded from the world for which he yearned. The letters to Goodyer in this period are filled with this theme, couched in language that reappears both in the verse letters and in these mixed-genre works. In the depths of his depression over his "wretched fortune"[44] he had written to Goodyer in 1608:

> I would fain do something. . . . to be no part of any body, is
> to be nothing. At most, the greatest persons, are but great
> wens, and excrescences; men of wit and delightfull conversa-

[40] This famous lyric was probably composed by the Earl of Oxford. See Steven W. May, "The Authorship of 'My Mind to Me a Kingdom Is,' " *Review of English Studies*, 26 (1975), 385-94.

[41] In *The Poems of Sir Walter Ralegh*, ed. Agnes M. C. Latham (1951; Cambridge, Mass., 1962), p. 11.

[42] Historical Manuscripts Commission, DeLisle and Dudley, II, 420.

[43] Although he was a man of no small wealth, Sir Robert Drury was a failed courtier. Knighted by Essex in the Low Countries when he was seventeen, he married the daughter of Sir Nicholas Bacon and tried to obtain Court preferment. At the time he traveled with Donne to France, he was desperate for a government post. Samuel Calvert wrote William Trumbull in July 1610 that Drury was going abroad "because he can purchase no other employment for all his bravadoes, only to spend time" (*Hist. MSS Comm. Downshire*, II, 328). See R. C. Bald, *Donne and the Drurys* (Cambridge, 1959).

[44] *Letters to Severall Persons*, p. 137.

tion, but as moales for ornament, except they be so incorpo-
rated into the body of the world, that they contribute something
to the sustentation of the whole . . . [I] needed an occupation,
and a course which I thought I entred well into, when I sub-
mitted my self to such a service, as I thought might imploye
those poor advantages, which I had. And there I stumbled too,
yet I would try again: for to this hour I am nothing, or so little,
that I am scarse subject and argument enough for one of mine
own letters.[45]

Without the prestige and identity conferred by place, Donne con-
ceived of himself as a social nonentity. This status is curiously
confirmed by a letter written by Jean Beaulieu to William Trumbell
in 1610, which refers to the author of *Pseudo-Martyr* as "Mr.
Donne, secretary to my Lord Chancellor,"[46] identifying him with
a position he had not held for some seven years!

After years of unsuccessful efforts to recover political patronage,
Donne could complain in the *First Anniversarie* that "The worlds
proportion disfigured is" because "those two legges whereon it doth
relie,/ Reward and punishment are bent awrie" (302-4)—not just
for mankind in general, but for himself in particular. Here, as in
the other encomiastic verse, a transcendently virtuous female sym-
bolizes the object of his desire, and without her either the world
is dead or he is dead to the world.[47] In the *Anniversaries* rejection
of the world is related to the experience of being rejected by the
world. In a society in which "some people have/ Some stay, no
more then Kings should give, to crave" (421-22), both Donne and
his wealthy patron Drury were among the impatient cravers for the
rewards of patronage.

They remained so after returning from France, especially because
Drury foolishly criticized the Elector Palatine, whom the Princess
Elizabeth was shortly to wed, a mistake for which Donne may have
tried to atone by composing an epithalamion.[48] Donne took up
residence with his family at Drury house, renewing his search for

[45] *Letters to Severall Persons*, pp. 50-51.

[46] *Hist. MSS Comm. Downshire*, II, 227.

[47] See "A Nocturnall upon S. Lucies Day," a poem that may have been connected
with Donne's relationship with Lady Bedford.

[48] See Bald, *Donne and the Drurys*, pp. 102-3. Drury tried unsuccessfully to get
the ambassadorships to France and Venice before approaching the King of Spain
for help (Bald, *Donne and the Drurys*, pp. 126, 131, 134). He died before obtaining
the kind of appointment he desired.

employment. Two events in 1612 significantly affected the conditions of courtly competition for place, the deaths of Prince Henry and of James's chief minister Robert Cecil, Earl of Salisbury. The first set adrift a number of gentlemen who had enjoyed the young Prince's patronage, including several of Donne's friends, who, along with the poet, produced a volume of elegies lamenting their political loss.[49] The second stimulated a great deal of courtly infighting for Cecil's position and its instruments of profit and power.[50] Though James kept the secretaryship vacant and the treasury in commission for two years, it was rumored widely soon after Cecil's death that Sir Henry Wotton was one of the prime candidates to replace him, an appointment that would have undoubtedly benefited Donne greatly. Meanwhile, Donne approached Robert Carr, Viscount Rochester (soon Earl of Somerset), announcing an "ambition" to "make my Profession Divinitie." Although he says he decided that "It is in this course, if in any, that my service may be of use to this Church and State," when the powerful royal favorite from whom he sought "favourable assistance" offered him a secretarial position as Sir Thomas Overbury's replacement, Donne put aside plans to enter the ministry.[51] Obviously still hoping for respectable secular employment, he became a client of this notorious man.

Bald remarks that "Donne's life during his last eighteen months as a layman does not present a particularly edifying spectacle."[52] Certainly the service to Carr was less dignified morally than that to Egerton earlier. The belated epithalamion Donne wrote to celebrate the scandalous Somerset-Essex marriage shamelessly depicts the degenerate Jacobean court as an ideal institution presided over by a just, liberal king, an environment in which the usual courtly vices of "lust" and "envy" (35) have been converted into "zeale" and

[49] See Bald, *John Donne*, pp. 268-69. For a discussion of the social and political significance of Prince Henry's death, see Leonard Tennenhouse's essay on Ralegh in this volume.

[50] See John Chamberlain's letters of 12 May 1612 and 17 June 1612 to Dudley Carleton (in *The Letters of John Chamberlain*, ed. Norman E. McClure [Philadelphia, 1939], I, 350-56), the second of which mentions a "multitude of competitors for the secretariship" including "Sir H. Nevil, Sir Thomas Lakes, Sir Charles Cornwallis, Sir George Carie, Sir Thomas Edmonds, Sir Rafe Winwod, Sir Henry Wotton, Sir John Hollis, Sir William Waade" (I, 355).

[51] I quote from the letter cited in Bald, *John Donne*, pp. 272-73. Donne approached this potential patron through a cousin of the same name, Sir Robert Ker, who remained a close friend for many years.

[52] Bald, *John Donne*, p. 300.

"love" (37). Supposedly James's courtiers have "no ambition, but to obey" (79), for the monarch rewards "vertue" (84) and good, dutiful men need not scheme for favors. Through his persona ("Idios"), Donne offers a "nuptiall song" (99) which, he says, "might advance my fame" (102), revealing his desperate need for help from Somerset and this patron's own royal master.[53] At the conclusion of the work, "Allophanes" (probably a fictional stand-in for Donne's friend Sir Robert Carr) requests permission to take the epithalamion where it will work to the poet's advantage:

> . . . let me goe,
> Backe to the Court, and I will lay'it upon
> Such Altars, as prize your devotion.
>
> (233-35)

This bald appeal for favors failed to bear fruit, for when Ker asked James for preferment for Donne, the King refused, advising ecclesiastical rather than governmental service.

Before accepting ordination, Donne attempted to raise the money he needed to pay off his debts. Looking once again for help from a patroness with whom relations had somewhat cooled, he composed the "Obsequies to the Lord Harrington, brother to the Countesse of Bedford." Somewhat disturbed about his own moral fitness to enter God's service, Donne mentions in this poem some of the vices and ignoble motives that are part of his secular career:

> . . . wee . . . may trye
> Both how to live well young, and how to die,
> Yet . . . we must be old and age endures
> His Torrid Zone at Court, and calentures
> Of hot ambitions, irreligions ice,
> Zeales agues, and hydroptique avarice,
> Infirmities which need the scale of truth,
> As well as lust, and ignorance of youth. . . .
>
> (121-28)

Hoping for the last time to use verse to obtain financial favors, Donne vows to write no more: "my Muse . . . hath spoke . . . her

[53] See Bald, *John Donne*, p. 274. About this time Donne wrote to his brother-in-law Sir Robert More: "no man attends Court fortunes with more impatience than I do" (Gosse, II, 46). See Margaret McGowan, " 'As Through a Looking Glass': Donne's Epithalamia and their Courtly Context," in *John Donne: Essays in Celebration*, ed. A. J. Smith (London, 1972), pp. 175-218.

last" (256, 258). The Countess responded by promising to pay off Donne's debts, but when her troubled financial situation prevented her from doing do, the poet was angrily disappointed.[54] He then decided to publish a collection of his poetry dedicated to Somerset, a course that would have signaled an even more disreputable social descent for him than the printing of the *Anniversaries*, an act he deeply regretted. Hence the tone of shame and embarrassment in the letter he wrote Goodyer announcing his plan and requesting the return of a borrowed manuscript of his verse:

> the going about to pay debts, hastens importunity. . . . One thing . . . I must tell you; but so softly, that if that good Lady [Bedford] were in the room, with you and this Letter, she might not hear. It is, that I am brought to a necessity of printing my Poems, and addressing them to my L. Chamberlain. This I mean to do forthwith; not for much publique view, but at mine owne cost, a few Copies. I apprehend some incongruities in the resolution; and I know what I shall suffer from many inter-pretations: but I am at an end, of much considering that; and, if I were as startling in that kinde, as ever I was, yet in this particular, I am under an unescapable necessity, as I shall let you perceive, when I see you. By this occasion I am made Rhapsoder of mine own rags, and that cost me more diligence, to seek them, than it did to make them. This made me aske to borrow that old book of you, which it will be too late to see, for that use, when I see you: for I must do this as a valediction to the world, before I take Orders.[55]

Gentlemen and courtiers before him, such as William Hunnis and George Gascoigne, had been forced into printing their verse in order to raise money, but this did not prevent Donne from expressing his characteristically strong aversion to publication. He planned to con-trol the situation somewhat by arranging for a very limited edition of his poetry: essentially he conceived of the venture as manufac-turing presentation copies for patrons and patronesses rather than as offering his verse to the general book-buying public. Thus he intended to include some of his encomiastic poetry in order to invite gratuities from the persons addressed. In any event, he was saved from the "stigma of print," probably through friends who gave him the necessary financial help. The publication of his poetry had to

[54] See Bald, *John Donne*, pp. 295-96, and the letter quoted on p. 297.
[55] Simpson, Gardner, and Healy, *Selected Prose*, pp. 144-45.

wait until 1633, two years after his death, even though his verse circulated in manuscript beyond his original coterie.

Donne's ordination in 1615 immediately opened King James's bounty to him. The patronage he had been denied as a layman for the previous dozen years he won as a churchman. He became a royal chaplain and was granted, as a result of some kingly coercion, an honorary doctor of divinity degree from Cambridge. As Bald remarks, "he appears as one who had mastered at last the arts of the courtier, and it is clear, even when he finally turned to the Church, that he did not intend to abandon those arts, but to rise by them."[56] "To Mr. Tilman after he had taken orders," written a few years after his own ordination and before the appointment to the prestigious deanship of St. Paul's, reveals Donne's continued preoccupation with status and place.[57] Engaging in the kind of self-persuasion that would justify his own decision to take orders, he asks:

> Why doth the foolish world scorne that profession,
> Whose joyes passe speech? Why do they think unfit
> That Gentry should joyne families with it;
> As if their day were onely to be spent
> In dressing, Mistressing and complement?
>
> (26-30)

As an ambitious courtier who had engaged in the very activities named in this last line, Donne argues a little too insistently that the ministry, that haven for prospectless younger brothers of the gentry, was a socially respectable profession:

> Let then the world thy calling disrespect,
> But goe thou on, and pitty their neglect.
> What function is so noble, as to bee
> Embassadour to God and destinee?
>
> (35-38)

Donne, of course, acted as James's, not God's, ambassador in joining his old friend James Hay (Viscount Doncaster) on the mission to Germany in 1619, an act of continuing service to the King that

[56] Bald, *John Donne*, p. 301.

[57] See Bald, *John Donne*, pp. 302-4, and Allen Barry Cameron, "Donne's Deliberative Verse Epistles," *English Literary Renaissance*, 6 (1976), 398-402.

doubtless helped win him his deanship.[58] Patronage still mattered to him, whatever his religious commitment, and, once earned, it nourished a brilliant ecclesiastical career. Maintaining courtly contacts, Donne enjoyed a socially esteemed and materially rewarding form of service in the Church, especially after he became Dean of St. Paul's, an appointment he owed largely to the infamous Duke of Buckingham.[59] Unlike his younger contemporary George Herbert, whose life as a country parson was a variation on the Elizabethan metaphor of withdrawal from Court, Donne did not really cease being a courtier. Flourishing in a career in which sermons and devotional prose rather than poems were his main literary currency, he succeeded at last in obtaining some of the substantial rewards patronage could bring.

[58] See Paul Sellin, "John Donne: The Poet as Diplomat and Divine," *Huntington Library Quarterly*, 39 (1976), 267-75. See Bald, *John Donne*, pp. 338-65.

[59] See Bald, *John Donne*, p. 375. Before Donne obtained the deanship, Chamberlain gossiped about him in much the same way he did about political scramblers: sec the letters of 20 March 1620 and 13 October 1621 (*Letters*, II, 296, 399). In 1630 Constantine Huygens acknowledged the social prestige Donne received with his appointment: "Dr. Donne, now Dean of St. Pauls in London, . . . on account of this remunerative post (such is the custom of the English) [is] held in high esteem" (quoted in *John Donne: The Critical Heritage*, ed. A. J. Smith [London and Boston, 1975], p. 80).

Sir Walter Ralegh and the Literature of Clientage

LEONARD TENNENHOUSE

TO understand the historical meaning of Ralegh's poetry and prose is to see his work in the larger context of a courtier's constant concern with patronage and clientage. Since Ralegh, like all courtiers, was entirely dependent on the system of patronage for advancement, preferment, place, and profit, it is not surprising to find that his literary activity should reflect the vicissitudes of his fortunes. Few courtiers enjoyed Elizabeth's favor as much as did Ralegh, and fewer still profited as much as Ralegh from that favor. Although the cultural myth suggested that the Queen's patronage could be won and maintained through the elaborate fictions of poetic compliment, the economic and political realities of patronage were such that a courtier's literary activity, which at best was considered mere courtly play, could never improve his fortunes nor repair a social fault. The success of Ralegh's poetry of clientage rested on his knowledge of the Queen's affection for him. When he was out of favor, it was political service and economic punishment—not poetic fictions—that enabled him to recover his place at Court. Later, as a prisoner of King James, his needs as a client changed from maintaining his social place to securing his very freedom. Ralegh's decision to seek the favor of Prince Henry by writing the *History of the World* indicates a shift in style from Elizabethan to Jacobean in terms of the mode and the language a courtier employed in pursuit of patronage. After all, the Court not only determined the fashion of writing; it even determined how such writing could be interpreted. The *History* failed as an act of clientage because, following the death of its original patron, it was subjected to a tendentious reading by the King. Sir Walter Ralegh's literary activity thus provides a unique insight into the social dynamics and

political realities by which the elaborate rules and considerable rewards of patronage affected the writing and the reading of courtiers' texts.

Ralegh's success as a client can best be seen in the financial rewards and political promotions he enjoyed in the 1580s. When he returned to Court from Ireland in December 1581, Ralegh received twenty pounds for his service in the Irish campaign. Within a year and a half, the Queen gave Ralegh part of Durham house for his use. In April 1583, she gave him the lease for two estates that belonged to All Souls College, Oxford, and in May she granted him the patent for wines. He received the license to export woolens in 1584, and within the year he was knighted.[1] In July 1585, Ralegh was made Lord Warden of the Stanneries, and in September, Lord Lieutenant of Cornwall and Vice Admiral for both Devon and Cornwall. In 1587, he was given the traitor Babington's estates, goods, and furniture, and he was made Captain of the Queen's Guard, replacing Sir Christopher Hatton when the latter became Lord Chancellor. Although Ralegh later acquired additional property, primarily in Ireland, the most important estate he subsequently received was the lease to Sherborne Castle and its surrounding manors in January 1591-92. Many courtiers only dreamed of such rewards from Elizabeth; Ralegh actually received them.

Ralegh's rapid advancement both enacted a common fantasy and violated a social norm. On the one hand, it indicated the potential place and profit to which a member of the gentry could rise at Court through the favor of the Queen and her counselors.[2] Contrary

[1] For a discussion of the various economic opportunities available at Elizabeth's court, see Wallace T. MacCaffrey, "Place and Patronage in Elizabethan Politics," *Elizabethan Government and Society: Essays Presented to Sir John Neale*, ed. S. T. Bindoff, J. Hurstfield, C. H. Williams (London, 1961), pp. 95-126. For further discussions of patronage, see H. R. Trevor-Roper, "The Gentry, 1520-1620," *Economic History Review*, Supplement 1 (1953); Lawrence Stone, "The Fruits of Office: The Case of Robert Cecil, First Earl of Salisbury, 1596-1612," *Essays in the Economic and Social History of Tudor and Stuart England in Honour of R. H. Tawney*, ed. F. J. Fisher (Cambridge, 1961), pp. 89-116; Lawrence Stone, *The Crisis of the Aristocracy, 1558-1641* (Oxford, 1965), pp. 209-11, 257-68, 290-92, 445-99; Arthur Joseph Slavin, *Politics and Profit: A Study of Sir Ralph Sadler, 1507-1547* (Cambridge, 1966), pp. 158-211; Alan G. R. Smith, *Servant of the Cecils: The Life of Sir Michael Hickes* (Totowa, N.J., 1977), pp. 51-80.

[2] In 1587 Ralegh was described by Sir Anthony Bagot as "the best hated man in England," quoted in Edward Thompson, *Sir Walter Ralegh* (New Haven, 1936), p. 33. Certainly one of the reasons he was so hated had to do with his remarkable rise.

to social probabilities, however, the rise was accomplished without powerful family, wealth, or the privileges of aristocratic birth. Since Ralegh's rise was almost exclusively a function of the Queen's direct patronage, he enjoyed some of the advantages of his social betters. Indeed, Ralegh's letters to Leicester in 1581 and in 1586 indicate a shift in tone from supplication to courtesy as Ralegh rose from the position of one who was entirely dependent on a great courtier for the Queen's favor to a position of one who was close enough to the Queen to intercede with Elizabeth on behalf of the Earl. When Ralegh wrote Leicester from Ireland in 1581, for example, he addressed the Earl as a patron whose favor would determine the client's career: "if your lordship shall please to think me your's, as I am, I will be found as redy, and dare do as miche in your service, as any man you may cummande."[3] Five years later and from a much improved position at Court, Ralegh wrote Leicester in the Netherlands, after the Earl let it be known that he believed Ralegh had spoken ill of him to the Queen at a time when Leicester's relations with Elizabeth were particularly strained:

> You wrate unto me in your laste letters for pioners to be sent over; wher uppon I moved her majestye, and found her very willing. . . .
> Also, according as your Lordshipe desired, I spake for one JUKES for the office of the back-house, and the matter well liked. In ought else your Lordshipe shall finde me most asured to my pouere to performe all offices of love, honour, and service towards you. But I have byn of late very pestilent reported in this place [i.e., the Netherlands] to be rather a drawer bake, than a fartherer of the action wher you govern. . . . all that I have desired att your Lordshipe's hands is, that you will ever-more deal directly with mee in all matters of suspect dublenes, and so ever esteem mee as you shall finde my deserving, good or bad.[4]

As this letter indicates, Ralegh clearly enjoyed the Queen's favor and could serve as an intermediary at Court for Leicester. Moreover, his personal relations with the Queen were such that he could

For a brief review of other reasons, see Stephen J. Greenblatt, *Sir Walter Ralegh: The Renaissance Man and his Roles* (New Haven, 1973), p. 55.

[3] Edward Edwards, *The Life of Sir Walter Ralegh . . . Together with his Letters* (London, 1868), II, 17,

[4] Edwards, *Ralegh*, II, 33.

request that he be approached directly on such a matter as "suspect dublenes." Despite the Queen's temporary displeasure with the Earl, his rank and power required Ralegh to observe a deferential stance toward the Queen's former favorite. It is clear, however, that Ralegh no longer depended on Leicester's patronage for advancement and had become a direct client of the Queen.

Most of Ralegh's extant poetry probably dates from his arrival at Court in the late 1570s to the period of his disgrace in the early 1590s.[5] Except for the dedicatory sonnets to the *Steele Glasse* and the *Faerie Queene*, all of this verse circulated privately at Court. Like the elaborate symbols of compliment the Queen enjoyed on her progresses or the meaningful gestures accompanying gifts presented to her, the poems Elizabeth's courtiers produced for her were clearly invested with political significance. An individual's social status and position of favor with regard to the Queen naturally determined the appropriate poetic strategy in all instances. Choice was limited by the literary languages employed at Court and by the meaning of particular conventions that would be understood there. Since the Queen was the ultimate source of all patronage, the courtly language of love poetry was especially appropriate for indirectly expressing attitudes toward the social transactions that depended upon the favor of a female monarch. The language of love, particularly of Petrarchanism, was exploited for the terms it had in common with the social and economic vocabulary of patronage. Such words as "service," "suit," "suitor," "love," "favor," "envy," "scorn," "hope," and "despair" could be used at the same time to create a romantic fiction and to characterize the dynamics of a real client-patron relationship. Consequently, the dramatic situation of an amorous relationship was manipulated in the poetry to convey the wish for service, the need for support, and the frustration of political ambitions, as well as the various compliments that assured loyalty by declaring fidelity.

In poetry designed for the Queen's eyes, as much of Ralegh's was, the lover's relationship to his mistress referred to that of courtier and patron. The romantic fiction, however, could not simply be turned into a political allegory. Normally, only the Queen and members of the poet's coterie were familiar with topical details or the specific occasion for a poem. They alone had the means to

[5] For the dating of the poems I have followed Agnes M. Latham. Citations of the poems, except where noted, are to *The Poems of Sir Walter Ralegh*, ed. Agnes M. Latham (1951; rpt. Cambridge, Mass., 1962).

decode the poetic fiction and distinguish, for instance, between complaint and compliment, or between the need for assurance and the expression of bitter disappointment. While it is no longer possible to reconstruct the original context for many of the poems, it is clear that a number of Ralegh's lyrics could only have been rhetorically successful if the patronage relationship were not only intact but also secure.

Such a poem as "Farewell False Love" is a complaint written as though Ralegh were an old man reflecting back on a misspent youth. The poem is found in a manuscript collection of Sir Thomas Henneage's verse as a companion piece to the Vice Chamberlain's "Most Welcome Love, Thou Mortall Foe to Lies."[6] Since Ralegh is identified in the manuscript as "Mr. Ralegh," the poems must have circulated before 1585, the year Ralegh was knighted. The format of the two poems suggests a Court game in which Henneage as the more successful of the two men took the proposition that love was a virtue, while Ralegh delivered a diatribe against false love. Ralegh's poem offers a litany of love's faults rather than citing any particular wound or slight, and since other Henneage poems that accompany this pair in the manuscript deal with Court life and praise of the Queen, it is quite likely that love in these two poems refers implicitly to the Queen's favor. If so, these two courtier poems would have been amusing precisely because their authors each enjoyed positions at Court, and the poet who complained with the hindsight of a life misled was in reality the younger of the two, whose rise had made him a courtier to be reckoned with.

In "Sweet are the Thoughts," a poem that itself invites a response, Ralegh declares that his hopes might be fulfilled, his requests granted, and fortune made to yield by the good will of his mistress. In contrast with the response to Henneage, the languages of love and clientage are interchangeable in this poem; such words as "Dread," "Hope," "Fortune," and "serve" can be read in terms of either a lover's request or a client's petition. The last lines, however, clearly indicate that the poem concerns the struggle for advancement: "Then must I needes advance my self by Skyll,/ And lyve to serve, in hope of your goodwyll." This lyric is similar in design (though different in tone) to "Sir Walter Ralegh to the Queen," another poem used to solicit a favorable response to service. By

[6] Bertram Dobell, "Poems by Sir Thomas Heneage and Sir Walter Raleigh," *The Athenaeum*, 14 September 1901, p. 349. The manuscript is now in the Houghton Library.

insisting that "Silence is a suitor," the speaker protests that his true feelings for the Queen cannot be expressed because of an "Excesse of duety" rather than a "Defect of Loue." The poem implies its own response when the speaker announces, somewhat disingenuously, that he would rather withdraw from the competition for her favor than chance revealing his suit for service:

> For knowing that I sue to serue
> A Saint of such Perfection,
> As all desire, but none deserue,
> A place in her Affection:
> I rather chuse to want Reliefe
> Then venture the Revealing. . . .
> (15-20)

Clearly the complaint of this poem would require that the lady prevent this silent suitor's leaving the field.

The rediscovery of a poem by Elizabeth that circulated in manuscript with Ralegh's "Fortune hath taken the away my love" provides evidence for the kind of response such poems by Ralegh in fact received.[7] The lover in Ralegh's poem laments that Fortune has taken all away from him by taking "the[e] away my princes" (3) and comes to the conclusion that although his mistress's affection has been conquered by fortune, "no fortune shal ever alter me" (24). It is important to note that the poetic fiction presumes that the lover is a victim through the accident of birth or class, and not through some fault or error on his part. The Queen's answering poem signals familiarity and favor. In contrast with the formal Petrarchanism of Ralegh's poem, Elizabeth's response is colloquial, "Ah silly pugge wert thou so sore afraid,/ Mourne not (my Wat) nor be thou so dismaid." She assures him of her constancy by insisting his fears are groundless. Chiding him for his doubts, she recasts the language of love as the language of patronage by promising him success if he trusts to her good will rather than to his own apprehension: "Revive againe & live without all drede,/ the lesse afraid the better thou shal spede." The term for success used here, "spede," is normally an economic term implying prosperity, profit,

[7] L. G. Black, "A Lost Poem of Queen Elizabeth I," *Times Literary Supplement*, 23 May 1968, p. 535. Ralegh's poem had been known only by its third stanza, quoted in Puttenham's *Arte of English Poesie*, until Walter Oakeshott discovered a copy of the entire poem, which he reproduced in *The Queen and the Poet* (London, 1960), pl. VIII.

or advancement. The familiarity of her response and the assurance she offers indicate that Ralegh could afford to question her constancy precisely because he could assume that the Queen's favor was secure.

In contrast with those poems that presuppose an affectionate bond between patron and client, such pieces as "Farewell to the Court," "Like to a Hermite poore," "My boddy in the walls captived," and *Ocean to Cynthia* appear to have been written when Ralegh was out of favor.[8] They all indicate some sense of repentance for error or fault, and each remembers a time past when there was comfort in the form of favor. "Like to a Hermite poore," for instance, lists acts of penance that the speaker hopes will bring a return of love now lost. The last six lines of this sonnet echo with familiar code words of clientage:

> A gowne of graie, my bodie shall atire,
> My staffe of broken hope whereon Ile staie,
> Of late repentance linckt with long desire,
> The couch is fram'de whereon my limbs Ile lay,
>
> And at my gate dispaire shall linger still,
> To let in death when Loue and Fortune will.

"My boddy in the walls captived" suggests that it is not the wounds of "spightfull envy" that cause him pain but the loss of comfort when he was denied access to the Queen: "Loves fire, and bewties lieght I then had store,/ Butt now close keipt, as captives wounted are,/ That food, that heat, that light I finde no more" (10-12). At several different points in *Ocean to Cynthia*, Ralegh speaks of the time "when first my fancy erred" (3) and "my error never was forthought/ Or ever could proceed from sence of Lovinge" (338-39). Such professions of error are important signals in poems of this type, because all poems of complaint seem to divide along this line and locate error either in the self or, alternatively, in the social world. Unlike "Fortune hath taken the away my love," the poem that locates fault in the self does not assume a secure client-patron relationship. Here the complaint is generally more strident and the pleas for compassion more urgent. The key to the poem's meaning

[8] It is very likely that these poems do not refer to the same events. "Like to a Hermite poore" was printed in *Britton's Bowre of Delights*, which appeared in 1591. "My boddy in the walls captived" and *Ocean to Cynthia* are found in the Hatfield House Manuscript which dates to no earlier than 1592.

resides not in the mere mention of exile but in the reason that the poet gives for falling into disfavor. If, for instance, the cause for rejection seems to be located in the social world or in the capriciousness of the mistress and not in the lover himself, then the poem is more likely a petition for preference than a plea for forgiveness, and the reader, therefore, should not always infer political disfavor from the fiction of a rejected lover.

Since nearness to the Queen was of central importance to opportunities for patronage, any forced absence, particularly at the Queen's insistence, was always damaging to one's prospects. The contempt-of-Court theme, so prevalent in Renaissance poetry, was either a luxurious indulgence for successful clients or a sign of frustrated ambition for unsuccessful ones. So long as patronage was certain, the poetry could register frustration, disappointment, even anger at forced absence and still be used to secure assurances of favor. In his "Colin Clouts come home Againe," Spenser reports hearing a "lamentable lay" from Ralegh "Of great unkindness, and of usage hard," which the Shepherd of the Ocean suffered at Cynthia's hand when she "from her presence faultless him disbarred" (164-68).[9] In this poetic account of his meeting with Ralegh in 1589, Spenser's phrase "faultless him disbarred" places Ralegh's poem among those using the Petrarchan code to emphasize the fickleness of the mistress as well as the faultlessness of the lover. Ralegh seems to have acknowledged the Queen's displeasure, but the work, as Spenser describes it, assumes no serious violation of the social rules governing patronage. Where simple allegorizing of the erotic situation would suggest that Ralegh had been ordered from Court, Spenser identifies Ralegh's complaint with the kind of poem that couched criticism in the language of love poetry in order to win assurances: "Right well he sure did plaine,/ That could great Cynthiaes displeasure breake" (174-75).

Forced but brief absence was indeed a punishment Elizabeth characteristically imposed on her courtiers for fighting, bad conduct, or ambitious presumption. Such exile, for instance, was expected earlier in the year for Essex when he enraged the Queen by participating in the Lisbon expedition against her expressed wishes. Although he was not sent away when he returned from the campaign, his followers spent several anxious weeks anticipating the worst. Soon

[9] *The Poetical Works of Edmund Spenser*, ed. J. C. Smith and E. De Selincourt (London, 1966).

after her anger cooled, Francis Allen wrote Anthony Bacon that Essex "hath chased mr. Ralegh from the court and confined him into Ireland."[10] Her failure to punish Essex and her renewed attention to the Earl would have indicated to Ralegh that, through no fault of his own, he had lost preference as the royal favorite.[11] Even if Ralegh had sufficient signals of disapproval to make withdrawal to Ireland a politic move, the kind of poem ascribed to Ralegh by Spenser implies a social context in which the relationship between courtier and patron was still relatively healthy. And there is external evidence to support this view. In December of 1589 Ralegh wrote his cousin Sir George Carew from London, ostensibly to discuss a suit he was fighting in Ireland. He mentions his actual reason for visiting Ireland earlier in the year and indicates his anger at those who presume he was out of favor:

> For my retrait from the court it was uppon good cause to take order for my prize; If in Irlande they thincke that I am not worth the respectinge they shall mich deceave them sealvs. I am in place to be beleved not inferiour to any man, to plesure or displesure the greatest; and my oppinion is so receved and beleved as I can anger the best of them.[12]

Ralegh was particularly disturbed that Sir William Fitzwilliam, Lord Deputy of Ireland, was supporting Lady Stanley's suit contesting Ralegh's right to lease Lismore, and he makes a point of assuring his cousin of his own good standing with the Queen: "When Sir William Fitzwilliam shalbe in Ingland, I take mysealfe farr his better by the honorable offices I hold, as also by that nireness to her majesty which still I injoy, and never more."[13] One can indeed infer a strain in Ralegh's relations at Court from his strong insistence

[10] Quoted in Thomas Birch, *Memoirs of the Reign of Queen Elizabeth* (1754; rpt. New York, 1970), I, 56.

[11] Such seeming arbitrariness on Elizabeth's part would only make sense in terms of her decision to promote Essex. Elizabeth always treated her favorites according to a different set of rules, and thereby created even more jealousy, envy, and backbiting than expected. In 1587 Essex was smarting from an argument he had with the Queen in which Ralegh's favored status with Elizabeth was the ostensible cause for the Earl's jealous rage. In a letter to Dyer, Essex complained about his frustration in his "competition of love." See Godfrey Goodman, *The Court of James the First* (London, 1839), II, 1-4.

[12] Edwards, *Ralegh*, II, 41-42.

[13] It is interesting to note that Ralegh here considers his nearness to the Queen to be of equal importance to the offices he holds—perhaps greater.

that he still enjoys a position near the Queen and from his emphatic denial of the gossip that celebrated his absence from Court. The fact is, however, that within a short time after his return to Court and the writing of this letter, the Queen ordered Fitzwilliam to dismiss Lady Stanley's suit against Ralegh.

In contrast with the poem Spenser heard, Ralegh's writing following his imprisonment for the secret marriage to Elizabeth Throckmorton highlights the differences between the social and economic realities of patronage and the fictions that express them. The cultural myth was that a client served the Queen out of love. The particular language by which Elizabeth was wooed and flattered denied the economic and social needs that made her patronage system such an effective instrument for maintaining personal loyalties. Although Ralegh presented himself in poetry as the Queen's loving suitor, the fact remained that he was Elizabeth's creation; his rise at Court depended entirely upon her favor, and those social and economic rewards he received demonstrated tangible proof of her favor. Since imprisonment or exile from the Court brought on by his own indiscretion threatened complete social and economic ruin, the question for Ralegh was obviously how to repair the damage and recover his position. In two quite different literary modes, a letter to Robert Cecil and *Ocean to Cynthia*, he appealed to the Queen for mercy. Significantly, both modes employ the same rhetoric of love, both exploit the same cultural myth of Elizabeth as Petrarchan mistress and goddess of chastity, both reveal the same anxiety over loss of place, both were intended for the Queen's eyes, and both were absolutely ineffective. Precisely because one of the preferred ways of wooing the Queen politically was through the language of love poetry, a secret marriage constituted more than a fictional betrayal of imagined service to his Petrarchan mistress. Elizabeth's patronage was primarily a social and economic reality, and the marriage was a violation of social rules that governed behavior at Court, rules that provided the ground upon which the elaborate fictions of courtship rested. Since Ralegh's fault was a social and political one, only social and economic reparations—not literary ones—could serve as fit atonement.

Despite the flattery and compliment, the language of love revealed even as it disguised the economic basis of the Queen's patronage. In the letter to Cecil and in *Ocean to Cynthia*, Ralegh reiterates his past service and the persistence of his loyalty, while at the same time attempting to minimize or rationalize the meaning of his of-

fense. The fact that Ralegh dealt with his disgrace by invoking the same fiction in both letter and poem indicates something of the power of this myth that represented relations with the Queen. The letter is particularly interesting since its language derives from the poetic mode and is so uncharacteristic of the normal language of courtly correspondence as to make Ralegh appear to some historians as either disingenuous or histrionic.[14] In the letter Ralegh writes, "My heart was never broken till this day, that I hear the Queen goes away so far of,—whom I have followed so many years with so great love and desire, in so many journeys, and am now left behind her, in a dark prison all alone."[15] Imprisoned in the Tower and unable to join her on her progress, he recalls her appearance on previous journeys as that of a true Venus or Diana. His own fault allows him to moralize mankind's fallen condition: "Behold the sorrow of the world! Once amiss, hath bereaved me of all." This moral language quickly gives way to the language of love, as he cites his past service: "All those times past,—the loves, the sythes [sighs], the sorrows, the desires, can they not way down one frail misfortune? Cannot one dropp of gall be hidden in so great heaps of sweetness?" Though he writes primarily in terms of emotional loss, the burden of his lament is revealed in the well-known Latin tag phrase, "*Spes et Fortuna, valete*," and in the subscription, "Your's not worthy any name or title, W. R." Here he succinctly acknowledges his error in terms of its social consequences.

As in the fragmentary *Ocean to Cynthia*, an admission of fault was an important part of Ralegh's rhetorical strategy. It allowed him to deny willful intent ("my error never was forthought") while flattering the person who could deprive him of social status and economic security ("Or ever could proceed from sence of Lovinge"). By locating the initial error in himself, he accepted the blame. By complaining both in letter and in poem that the harshness of the punishment was in being denied access to the Queen, he objected to his desperate political straits while he accepted the fact of his punishment.

Ralegh was released from the Tower five weeks after he was imprisoned, not in response to "the loves, the sythes," and "the sorrows" of the lover, however, but in response to the need of the

[14] See, for example, A. L. Rowse, *Ralegh and the Throckmortons* (London, 1962), p. 163; and Willard M. Wallace, *Sir Walter Raleigh* (Princeton, 1959), p. 96.

[15] Edwards, *Ralegh*, II, 51-52.

Queen and the Privy Council for this Captain's services in securing the prize *Madre de Dios* from looters.[16] The economic basis of Ralegh's penance became clear with the distribution of the profits from the venture. Ralegh complained that as chief investor he received just two thousand pounds for the thirty-four thousand he had invested. The greatest share of the profits did in fact go to Elizabeth, who had a minor interest in the venture. It is only reasonable to assume that her eighty thousand pounds came from what she invested, plus the approximate return Ralegh would have enjoyed under ordinary circumstances. Although no one admitted it, her profit was obviously increased at Ralegh's expense, much as if he had been fined. And while he was not replaced as Captain of the Guard, he was further punished when he was not permitted to attend at Court for what amounted to a five-year period. For transgressing the rules upon which his social status, political power, and economic well-being rested, Ralegh was in effect punished with the equivalent of a heavy fine, exile from Court, and a greatly weakened political position.

The desires, privations, and gratifications Ralegh expressed in the language of courtier poetry were not literally those of a lover; but, on the other hand, this literary myth was not mere fiction. By encouraging her courtiers to make suit to her in the poetic language of love, Elizabeth had institutionalized her personal metaphor for rule. Petrarchanism consequently became, not simply one of several vocabularies to express the economic transactions of patronage, but the one that appeared to have the most strategic value in dealing with a female monarch—and certainly the one that Elizabeth preferred. This encoded language enabled Ralegh and his contemporaries to broach issues and express feelings that could not be addressed openly or stated overtly through ordinary discourse. Given the competitive nature of the Court and the seeming capriciousness by which patronage was distributed, furthermore, the elaborate metaphors of courtship articulated the social myth that explained the distribution system and reconciled its contradictions. The metaphor of courtly love translated political service into love, reward into favor. And thus the arbitrariness by which some enjoyed profit

[16] Sir John Hawkins wrote Burghley, "if it might please your Lordship to be a means to Her Majesty, that for the time, he [Ralegh] might be in some other place near London, it might set forward Her Majesty's service, *and might benefit her portion,* for I see none of so ready a disposition to lay the ground how Her Majesty's portion may be increased as he is." Quoted in Edwards, *Ralegh,* I, 151-52.

and promotion was explained by the logic of love. Such logic was notably irrational, but it still provided a tolerably coherent interpretation of patronage.

With the change of monarchs, however, the close connection between patronage and love poetry could no longer be exploited in quite the same way. Now the source of patronage was a king. Petrarchanism could still be used for approaching Court ladies, and it still served members of a coterie for commentary on each other's successes and failures as clients. But the preferred literary style for patronage with the new monarch was drawn from the texts he wrote and those he promoted.

As a rule, ambitious young men at Elizabeth's court did not write moral and philosophical works in quest of political patronage. Nor did they publish the love poetry they did write: it was too personal when it commented on a patronage relationship, and it seemed to them too ephemeral when it circulated outside of a coterie.[17] Because of James's interests, however, the tradition of intellectual prose and poetry assumed greater importance. A man like John Davies was able to win James's favor early on by sending him a copy of a long philosophical poem. Later in the reign, such a failed courtier as John Donne could hope to remove the stigma of past indiscretions with his *Pseudo-Martyr*.[18] While Elizabeth seemed to have invited her courtiers to compliment her with poetic conceits and romantic fictions, neither she nor her Court approved of publishing such "toys."[19] James, in contrast, preferred to see himself as a man of deep learning, and he responded favorably to lavish praise of his intellectual abilities. The publication of works whose subject matter was designed to appeal to this interest could win the King's favor, even for someone not at the Court. If it accomplished

[17] See J. W. Saunders, "The Stigma of Print: A Note on the Social Bases of Tudor Poetry," *Essays in Criticism*, 1 (1951), 139-64. Although courtiers publicly regarded such poetry as ephemeral, it was obviously an extremely important cultural practice that went well beyond aesthetic pleasure and courtly game.

[18] For a discussion of Davies' *Nosce Teipsum* and its success with James see *The Poems of Sir John Davies*, ed. Robert Krueger with introduction and commentary by the editor and Ruby Nemser (Oxford, 1975), pp. xxxiv-xxxvii, xliv. For Donne's *Psuedo-Martyr* see R. C. Bald, *John Donne: A Life* (Oxford, 1970), pp. 226-27, and Arthur Marotti's essay in this volume.

[19] "Toys" is a term attributed to Elizabeth to describe her own poem "The doubt of future foes." Quoted in Black, "A Lost Poem."

nothing else, writing a serious work for publication could be construed as an act of service in a way that love poetry never could.

Ralegh's *History of the World* presents itself as such an act of service. In its structure and style, however, it fails to fulfill the model of providential history it presupposes, and those features that make it problematic can be traced to Ralegh's situation as a client. When he began the project, Ralegh was neither a favored member of the Court nor an ambitious outsider, but a prisoner of the King. Confined to the Tower and living under a suspended sentence of death for his role in the Bye plot, it must have been obvious to Ralegh that only James could have countenanced the vigorous prosecution of a case based on circumstantial and fabricated evidence.[20] Very much in need of a patron, Ralegh hoped to neutralize the King's animosity through the intercession of Prince Henry, in whose service he undertook to write the *History*. As interesting as this work is for the social and literary conventions Ralegh observed and for the rhetorical strategies these conventions imply, the *History of the World* also provides a unique opportunity to examine the impact of a patron's death on a work whose specific function was as an act of clientage. For the portion of the text written after Henry's death is at variance with the work's original design, both in its method of narration and in its implicit philosophy of history; and these perplexing changes in style and structure can be correlated with a breakdown in the patronage relationship.

It is not clear when Ralegh made Prince Henry's acquaintance, but we do know that in 1608 the Prince asked Ralegh's advice on the construction of the *Ark Royal*. Moreover, when James seized Sherborne, Ralegh's manorial estate, to give to his favorite, Robert Carr, the Prince interceded on Ralegh's behalf, claiming Sherborne for himself and promising to hold it for the imprisoned courtier until his release. Within the year Ralegh began to write position papers for Henry and continued in this capacity until the Prince's death. Such works as "Observations and Notes concerning the Royal Navy and Sea Service" (1609?), "Concerning a Match . . . between the Lady Elizabeth and the Prince of Piedmont" (1611), and "Touching a Marriage between Prince Henry and the Daughter

[20] See Edwards, *Ralegh*, I, 339-439 for an extensive discussion of the charges, the evidence, and the trial. Willard M. Wallace points out that "James feared him [Ralegh], [Lord Henry] Howard hated him, and Cecil distrusted him" (*Raleigh*, p. 195). Neither Cecil nor Howard could have forced the conviction, if they had not been encouraged by James.

of Savoy" (1612) seem to have circulated among the Prince's advisors, enabling Ralegh to play an unofficial role resembling the one he enjoyed officially under Elizabeth.[21] Whatever the actual bond between Prince and prisoner, it was assumed by Court gossips to be a close one, for six days after Henry died John Chamberlain wrote Dudley Carleton, "[Ralegh] hath lost his greatest hope [for he] was grown into special confidence with him, insomuch that he had moved the king divers times for him [Ralegh] and had lastly a grant that he shall be delivered out of the tower before Christmas."[22] It was no mere coincidence that Ralegh began to write the *History* shortly after Prince Henry claimed Sherborne and prevented the King from giving it to Carr.[23]

Ralegh's *History of the World* has many of the features of a universal history: emplotment on a Biblical chronology, the reconciliation of Biblical events with classical legend, the language of Christian moralizing, and the repeated assertion that history is controlled by God.[24] Although most of Ralegh's readers were not aware of the fact, we now know that his actual historiographic accomplishment was not particularly original. A limited number of sources provided not only all the information for the narrative, but also the relevant citations of ancient authorities, the opinions of Church Fathers, and the arguments of a variety of Catholic and Protestant Biblical commentators.[25] By relying on these sources, Ralegh was able to create the impression of learning and industry, an impression

[21] For dates of the prose works I follow Pierre Lefranc, *Sir Walter Ralegh Écrivain* (Paris, 1968), pp. 50-55.

[22] *The Letters of John Chamberlain*, ed. Norman E. McClure (Philadelphia, 1939), I, 389.

[23] Ralegh lost Sherborne on 9 January 1609 (New Style). Lefranc suggests January 1609 as the likely month in which Ralegh began the *History* (Lefranc, *Ralegh Écrivain*, pp. 638-42).

[24] For an account of such historiographical writing see C. A. Patrides, *The Grand Design of God: The Literary Form of the Christian View of History* (Toronto, 1972); Herschel Baker, *The Race of Time: Three Lectures on Renaissance Historiography* (Toronto, 1967), pp. 15-41; Philip Edwards, *Sir Walter Ralegh* (London, 1953), pp. 150-54. For a survey of history writing in the English Renaissance, see F. Smith Fussner, *The Historical Revolution: English Historical Writing and Thought, 1580-1640* (New York, 1962) and F. J. Levy, *Tudor Historical Thought* (San Marino, Calif., 1967).

[25] Arnold Williams, "Commentaries on Genesis as a Basis for Hexameral Material in the Literature of the Late Renaissance," *Studies in Philology*, 34 (1937), 191-208; and Arnold Williams, *The Common Expositor: An Account of the Commentaries on Genesis, 1527-1633* (Chapel Hill, N.C., 1948), pp. 34-36.

crucial for the use he would make of the project. The subject matter of the history, along with its many digressions and asides, enabled Ralegh to present himself as a wise and experienced counselor intent upon instructing and advising a young man who would someday be king. In Books I and II, which deal with the period from the Creation to the fall of Jerusalem, Ralegh's discussion ranges widely over theological disputes, and he calls on his experience as an explorer to settle various issues of Biblical geography. In Books III and IV, which deal with events from the fall of Assyria to the rise of Greece, he focuses on military and political concerns, while his asides deal with Court behavior and the mechanics of statecraft. As advice to a prince, the *History* clearly was meant to serve the interests of its patron. But there were aspects of the work designed to serve the client as well.

Less frequent than the learned digressions but nonetheless prominent are a series of interspersed comments that indirectly draw attention to the narrator. Taken as a whole, these self-referential allusions read like an *apologia pro vita sua*. In speaking about one of Alexander's generals who fell from power through court machinations, for example, Ralegh says, "Surely it is a great injustice to impute mischief contrived against worthy men to their own proud carriage, or some other ill deserving."[26] He compares the suffering of such men to that of Job and suggests that worthy men who are so victimized ought to be the more valued for their resolution. Ralegh was particularly sensitive to the fact that for over twenty years his enemies had spoken of him as the proudest man in England. He certainly knew of the ballads and poems that circulated after his trial, most of which celebrated his misfortunes as just punishment for an arrogant man. By citing an example of a proud man who was a worthy general and a trusted advisor to a monarch and then suggesting that his fall be compared with Job's, Ralegh replied to various acts of character assassination against himself with a morally flattering historical context in which the reader could interpret Ralegh's own fall. There are several points in the text where such comparisons with the author's own circumstances can be drawn, all of which, of course, depend on the reader's reading the *History* analogically in light of the narrator's identity. Ralegh could count on his readers to look for these analogues. He could

[26] *The Works of Sir Walter Ralegh* (Oxford, 1829), V, 420.

not prevent them from discovering analogues where none existed, however.

In contrast with philosophical essays or religious tracts, history written by a courtier was inevitably viewed with suspicion. Generally only two kinds of courtiers wrote histories: men who had fallen or given up hope of rising and men who, in anxious pursuit of an office, hoped to flatter the King. Bacon provided a noteworthy example of the latter when, in 1610, he proposed to James a history of the King's reign. Lest his intentions be misconstrued, Bacon suggested several self-imposed restrictions, two of which were: "First that if your majesty do dislike any thing you would conceive I can amend it upon your least beck. . . . and lastly it is for your majesty's reading."[27] At this time Bacon still sought the Attorney Generalship and clearly believed that such an act of flattery in the guise of writing history would be useful to his quest. It is significant that while an aspiring politician he never undertook the project; only after his fall did he write his famous history of Henry VII's reign. Bacon's voluntary restrictions were designed to circumvent the two most obvious suspicions aroused by a historian-courtier: either that he was not serious in his pursuit of office, or worse, that he was a malcontent who, by suggesting unfavorable comparisons with examples drawn from the past, sought to undermine the present government and the social order it maintained.

No less an authority on the behavior of courtiers than Robert Cecil expressed just these suspicions when Fulke Greville approached him about writing a history of Elizabeth's reign. Greville reports that Cecil questioned his project, "why I would dream out any time in writing a story, being as likely to rise in this time as any man he knew; then in a more serious manner examining me, how I could cleerly deliver many things done in that time, which may perchance be construed to the prejudice of this."[28] Precisely this distrust of the author's motives evidently prompted John Donne to write his well-known problem on Ralegh's *History of the World*:

Why was Sir Walter Ralegh thought the fittest man to write the history of these times? Was it—
Because that being told at his arraignment that a witness

[27] *The Works of Francis Bacon*, ed. James Spedding, Robert Ellis, and Douglas Heath (1857-78; rpt. Stutgartt-Bad Cannstatt, 1962), XI, 218-19.
[28] *The Works . . . of Fulke Greville, Lord Brooke*, ed. Alexander B. Grosart (1870; rpt. New York, 1966), IV, 217.

accusing himself had the strength of two, he may seem by writing the ills of his own time to be believed? Or is it because he might re-enjoy those times by the meditation of them? Or because, if he should under take higher times, he doth not think that he can come nearer to the beginning of the world? Or because, like a bird in a cage, he takes his tunes, from every passenger that last whistled? Or because he thinks not that the best echo which repeats most of the sentence, but that which repeats less more plainly?[29]

Like Cecil, Donne knew that one could write a history analogically, using the past to criticize the present. Despite Ralegh's intentions to restrict opportunities for such criticism only to a defense of his own condition and not to imply any attack on the King or his government, it was inevitable that Ralegh's audience would seek analogues wherever they might find them.[30]

In itself the *History* is quite orthodox: its burden is that ambition, pride, envy, and ignorance are faults by which both men and kingdoms fall.[31] Readers sympathetic to Ralegh read it as an honest history, intended as an act of clientage by a man who was offering advice to the prince and an *apologia* for himself. Hostile readers read it as a malcontent's complaint, an attack on the present times by a man who was seeking revenge for his fall and who dared insinuate he had been unjustly punished. When the *History* was published in 1614, two years after Prince Henry's death, James construed it as a personal attack and had the censors call it in. Because the very decision to write a history was bound to raise the question of motivation, Ralegh could not control speculation concerning his ulterior purposes. He could only design the work for his patron and hope that Henry's public approval would allay the suspicions of potentially hostile readers. The loss of his intended

[29] Edmund Gosse, *The Life and Letters of John Donne* (1899; rpt. Gloucester, Mass., 1959), II, 52-53.

[30] Anticipating the likelihood of analogical readings, Ralegh protests his innocence to the reader at the end of his preface:

It is enough for me (being in the state that I am) to write of the eldest times: wherein also why may it not be said, that in speaking of the past, I point at the present, and tax the vices of those that are yet living, in their persons that are long since dead; and have it laid to my charge. But this I cannot help, though innocent (*Works*, II, lxiii).

[31] For a discussion of the orthodoxy of the *History*, see Ernest A. Strathmann, *Sir Walter Ralegh: A Study in Elizabethan Skepticism* (New York, 1951).

audience, then, would inevitably have influenced the design of Ralegh's *History of the World*, for he, quite likely, was finishing Book IV and beginning the final Book V when Prince Henry died in November 1612. Significantly, the account not only stops abruptly with the events of 168-167 B.C., a fact that has long puzzled scholars, but by ending with the rise of Rome, followed by Ralegh's famous meditation on death, it also excludes all mention of the birth, death, and resurrection of Christ. Ralegh is unique among providential historians in neglecting to use the incarnation to demonstrate the import of God's control of history.[32] To understand why the narrative became decentered—why it swerved from its ostensible purpose and did not close according to conventional expectations—it is necessary to understand the impact of Prince Henry's death on Ralegh's quest for patronage.

In the Prince's household alone there were more than five hundred people who rested their hopes on the Prince's patronage. His death was devastating even to those clients more favorably situated than Ralegh, for with little hope of a place at James's court, most had tied their particular political, social, and religious interests to Henry. Within days of the Prince's death, Sir John Holles, the Prince's treasurer, wrote both to the Archbishop of Canterbury and to the Duke of Lennox lamenting his personal loss even as he offered each correspondent his services. In his letter to the Archbishop, Holles sounded very much as Ralegh had twenty years earlier when he wrote to Cecil from the Tower lamenting his loss of place at Court. Although Ralegh had recovered his place after due punishment, Holles quite literally had to find a new patron. Accordingly, he wrote to the Archbishop, "now I may cry out *Spes et Fortuna valete*! My hopes and fortune lie in the grave with him."[33] Holles's letters reveal the desperation of a man financially well off who nonetheless felt keenly the loss of a patron who had offered social status, political power, and economic opportunity. John Chamberlain's letter to Dudley Carlton perhaps best describes the mourning of Prince

[32] John Racin, *Sir Walter Ralegh as Historian: An Analysis of "The History of the World"* (Salzburg, 1974), pp. 139-44; and Greenblatt, *Ralegh*, pp. 149-50. C. A. Patrides acknowledges the problem but argues that the *History* is not Christocentric but theocentric (*The History of the World*, ed. C. A. Patrides [Philadelphia, 1971], pp. 20-22).

[33] Historical Manuscripts Commissions, Portland, IX, 33. These letters have been commented on in J. W. Williamson, *The Myth of the Conquerer: Prince Henry Stuart, a Study in 17th Century Personation* (New York, 1978), pp. 174-75.

Henry's clients: "There is great desolation among his followers and many of them exceedingly disappointed."[34] Desolation and disappointment are precisely the terms with which to describe what must have been Ralegh's reaction to the loss of his patron.

The death of the Prince not only promised continued imprisonment, but guaranteed the permanent loss of Ralegh's social and financial legacy, a blow of equal gravity. Having been granted to Ralegh just a few months before the discovery of his marriage brought him into disgrace, the estate of Sherborne represented the height of Ralegh's power and social status under Elizabeth. It was the major property in which he invested time, care, and a great deal of money. Although he had made a will of conveyance in 1602 to place the estate in the hands of his son, a scribal error ultimately rendered the document void, and during his period of imprisonment the King made it evident that he wanted Sherborne for his favorite, Robert Carr. After a four-year legal battle which Ralegh lost, he wrote Robert Carr in 1609 begging him to refuse the King's offer of the estate:

> After manye great losses, and manye yeares sorrowes, of both which I have cause to feare I was mistaken in ther endes, it is come to my knowledge that yourself . . . have bene persuaded to geve me and myne our last fatall blowe, by obtayninge from his Majestie the inheritance of my children and nephewes, lost in law for want of wordes. . . .
>
> . . . for yourselfe, Sir, seinge your daye is but now in the dawne, and myne come to the eveninge, . . . I beseich you not to begynne your first buildings upon the ruyns of the innocent; and that ther greifes and sorrowes doe not attende your first plantacion.[35]

Since Prince Henry had interceded and arranged to hold Sherborne until Ralegh's release from the Tower, the death of the Prince indeed meant the loss of Sherborne and hence, in effect, Ralegh's social obliteration.

In one of those characteristic digressions that seem to take on particular significance in the light of the author's personal circumstances, Ralegh, near the beginning of Book V, sternly condemns the practice of creating lavish manorial estates:

[34] *Letters*, I, 389.
[35] Edwards, *Ralegh*, II, 326-27.

We have now greater giants for vice and injustice, than the world had in those days [when there were giants] for bodily strength; for cottages, and houses of clay and timber, we have raised palaces of stone; we carve them, we paint them and adorn them with gold; insomuch as men are rather known by their houses than their houses are known by them; we are fallen from two dishes to two hundred; from water to wine ... from the covering of our bodies with skins of beasts, not only to silk and gold, but to the very skins of men.[36]

The details and associational logic of this passage evoke Sherborne and reveal the author's anger at its loss. As he lists the excesses of vice in the movement from houses to palaces and then to the most startling excess of all, the vision of men covering their bodies with the skins of other men, a riot of excess seems to appropriate everything for its voracious needs. The terrible image of a flayed man's skin, which is a man's physical sign, in association with a manorial estate, which is a man's social sign, indicates what Carr's acquisition of Sherborne meant to Ralegh.

The narrative of Book V begins in much the same manner as that of the preceding four books: namely, with the weaving together of various sources, liberally sprinkled with digressions and comments. There are a number of references to events during Ralegh's own lifetime. When he discusses Dionysius II's conquest of Syracuse, for example, Ralegh's account of the sea combat leads him to comment on the battle of Lepanto. The betrayal of the Carthaginians by Dionysius reminds Ralegh that he witnessed such treachery in the French wars of the seventies, and he recounts what he saw in his first military adventure. He returns to the chronology of the historical narrative only to break off again with a long digression about the Armada strategies of 1588, which he helped devise. Ralegh concludes this digression with: "Of the art of war by sea, I had written a treatise for the lord Henry, Prince of Wales ... but God hath spared me the labour of finishing it by his loss."[37] After this, its first mention of Henry's death, the *History* continues for several hundred more pages. But the loss of Ralegh's primary audience radically alters the narrative hereafter.

In fact, Ralegh loses control of the narrative. At first he abandons the illusion of mastery by insisting on himself as the subject of the

[36] *Works*, VI, 30.
[37] *Works*, VI, 82.

discourse, with personal recollections and extensive digressions. But halfway through this last book, even that attempt to maintain control vanishes; the first-person voice of the narrator disappears altogether.

The last half of Book V appears to come from Polybius, Plutarch, and Livy. My collation of the sources with Ralegh's text, however, indicates that he did not put together the narrative from these sources himself, but instead translated and paraphrased a text that was probably based primarily on Livy (though drawing on the other two historians).[38] No doubt the *History* ends with the events of 168-167 B.C. because Ralegh's copy-text adopted Livy's chronology; this is precisely the point where the last extant book of Livy ends. It seems reasonable to conclude, then, that, since the *History* had ceased to have the specific function for which it was being written, the intricate historical narrative simply gave way to paraphrase and translation until Ralegh's main source ran out. In the final two pages of the work, the author speaks again in his own voice, explaining that he has recounted the rise and fall of three of the four empires. He has left Rome flourishing, although "the storms of ambition shall beat her great boughs and branches one against another, her leaves shall off and her limbs wither and a rabble of barbarous nations shall enter the field, and cut her down." For the rest, he says, boundless ambition will continue to drive the world. The end is death, which alone can make man know himself.

The *History* concludes with the great paean to death, but with no mention of Christ and the Resurrection:

> O eloquent, just, and mighty Death! whom none could advise thou hast persuaded; what nine hath dared, thou hast done; and whom all the world hath flattered, thou only has cast out of the world and despised; thou hast drawn together all the far-stretched greatness, all the pride, cruelty, and ambition of man, and covered it all over with these two narrow words, *Hic Jacet*!

[38] I am indebted to Professor Kenneth Walters for his generous help with the collation of the Greek and Latin texts. There was no copy of Livy in Ralegh's library, but there were several compendia of ancient historians including J. Bonutus, *Historia Antiqua* (Heidelberg, 1599); see Walter Oakeshott, "Sir Walter Ralegh's Library," *The Library*, 5th Ser., 23 (1968), 285-327. It is possible, though not likely, that Ralegh was working from a summary prepared by someone such as Robert Burhill, his chaplain. Racin has reviewed the issue of the help Ralegh may have received; see Racin, *Ralegh as Historian*, pp. 18-27.

Lastly, whereas this book, by the title it hath, calls itself The First Part of the General History of the World, implying a second and third volume, which I also intended, and have hewn out; besides many other discouragements persuading my silence, it hath pleased God to take that glorious prince out of the world to whom they were directed, whose unspeakable and never enough lamented loss hath taught me to say with Job, *Versa est in luctum citherea mea, et organum meum in vocem flentium.*

By celebrating death as the great leveler, Ralegh globalizes his private tragedy. He represses the identity of the real victim, himself, and substitutes the world, thereby making all of history into tragedy. It was after finishing these paragraphs that Ralegh wrote the famous preface where he briefly reviews the rise and fall of European monarchies. In the words that conclude the book, he not only confirms his view of history as tragedy, but is more ruthlessly providential than anywhere else in his entire narrative. It is here as well that he speaks out as tragic victim, addressing the reader in the very last paragraph to say that his book "is now left to the world without a master. . . . I know that as the charitable will judge charitably: so against those *Qui gloriantur in malitia*, my present adversity hath disarmed me. I am on the ground already and therefore have not farre to fall."[39] Ralegh presents himself as pathetically vulnerable to his enemies in these final words. He asks for sympathy as the tragic example of the client without a patron.

Ralegh's lament that his book had come into the world without a patron was justified anew when James ordered all available copies to be seized.[40] Although the author was not identified on the title page, the text had been entered in the Stationer's Register under Ralegh's name in 1611, and the many references to the author's own experiences clearly marked the work as Ralegh's. In 1617, shortly after Ralegh was released from the Tower to find El Dorado for the King, the *History* was reprinted with a title page bearing Ralegh's name. Not only was this issue permitted to be sold, but James even marketed those copies he had confiscated several years before and pocketed the profits.

[39] *Works*, II, lxiv.

[40] For an account of the publication history of this work, see John Racin, "The Editions of Sir Walter Ralegh's *History of the World*," *Studies in Bibliography*, 17 (1964), 199-209.

The history of Ralegh's *History* exemplifies a feature common to many courtier texts. On the one hand, like much of Ralegh's poetry, the *History* was written in the context of the social institution of patronage. As was the case with his verse, the *History* could not create a desired relationship; it could only reflect one that existed prior to the writing of the text. On the other hand, a change in the client's status, brought about in this case by the death of the patron, produced changes in the literary strategies employed. And as was again the case with Ralegh's verse, the manner in which the *History* was read reflected the social relationship between author and audience. When Ralegh published his *History*, he was a forlorn client of the dead Prince and a prisoner of the King. James was naturally suspicious of Ralegh's motives, and the work was considered dangerous. But as soon as Ralegh was released from the Tower to serve the King,[41] that is, to become the King's client, his *History* could be safely published and read without suspicion of the author's intent. The words of the text had not changed between 1614 and 1617, but their context had. It was not the efficacy of the author's language, then, so much as the social realities of the patronage system that governed both the production and the reception of Ralegh's literary work.

[41] The most comprehensive account of Ralegh's Guiana voyage is V. T. Harlow, *Ralegh's Last Voyage* (London, 1932).

Theatre

The Royal Theatre and the Role of King

STEPHEN ORGEL

M Y ultimate concern in this essay is with royal patronage of the theatre in Stuart England, but I want to begin with a larger context and with certain related but, I believe, prior questions. My subject is as much involved with royal actors as with royal audiences, and I wish to consider first the kinds of roles and imagined worlds Renaissance monarchs caused to be created for themselves, and the kinds of theatres they required in which to perform those roles. I am starting, that is, with the role of king. My theme is expressed in the opening lines of a sonnet by King James I, a prefatory poem to his handbook of kingship, *Basilicon Doron*. "God gives not kings the style of gods in vain,/ For on his throne his sceptre do they sway." The Renaissance monarch assumed that his authority derived from the one true God, but his sense of himself, the roles he adopted, his mode of asserting his authority and validating his power, also required a host of lesser gods—indeed the whole of the classical pantheon—and a good deal of theatrical apparatus.

The choice of mythological personae for the Renaissance prince was an almost universal one. It was a choice in which the mythographers generally concurred; and in fact one of the earliest theories of mythological interpretation, proposed in the third century B.C. by the Sicilian writer Euhemerus, made the relationship between kings and gods direct and explicit. Euhemerus maintained that the gods were in fact originally kings and heroes who had been idealized by their societies. Rationalistic and essentially debunking, Euhemerism was the preferred method of mythological analysis in late antiquity, though it was eventually replaced as the central interpretive mode by various allegorical and mystical theories. It never died

out, however, and it reappears in Renaissance mythographies, usually in tandem with other more arcane interpretive strategies. From modern commentators Euhemerism has earned little but scorn; it is, they observe, preposterously reductive. Why should a culture devise something as complex as a myth to explain that there once was a king who introduced winemaking, or was especially lecherous, or had a remarkable herd of cattle?

We may admit the justice of the critique without being persuaded that it has disposed of the question. No doubt the fact of historical kings is simple; but a culture's feelings about them are not. It is self-evident that much classical mythology expresses complex attitudes toward kingship and the exercise of power: God gives not kings the style of gods in vain. The validity of Euhemerism is amply demonstrated by monarchs themselves, to whom pagan myth has always provided a rich and, indeed, a natural mode of expression. Postclassical mythography, in fact, owes as much to the patronage of kings as to the imagination of poets and the industry of scholars. Hugh IV, the King of Cyprus and Jerusalem, who commanded Boccaccio to recover for him the genealogies of the ancient gods, was only the first of a succession of governors to see the relevance of this arcane and pagan study to their own situations.

In Boccaccio's case, moreover, not only the subject but the mode of organizing the treatise—according to genealogies—was prescribed by the King. We might observe from the outset that if it is the meaning of ancient fables we are interested in, a genealogical organization is neither an obvious nor a particularly useful one. Why did the King want genealogies? Why should a mythography have a time scheme at all? The major sourcebook for Renaissance mythographers, Ovid's *Metamorphoses*, is loosely built around family groups and does have a clear, though pseudo-historical, purpose: it describes the descent of the empire, from the creation of the world, through the age of gods and heroes, to the founding of Rome and the eventual deification of Julius Caesar and Augustus. The reason Ovid is not concerned with history is that he wishes to show not how Rome developed, but its divine origin and its continuing involvement with the divine. There is nothing particularly spiritual, and little that is even ennobling, about this involvement— the progression Ovid describes runs, on the whole, downhill—but the world of myth for Ovid, as in very different ways for Virgil, nevertheless validates the empire and the reigning dynasty.

Boccaccio takes this sort of cultural validation to be the meaning

of mythology itself. He explains in the preface to the *Genealogies of the Gods* that myths were devised by the ancients to dignify themselves and justify their existence by inventing a divine, if fabulous, heritage; and he sneers at the pagan desire to be considered descendants of gods.[1] The scorn is no doubt chiefly intended as an assertion of his own adherence to the one true faith; in any case, it rapidly disappears, and mythography becomes an undertaking of the utmost seriousness for Boccaccio. The composition of the *Genealogies* occupied the last thirty years of his life, and the work was not completed until long after the death of the King of Cyprus and Jerusalem, its royal patron. Nevertheless, the royal command remained constantly in view: it is very much a king's book. To see the gods' power and glory deriving not from their divinity but from their lineage was precisely to see them as kings. So power is legitimized; and later mythographies often retain the genealogical form, even without the royal context. The Renaissance is, in the most profound ways, concerned with the issue of legitimacy, in its ideologies as well as its aristocracies. The very term Renaissance, coined by Alberti in the mid-fifteenth century, was designed to validate a radically new concept of artistic style (in this particular case architectural) by insisting on its classical antecedents. And the same writers who open their treatises with assertions about the blindness, foolishness, and vanity of pagan fables often go on to invest considerable effort in harmonizing classical myth with Christian truth. "This may be no fable," says Ovid's seventeenth-century translator George Sandys of one of the labors of Hercules, pointing out that the Bible recounts a similar story about Samson.[2] What is being established in claims of this sort is the legitimate descent of the true faith. For Renaissance humanists like Erasmus and Milton, the classical heritage of Christianity is emotionally far more central to its validity than the fact of revelation.

The emphasis on mythological genealogy in the Renaissance is a special case, but it springs from a broad and general conviction that in classical culture could be found the deepest and best expression of the age's own ideals and ambitions. But why in the lies of pagan writers, rather than in the truths of revealed religion? As with most such questions, even to pose the problem in that way is to misrepresent it. The tension between Christianity and humanism

[1] A translation of the preface and books XIV and XV will be found in Charles G. Osgood, *Boccaccio on Poetry* (Princeton, 1930).

[2] *Ovid's Metamorphosis Englished* (1632), p. 336.

in the age rarely presented itself as so simple an antithesis. The sixteenth-century Puritan translator of Ovid, Arthur Golding, assures his readers that the *Metamorphoses* displays examples of what to avoid, lessons about the destructiveness of passion and excess; but he also emphasizes, paradoxically, how fully the immortal gods embody our humanity, and he recommends that we read the poem as we read the Holy Scriptures. Surely that conviction of the permanence of the things of this world, that vision of cosmic sensuality and divine passion, is in part what the Renaissance found so compelling. More than this, the impulse to be classical, to recreate and impersonate a world not of saints and angels but of gods and heroes, clearly expresses some of the age's most profound needs. The saints, after all, present a largely passive ideal, and the central Christian myth is one that celebrates victory through suffering. Even the most Christian king could not fight as Christ, but only for him. Hence, late in the Renaissance, shortly after the founding of the Jesuit order, we start to find the curious phenomenon of Jesuit mythology: it cannot be accidental that the major codifiers and interpreters of pagan myth in the seventeenth century were the representatives of the Church Militant. Their voluminous handbooks, to be sure, are concerned with exposing the errors of paganism; but they also served to preserve its pantheon and celebrate its heroes.

Modern historians of the subject regularly claim that Renaissance mythographers spiritualized and internalized their fables. In fact, the truth more often seems to me just the opposite. The pressure is not toward spiritualizing the physical, but toward embodying and sensualizing the moral and abstract. The increasing tendency in the Renaissance to illustrate mythographies, and to treat them as iconologies—systems of images—is clear evidence of this. Such a tendency has nothing to do with abstraction; on the contrary, it is essentially antianalytic, opposed to elucidation. I think it is most to the point to observe the age's compulsion to keep retelling the tales, all the while insisting that it did not believe them, that it wished to avoid them, that it saw through them; all the while searching out ways to assert that these stories of pride, envy, wrath, sloth, lust, avarice, gluttony—but especially of pride and lust—if rightly read, were not vicious but virtuous.

Even in the seventeenth century, then, even if one were a Puritan or a Jesuit, to be in touch with the classical past and the world of pagan myth was also somehow to be in touch with one's deepest feelings about one's own culture. The conviction was, of course,

as I have suggested already, rarely unequivocal. Indeed, there was an extensive debate among sixteenth-century theorists, most energetically in Italy, over whether Christian poets ought to use pagan materials at all; but it serves primarily to emphasize the fact that classical mythology in large measure constituted the substance of Renaissance literature and art. The first English mythography was written by an Anglican churchman named Stephen Batman and was intended as a warning against paganism—it includes among its false gods a number of Anabaptists and Catholic theologians. Its title, however, is characteristically ambivalent: *The Golden Book of the Leaden Gods*. It was the leaden gods that provided roles and moral fables for the leaders of Renaissance society. Queen Elizabeth appears again and again as Astraea, not as the Virgin Mary; and though we do hear of James I as Solomon (chiefly in parliamentary addresses and sermons—and, of course, he is so depicted in Rubens' ceiling for Inigo Jones's Whitehall Banqueting House) we nevertheless see him much more often, and in a sense more palpably, as Pan, Neptune, Hesperus, Aeneas. And the fables in which he adopts these roles insistently repeat a small number of familiar Renaissance themes: vindication, reconciliation, restoration. Here are some titles: *Mercury Vindicated from the Alchemists at Court, Time Vindicated to Himself and to His Honors, Pleasure Reconciled to Virtue, Love Restored, Love Freed from Ignorance and Folly, The Golden Age Restored*. All suggest a past that needs to be revised, a present that needs to be validated.

The enacting or performance of such roles, however, required a special kind of theatre, and one of the most characteristic cultural, social, and, especially, political phenomena in the Renaissance involves the development of that theatre. Figure 10.1, for example, shows an engraving of the famous *Balet Comique de la Royne*, performed before Henri III and Cathérine de Medici in 1581. The performance takes place not in a theatre but in a banqueting hall, the entire floor of which becomes the stage. The royal spectators are in the foreground, with their backs to us; the action of the ballet is presented as a transaction between the performers and the monarchs. The rest of the audience sits in two galleries on either side; the spectacle they watch is not the ballet, but the monarchs watching the ballet.

Fifty years later Cardinal Richelieu added a *salle de comédie* to his palace. It was a highly sophisticated theatre, designed to take

into account the latest developments in stage design and scenic machinery. Nevertheless, when the Cardinal entertained the King, the arrangement of the hall was the traditional one (Figure 10.2).[3]

The centrality of the monarch was emphasized still further when the spectacle involved perspective settings. In England, these especially characterized the royal theatre. The chair of state was placed at the focal point of the perspective, so that the King's seat was the best in the house, and the court arranged itself around him in a hierarchy determined by the laws of optics. The closer one sat to the King, the better one's place was, and only the King's place was perfect. Such a theatre was programmatically developed by Inigo Jones from 1605 onward.[4] Figure 10.3, for example, shows his arrangement of the Great Hall of Whitehall Palace for the pastoral *Florimène* in 1635. The spectators are seated in boxes and tiers around three sides of the hall. The royal box is exactly halfway between the front of the stage and the back wall of the hall—the monarchs sit in the exact center of the audience, and the area before them is left clear. Jones has also indicated the location of four other boxes on the plan. The best, those directly behind the thrones to the right and left, belong to the Countess of Arundel, wife of the famous collector who was instrumental in the creation of the royal art collection, and to an unnamed marchioness. Close to the stage is a box for Sir Thomas Edmondes, distinguished diplomat, former ambassador to Paris and Brussels, royalist Member of Parliament— but not an aristocrat, hence his distance from the throne. And Jones has placed himself in a box labeled "master surveyor" in the upper tiers on the King's right.

The plan also shows that the stage is constructed in two sections. The front consists of a proscenium arch and four angled side wings; behind this is a group of movable shutters and scenes of relieve (cutout settings arranged in layers that gave an impression of great depth to the rear of the stage). The effect of all this on a spectator— or at least on one in the royal box—is elegantly conveyed by Jones's scenic designs.[5] Figures 10.4 and 10.5 are for the pastoral and for Aurelian Townshend's masque *Albion's Triumph*, respectively.

[3] The best account of the event is that of Timothy C. Murray, "Richelieu's Theater: The Mirror of a Prince," *Renaissance Drama*, 8 (1977), 275-98.

[4] I am summarizing my own detailed survey of Jones's theatre in Stephen Orgel and Roy Strong, *Inigo Jones* (London and Berkeley, 1973), especially chapters I, II, and IV.

[5] For a fuller discussion of *Florimène* see Stephen Orgel, *The Illusion of Power* (Berkeley, 1975), pp. 27-36.

In both of these we shall observe how strongly the central axis is emphasized, mirroring the arrangement of the hall. On the Continent, perspective settings were common in public theatres, where they merely added to the spectacular effect, as well as at courts; in England, on the contrary, the use of such scenery was a royal prerogative, strictly preserved. Illusionistic sets were to be seen only at Court or when royalty was present. They were never used in public theatres and were employed in university productions only on the rare occasions of a royal visit. The perspective stage was, in pre-Restoration England, reserved for monarchs.

James I and Charles I required not only theatres, however; they required players as well. After James's accession in 1603, all the major theatrical companies were placed under royal patronage. Both too much and too little has been made of this fact. It clearly involved a rise in social status for the acting profession (the King's Men were now entitled to call themselves gentlemen), but it could have made little difference to the daily operation of the business of the stage—the players still derived most of their income from public performances. Recent attempts to show that the King's Men began to produce plays primarily for the Court, with covert allegorical schemes relating to current political issues, have foundered on their own bad scholarship. What is evident is that when the royal players were called to Whitehall to assist in the celebration of a particular event by performing a play, they selected (or they were instructed to select) a piece that was appropriate to the occasion, and that might include some revisions to accommodate the fact of a royal audience. (This, I take it, is why, for example, Hecate, after raising an apparition particularly harrowing to Macbeth, but particularly flattering to James I, concludes the compliment by leading her witches in an "antic round,/ That this great king may kindly say/ Our duties did his welcome pay" [IV.i.130].) The increasing appearance of mages and philosopher kings in Shakespeare's late plays may have had something to do with James I in Shakespeare's mind, but it can hardly have had much to do with the fact of royal patronage—or else the company would have gone on commissioning plays about mages from all its playwrights until 1625. The situation changed significantly under Charles I and his Queen, Henrietta Maria, who essentially took command of the royal theatricals, commissioning plays themselves, and where necessary overruling the dramatic censor; but until the death of James, what the King's Men provided that was specifically the King's was the professional

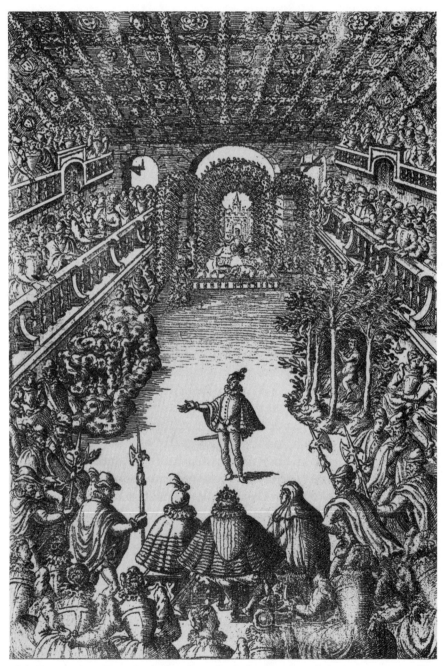

10.1. Frontispiece. From B. de Beaujoyaulx, *Balet Comique de la Royne* (Paris, 1581).

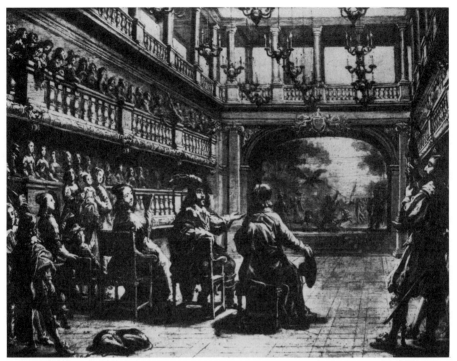

10.2. Unknown artist. *Cardinal Richelieu Entertains the King and Queen in the Theatre of the Palais Cardinal*, Grisaille.

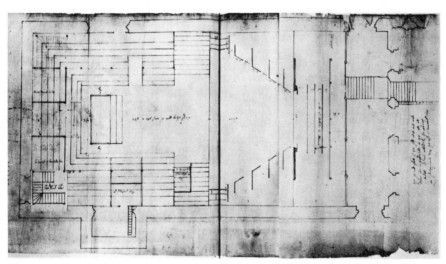

10.3. Inigo Jones. Floor Plan for *Florimène*.

roles in the Court masques. The theatre that was created by royal patronage was the theatre of the masque, and it was uniquely responsive to the minds of its patrons.

To view the question exclusively in these terms, however, is to view it onesidedly. The point is not only that the Stuart monarchs required the stage and therefore subsidized it. The stage too increasingly required a new kind of patronage. In medieval England actors were roving vagabonds; the patronage of a powerful lord or a government official provided a measure of security. By Elizabeth's time the patronage of Lord Strange, the Lord Admiral, or the Lord Chamberlain was providing something more broad and important: legitimacy, a recognized and accepted place within the social order.

The concept of legitimacy in theatre is worth pausing over—it is still an issue, as the familiar and immediately comprehensible expressions "the legitimate drama" and "the legitimate stage" demonstrate. Legitimate drama, says the *Oxford English Dictionary*, is the body of Shakespearean and other plays of recognized literary merit; it cites a usage from 1884. By Victorian times, theatre had become legitimate by turning into drama, by being literature instead of spectacle. "The legitimate stage" is apparently an Americanism (the *OED* does not record it), devised initially to distinguish regular plays from burlesque and variety shows, and later from the movies. Here again, it is the popular appeal of the theatre, its value as entertainment, that is obviously felt to be problematical. I think it is important to observe that there is no other art that we describe in such terms. Thus, we might want a word that would allow us to make a critical distinction between Cezanne drawings and *New Yorker* cartoons: would we ever invoke the concept of legitimacy to do it? We distinguish kinds of music by summoning up notions of the classical or the "serious," as opposed to the "popular": there is undoubtedly snobbishness and a tendency to moralize detectable in this, but nothing that suggests that some kinds of music are either unlawful or bastards—illegitimate. But theatre has since Roman times hovered on the edge of unlawfulness. Is it merely coincidental that the actor Shakespeare in 1596, claiming the status of a gentleman by petitioning for a family coat of arms, took as his motto an assertion precisely of the legitimacy of his claim: *Non Sanz Droict*?

The theatre's first line of defense against the ever-present charge of illegitimacy was its alliance initially with the aristocracy and later with the Crown. It is to the point that as the seventeenth century progresses theatres get smaller and smaller, more and more elitist.

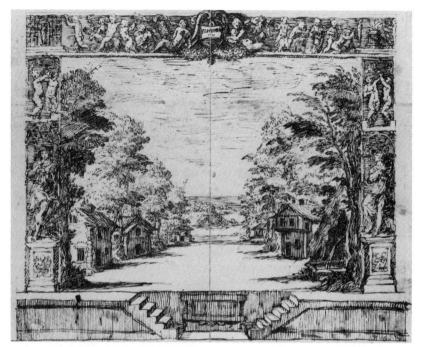

10.4. Inigo Jones. Setting for *Florimène*.

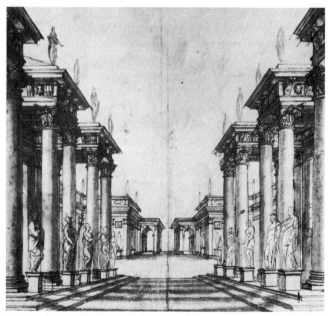

10.5. Inigo Jones. Setting for *Albion's Triumph*.

But the Renaissance stage solicited another kind of patronage as well, and this in the long run was to prove the more effective. I am referring to the increasing tendency in the age to publish plays and then to collect them in large and expensive folios—to make of theatre, that is, what is implied by the expression "legitimate drama." Elizabethan playbooks were published for the most part either without the authorization of the theatrical company or after the company felt the commercial value of the play on the stage was exhausted. The printed texts must have been bought primarily by people who had seen and liked the plays, to serve as *aides-memoires*. The players, however, seem to have feared that the quartos would function as alternatives to, or substitutes for, actual performances, and that publication would reduce the number of paying spectators. But this is not the whole story, because if publication did not benefit the theatrical companies, it did benefit the playwrights (though of course it benefited most of all the Guild of Stationers). What I think we see in the pattern of dramatic publication as the seventeenth century progresses is an increasing emphasis on the authority of the playwright. In a company like Henslowe's or Shakespeare's, the dramatist was the low man; he took his orders from the players and had no control over the ultimate disposition of his text, which, moreover, he was legally enjoined from printing. (Shakespeare is a very special case, being one of the owners of the company he wrote for—he was literally his own boss.) But by the early years of the seventeenth century, we start to find playwrights publishing texts that are claimed to be more correct, or more complete, than those performed by the players—that are claimed, that is, to be the true play, the whole play. The spectacle of theatre in this way becomes drama, a form of poetry; and as it moved upward on the generic scale, so it did on the social scale as well.

For a play to become literature means that it is no longer an ephemeral experience, truly possessed only by its performers. To possess the play as it appeared in quarto, one had only to be literate and sufficiently affluent to invest 6d.—half a day's wages for a skilled workman. These were doubtless relatively modest requirements in the society of London and Westminster, and a reasonable proportion of the Globe's patrons must have been at least potential purchasers of playbooks. But what happens when plays are published in folio and sell for £1? Now the drama has new patrons: the rich, the aristocratic collectors, men with libraries; and the publishers assume that their clientele will be people of seriousness,

learning, and taste. Thus Jonson's plays are presented as *Works*, Shakespeare's as *Comedies, Histories and Tragedies*—two classic genres and a modern one of unquestionable gravity. How new all this is may be understood if we recall that Sir Thomas Bodley's library at Oxford, in the terms of its foundation in 1611, explicitly excluded books of plays. But Jonson's, Shakespeare's, and Beaumont and Fletcher's folios, like the volumes they imitate—the great humanist editions of the ancient dramatists—are not playbooks. They present themselves as classics.

Publication of this sort represents a new kind of bid for the patronage of the rich and powerful, and it postulates for the theatre a degree of respectability that was quite unknown in England a generation earlier. The Elizabethan and Jacobean stage had been on the whole (though decreasingly so) a genuinely popular medium. But by 1633, when William Prynne was prosecuted for treason for attacking the royal theatricals at Whitehall, a significant alliance clearly existed between the theatre and the Court, and a large segment of the population considered the alliance subversive.[6] Charles I had succeeded in creating a theatre that was genuinely his own.

[6] The background of the case and its extraordinary effects are analyzed in *Inigo Jones*, I, 51 and 63ff.

ELEVEN

Women as Patrons of English Renaissance Drama[1]

DAVID M. BERGERON

IN the attempts to reassess the position of English women in the society of late Tudor and early Stuart times no one, to my knowledge, has looked very closely at their relationship to one of the most popular endeavors: namely, the theatre. We know, of course, that women were not allowed as actors on the regular stage; and yet they performed frequently in other dramatic entertainments, principally masques. Several writers have detected a decline in the status of women after the death of Elizabeth and the advent of the anti-feminist Jacobean court, but I do not think that the issue is that simple.[2] Indeed, two recent essays find evidence of "modern feminism" and the development of "women's rights movements" in the literature.[3]

Somewhere between these two opposing arguments lies the truth. That James did not care much for women is clear, but women maintained positions of prominence at Court and in the arts nevertheless. And curiously, one of the movements that contributed to the supposed emergent feminism was, of all things, Puritanism—an

[1] For support of this research I am indebted to a grant-in-aid from the American Council of Learned Societies and to the General Research Fund of the University of Kansas.

[2] The argument of Jean Gagen in *The New Woman: Her Emergence in English Drama 1600-1730* (New York, 1954), p. 16, and in Pearl Hogrefe, *Tudor Woman: Commoners and Queens* (Ames, Iowa, 1975), p. 142.

[3] Catherine M. Dunn, "The Changing Image of Woman in Renaissance Society and Literature," in *What Manner of Woman: Essays on English and American Life and Literature*, ed. Marlene Springer (New York, 1977), pp. 15-38; David J. Latt, "Praising Virtuous Ladies: The Literary Image and Historical Reality of Women in Seventeenth-Century England," in *What Manner of Woman*, ed. Springer, pp. 39-64. Apparently neither writer had a chance to consult Professor Hogrefe's book.

argument that has been convincingly advanced by Juliet Dusinbere.[4] As Dusinbere observes, "The drama from 1590 to 1625 is feminist in sympathy" (p. 5), and this is true not only of Shakespeare but of almost all his contemporaries. Nor is there any appreciable diminution in the status of women with the death of Elizabeth; I would argue, in fact, that there is a significant index of the importance of women for the drama, not as characters in plays—for that is another subject—but rather as sponsors and patrons of theatrical activity.[5]

There are a number of obvious ways in which women impinge on English drama of the Renaissance. Clearly they constituted a large part of the audience, whether in the public theatres or at private performances, and from one there is an eyewitness account of theatrical events. The Lady Anne Clifford kept a diary, revealing much about her intellectual life—her reading of Montaigne, Chaucer, Spenser, the *Arcadia*, Ovid, Augustine—and her social life, including her attendance at dramatic performances.[6] She was present for several masques, saw Fletcher's *The Mad Lover* in 1617, and noted the burning of the Banqueting House at Whitehall in January 1619.

Women could also sponsor theatrical events. When Queen Elizabeth was on progress in 1592, the dowager Lady Russell, widow of Francis Russell, second Earl of Bedford, acted as hostess for Elizabeth's stop at Bisham in August. She provided dramatic entertainment of a typical sort, common to many progress shows for the Queen.[7] Pastoral figures, such as Pan and Ceres, welcoming and praising the sovereign, dominated the brief pageant entertainment. As one scholar has noted: "Lady Russell had invited all the wit,

[4] *Shakespeare and the Nature of Women* (London, 1975), p. 5.

[5] Other studies that are of some interest: Gamaliel Bradford, *Elizabethan Women* (Cambridge, Mass., 1936); Carroll Camden, *The Elizabethan Woman* (Houston, 1952); Ruth Kelso, *Doctrine for the Lady of the Renaissance* (Urbana, Ill., 1956); Mary R. Mahl and Helene Koon, eds., *The Female Spectator: English Women Writers before 1800* (Bloomington, Ind., and London, 1977); M. Philips and W. S. Tomkinson, *English Women in Life and Letters* (Oxford, 1926); Roger Thompson, *Women in Stuart England and America: A Comparative Study* (London and Boston, 1974).

[6] V. Sackville-West, *The Diary of the Lady Anne Clifford* (London, 1923). G. E. Bentley in *Jacobean and Caroline Stage* (Oxford, 1956) has cited most, but not all, of Lady Anne's theatrical references. See also George C. Williamson, *Lady Anne Clifford . . . Her Life, Letters, and Work* (Kendal, 1922).

[7] For brief discussion see David M. Bergeron, *English Civic Pageantry 1558-1642* (London and Columbia, S.C., 1971), p. 62. For the text of the entertainment see John Nichols, *Progresses of Elizabeth* (London, 1823), III, 130-36.

the talent, and distinction, which she could convene, for the entertainment of her royal mistress, who prolonged her stay at Bisham several days."[8]

There were even women dramatists, though we have no evidence that their plays were performed or were intended to be performed. Mary Herbert, Philip Sidney's sister and a translator and writer of some skill, produced a brief pastoral dialogue, *Thenot and Piers in Praise of Astraea* (1592), and *Antonie* (1592), a translation of Robert Garnier's French play. And *Mariam, the Fair Queen of Jewry* (1613 text, written 1602-05) by Elizabeth Cary (wife of Henry Cary, Viscount Falkland) has the distinction of being the only extant play written by a woman in this era that was not a translation. Proficient in several languages, Elizabeth Cary did a number of translations, primarily of religious writings, but also of the epistles of Seneca.[9]

Though they never appeared on the public theatre stage, women did appear regularly in private performances of masques, not only joining in the final dances but also impersonating some of the symbolic and mythological figures in the masque proper. The list of masque "actresses" is as impressive as it is long—some forty-six in Jonson's masques alone, starting with Queen Anne and later Queen Henrietta Maria and including Lady Anne Clifford and others.[10] A perplexing comment in Jonson's *Conversations* suggests that perhaps he was planning to use women in a pastoral play of some sort:

> . . . he heth a Pastorall jntitled the May Lord, his
> own name is Alkin Ethra the Countess of Bedfoords
> Mogibell overberry, the old Countesse of Suffolk ane
> jnchanteress other names are given to somersets Lady,
> Pemb[r]ook the Countess of Rutland, Lady Wroth.[11]

Henrietta Maria provoked controversy because of her theatrical activities. She encouraged plays and masques at Court, and she often performed in the masques. In February 1626, she and her ladies performed a French pastoral at Court, "at which there was

[8] J. H. Wiffen, *Historical Memoirs of the House of Russell* (London, 1833), II, 14.

[9] Hogrefe, *Tudor Women*, pp. 133-34.

[10] For a list see Herford and Simpson, *Ben Jonson*, X (Oxford, 1950), 440-45.

[11] Herford and Simpson, *Ben Jonson*, I (Oxford, 1925), 143. The speculation that the play was *The Sad Shepherd* is inconclusive.

some murmuring."[12] The pastoral was Racan's *Artenice*, and it was "Queen Henrietta's speaking like a common player in the first part of her performance and the masculine dress of some of the ladies which raised the eyebrows."[13] In January 1633, after months of preparation and rehearsal, the Queen performed in Walter Montagu's pastoral, *The Shepherd's Paradise*.[14] This was enough to stir William Prynne's blood and pen, leading to his *Histrio-Mastix* and thus to his prosecution. Tradition and the Puritans notwithstanding, one could have seen women performing in dramatic shows.

During the period from the accession of Elizabeth to the closing of the theatres patronage of the drama took several forms, beginning with the crucially important sponsorship of the Court itself. The Court remained the single most significant institution for the support of drama, including within its bureaucracy a Master of the Revels, and ultimately, in the reign of King James, placing all the principal acting companies under royal patronage. City governments and trade guilds were also active, producing and financing civic pageants, such as royal entries and Lord Mayor's shows. The Inns of Court made their contribution by sponsoring drama and preparing masques for special occasions. With the advent of public theatre buildings in the latter part of the sixteenth century a new group of patrons emerged: namely, the paying, theatre-going audience. What this meant to the flourishing of drama is simply incalculable: it created a class of professional dramatists and actors, able to earn their living exclusively from theatrical endeavors. The final major group of theatre-patrons was a diverse and wide-ranging collection of noblemen and courtiers, including women, who served, like Leicester and the Lord Chamberlain, as sponsors of acting companies or caused certain dramatic shows to take place. Though they lost some of their prominence when James took over the companies, such noblemen nevertheless remained important in both direct and indirect ways by their continued patronage of drama.

Recent scholarship has come a long way toward understanding the functioning of the early English theatre. Discarded is the misleading and naive view of W. J. Lawrence, who once claimed: "In those days all writing done for pay was looked upon as soiled in the process, and unworthy of patronage."[15] Such a simplistic ap-

[12] Bentley, *Jacobean and Caroline Stage*, III, 453.
[13] Bentley, *Jacobean and Caroline Stage*, IV, 549.
[14] Bentley, *Jacobean and Caroline Stage*, IV, 917-20.
[15] "The Dedication of Early English Plays," *Life and Letters*, 3 (1929), 31.

proach was countered more than half a century ago by Virgil Heltzel in his essay, "The Dedication of Tudor and Stuart Plays."[16] But Heltzel had his own excesses, as when he claimed that "during the entire reign of Queen Elizabeth and for some years after, the ordinary stage play was not thought worthy of patronal favor and none was dedicated" (p. 74). Heltzel thought 1613 a kind of turning point, after which dedications of regular drama increased. But before then Jonson had dedicated *Volpone* (1607) to the universities, *Catiline* (1611) to William Herbert, *The Alchemist* (1612) to Mary Wroth, and special issues of *Cynthia's Revels* (1601) to Camden and the Countess of Bedford, while Chapman had dedicated the *Tragedy of Byron* (1608) to Walsingham and *The Widow's Tears* (1612) to John Reed, to cite the most obvious examples. And neither Lawrence nor Heltzel called attention to the number of women who were dedicatees of the dramatic texts. It is by a study of such dedications that we can gain some understanding of the nature of women's significance as patrons.[17]

Why did some dramatists dedicate their plays to women? The answers are seldom certain. If we expect in each case to pinpoint some deed, some beneficence, that led the dramatist in gratitude to dedicate his play to a particular woman, we shall be both frustrated and disappointed. One thing, however, is clear: writing a play and dedicating it to a patroness in hope of some immediate financial reward does not seem to have ranked very high on the list of purposes. There are several other themes that run through the dedications. In some instances the dramatist wished to become known to the woman, with the implied expectation of some benefit. But many dramatists simply sought recognition, hoping that the patroness' name would lend a kind of luster to their effort. Some writers acknowledged previous benefits from the patroness. Others used the dramatic text as the occasion to celebrate an event or to celebrate and honor the woman. In those cases where the woman was herself a writer, the dedication became a means of tribute to a fellow writer also serving the muses. And some dedications seem to exist in order

[16] In *Studies in English Language and Literature Presented to Professor Dr. Karl Brunner*, ed. Siegfried Korninger, *Wiener Beiträge zur Englischen Philologie*, 65 (1957), 74-86.

[17] In a brief note Franklin B. Williams calls attention to the prominence of women as patronesses of all forms of writing. He finds that 733 women had books dedicated to them in the STC period ("The Literary Patronesses of Renaissance England," *Notes and Queries*, 207 [1962], 365).

to provide the writer, either the dramatist or his publisher, the opportunity to defend drama, either in the particular or in the abstract. These ideas and purposes will become apparent as we turn to a study of the women singled out as patronesses of drama.

The fourteen women that I have identified as patrons of drama—that is, as recipients of dramatic dedications—range from the well known to the relatively obscure. The most vexing problem is to determine the circumstances that might have led to the dedication or the context for it. Four of the women share a dedicatory statement with someone else. The 1591 revision by Robert Wilmot of *Tancred and Gismund*, for example, praises Mary, Lady Petre (wife of John, Baron Peter) and Anne, Lady Gray (wife of Baron Gray of Groby) for their rare virtues as noted by many people "(which are not a fewe in Essex)."[18] Wilmot wishes to be known to them and has "deuised this waie . . . to procure the same." He says "I shall humblie desire ye to bestow a fauourable countenance vpon this little labor, which when ye haue graced it withall, I must & will acknowledge my selfe greatly indebted vnto your Ladyships." Calling them a "worthy pair," Middleton dedicates his *The World Tossed at Tennis* (1620) to Mary Howard and her husband Charles, Baron of Effingham. Obviously these are Middleton's friends, and he offers this drama to them to celebrate their wedding: "Being then an entertainment for the best—/ Your noble nuptials comes to celebrate."[19] John Ford hopes that Mary and John Wyrley will look with favor on *The Lady's Trial* (1639), which he offers "to the mercy of your *Iudgements*: and shall rate *It* at a higher value . . . if you onely allow *It* the favour of *Adoption*."[20] In these brief examples one observes three different motivations for the dedications: to become known to the patroness, to honor a special event, and to have the play received favorably.

Bridget Radcliffe, the Countess of Sussex, is the recipient of Thomas Kyd's adulation in the dedication to his translation of Garnier's *Cornelia* (1594), in what seems a rather blatant appeal for reward. Though Kyd first modestly refers to his work as "rough, vnpollished," he warms to the task and finally declares: "A fitter present for a Patronesse . . . I could not finde."[21] He is aware of

[18] Robert Wilmot, *Tancred and Gismund* (London, 1591), sig. ★ 2ᵛ.

[19] *The Works of Thomas Middleton*, ed. A. H. Bullen (London, 1886), VII, 141.

[20] *The Lady's Trial* (London, 1639), sig. A3ᵛ.

[21] Kyd, *Cornelia* in *The Works of Thomas Kyd*, ed. F. S. Boas (Oxford, 1955), p. 102.

the Countess' "noble and heroick dispositions" and her "honour-
able fauours past (though neyther making needles glozes of the one,
nor spoyling paper with the others Pharisaical embroiderie)," and
he thus presumes upon her "true conceit and entertainement of
these small endeuours, that thus I purposed to make known my
memory of you and them to be immortall." Whether the Countess
rewarded Kyd is uncertain, but she was also the dedicatee of other
literary works, including Greene's *Philomela.*[22]

Philip Massinger cites the precedent of Italy, where women have
granted patronage and protection to writers (though he need not
have looked across the waters), as justification for sending his play
The Duke of Milan (1623) to Katherine Stanhope (wife of Philip
Lord Stanhope, eventually Earl of Chesterfield). He leaves these
"weake, and imperfect labours, at the altar of your fauour" because
"there is no other meanes left mee (my misfortunes hauing cast me
on this course)" than to let the world know "that I am ever your
Ladyships creature."[23] Lady Katherine was also the dedicatee of a
few other works, primarily religious writings, all after Massinger's
desperate plea for assistance.

Though little is known of Samuel Brandon, the author of *Virtuous
Octavia* (1598), he seems to have been acquainted with Lady Lucy
Audley (Audelay), wife of George, first Earl of Castlehaven, to
whom he dedicated this play. He proclaims her "Rare Phoenix"
and "Rich treasurer, of heauens best treasuries."[24] And he closes:
"These lines, wherein, if ought be free from blame,/ Your noble
Genius taught my Pen the same."

Certainly Ben Jonson knew Mary Wroth, to whom he addressed
three poems, *Epigrammes* ciii and cv and *Under-wood* xxx, and his
play *The Alchemist* (1612). Mary Wroth, a niece of Philip Sidney
and wife of Sir Robert Wroth, was characterized by Jonson to

[22] References come from Franklin B. Williams, *Index of Dedications and Com-
mendatory Verses in English Books before 1641* (London, 1962). Arthur Freeman
explores Kyd's relationship to the Radcliffe family, suggesting that Henry, fourth
Earl of Sussex might have been a patron of Kyd; see *Thomas Kyd: Facts and
Problems* (Oxford, 1967), pp. 34-37.

[23] *The Duke of Milan* (London, 1623), sig. A3. As the recent editors of Massinger
point out, Katherine Stanhope was the "sister of Fletcher's patron, the earl of
Huntingdon, and this relationship is surely the reason for Massinger's approaching
her" (*The Plays and Poems of Philip Massinger*, ed. Philip Edwards and Colin
Gibson [Oxford, 1976], I, xxxiii).

[24] Brandon, *The Virtuous Octavia* (London, 1598), sig. A2.

Drummond as "unworthily married on a jealous husband."[25] Praised by a number of writers, including Chapman in his translation of the *Iliad*, she also performed in Jonson's *Masque of Blackness*. Not surprisingly, then, Jonson dedicates one of his finest dramas to her, praising her value, uncommon "in these times."[26] And Jonson's relatively brief statement provides him the occasion to glance at those who indulge in fulsome praise: "But this, safe in your iudgement (which is a SIDNEYS) is forbidden to speake more; least it talke, or looke like one of the ambitious Faces of the time: who, the more they paint, are the lesse themselues." Intentionally or not, Jonson draws a link between the dedication and the play proper, whose character *Face* is essential in the grand con game of alchemy and who takes on many guises, each one making him less himself. Jonson's satiric bent, which has full rein in the play, surfaces in the dedication to the patroness. It is also interesting to note that *Epigramme* ciii emphasizes Mary Wroth's Sidney connection and *Epigramme* cv finds in her "all treasure lost of th'age before," both themes in *The Alchemist* statement, suggesting that they may all have been written about the same time.

In the final decade before the theatres close, Joseph Rutter, who according to Bentley became a disciple of Jonson in his old age, celebrates the virtues of Lady Theophilia Cooke (Coke) in the translation of the second part of *The Cid* (1640). He recalls a conversation and wishes that the French author of the play (Corneille) had her wisdom; he offers the play to her patronage "lest I be thought indiscreet in placing it else-where, or unmindfull of what I owe you, though this be the least part of that returne which is meant to you."[27] In 1635 three other works were dedicated to Lady Theophilia. Reflecting apparent long experience with the Willoughby family, William Sampson selects Ann to be patroness for his *The Vow Breaker* (1636): "it properly prostrates it selfe to you, for a patronesse."[28] He praises her "Candor, beauty, goodnes, and vertues: against those foule mouthd detractors, who . . . sought to villifie an unblaunchd Laune, a vestall puritie, a truth like Innocence." In part Sampson is responding to his critics, "ignorant Censurers (those Critticall Momes that have no language but satirick Calumnie)." But he closes with a wish for Ann Willoughby: "con-

[25] Herford and Simpson, *Jonson*, X, 50.
[26] *The Alchemist* (London, 1612), sig. A2ᵛ.
[27] *2 The Cid* (London, 1640), sig. A4.
[28] *The Vow Breaker* (London, 1636), sig. A3.

tinue ever in that noble pedigree of vertues, . . . heaven keepe you from faunning parasites, and busie gossips, and send you a Husband, and a good one." (She was eventually married to Thomas Aston.)

A personal relationship in these cases makes the woman a natural choice for patroness of the drama. The dramatist James Shirley more explicitly than others confronts the issue of selecting a woman for patroness instead of a man. In the dedication of *Changes, or Love in a Maze* (1632) to Dorothy Shirley (no relation) he acknowledges "custom, that to men/ Such poems are presented; but my pen/ Is not engag'd, nor can allow too far/ A Salic law in poetry, to bar/ Ladies th'inheritance of wit."[29] But, as the evidence shows, by 1632 singling out women as dedicatees of drama, if not commonplace, was not uncommon.

Elizabeth Cary, referred to above as a dramatist, was the dedicatee for *The Workes of Mr. Iohn Marston* (1633); she was cited for recognition by the publisher of the volume, William Sheares. He uses the dedication as a means of defending drama and touting the virtues of the plays contained in the collection. He does not understand why plays "should appeare so vile and abominable, that they should bee so vehemently inveighed against."[30] Perhaps it is because they are "plays": "The name it seemes somewhat offends them, whereas if they were styled Workes, they might haue their Approbation also" (sig. A3ᵛ). Hoping to have "pacified that precise Sect," Sheares has styled the collection *The Works of Mr. IOHN MARSTON.* He next praises Marston, "equall unto the best Poets of our times," whose work is "free from all obscene speeches" and who is "himselfe an enemie to all such as stuffe their Scenes with ribaldry, and lard their lines with scurrilous taunts and jests" (sigs. A3ᵛ, A4). This defense makes one wonder if Sheares has read the plays carefully and observed the language of, for instance, *The Dutch Courtesan.* Because Elizabeth Cary is herself a writer "well acquainted with the Muses," Sheares is "imboldened to present these Workes unto your Honours view" (sig. A4). Indeed, the report is that Lady Elizabeth is "the Mirror of your sex, the admiration, not onely of this Iland, but of all adjacent Countries and Dominions,

[29] *The Dramatic Works and Poems of James Shirley,* ed. Alexander Dyce (1833; rpt. New York, 1966), II, 272.

[30] *The Workes of Mr. Iohn Marston* (London, 1633), sig. A3. Elizabeth's husband, Henry Cary, was the subject of Jonson's *Epigramme* lxvi.

which are acquainted with your rare Vertues, and Endowments" (sig. A4ᵛ). Sheares does not seem to speak from personal knowledge of the woman; and can we suppose that he knew that she had become a Catholic? It is difficult to see how such a dedicatee would quieten the "precise Sect." In any event, he obviously thought her reputation sufficient to enhance his publishing venture. She had, after all, been the dedicatee of several other works, beginning with Drayton's *Englands Heroicall Epistles* (1597).

The final two women who were patrons of drama are the best known: the Countess of Bedford and the Countess of Pembroke. Lucy Russell, wife of Edward, third Earl of Bedford, was the recipient of more dedications than any other woman associated with the drama; these dedications, coming from such writers as Daniel, Davies, Drayton, Florio, Chapman, and Jonson, range over a forty-four year period, 1583 to 1627, suggesting her continuing prominence and importance for writers. The fortunes of John Donne were also closely involved with the Countess.[31] Hers is an explicit case of reward and support to a number of writers. With regard to the drama, she is of importance particularly to Jonson and Daniel.

Because of her prominence at Court and her influence with Queen Anne, the Countess doubtless paved the way for Jonson's masques. She herself performed in *The Masque of Blackness, Masque of Beauty, Hymenaei,* and *The Masque of Queens*; "she organized *Lovers Made Men* for Lord Hay in 1617."[32] In a special issue of *Cynthia's Revels* (1601), Jonson included an address praising the Countess. Because it is brief and not often reprinted, I quote the entire dedication, entitled "Author *ad Librum*," found in the copy in the William Andrews Clark Library, Los Angeles:

> Goe little Booke, Goe little *Fable*
> vnto the bright, and amiable
> *LVCY* of *BEDFORD*; she, that Bounty
> appropriates still vnto that *County*:
> Tell her, his *Muse* that did inuent thee
> to *CYNTHIAS* fayrest *Nymph* hath sent thee,
> And sworne, that he will quite discard thee

[31] See Patricia Thomson, "The Patronage of Letters under Elizabeth and James I," *English*, 7 (1949), 278-82. Also see her essay, "The Literature of Patronage, 1580-1630," *Essays in Criticism*, 2 (1952), 267-84.

[32] Herford and Simpson, *Jonson*, X, 440.

if any way she do rewarde thee
But with a *Kisse*, (if thou canst dare it)
of her white Hand; or she can spare it.

One can be reasonably sure that Jonson hoped for and indeed received more than a simple kiss for his dramatic text. *Epigrammes* lxxvi, lxxxiv, and xciv also celebrate Lucy Russell.

When Jonson was in jail for his part in *Eastward Ho*, he apparently wrote a letter to the Countess, or at least that is the conjecture of his modern editors Herford and Simpson. He begs for help: "if it be not a sinne to prophane yor free hand with prison polluted Paper, I wolde intreate some little of your Ayde, to the defence of my Innocence."[33] Jonson marvels that he is in jail: "our offence a Play, so mistaken, so misconstrued, so misapplied, as I do wonder whether their Ignorance, or Impudence be most, who are our adversaries." He closes with the implied request for help: "What our sute is, the worthy employde soliciter, and equall Adorer of youre vertues, can best enforme you" (I, 198). Whether the addressee was indeed the Countess of Bedford, which seems most plausible, and whether she assisted, we do not know; but Jonson was freed from prison, and surely such influential friends as the Countess could only help his case. We may have here, in fact, an unusually effective instance of patronage, in which the patroness aids the cause of drama by helping gain the release of the dramatist from prison. But then, implicit in the role of patron is the task of protector.

The Countess of Bedford was of considerable help to Samuel Daniel. She, "who had charge of the Queen's masque for the first Christmas of the new reign, recommended Daniel to the Queen";[34] the result was Daniel's *The Vision of the Twelve Goddesses*, performed on 8 January 1604 at Hampton Court and dedicated to the Countess. Daniel's pastoral *The Queen's Arcadia* was presented before the Queen and the Countess at Christ Church, Oxford in August 1605. "He long continued to profit by Lady Bedford's introduction to the Queen, for she appointed him together with John Florio, to be a Groom of her Privy Chamber."[35]

In the authorized text of the masque Daniel offers a 210-line

[33] Herford and Simpson, *Jonson*, X, 197.

[34] Joan Rees, *Samuel Daniel: A Critical and Biographical Study* (Liverpool, 1964), p. 90.

[35] John Buxton, *Sir Philip Sidney and the English Renaissance* (London, 1954), p. 229.

statement, certainly the longest dedication of a dramatic text. He provides a lengthy account of "the intent and scope of the project," describing all the mythological figures, their iconography, and their function, and thereby greatly enhancing the understanding of the masque. Rather than get involved in the complex and sometimes contradictory iconological interpretation of figures, Daniel says that "we took their aptest representations that lay best and easiest for us."[36] He provides this extended account because he does not want the experience to slip into oblivion, for "(by the unpartial opinion of all the beholders, strangers and others) it was not inferior to the best that ever was presented in Christendom" (p. 30). And equally important, the dedication offers the means whereby Daniel "might clear the reckoning of any imputation that might be laid upon your [the Countess'] judgment for preferring such a one to her Majesty in this employment" (p. 30). Not only did the Countess make it possible for Daniel to write the masque; she also performed the role of Vesta in the entertainment.

The literary and dramatic fortunes of Daniel are much involved also with the patronage of Mary Herbert, Countess of Pembroke, renowned for her support of writers. Pearl Hogrefe sums up Mary Herbert's contribution to literature: "She gave practical help and encouragement to many writers when she became the Countess of Pembroke and lived at Wilton House; she influenced the writing of her brother, Philip, during his brief life; she edited and published all his prose and his poetry after his death; she published her own translations from French and Italian and had an outstanding part in turning the Psalms into Elizabethan lyrics."[37] Understandably

[36] "The Vision of the Twelve Goddesses," ed. Joan Rees in *A Book of Masques in Honour of Allardyce Nicoll* (Cambridge, 1967), p. 26.

[37] Hogrefe, *Tudor Women*, p. 124. In her dissertation Mary Ellen Lamb suggests that the importance and extent of the Countess' patronage has been exaggerated: "her husband's wealth, her brother's fame, and her own reputation for generosity were probably responsible for the many single works dedicated to her by authors who do not seem to have been acquainted with her" ("The Countess of Pembroke's Patronage," Ph.D. Dissertation, Columbia University, 1976, p. 255). The facts are that some thirty texts were dedicated to her, the second highest number of books dedicated to a woman other than royalty (the first being the Countess of Bedford with thirty-eight)—see Williams, "The Literary Patronesses of Renaissance England," p. 366. Ms. Lamb further claims that "A patron's influence cannot be assumed for every author who dedicated a work; it must be indicated in some other way besides a dedication or the possible use of a literary model" (p. 241). But such a view creates more problems than it solves. The simple act of dedicating a text does indicate influence, whatever it may prove precisely about an act of patronage.

she is the recipient of a number of dedications of literary works from such writers as Daniel, Spenser, Davies, Breton, Morley, and Fraunce.

In the drama there are several acknowledgments of her as patron- ess. Abraham Fraunce dedicates *Amyntas Pastoral* (1591) to the Countess, saying, "If *Amyntas* found fauour in your gracious eyes, let *Phillis* bee accepted for *Amyntas* sake."[38] Fraunce for the most part discusses and defends poetic form. If we may strain the point slightly and allow Sidney's *Arcadia* (1598 edition) as partially a dramatic text because it includes *The Lady of May*, a progress entertainment of 1578, then Sidney's dedication of the romance to his sister may be included. His moving statement credits her with being the inspiration for his work: "For my part, . . . I could well find in my heart, to cast out in some desert of forgetfulnes this child, which I am loth to father. But you desired me to do it, and your desire, to my heart is an absolute commandement. Now, it is done onely for you, onely to you."[39] Most of it, he says, was written in her presence. The chief protection for his work, Sidney writes, will be "bearing the liuerie of your name" (sig. ¶3ᵛ). In the most personal statement in any of the dedications examined here, Sidney closes: "And so . . . you will continue to loue the writer, who doth ex- ceedingly loue you, and moste moste heartilie praies you may long liue, to be a principall ornament to the family of the *Sidneis*," which is exactly what Mary Herbert did. She, of course, is no ordinary or conventional patroness for her brother's work: she inspired it and brought it to light by editing and publishing it.

More typical is William Gager's address to the Countess in his *Ulysses Redux* (1592). He does not know her personally: "Nimis inverecunde facio, illustrissima Domina, qui tibi, ne de facie, vix de nomine, cognitus, literis tamen meis Celsitudinem tua[m] inter- pello" (I am perhaps acting audaciously, most illustrious lady, who am known to you if not by appearance then at least by name, thus to intrude upon your ladyship with my writings).[40] But he is en- couraged to be audacious, has heard much about her, and has admired her brother and the whole family, "totam etiam Sid- neiorum gentem." Because of her extraordinary spirit and candor, he has sought some means to be known to her, "vt aliqua tibi honesta ratione innotescerem"; and nothing could be more honest

[38] *Countess of Pembrokes Ivychurch* (London, 1591), sig. A2.
[39] *The Countess of Pembrokes Arcadia* (London, 1598), sig. ¶3.
[40] Gager, *Ulysses Redux* (Oxford, 1592), sig. A2.

than literature, "ac praesertim poetica." Gager also recalls the indebtedness of many poets to her ("debent Poete nostri" [sig. A2]) and makes a valuable observation about patronage: it aids the giver as well as the recipient by providing glory. The dedication closes with Gager's wish that she will favorably receive his *Ulysses* and with confidence that she will: "Quare peto a te, Nobilisima Comitissa, vt Vlysi, non in Ithacam, sed in scenam iam primum venienti, tanquam altera Penelope, saltem manum tuam exosculandam porrigere digneris. Quod te prestituram, plane confido." (Therefore, most noble Countess, I ask you to be another Penelope and deign at least to extend your hand to be kissed by Ulysses as he comes, not to Ithaca, but now for the first time onto the stage. And I have full confidence that you will do so [Sigs. A2ᵛ-A3]). Her expected act of favor Gager describes as "humanitate."[41]

At the time that Gager was writing his academic dramas, the Countess was leading a whole group of writers, including Kyd and Daniel, in translating Garnier's tragedies. It is unclear why Mary Herbert should have wished to make these French classical plays available in English, but one reasonable speculation is that this program of translation and these particular dramas fit the ideas found in Philip Sidney's *Apologie*.[42] At any rate, the true course of English drama passed them by; theirs, as it turned out, was a program of the past, not the future charted by Marlowe and Shakespeare.

Having already dedicated *Delia* and *Rosamond* to the Countess, Daniel seemed a prime candidate for carrying the English Garnier banner and hewing to classical principles of dramatic construction. By 1594, Daniel was "deeply immersed in the Wilton atmosphere and *Cleopatra* is Pembroke work in a much fuller sense than *Delia* and *Rosamond* are. Daniel is keenly aware that this verse drama

[41] One might also include Christopher Marlowe in the list of dramatists who wrote dedications to the Countess, though Marlowe's statement is prefixed to *Amintae Gaudia Authore Thoma Watsono* (1592). The dedication, signed by "C. M." and in Latin, sounds several familiar themes. Marlowe promises that "in the foremost page of every poem" he will "invoke thee as Mistress of the Muses to my aid" (Mark Eccles' translation in *The Complete Works of Christopher Marlowe*, ed. Fredson Bowers [Cambridge, 1973], II, 539). Marlowe's exact relationship to the Countess is indeterminate.

[42] See, for example, Alexander M. Witherspoon, *The Influence of Robert Garnier on Elizabethan Drama*, Yale Studies in English, 65 (New Haven, 1924), p. 67, and *passim*.

marks a new and probably decisive stage in his literary career."[43]
The play is an excellent example of what the "Pembroke school"
aimed at: "a shapely and complete artefact that could be fingered
piece by piece and admired for its skill and polish."[44] How many
other literary figures of this era self-consciously set out to shape the
direction of dramatic form with a clear-set system of principles?
The Countess of Pembroke is a patron of extraordinary quality,
even if theatre history may in retrospect see the effort as a failure.

In the dedicatory statement prefaced to *Cleopatra* (1594), Daniel
touches on several issues as he directs his thanks and praise to the
Countess. He begins with an acknowledgment of the Countess'
involvement with—and inspiration for—his translation:

> Loe heere the worke which she did impose,
> Who onely doth predominate my Muse:
> The starre of wonder, which my labours chose
> To guide their way in all the course I vse.
> Shee, whose cleere brightnes doth alone infuse
> Strength to my thoughts, and makes mee what I am;
> Call'd vp my spirits from out their low repose,
> To sing of state, and tragick notes to frame.[45]

He admits that his drama is a direct response to the Countess' own
Antonie: "thy well grac'd *Anthony*/ . . . Requir'd his *Cleopatras*
company" (14, 16). And he acknowledges her support: "thou so
graciously doost daine,/ To countenaunce my song and cherish mee"
(29-30). Thus he must labor to be worthy of this investment: "I
must so worke posterity may finde/ How much I did contend to
honour thee" (31-32). As Daniel closes this extended statement, he
voices what must have been a common idea for those who sought
in patronage, if not financial reward, at least recognition:

> But, (Madam,) this doth animate my mind,
> That fauored by the Worthyes of our Land,
> My lynes are lik'd; the which may make me grow,
> In time to take a greater taske in hand.

> (109-12)

But Daniel also provides an apology for the Pembroke endeavor
on both aesthetic and moral grounds. Their cause is no less than

[43] Rees, *Samuel Daniel*, p. 43.
[44] Rees, *Samuel Daniel*, p. 48.
[45] Daniel, *Cleopatra* (London, 1594), sig. H5, lines 1-8.

"To chace away this tyrant of the North:/ *Gross Barbarism*" (34-35), first encountered and done battle with by Philip Sidney, thereby emboldening others to wrest "that hidious Beast incroching thus" (40). The references to "darkness," "foe," and "Monsters" assure a stridently moral tone to the effort of poetry: this is no ordinary defense of drama as seen, for example, in the comment by William Sheares affixed to the Marston edition. In a nationalistic vein Daniel defends their style against the disregard of their European counterparts, "That they might know how far *Thames* doth out-go/ The musique of Declyned Italie" (77-78). He wishes that the work of Sidney and Spenser were better known, enchanting the world "with such a sweet delight" (91), thus demonstrating "what great ELIZAS raigne hath bred./ What musique in the kingdome of her peace" (93-94).

It is clear that Daniel needs the patronage of the Countess far more than she needs him: "Although thy selfe dost farre more glory giue/ Vnto thy selfe, then I can by the same" (51-52). He praises her translation of the Psalms, "In them must rest thy euer reuerent name" (61). By such artistic efforts and by, one supposes, her acts of patronage the Countess has achieved a fame that will be known "When *Wilton* lyes low leuell'd with the ground" (66). And, in words reminding us of Shakespeare's *Sonnets*, Daniel says: "This Monument cannot be ouer-throwne,/ Where, in eternall Brasse remaines thy Name" (71-72).

Later editions of *Cleopatra* provide an interesting insight into the waxing and waning of patronage. As Joan Rees points out, the verse dedication was omitted in the editions of 1605 and 1607; but by the 1611 text the dedication, slightly revised, reappeared, suggesting that the Countess had resumed her patronage of Daniel.[46] Though he covers much of the same ground, there are some changes, as one would expect in a statement written nearly twenty years later. He acknowledges their renewed relationship: "And glad I am I haue renewed to you/ The vowes I owe your worth, although thereby/ There can no glory vnto you accrew."[47] The dedication begins by calling attention to the obvious fact that the Countess is a woman, a point not emphasized in the 1594 verses:

> Behold the work which once thou didst impose
> Great sister of the Muses glorious starre

[46] Rees, *Samuel Daniel*, p. 149.
[47] Daniel, *Certaine Small Workes* (London, 1611), sig. E4.

Of femall worth, who didst at first disclose
Vnto our times, what noble powers there are
In womens harts, and sent example farre
To call vp others to like studious thoughts . . .
 (sig. E3).

Why Daniel should make this point in 1611 is uncertain; perhaps
in the era of the male-dominated Court it was worth noting the
remarkable accomplishments of women and of the Countess in
particular.

 This study of women patrons of the drama may be seen as a
verification of Daniel's comment that there are noble powers in
women's hearts, powers that led to the creation and active support
of the drama, that inspired some dramatists to do their work, that
provided financial support, that offered the much-desired but some-
times elusive quality of favorable recognition. Assessing the con-
tribution of women to the flourishing of drama during the Renais-
sance is not a simple matter of tallying monies expended, but rather
of taking into account reputations secured, possibilities gained,
doors opened, and the more intangible qualities of guiding and
supporting spirits. Without understanding the role of women as
patrons we are left with a partial and incomplete picture of the-
atrical activity in this its richest period.

The Visual Arts

TWELVE

⊠

Artists, Patrons, and Advisers in the Italian Renaissance[1]

⊠

Charles Hope

ONE of the most celebrated documents about Renaissance patronage is the program provided by Isabella d'Este for Perugino in 1503 in connection with a painting for her *studiolo* now in the Louvre, the *Combat of Love and Chastity* (Figure 12.1). This program was almost certainly devised by Paride da Ceresara, a Mantuan citizen of wide literary and intellectual interests. It specified the content of Perugino's composition in great detail:

> Our poetic invention, which we greatly want to see painted by you, is a battle of Chastity against Lasciviousness, that is to say, Pallas and Diana fighting vigorously against Venus and Cupid. And Pallas should seem almost to have vanquished Cupid, having broken his golden arrow and cast his silver bow underfoot; with one hand she is holding him by the bandage which the blind boy has before his eyes, and with the other she is lifting her lance and about to kill him. By comparison Diana must seem to be having a closer fight with Venus for victory. Venus has been struck by Diana's arrow only on the surface of the body, on her crown and garland, or on a veil she may have around her; and part of Diana's raiment will have been singed by the torch of Venus, but nowhere else will either of them have been wounded. Beyond these four deities, the most chaste nymphs in the trains of Pallas and Diana, in whatever attitudes and ways you please, have to fight fiercely with a lascivious crowd of fauns, satyrs and several thousand cupids; and these cupids must be smaller than the first, and not bearing gold bows and silver arrows, but bows and arrows of some baser material such as wood or iron or what you

[1] I should particularly like to thank Elizabeth McGrath for invaluable criticisms and suggestions.

293

please. And to give more expression and decoration to the picture, beside Pallas I want to have the olive tree sacred to her, with a shield leaning against it bearing the head of Medusa, and with the owl, the bird peculiar to Pallas, perched among the branches. And beside Venus I want her favourite tree, the myrtle, to be placed. But to enhance the beauty a fount of water must be included, such as a river or the sea, where fauns, satyrs and more cupids will be seen, hastening to the help of Cupid, some swimming through the river, some flying, and some riding upon white swans, coming to join such an amorous battle. On the bank of the said river or sea stands Jupiter with other gods, as the enemy of Chastity, changed into the bull which carried off the fair Europa; and Mercury as an eagle circling above its prey, flies around one of Pallas's nymphs, called Glaucera, who carries a casket engraved with the sacred emblems of the goddess. Polyphemus, the one-eyed Cyclops, chases Galatea, and Phoebus chases Daphne, who has already turned into a laurel tree; Pluto, having seized Proserpina, is bearing her off to his kingdom of darkness, and Neptune has seized a nymph who has been turned almost entirely into a raven.

I am sending you all these details in a small drawing, so that with both the written description and the drawing you will be able to consider my wishes in this matter. But if you think that perhaps there are too many figures in this for one picture, it is left to you to reduce them as you please, provided that you do not remove the principal basis, which consists of the four figures of Pallas, Diana, Venus and Cupid. If no inconvenience occurs I shall consider myself well satisfied; you are free to reduce them, but not to add anything else. Please be content with this arrangement.[2]

The relationship between artist, patron, and adviser reflected in this commisssion is often seen as a paradigm of Renaissance patronage, especially in the case of works of art with nonreligious subjects. Indeed, such a relationship is taken as a precondition, whether or not explicitly stated, of many recent discussions of icon-

[2] Fiorenzo Canuti, *Il Perugino* (Siena, 1931), II, 212ff.; this translation from D. S. Chambers, *Patrons and Artists in the Italian Renaissance* (London, 1970), pp. 136ff. The entire documentation for this commission is in Canuti, *Il Perugino*, II, 208-37.

12.1. Pietro Perugino. *The Combat of Love and Chastity.*

ographic problems of this period. It is assumed that the artist was merely an executant, working to a detailed program rich in abstruse allusions to a literary and philosophical culture in which he can rarely, if ever, have fully participated. But even his patron, it would seem, was not entirely at home in this culture. For it is believed that the devising of programs was entrusted to a learned "humanist adviser." Thus many works of Renaissance art have come to be regarded as direct illustrations of the ideas of an intellectual elite whose primary interest was not painting or sculpture, but erudite texts. So widespread is this belief that even ostensibly simple subjects, such as familiar episodes from classical mythology, have come to be interpreted in the most complicated way, on the assumption that they were chosen by an adviser for some hypothetical "second level of meaning," and that every detail in the composition must be iconographically significant. Yet why patrons should have behaved in this way, why the content of works of art should always have been of such importance to them, and why they should have regarded humanists as appropriate people to consult on the matter are issues that are scarcely discussed.

The purpose of this paper is to examine, if only in the most general way, the available evidence about the role of advisers and the actual behavior of patrons. For the only way to test the validity of current iconographic interpretations is to study the kind of instructions artists were given and to try to establish who was responsible for devising these instructions and under what circumstances. This is by no means a simple matter, since the type of documentary evidence that one would ideally require is exceedingly rare. The program sent to Perugino, in fact, is virtually the only one of its kind to survive from the years around 1500—a circumstance that in part explains the importance that historians have attached to it. But from the mid-sixteenth century onwards equally elaborate programs have been preserved in considerable numbers. Examples from different parts of Italy and involving different types of commissions include Annibal Caro's proposals for Taddeo Zuccaro's decorations at Caprarola, his suggestion for the obverse of a medal of the bishop of Fossombrone, the recommendations of Cosimo Bartoli and Vincenzo Borghini for Vasari's frescoes in the Palazzo Vecchio, the instructions sent to Titian in connection with the ceiling paintings for the town hall of Brescia, as well as numerous schemes for triumphal entries and other court festivals, of which

the most fully documented are the arrangements devised by Borghini for the marriage of Francesco de' Medici in 1565.[3]

It does not follow, however, that artistic commissions at this period always involved the provision of detailed programs. This practice is known to have occurred only in connection with projects whose iconographic content was of paramount importance, as was obviously the case in most of the examples just cited. In this respect the behavior of patrons was no different at earlier or later periods; the iconography of the decoration of public buildings, of dynastic marriage celebrations, or of medals is almost always a subject for concern and careful planning. But at first sight Caro's program for Caprarola, a semi-private building, is less easily explained on such grounds. It more obviously reflects a distinctive characteristic of the taste of its period, a delight in the conspicuous display of erudition in the choice of unexpected but appropriate themes.[4] Thus, in accordance with the principle of decorum, all the subjects devised for Alessandro Farnese's study were associated with solitude, and include such bizarre figures as Druids, Gymnosophists, and Essenes. The point here is not merely that Caro's program was learned, but that it was seen to be so. To unravel the iconography was evidently a sort of intellectual game, like explaining an *impresa*; and on this occasion Caro seems to have gone out of his way to make it as difficult as possible.

This half-pretentious, half-playful attitude in devising schemes of this kind is well illustrated by Cellini's account of the origin of his famous salt-cellar (Figure 12.2).[5] The project was first suggested to him by Cardinal Ippolito d'Este during a visit to the studio with two literary friends, Luigi Alamanni and Gabriele Cesano, each of

[3] For Caro's programs, see Annibal Caro, *Lettere familiari*, ed. Aulo Greco (Florence, 1957-61), I, 178ff. and III, 131-40, 237-40; for the Brescia program, see Harold E. Wethey, *The Paintings of Titian* (London, 1969-75), III, 251-55; for the programs for Palazzo Vecchio, see especially Karl Frey, *Der literarische Nachlass Giorgio Vasaris* (Munich, 1923-30), I, 410-15, 437-42, 447-51, 526-31 etc.; a full bibliography of the 1565 marriage celebrations in Florence appears in Annamaria Petrioli Tofani, *Mostra di disegni Vasariani* . . . (Gabinetto disegni e stampe degli Uffizi, XXII) (Florence, 1966), pp. 6ff., the most interesting text for the present discussion being Borghini's report to Cosimo I, dated 5 April 1565, in Giovanni Bottari and Stefano Ticozzi, *Raccolta di lettere sulla pittura, scultura ed architettura* (Milan, 1822-25), I, 125-204.

[4] For a discussion of this program, and of many of the issues raised in this paper, see E. H. Gombrich, "Aims and Limits of Iconology," *Symbolic Images* (London, 1972), pp. 1-25, especially pp. 9-11.

[5] Benvenuto Cellini, *Vita*, ed. Orazio Bacci (Florence, 1901), pp. 247ff.

whom proposed an iconographic scheme. Alamanni wanted Cellini to show "a Venus with a cupid, together with many pretty details, all appropriate to the subject," while Cesano wanted "an Amphitrite, the wife of Neptune, with some of those Tritons of Neptune and many other things."[6] But Cellini rejected these suggestions, on the grounds that "Many things are beautiful enough in words which do not work well when they are actually executed."[7] His own solution, with a reclining male figure representing the sea, for the salt, and a female figure representing the land, for the pepper, with other appropriate details, was iconographically quite as sophisticated as those of Alamanni and Cesano, and in its visual effect far superior, allowing him as it did to display a beautifully elegant *contrapposto* in his treatment of the principal figures.[8]

The most interesting aspect of this account is the difference of approach between Cellini on the one hand and Alamanni and Cesano on the other. The sculptor took as his starting point the problem of devising a satisfactory composition, and only then chose an appropriate subject to fit; indeed, he did not even bother to record that the man was Neptune and the woman Tellus. The Cardinal's learned friends could only produce something "good enough when described, but not when executed."[9] Such advisers always had learning in plenty to show off. That, after all, was why they were consulted in the first place; but the visualization of their clever ideas was often a problem for the unfortunate artists. As a result, virtually every work of art from this period known to have been based on a learned program is immediately recognizable as such, either from the unusual subject matter or from the proliferation of obviously meaningful detail (Figures 12.3 and 12.4). By the same token, no instances are known in which a detailed program was provided for a standard theme such as an episode from Ovid. As Federico Gonzaga wrote to Titian in 1534 to commission two pictures on behalf of his brother Ferrante: "In one of them I want the Rape of Pros-

[6] My translation of Cellini's record of Alamanni's words, "una Venere con un Cupido, insieme con molte galanterie, tutte approposito" and Cesano's, "una Hamphitrite moglie di Nettunno, insieme con di quei Tritoni di Neptunno e molte altre cose" (Cellini, *Vita*, p. 247).

[7] My translation of Cellini: "molte cose son belle da dire, che faccendole poi non s'accompagniano bene in opera" (Cellini, *Vita*, p. 247).

[8] For the concept of *contrapposto*, see D. Summers, "*Contrapposto*: Style and Meaning in Renaissance Art," *Art Bulletin*, 69 (1977), 336-61.

[9] My translation of Cellini: "cose assai belle da dire, ma non da fare" (Cellini, *Vita*, p. 247).

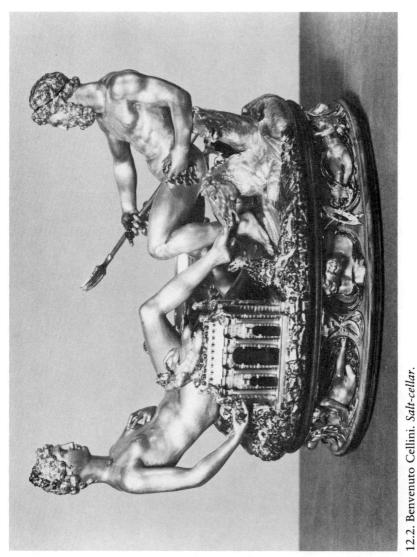

12.2. Benvenuto Cellini. *Salt-cellar*.

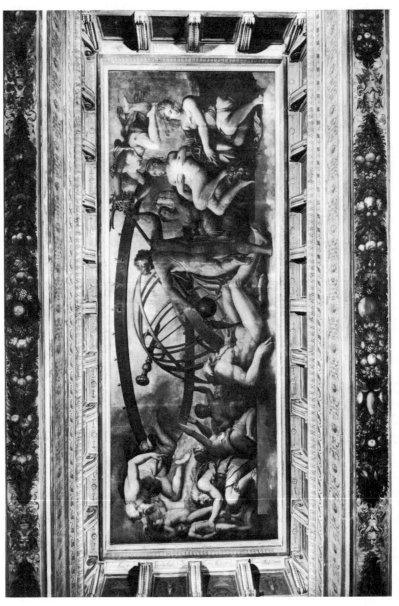

12.3. Giorgio Vasari. *Saturn Castrating Uranus.*

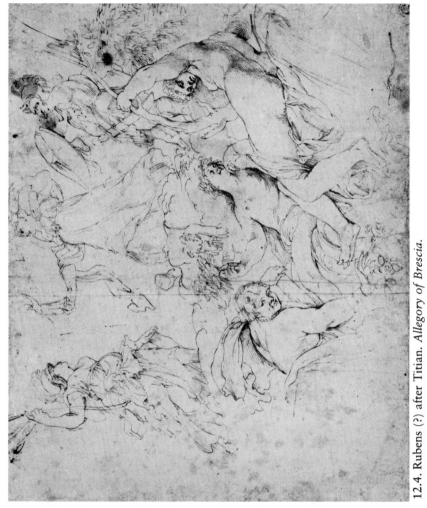

12.4. Rubens (?) after Titian. *Allegory of Brescia.*

erpina, on the subject of which I shall say no more, since you are very well informed and know what figures are needed."[10]

That Federico's attitude is typical is something that many historians now seem to find hard to credit, so convinced are they of the presence of deeper levels of meaning in straightforward subjects. Their principal justification in this point of view comes not from surviving documents about the processes of patronage, but from the manuals of Cartari and others, which treat mythology from an essentially antiquarian standpoint, summarizing in a quite unsystematic way the various interpretations—historical, physical, and moral—that had been proposed to explain the legends of the classical gods.[11] It has yet to be shown, however, that such interpretations were thought to be relevant, as a rule, to works of art, let alone that they reflect the kinds of associations that classical myths possessed for sixteenth-century patrons. Indeed, there is one particularly telling piece of evidence that patrons could enjoy representations of mythological themes entirely for their own sake, without worrying about any deeper significance that might in certain contexts have been attached to them. It is a well-known letter from no less a figure than Annibal Caro, addressed to Vasari:

> It is my desire to possess a notable work of your hand both for the sake of your reputation and for my satisfaction; because I want to be able to show it to certain people who know you better as a quick painter than as an excellent one. . . . As to doing it quickly or slowly I leave that to you, because I think that it is also possible to do things quickly and well when the frenzy seizes you as happens in painting, which in this respect as in all others is very much like poetry. . . .
>
> And as to the invention of the subject matter, I also leave this to you, remembering another similarity that painting has with poetry; all the more so since you are both a poet and a painter, and since in each of these pursuits one tends to express one's own ideas and conceptions with more passion and zeal than those of any other person. Provided there are two nude figures, a male and a female (which are the most worthy sub-

[10] My translation of Federico's letter: "In uno vorria che fosse il rapto di Proserpina, sopra il che non se vi dice altro, che voi ne siete instruttissimo, et sapete che figure vi bisognino" (C. Gaye, *Carteggio inedito d'artisti* . . . [Florence, 1839-40], II, 252).

[11] Jean Seznec, *The Survival of the Pagan Gods* (New York, 1961), especially pp. 219-56.

jects of your art), you can compose any story and any attitudes you like. Apart from these two protagonists I do not mind whether there are many other figures provided they are small and far away; for it seems to me that a good deal of landscape adds grace and creates a feeling of depth. Should you want to know my inclination I would think that Adonis and Venus would form an arrangement of the two most beautiful bodies you could make, even though this has been done before. And as to this point it would be good if you kept as closely as possible to the description in Theocritus. But since all of the figures he mentions would result in too intricate a group (which, as I said before, would not please me) I would only do Adonis embraced and contemplated by Venus with that emotion with which we watch the death of the dearest; let him be placed on a purple garment, with a wound in his thigh with certain streaks of blood on his body with the implements of the hunt scattered about and with one or two beautiful dogs, provided this does not take up too much space. I would leave out the nymphs, the Fates and the Graces who in Theocritus weep over him, and also those love-gods attending him, washing him and making shade with their wings, and only put in those other love-gods in the distance who drag the boar out of the wood, one of them striking him with the bow, the other pricking him with an arrow and the third pulling him by a cord to take him to Venus. And if possible I should indicate that out of this blood are born the roses and out of the tears the poppies. This or a similar invention I have in my mind because apart from the beauty it would need emotion, without which the figures lack life.

Should you not want to do more than one figure, the Leda, particularly the one by Michelangelo, pleases beyond measure. Also that Venus which that other worthy man painted as she rose from the sea would, I imagine, be a beautiful sight. Even so (as I said before) I am satisfied to leave the choice to you.[12]

Caro's principal concern was to acquire a satisfactory composition, his preference for two nude figures, one male and one female,

[12] Caro, *Lettere familiari*, II, 62-64; this translation from E. H. Gombrich, *The Heritage of Apelles* (Oxford, 1976), pp. 124ff. The poem on which Caro based his invention is no longer ascribed to Theocritus; it was later used as an iconographic source by Federico Zuccaro (G. Smith, *The Casino of Pius IV* [Princeton, 1977], pp. 77ff.).

bringing to mind Cellini and his salt-cellar. It is true that he goes into great detail in suggesting what he wanted, but his standpoint is very different from that of Isabella d'Este. The subject of Venus and Adonis was chosen not for any intrinsic meaning, but because it was thought suitable for an artist; and the paraphrase of the poetic text was surely included to save Vasari the trouble of looking it up and translating it for himself. It is significant too that the text was merely to serve as a basis for the picture; Caro did not expect Vasari to follow it with slavish accuracy.

This point is worth emphasizing, since historians are now sometimes surprised when painters diverge from texts of this kind. A case in point is provided by Titian's *poesie* for Philip II (Figure 12.5), which in some respects differs notably from the *Metamorphoses*. It is quite unnecessary to try to explain these differences, as some scholars have done, on iconographic grounds, let alone to suppose that the series as a whole had a complex and coherent program.[13] A careful reading of the documents indicates that Titian himself chose the subjects and changed them several times without reference to his patron.[14] Philip, like Caro, expected to receive beautiful poetic paintings; to seek for deeper meanings in them would be quite inappropriate. On occasion, indeed, artists could dispense with texts and precisely predetermined themes altogether, as Giambologna did with his *Rape of the Sabines*, which received its title only after it was completed.[15]

Perhaps the most important distinction between the attitude of patrons like Caro and Philip II and that of Isabella d'Este lay in the status they accorded to artists. While Perugino was permitted virtually no initiative, Titian, throughout his entire association with Philip, scarcely ever received any instructions about the subjects of

[13] See, for example, H. Keller, *Titians Poesie für König Philipp II von Spanien* (Wiesbaden, 1969); M. Shapiro, "Titian's *Rape of Europa,*" *Gazette des Beaux-Arts*, 6ᵉ pér., 77 (1971), pp. 109-16; M. Tanner, "Chance and Coincidence in Titian's *Diana and Actaeon,*" *Art Bulletin*, 66 (1974), 535-50.

[14] A. Cloulas, "Documents concernant Titien conservés aus Archives de Simancas," *Mélanges de la Casa de Velázquez*, 3 (1967), 201-88; Luigi Ferrarino, *Tiziano e la Corte di Spagna* (Madrid, 1975).

[15] For this famous episode see David Rosand, "Art History and Criticism: The Past as Present," *New Literary History*, 5 (1973-74), 435-45, and especially pages 439-41. Rosand points out that Giambologna's sculpture cannot be seen simply as a stylistic exercise devoid of content; he was, after all, working in "a particular expressive mode," that of heroic, struggling male and female figures.

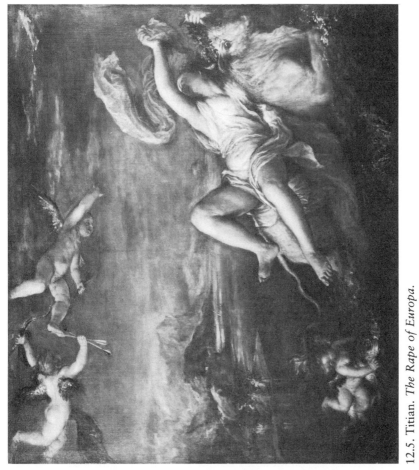

12.5. Titian. *The Rape of Europa.*

his paintings, whether religious or profane.[16] By his time artists were simply not prepared to accept a totally subordinate position, nor were they expected to do so. Thus Caro prefaced his proposals for the decoration of Alessandro Farnese's study at Caprarola with the words:

> The themes to be painted in the Study of the illustrious Monsignore Farnese must needs be adapted to the disposition of the painter, or he must adapt his disposition to your theme. Since it is clear that he did not want to adapt to you we are compelled to adapt to him to avoid muddle and confusion.[17]

Again, Vincenzo Borghini, in submitting his scheme for the entry of Francesco de'Medici's bride into Florence, deliberately avoided going into great detail, for, as he said:

> there is an additional consideration, namely that since one has to employ different artists, everyone will be eager (while not departing from the invention given to him) to display his ingenuity, to show off a little and provide a sample of his talent. This should be allowed and even encouraged, since each artist will exert himself and make something beautiful.[18]

Titian, it is true, had to follow a very detailed program in his paintings for Brescia; but this document was not compiled until some months after he had begun work on the project, his own ideas having failed to satisfy his patrons.[19] As for Vasari, he settled the

[16] Apart from portraits, the only pictures known to have been specifically requested by Philip are the *Martyrdom of St. Lawrence* in the Escorial (see Cloulas, *Mélanges*, p. 265) and the *Allegory of Lepanto* in the Prado (see J. Martínez, "Discursos practicables," in *Fuentes literarias para la historia del arte español,* F. J. Sánchez Cantón ed. [Madrid, 1923-41], III, 41).

[17] Caro, *Lettere familiari*, III, 237; this translation from Gombrich, "Aims and Limits of Iconology," p. 9.

[18] My translation of Borghini: "Ed, oltre a tutto questo, ci è quest'altra considerazione, che avendosi ad allogar a diversi maestri, ognuno arà caro (non uscendo dell'invenzione data loro) d'esercitar l'ingegno suo, e far un po' di mostra e dar saggio del suo valore; il che è da permettere, anzi da desiderare, perchè ognuno si assottiglierà, e farassi di belle cose" (Bottari and Ticozzi, *Raccolta di lettere*, I, 128).

[19] The contract dates from 3 October 1564, but the program was sent to Titian only on 6 August 1565, some time after he had begun one picture "secondo la sua intentione" (see Carlo Pasero, "Nuove notizie d'archivio intorno alla Loggia di Brescia," *Commentari dell'Ateneo di Brescia*, 151 [1952], 49-91, especially pp. 55ff.).

program for the Palazzo Vecchio himself in consultation with his advisers, whose suggestions were open to modification.[20] It is evident, too, that much of the detailed content of the frescoes, such as the emphasis on artistic patronage in the Sala di Cosimo il Vecchio, was Vasari's own responsibility.[21] This should not surprise us, since his expertise in iconography was considerable, as is shown, for example, by his scheme for the lost façade frescoes on the palace of Sforza Almeni.[22] But Vasari was not alone among artists in possessing this competence, as well as this taste for complexity. Both Federico Zuccaro and Jacopo Zucchi devised iconographic schemes of the utmost elaboration.[23]

By the mid-sixteenth century, then, the practice of consulting learned advisers was well established, but by no means an invariable rule. The use of highly complex imagery was partly a matter of taste, partly dependent on the nature of the commission. If there were erudite allusions, the spectator would have known very well that he had to find them, since the kinds of interpretations that might appropriately be applied to a work of art were generally evident from its context as well as its appearance. But it would be wrong to imagine clever laymen imposing incomprehensible instructions on docile and ignorant artists: the conventions governing the use of iconography were well known to both parties, and there exist plenty of works of art from this period, both simple and complicated in their meaning, that were devised entirely by the artists.

If we compare this situation with the case of Isabella and Perugino, there are obvious parallels. In particular, the actual appearance of the *Combat of Love and Chastity* is absolutely characteristic of a painted program. The mass of quaintly juxtaposed and familiar

[20] As indicated, for example, by the following remark of Bartoli in a letter to Vasari about the decoration of the Sala degli Elementi: "Questo é quanto mi occorre circa alla historia presente per voler cosa che, secondo me, havessi del buono: pur mi rimetto sempre al parer vostro et di chi più di me se ne intende" (Frey, *Der literarische Nachlass Giorgio Vasaris*, I, 412). Comments of the same kind occur frequently in these documents.

[21] Compare the program (Frey, *Der literarische Nachlass Giorgio Vasaris*, I, 439-42), in which no artist is mentioned by name, with Vasari's own account in the *Ragionamenti* (Giorgio Vasari, *Le opere*, ed. Gaetano Milanesi [Florence, 1875-1885], VIII, 85-103).

[22] Frey, *Der literarische Nachlass Giorgio Vasaris*, I, 373-78.

[23] For Zuccaro and his *Porta Virtutis*, see D. Heikamp, "Ancora su Federico Zuccaro," *Rivista d'arte*, 33 (1958), 45-50; for Zucchi's frescoes in Palazzo Ruspoli, see F. Saxl, *Antike Götter in der Spätrenaissance*, Studien der Bibliothek Warburg, VIII (Berlin, 1927).

episodes from mythology in the background, combined with warring groups of women, putti, and satyrs in the foreground, reveal all too clearly that we have here a laborious allegorical invention devised by someone of limited imagination trying to be too clever. It is not in the least the type of composition that Perugino would normally have produced. But at the same time there are important differences from later practice. One of these, already mentioned, is the total lack of initiative that Isabella expected of the painter. The second, to which I shall return shortly, concerns the actual character of the program and the intended context of Perugino's picture.

As regards Isabella's own attitude, the degree to which Perugino's inventiveness was constrained makes one wonder why she was so keen to obtain his services in the first place. She was certainly well aware of his reputation, which was then at its height (in 1500 Agostino Chigi called him the best painter in Italy),[24] and presumably for this reason chose to employ him. But she then gave him no opportunity to display his talent, as the following letter, written to her agent in Florence, vividly illustrates:

> Domenico Strozzi has informed me that Perugino is not following the scheme for our picture laid down in the drawing. He is doing a certain nude Venus and she was meant to be clothed and doing something different. And this is just to show off the excellence of his art. We have not, however, understood Domenico's description very well, nor do we remember exactly what the drawing was like; so we beg you to examine it well together with Perugino, and likewise the instructions that we sent him in writing. And do your utmost to prevent him departing from it, because by altering one figure he will pervert the whole sentiment of the fable.[25]

In the circumstances it is hardly surprising that Perugino carried out the commission with a notable lack of enthusiasm.

The implication, I think, is that even around 1500 a major artist did not expect a patron to behave in such a way. This is corroborated by other evidence. It is perhaps significant, for example, that Isabella's agents took the trouble to write the entire program into a legal contract. So far as I know, no contracts apart from this exist from these years for nonreligious easel paintings. In this instance

[24] Canuti, *Il Perugino*, II, 239.

[25] Canuti, *Il Perugino*, II, 228; this translation from Chambers, *Patrons and Artists*, p. 140.

the unusual step was surely taken to ensure that Perugino would follow instructions. Of course, one might argue that the existence of many contracts of comparable rigor involving religious pictures would indicate that artists were used to working to strict programs. But such an argument is not really applicable here. In a period when the labor expended on a picture, and therefore its cost, was commonly equated with the number of figures it contained, patrons were bound to specify in detail what was to be shown. But Isabella's motive was different, since she expressly permitted Perugino to leave out certain figures; the only thing he could not do was to add more. Equally unsatisfactory would be the argument that an exhaustive program was supplied because Perugino was unfamiliar with non-religious subjects. It is quite evident from the text that he was expected to know how to represent Pallas, Diana, Pluto, Proserpina, and all the other mythological figures in the picture.

If Perugino found Isabella's attitude unwelcome and unusual, he was not alone. In 1501 and again in 1505 the marchioness tried to obtain another picture for her *studiolo*, this time from Giovanni Bellini; but on each occasion Bellini simply declined to accept her instructions.[26] As Bembo explained to her in 1506:

> The invention, which you tell me I am to find for his drawing, must be adapted to the fantasy of the painter. He does not like to be given many written details which cramp his style; his way of working, as he says, is always to wander at will in his pictures, so that they can give satisfaction to himself as well as to the beholder.[27]

Faced with this attitude, Isabella had at one point declared that "we are content to leave the subject to his judgment, so long as he paints some ancient story or fable or shows something of his own invention representing an antique subject with a beautiful meaning."[28] When even this concession failed to arouse the enthusiasm

[26] The principal documents appear in W. Braghirolli, "Carteggio di Isabella d'Este Gonzaga intorno ad un quadro di Giambellino," *Archivio Veneto*, 13 (1877), 375-83, with translations in Chambers, *Patrons and Artists*, pp. 126-33; but see also J. M. Fletcher, "Isabella d'Este and Giovanni Bellini's 'Presepio,' " *Burlington Magazine*, 113 (1971), 703-13, with further references.

[27] Gaye, *Carteggio inedito d'artisti* II, 71 (dated 1505); Chambers, *Patrons and Artists*, p. 131.

[28] My translation of her letter: "siamo contente remetterne al judicio suo, pur chel dipinga qualche historia o fabula antiqua, aut de sua inventione ne finga una che representi cosa antiqua, et de bello significato" (Braghirolli, "Carteggio di Isabella d'Este," p. 377).

of the painter, she asked for a *Nativity*, with "the Madonna, our
Lord God, St. Joseph, a St. John the Baptist and the animals,"[29] to
which Bellini very reasonably responded that the Baptist would be
out of place in such a subject.[30]

Isabella's ideas about iconography, so neatly illustrated by this
episode, are characteristically muddled. Even the Perugino com-
mission, superficially so similar to those from a later period already
discussed, appears on closer examination to be both different and
eccentric. The picture itself was to be part of a series of compositions
identical in format, forming a single decorative ensemble—a normal
context, at least for the later period, in which to find a compre-
hensive program. But the pictures in Isabella's *studiolo* were evi-
dently not all closely related in theme. The decoration was spread
out over many years, different advisers were consulted for different
commissions, and in the case of Bellini, as we have seen, Isabella
was prepared to leave the choice of subject to the artist. She would
settle for anything that had "some ancient story or fable with a
beautiful meaning." The *Combat of Love and Chastity* illustrates
only too clearly what she had in mind—the pedantic elaboration
of a banal allegory, conceived with little or no regard for the dis-
tinction between a painting and a text. This attitude seems entirely
typical of Isabella's rather pretentious personality; but whether it
reflects the normal outlook of contemporary patrons remains to be
seen.

Not that Isabella herself was consistent. If her acquisitive instincts
were sufficiently aroused she could forget about beautiful meanings.
This happened in 1501, when she was prepared to allow Leonardo
da Vinci to choose his own subject in an effort to induce him to
provide an example of his work for her *studiolo*.[31] Another instance
occurred in 1510, after the death of Giorgione, when she wrote to
an acquaintance in Venice, Taddeo Albano, asking him to purchase
"*una pictura de una nocte, molto bella et singulare,*" which was
supposed to have been found in the artist's studio.[32] It has some-

[29] My translation of her letter: "Questo presepio desideramo l'habii presso la M.ª
el nostro S.ʳᵉ Dio, S. Isep. uno S.ᵗᵒ Joanne Baptista et le bestie" (Braghirolli, "Car-
teggio di Isabella d'Este," p. 379).
[30] My translation of her letter: "li parea chel fosse fuora de propoixito ditto santo
a questo prexepio" (Braghirolli, "Carteggio di Isabella d'Este," p. 380).
[31] Luca Beltrami, *Documenti e memorie riguardanti la vita e le opere di Leonardo
da Vinci* (Milan, 1919), p. 65; Chambers, *Patrons and Artists*, p. 144.
[32] Terisio Pignatti, *Giorgione* (Venice, 1969), p. 160.

times been suggested that Isabella was alluding here to a Nativity scene, a *presepio*; but there is no evidence that the phrase *"una pictura de una nocte"* was used at this period or any other to indicate such a subject. In a letter about the acquisition of a picture one would expect Isabella to have been as clear as possible about her wishes. Presumably, therefore, she wanted a painting by Giorgione with a nocturnal setting and was not much concerned about the ostensible theme. In his reply Albano reported that the marchioness had been misinformed, but that Giorgione had painted *"una pictura de una nocte"* for Taddeo Contarini and another for Vettore Becharo, neither of which was for sale.[33] Fifteen years later Marcantonio Michiel noted that Contarini owned three works by Giorgione, the *Three philosophers*, now in Vienna, the *Birth of Paris*, and *"l'Inferno cun Enea et Anchise,"* which was presumably the night scene in question.[34]

This episode, incidentally, may throw some light on contemporary attitudes to Giorgione, the Venetian artist whose pictures are most commonly associated with humanist ideas and learned allusions. What it seems to imply is that he was admired then for much the same reasons as now, namely for his skill in depicting natural effects of a kind hitherto unfamiliar in painting; and this aspect of his reputation clearly underlies the discussion in the first edition of the *Vite* of the *Storm at Sea* in the Scuola di San Marco, even though Vasari was mistaken in his attribution.[35] Thus even if the *Tempesta* (Figure 12.6) had an allegorical or anecdotal subject (which is by no means certain), this was presumably chosen not for its intrinsic significance, its "beautiful meaning," but because it gave Giorgione a pretext for painting something particularly suited to his special gifts, that is to say a storm. This does not mean that there was nothing "humanist" in the commission; on the contrary, the patron may well have had in mind Apelles, and Pliny's famous remark that "he painted the unpaintable—thunder, lightning and thunderbolts."[36]

[33] Pignatti, *Giorgione*, p. 160.

[34] Pignatti, *Giorgione*, p. 160.

[35] See Vasari's comments, reprinted in Pignatti, *Giorgione*, pp. 161ff.; his subsequent attribution to Palma Vecchio is altogether more plausible (Pignatti, *Giorgione*, p. 135).

[36] Pliny, *Historia Naturalis*, XXXV, 96. The possible relevance of this passage to the *Tempesta* was suggested by Oliver Logan, *Culture and Society in Venice 1470-1790* (London, 1972), p. 229. Logan himself does not exclude the possibility of a recondite program, but the actual appearance of the picture does not bear this out.

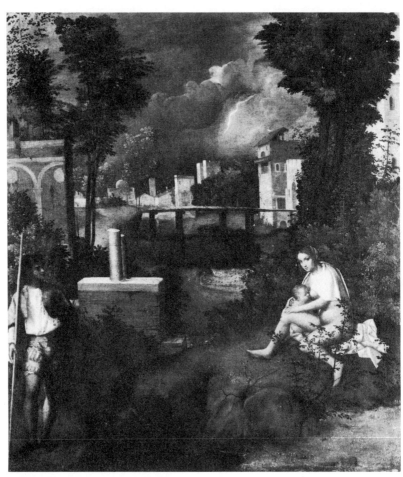

12.6. Giorgione. "*La tempesta.*"

Isabella is not the only patron of this period whose dealings with artists can be studied in some detail. Her brother Alfonso, for example, whose commissions were certainly of comparable aesthetic quality, does not seem to have shared her intellectual pretensions. In 1514 he acquired Bellini's *Feast of the Gods* (Figure 12.7), one of the largest oil paintings of a mythological subject produced in Venice up to that time; and on this occasion there can be no question of a detailed program, or of the artist consulting a learned adviser. As Philipp Fehl has demonstrated, the composition, showing the story of Lotis and Priapus, is based neither on Ovid's canonical text in the *Fasti* nor on Giovanni de' Bonsignori's short paraphrase in his Italian version of the *Metamorphoses*; instead, it follows Bonsignori's commentary on this passage, which gives an entirely different version of the legend, one that does not appear in classical literature.[37] It was only after the picture was finished that the figures, who had started life as mere mortals, were given their Olympian attributes.

Four years later Alfonso commissioned another painting for the same cycle, the *Worship of Venus*. On this occasion he was more careful about his instructions, providing the artist, Titian, with a written program, evidently an extract from Philostratus.[38] Although the use of ekphrastic texts is common enough in the Renaissance,

Should one then suppose that it has no narrative or allegorical content? Against this hypothesis it is usually argued that there are no other Renaissance paintings so devoid of conventional subject matter. This is true enough, but inconclusive, since the picture quite simply looks like nothing else of the period: if it had not survived, no historian would have supposed that anything of the kind could have been produced at this time.

[37] Philipp Fehl, "The Worship of Bacchus and Venus in Bellini's and Titian's Bacchanals for Alfonso d'Este," *Studies in the History of Art* (Washington, D.C., 1974), pp. 37-95, especially pp. 45-51.

[38] It might be supposed that Titian was sent a new program based on Philostratus, rather than simply a translation of the text itself. But the following passage in his letter of acknowledgment to Alfonso d'Este does not support this theory: "L'altro giorno . . . recevi le lettere sue . . . et lette le lettere et la informazione inclusa mi è parso tanto bella et ingeniosa, che non so che si potesse trovare, et veramente quanto più vi ho pensato, tanto più mi son confirmato in una oppinione che la grandezza de l'arte di pictori antichi era in gran parte, anzi in tutto aiutata da quelli gran Principi, quali ingenioisissimi li ordinaveno, di che poi haveano tanta fama et laude" (Guiseppe Campori, "Tiziano e gli Estensi," *Nuova antologia di scienze, lettere ed arti*, Ser. I, 27 [1874], 586). Despite these words, it is questionable whether Titian seriously believed that ancient artists customarily worked to written programs: the comments in his letter (which is not autograph) can hardly be regarded as more than a graceful compliment to his patron.

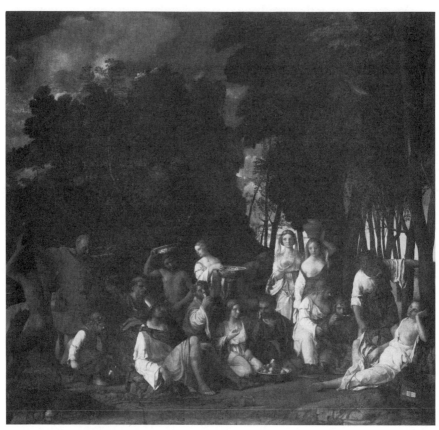

12.7. Giovanni Bellini. *The Feast of the Gods.*

they do not, of course, particularly lend themselves to the kind of moralistic interpretation favored by Isabella, nor do any classical sources suggest that such interpretations would have been appropriate. Even here Titian did not follow the text exactly, or indeed the earlier version of the subject begun by Fra Bartolommeo, but added two women at the right who are not mentioned by Philostratus.[39] In his second picture for this decorative scheme, *Bacchus and Ariadne*, Titian was apparently permitted an even greater measure of initiative. This composition was not based on a single ekphrastic text, but seems to contain features from both Ovid and Catullus.[40] So far as one can see, the choice of elements from the different literary sources was dictated by the desire to create an effective *all'antica* design, rather than by detailed considerations of iconography. The person who consulted a learned adviser, therefore, was surely Titian, not his patron.[41]

The commission from this period that has provoked the most speculation about the kind of instructions given to the artist is the decoration of the Stanza della Segnatura. John Shearman's discovery that this room was indeed Julius II's private library has resolved the most puzzling features of its iconography.[42] Even if Raphael received advice about the subsidiary subjects on the ceiling, which are ingeniously apposite, the basic scheme of the walls, showing the famous figures of theology, philosophy, and poetry above cases of books devoted to these subjects, followed a familiar and conventional pattern of library decoration. There was an obvious precedent in the Vatican itself, in the Biblioteca Latina.[43] Raphael's great innovation was to arrange the figures according to the conventions of history painting, and this ingenious formal solution is one thing that is unlikely to have been suggested by a humanist. Indeed, as John White demonstrated in his analysis of the preliminary draw-

[39] Fehl, "Worship of Bacchus and Venus," pp. 62-67.

[40] Fehl, "Worship of Bacchus and Venus," pp. 68ff., with further references.

[41] The picture is unusually well documented, but nowhere in the letters of Alfonso or of his ambassador in Venice, Tebaldi, is there any reference to a written program. Had such a document existed, Tebaldi presumably would not have troubled to report to the Duke on one occasion that "Heri vidi la tela de Vostra Excellentia ne la quale sono dece figure, il carro, et animali che tirano" (Adolfo Venturi, *Storia dell'arte italiana* [Milan, 1928], vol. IX, pt. 3, p. 116).

[42] J. Shearman, "The Vatican Stanze: Functions and Decoration," *Proceedings of the British Academy*, 67 (1971), 379-83.

[43] Deoclecio Redig de Campos, *I Palazzi Vaticani* (Bologna, 1967), p. 61 and Fig. 28.

ings, the precise subject of the *Disputa* was fixed on only after Raphael's composition had been developed through a number of stages.[44] It is also evident that the artist did not receive exhaustive instructions about the figures to be included in each fresco. In the *School of Athens* (Figure 12.8) only the most famous philosophers, such as Plato, Aristotle, and Pythagoras, are clearly identified by their attributes; and it seems most improbable that visitors were supplied with a diagrammatic key that would have enabled them to identify the other figures, most of whom have no distinctive attributes. Raphael, in fact, simply included as many figures as he needed for a satisfactory composition, showing them different in age and appearance in accordance with the requirements of variety. Even the celebrated Diogenes, as we know from the cartoon in the Ambrosiana, was only an afterthought.

This discussion so far has concentrated on nonreligious pictures, since for them there is the greatest uncertainty about the attitude of patrons. In religious commissions, by contrast, iconography can readily be assumed to have been a matter of prime importance. But it seems that even here the artist was sometimes permitted a surprising degree of initiative. For example, when Lorenzo Lotto designed a series of *intarsie* for Santa Maria Maggiore in Bergamo— an expensive and ambitious project—it was he who suggested the subject of *Lot and his daughters* "because the theme of the five cities of Sodom pleases me and because my name Lotto is included there."[45] For another subject he proposed *Joshua stopping the sun*, a subject "which I heard our preacher mention during Lent."[46] Although in this instance he asked his patrons to send him the story in writing, he certainly did not believe that it was always necessary to follow the Biblical text with slavish accuracy. As he wrote in connection with some suggestions provided by a cleric in Bergamo, "provided the story is known and recognised for what it is, that is enough without all the details of the text of the Scriptures or their

[44] J. White, "Raphael and Bruegel: Two Aspects of the Relationship between Form and Content," *Burlington Magazine*, 103 (1961), 230-35.

[45] "io ho cominciato . . . uno de li picoli che non mi é dato da nissuno, ma per piacermi el sugeto di le cinque città di Sodoma et per esserci inserto el mio cognome Loto" (Luigi Chiodi, *Lettere inedite di Lorenzo Lotto* [Bergamo, 1962], p. 39).

[46] "Et penso che per uno de li quadri de li pilastri, seria al proposito quel di Josué che firmò il sole che in questa quadragesima lo sentì ricordar dal nostro predicator" (Chiodi, *Lettere inedite*, p. 43).

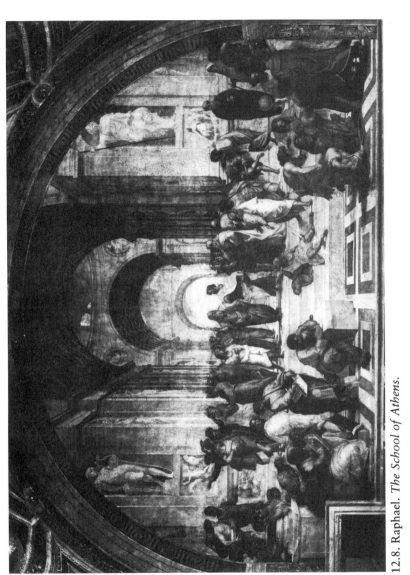

12.8. Raphael. *The School of Athens.*

interpretations."[47] It was Lotto, too, who was responsible for choosing the subjects of the bizarre *imprese* from a selection sent by his patrons.[48]

From these examples one could reasonably doubt whether the program for Perugino typified the relationship between artist and patron in the early sixteenth century, either in its rigor or in its complexity. Isabella's customary attitude to the artist she employed is decidedly dictatorial and old-fashioned. One cannot ever imagine her caught up in the kind of enthusiasm and involvement in an artistic commission that was displayed by her father in 1493, when he remained for four days from morning to evening alone in his study with Ercole de'Roberti, who was working on the cartoon of some "history or fable," not bothering even to go riding or play chess—or consult a learned adviser—while his courtiers waited outside, bored and restless.[49] The way in which Isabella simply imposed her wishes on Perugino has more in common with the behavior of Galeazzo Maria Sforza, as revealed in his instructions for the painted decoration of the Castello Sforzesco in Milan, dated 1472 and 1474.[50] In these the content and composition of the planned frescoes was minutely specified. One scene, for example, was to include a procession of some twenty named individuals, dressed in a particular way, and "All the said Orators, brothers, captains and generals are to be painted in a lifelike way, with their names inscribed in letters of gold, and likewise the names of their best horses, in the most convenient places where they least interfere with the composition, and some figures are to be painted in front, and others behind, as his excellency thinks best."[51] In another room was to be a hunting scene, once more full of portraits of named individuals;

[47] My translation of his letter: "purché 'l sia judicata et conosciuta per quella istoria, el basta sanza tute le particularità del texto de la Scriptura o sensi di essa" (Chiodi, *Lettere inedite*, p. 57).

[48] Chiodi, *Lettere inedite*, p. 53.

[49] Adolfo Venturi, "Ercole de'Roberti fa cartoni per le nuove pitture della delizia di Belriguardo," *Archivio storico dell'arte*, 2 (1889), 85. Venturi mistakenly states here that the patron was Alfonso rather than Ercole d'Este.

[50] L. Beltrami, *Il Castello di Milano* (Milan, 1894), pp. 280-82, 365-71.

[51] My translation of his instructions: "Tutti li suprascripti signori Oratori, fratelli, capitani et conducteri siano tracti dal naturale et gli sia descripto el nome loro al mordente in lettere doro, et similiter li nomi deli cavalli megliori che habiano, neli loci più convenienti e che manco impazino la pictura, e se averanno a dipingere chi nanti et chi dreto, como parerà ad sua signoria" (Beltrami, *Il Castello di Milano*, p. 367).

"and all these people are to be shown in different hunting poses. Likewise Alessio should be painted on horseback, having struck down a stag whose legs are raised towards the sky in the most beautiful manner possible."[52] Yet another fresco was to show, among many figures, "the Marquis of Mantua and the Marquis of Monferrat both represented in the same way, in such a manner and pose that one cannot suppose either to be greater than or superior to the other."[53]

There is nothing here of Isabella's laborious allegorical allusions, which would clearly have been out of place. But the role assigned to the Milanese artists is exactly like that expected of Perugino. The pictures themselves are lost, but Galeazzo Maria's instructions sound just as much like a recipe for aesthetic failure, taking as they do no account of the purely visual problems involved in creating successful compositions. Galeazzo Maria's schemes belong essentially to the genre of the contemporary Camera degli Sposi. Mantegna, however, was surely not subject to the same constraints on the part of his patron: he may have been told whom to include in his frescoes, but the decisions about the arrangement and pose of the figures were surely left largely to him, just as he must have been responsible for the marvelous invention of the ceiling (Figures 12.9 and 12.10). In the case of the *Combat of Love and Chastity* one can only feel that Isabella had herself to blame for the fact that she found it a disappointment. Given the nature of the program, could Perugino have done any better? He at least would certainly have endorsed Cellini's comment that "Many things are beautiful enough in words which do not work well when they are actually executed."

In discussions of written programs this simple point is all too often overlooked. The more the content of a work of art is specified in advance by a patron or adviser, the more its appearance is predetermined. Galeazzo Maria Sforza and Isabella d'Este both failed to recognize this, but other patrons, even in the fifteenth century, were more sophisticated. In the monument to Doge Andrea Ven-

[52] My translation of his instructions: "E tutti questi stagano in acti da caciatori differenti. Item che Alexio sia depincto che uno cervio labia butato da cavallo, e lui alci le gambe suso al cello in più bello acto sia possibile" (Beltrami, *Il Castello di Milano*, p. 280). The more literal reading, that Alessio was to have his legs in the air, seems unlikely.

[53] My translation of his instructions: "Il marchese da Mantua e lo marchese de Monferrà ambiduij ad paro, in tal forma e acto che nol se possa comprendere luno essere superiore ne magiore de laltro" (Beltrami, *Il Castello di Milano*, p. 281).

dramin, for example, one might reasonably expect priority to have been given to the iconography. Verrocchio's project, preserved in a drawing, was based on the traditional Venetian console monument and gave special prominence to the figure of Justice. But the tomb as finally executed by Tullio Lombardo after Verrocchio's death had an entirely different program. The triumphal arch format he adopted, derived from the monument to Doge Pietro Mocenigo, did not permit the same emphasis on a single Virtue. One can hardly suppose that a change in program on the part of the patrons led to a change in the design. On the contrary, it was surely Tullio's choice of an architectural format characteristic of the Lombardo shop that necessitated a new iconographic scheme.[54] In the same way, at a later date, Michelangelo's various ideas for the New Sacristy can only be understood as solutions to a formal problem; detailed consideration of the iconography must have figured very little in his thinking until the design was to his satisfaction. For this reason the suggestion that the scheme was evolved to symbolize, for example, a Neoplatonic program about the ascent of the soul is singularly unrevealing about Michelangelo's creative process. If any such interpretation was proposed at the time by him or anyone else—and it is a type of interpretation for which there are no obvious parallels—it must have been to some extent at least an *ex post facto* rationalization.[55] A similar observation can be made about the Julius tomb. The earliest project, of 1505, already included a number of naked male figures, the so-called *Slaves* or *Prisoners*. These were later identified by Vasari and Condivi as personifications of provinces or of the arts. If either interpretation had been intended by Michelangelo from the first, he was not only committing an extraordinary solecism but also ensuring that the figures' significance would be misunderstood, since such personifications should have been and always were female.[56] Yet it is likely that he was Condivi's informant, and perhaps also Vasari's. Did he simply feel obliged to

[54] W. Stedman Sheard, " '*Asa Adorna*': The Prehistory of the Vendramin Tomb," *Jahrbuch der Berliner Museen*, 20 (1978), 117-56, especially pp. 143ff. In Verrocchio's scheme (reproduced on p. 137) Justice was flanked by two subordinate allegorical figures, identified by Stedman Sheard not wholly convincingly as Triumph and Fame. In a later scheme (reproduced on p. 141) the subordinate figures were Temperance and Fortitude.

[55] For a good recent discussion of the iconography, see H. von Einem, *Michelangelo* (London, 1973), pp. 96ff., 105-10.

[56] I know of few exceptions to this principle, and Michelangelo himself certainly observed it in the New Sacristy.

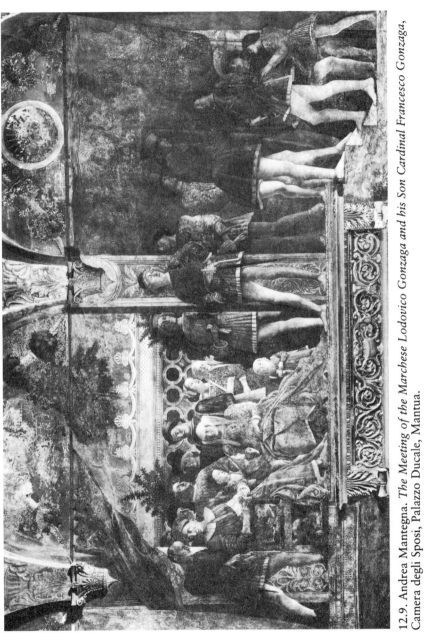

12.9. Andrea Mantegna. *The Meeting of the Marchese Lodovico Gonzaga and his Son Cardinal Francesco Gonzaga,* Camera degli Sposi, Palazzo Ducale, Mantua.

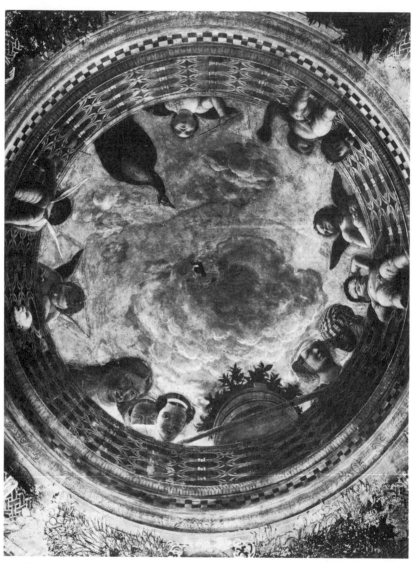

12.10. Andrea Mantegna. Ceiling fresco. Camera degli Sposi, Palazzo Ducale, Mantua.

provide some explanation, however implausible? Whatever the answer, it seems that conventional considerations of iconography did not interest him. He was preoccupied above all by the expressive possibilities of male nudes; and if his statues could not be incorporated into a comprehensible program this was perhaps a price he was prepared to pay.

Another instance in which formal considerations seem to have influenced iconography is provided by Ghiberti's Doors of Paradise on the Florence Baptistery. Leonardo Bruni's program for these doors, apparently the earliest such document to survive, assumes that the sculptor, then still to be chosen, would follow the scheme used by Andrea Pisano and Ghiberti for the earlier sets of doors, with twenty-eight panels, eight of them containing figures of prophets and the rest scenes from the Old Testament.[57] In adopting this arrangement Bruni seems to have been following the intentions of the patrons, as he himself indicated in a celebrated letter:

> It is my opinion that the twenty stories of the new doors, which you have decided should be chosen from the Old Testament, should mainly have two qualities; one, that they should show splendour, the other, that they should have significance. By splendour I mean that they should offer a feast to the eye through variety of design; significant I call those which are sufficiently important to be worthy of memory. . . . It will be necessary for the person who is to design them to be well informed about each story, so that he may well distribute the figures and their actions, and that he should be graceful and understand ornament. . . . I would very much like to be with whoever has the job of designing it, to make sure that he takes into account the whole significance of each story.[58]

The actual division of the doors into ten large rectangular panels is an innovation for which Ghiberti himself claimed responsibility in the following passage in the *Commentaries*:

> I was commissioned [to do] the other door, that is the third door of San Giovanni, and I was given a free hand to execute it in whatever way I thought it would turn out the most perfect

[57] Richard Krautheimer, *Lorenzo Ghiberti* (Princeton, 1970), II, 373.

[58] Krautheimer, *Lorenzo Ghiberti*, p. 372; this translation from E. H. Gombrich, *Norm and Form* (London, 1966), p. 21. See also Michael Baxandall, *Giotto and the Orators* (Oxford, 1971), pp. 19ff.

and most ornate and richest. I began this work in panels which were one and a third braccia in size.[59]

Krautheimer, in his study of Ghiberti, questions the truth of this account. He observes that whereas Bruni had given equal emphasis to both minor and major episodes, devoting, for example, three panels to Joseph and one to Noah, in the doors as actually executed there is a much more sophisticated approach to narrative, with the Biblical story divided into ten self-contained "chapters," each devoted to a single significant theme. According to Krautheimer, this innovation must reflect the intervention of someone versed in the method of Scriptural exegesis associated with St. Ambrose; and he finds evidence for his hypothesis in certain details of the panels themselves, which, he claims, reveal an unusually sophisticated knowledge of theology.[60]

The principal flaw in this theory lies in the assumption of a high degree of visual sensitivity on the part of the adviser. Such people were seldom so imaginative. The most that one might plausibly expect of an adviser would be to give equal weight to each major narrative element by devoting two or four panels to it. But does one really need a knowledge of St. Ambrose to see the clumsiness in Bruni's distribution of subjects? This is just the kind of fault that one would expect to be recognized by a great artist; and the remedy adopted, involving a total revision of the original plan, is wholly unexpected on the part of an adviser, but entirely understandable for a sculptor who in a recent commission, the Siena font, had been working on large rectangular panels. Moreover, as Creighton Gilbert has pointed out, the fact that the early panels each show several separate episodes whereas the later ones treat only one or two is difficult to reconcile with the idea of Ghiberti working to a detailed program given to him at the outset; instead, it surely reflects an evolution in his own approach to the problem of illustrating a narrative text.[61]

As regards the theological content, much effort has been devoted by Krautheimer and others to establishing a coherent rationale for the choice of subjects, for example in typology.[62] But apart from

[59] This translation from Krautheimer, *Lorenzo Ghiberti*, I, 14.

[60] Krautheimer, *Lorenzo Ghiberti*, I, 171-76.

[61] C. Gilbert, "The Archbishop on the Painters of Florence, 1450," *Art Bulletin*, 41 (1959), 84.

[62] U. Mielke, "Zum Programm der Paradiesetür," *Zeitschrift für Kunstgeschichte*, 34 (1971), 115-34; E. M. Angiola, " 'Gates of Paradise' and the Florentine Baptistery," *Art Bulletin*, 60 (1978), 242-48.

the Old Testament no single text has been found that adequately accounts for the themes illustrated. This is not altogether surprising, since it is clear that Bruni, at least, was not asked by the patrons to devise any very sophisticated theological program. Had this been their intention they would presumably have consulted a theologian instead. Taking his terminology from rhetoric, Bruni himself proposed only two criteria for his selection of subjects—that they should "offer a feast to the eye through variety of design," and that they should be "sufficiently important to be worthy of memory." This seems an eminently sensible approach to the task at hand, which was, after all, to plan the adornment of a set of doors to complement those already installed, not to compose a theological treatise. The scheme as finally executed appears to have been devised on an equally straightforward basis: most of the episodes represented appear in Bruni's program, and the remainder fulfill his recommendations very adequately. Thus one can readily understand why Ghiberti should have shown the Meeting of Solomon and Sheba in preference to the Judgment of Solomon: it is certainly equally worthy of memory, and it offers, one might think, a still greater feast to the eye.[63]

Krautheimer, however, suspects that this panel may contain at least one detail that presupposes the intervention of a theologically-learned adviser, namely the bird released by the man at the left, which he relates to an incident in an Aramaic text, the Targum II to the Book of Esther.[64] Yet nothing in this obscure text indicates that the bird was present at the Queen's encounter with Solomon. In any case, it is identified there as a hoopoe (or, according to another version, a wood grouse), whereas the bird in Ghiberti's panel looks like a falcon, a common enough animal for a royal entourage, like the monkey on the shoulder of another bystander; creatures of both kinds appear, for example, in the procession following the three kings in Gentile da Fabriano's *Adoration of the Magi*. But it is to a detail in the Noah panel that Krautheimer attaches more importance, namely the Ark (Figure 12.11). He believes that because it is shown as a pyramid, Ghiberti must have been told about Origen's second homily *In Genesim*, which describes it in this way. Unfortunately, Krautheimer's assertion that

[63] E. H. Gombrich, *Topos and Topicality in Renaissance Art* (London, 1975), p. 9. I have refrained from discussing the question of topical allusions in the doors, since this is fully explored by Gombrich (pp. 3-9).

[64] Krautheimer, *Lorenzo Ghiberti*, I, 177, following M. Semrau, "Notiz zu Ghiberti," *Repertorium für Kunstwissenschaft*, 50 (1929), 151-54.

Origen's reconstruction of the Ark was accepted by no other the-
ologian could not be further from the truth. Until Hugh of St. Victor
this interpretation was undisputed: all the early authorities accepted
that the Ark was a pyramid, and the idea even appears in the most
popular work of reference, Petrus Comestor's *Historia Scholas-
tica*.[65] Ghiberti may have been the first major artist to show it as
such, but it does not follow that he was working to an elaborate
theological program. All one can say is that he read Genesis vi. 15-
16, which mentions the window, the door, the three levels and the
dimensions (which he carefully inscribed on the sides of his struc-
ture), and then, in order to discover what the Ark was actually
supposed to look like, consulted someone with the requisite ele-
mentary knowledge of theology.

As in every other panel of the doors, one finds here evidence of
Ghiberti's scrupulous attitude, particularly toward the Biblical text,
which everywhere adequately explains the iconography. Nor is
there any reason to suppose that an adviser provided him with more
than translations of the relevant passages and clarification of dif-
ficult points, much as Bruni had suggested.[66] Nor does the choice
of figures in the borders reveal a greater degree of theological so-
phistication: as Krautheimer himself concedes, their relationship to
the stories they accompany "is, on the whole, amazingly simple."

I have placed such emphasis on the Doors of Paradise because
in this commission, perhaps more than any other, we see the pitfalls
in current ideas about learned advisers. It was, after all, probably
the most important single sculptural project of the fifteenth century,
and a suitable place if anywhere for an elaborate program. We even
know that the patrons consulted an outstanding humanist. The
scheme he proposed is predictably unimaginative, not least in its

[65] Don C. Allen, *The Legend of Noah* (Urbana, Ill., 1949), pp. 71ff.; Patrologia
Latina, CXCVIII, 1082: "Fecit Noe, juxta praeceptum Domini, arcam de lignis
levatis, id est politis, vel quadratis . . . Fuit ergo haec arca in fundamento quadrata,
sed in forma altera parte longiori, ab angulis in arctum conscendens, donec in cubito
summitas ejus perficeretur." This passage of Petrus Comestor, incidentally, accounts
for Ghiberti's use of square panels in his Ark, a feature which Krautheimer associates
with St. Ambrose. Gilbert ("The Archbishop on the Painters of Florence," p. 84, n.
40), rightly observes that Origen envisaged the Ark as a truncated pyramid, its
summit consisting of a square with sides of one cubit; but Ghiberti's omission of
this feature could well be explained by his using Comestor's less explicit text.

[66] For the background to Ghiberti's concern for historical accuracy in the con-
temporary attitudes of Florentine humanists, see Gombrich, *The Heritage of Apelles*,
pp. 93-110, and Gombrich, *Norm and Form*, pp. 5ff.

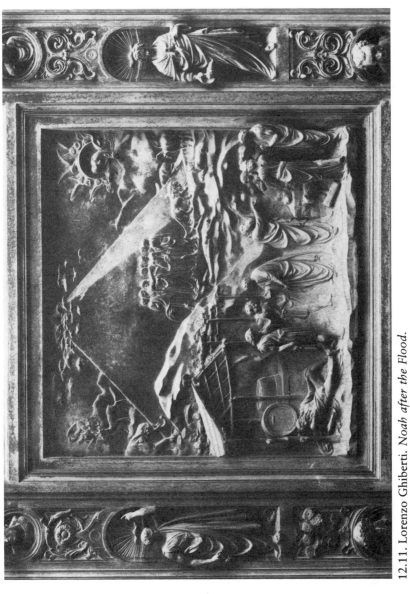

12.11. Lorenzo Ghiberti. *Noah after the Flood.*

disregard of purely visual considerations. Undisturbed by this fact, and despite the testimony of Ghiberti himself, historians have none-theless tried to persuade themselves of the existence of a vastly more subtle program, as if this were a necessary concomitant of a great work of art. In so doing they have had to assign to Ghiberti an implausibly minor role in the conception of the doors, to his patrons a singularly curious set of motives, and to the unidentified adviser a degree of sophistication and ingenuity that is unparalleled as well as unrealistic. Only the most unhistorical view of Renaissance art and advisers could lead one to be amazed at the simplicity of an iconographic program.

The argument so far has been concerned primarily with the mech-anism of patronage, but this is not the only evidence available about learned advisers. Equally relevant is Renaissance artistic theory, much of which was written by the kind of people who are supposed to have served in this role. Is there any literary evidence that the provision of detailed programs was a common type of intellectual activity, or a normal feature of the relationship between artist and patron? In this context one cannot overlook the familiar observation that contemporary art is little discussed in early Renaissance lit-erature, and that most humanists—at least in the fifteenth century—seem to have taken little interest in the subject. Either they thought it unworthy of serious consideration or regarded it as an autono-mous activity best left to specialists. When art is mentioned at all it is within a highly conventionalized framework. Thus there are plenty of poems about artists and their work, many of them imi-tations of Petrarch's sonnets on the portrait of Laura, as well as endless repetitions of the familiar art-historical topoi of antiquity. This second category is the more relevant, since classical writers, especially Pliny, offered Renaissance intellectuals a fully developed way of thinking about artistic activity. But one thing they would not have found in ancient texts was any indication that artists worked to programs provided by patrons or advisers. Instead, they could have read in Plutarch, for example, how the artists themselves disputed about the propriety of showing Alexander the Great with a thunderbolt.[67] The humanist adviser, as we now understand the term, has no classical precedent, nor is there much indication in early Renaissance literature of his existence or activity. Had the production of learned programs been as common as is often sup-

[67] Plutarch, *De Iside et Osiride*, 24. I owe this reference to Elizabeth McGrath.

posed, this omission would be rather surprising. After all, one would think of it as a way in which intellectuals could most conspicuously have displayed their ingenuity and erudition; yet almost no one before the mid-sixteenth century seems to have been praised for a program.

Of literary works specifically concerned with art, the most important early source, Alberti's *De Pictura*, was written for a humanistically-educated public rather than for practicing artists. In the ideal situation he was describing, Alberti wanted painters to be learned, and he suggested that

> it will be of advantage if they take pleasure in poets and orators, for these have many ornaments in common with the painters. Literary men, who are full of information about many subjects, will be of great assistance in preparing the composition of a *historia*, and the great virtue of this consists primarily in its invention.[68]

As an example of an excellent invention Alberti cited the *Calumny of Apelles*, whose complex allegorical content, as described by Lucian, has something in common with Perugino's *Combat of Love and Chastity*.[69] But Alberti was not advocating a procedure such as Isabella was later to adopt. It is the artist, if anyone, who consults the adviser, and it was Apelles himself who devised the *Calumny*. Another successful invention mentioned by Alberti is the *Three Graces*, of which he wrote:

> You can appreciate how inventions of this kind bring great repute to the artist. I therefore advise the studious painter to make himself familiar with poets and orators, and other men of letters, for he will not only obtain excellent ornaments from such learned minds, but he will also be assisted in those very inventions which in painting may gain him the greatest praise. The eminent painter [sic] Phidias used to say that he had learned from Homer how best to represent the majesty of Jupiter. I believe that we too may be better endowed and more accomplished painters from reading our poets, provided we are more attentive to learning than to financial gain.[70]

[68] Leone Battista Alberti, *On Painting and On Sculpture*, ed. Cecil Grayson (London, 1972), p. 94.

[69] Alberti, *On Painting and On Sculpture*, pp. 94-96.

[70] Alberti, *On Painting and On Sculpture*, p. 96.

One painter who seems to have been influenced by Albertian ideas was Botticelli, who produced the first modern version of the *Calumny* (Figure 12.12). Here virtually the entire invention was evidently provided by a man of letters. But another work by Botticelli, *Mars and Venus* (Figure 12.13), exemplifies more clearly what Alberti seems to have had in mind when he suggested that painters might obtain "ornaments" from writers. In this picture we see a complacent, composed Venus and an exhausted, naked Mars, whose weariness is surely not due to his military exertions. Venus has proved stronger than Mars, a simple enough theme, obviously appropriate to a marriage picture such as this seems to be, and one that Botticelli could easily have thought up for himself. There is nothing that presupposes or even suggests the existence of a learned program, whether involving Neoplatonism, astrology, or anything of the kind.[71] The humanist "ornament" is the group of satyrs playing in the armor of Mars, which so beautifully complements the slightly comic subject. As has long been recognized, this motif is taken from Lucian's description of the *Marriage of Alexander and Roxana* by Aetion, although there the playful figures were cupids, to indicate, so Lucian suggested, that Alexander had not lost his love of arms—a gloss that would obviously have been out of place in Botticelli's composition.[72] In *Mars and Venus*, by contrast, the satyrs merely emphasize the sexual innuendo as they struggle to support the lance, a familiar phallic symbol of the period whose meaning is underlined by Botticelli's discreet suggestion that it is broken.[73]

But it was not only to acquire such "ornaments" that artists needed to consult "poets and orators." When Alberti was writing, only humanists had easy access to and familiarity with texts helpful to painters and sculptors for their "inventions." This made it virtually inevitable, for example, that when in 1447 Leonello d'Este proposed decorating his study with a series of pictures of the Muses

[71] For these interpretations, see Ronald Lightbown, *Botticelli* (London, 1978), II, 56, with further references. Lightbown himself rejects the more esoteric readings of Botticelli's mythologies (I, 90-93, 99).

[72] Another such "ornament" is the conch shell held by one of the satyrs, a detail for which Botticelli seems to have been indebted to Politian (V. Juřen, " 'Pan Terrificus' de Politien," *Bibliothèque d'Humanisme et Renaissance*, 32 [1971], 641-45).

[73] As Suzanne Butters has reminded me, "Rompere una lancia" is a very common metaphor for sexual intercourse, and obviously relevant to Botticelli's picture. Lightbown (*Botticelli*, I, 91) even points out that the lance is of a type used in tournaments. If it were intact, it ought to project to the right of the head of Mars.

he consulted Guarino about their attributes.[74] At that date a painter could only have come up with a set of virtually undifferentiated young girls. But with the diffusion of printed texts and printed images the Albertian ideal of the learned artist became for the first time a realistic possibility. Is it just fortuitous that the expanding production of pictures with non-religious themes in the years around 1500 coincides with the development of printing? Recent research provides increasing evidence of artists consulting published texts, if only those available in Italian. Bellini did so for *The Feast of the Gods*; and it has been shown that Giulio Romano must have used an Italian version of the *Metamorphoses* when he painted the Sala dei Giganti, as apparently did Titian for *Diana and Actaeon* and the *Rape of Europa*.[75] The extent of this practice is still unclear, since in attempting to find written sources for works of art of the period scholars generally devote their attention to original rather than vernacular texts of the classics, an approach whose validity is open to question.

In advising artists to seek the help of literary men in devising their subjects, Alberti must have had in mind Horace's famous simile "ut pictura poesis," which would be central to all discussion of artistic theory for at least two centuries.[76] Painters were like poets, it was thought, because they drew their material from the same repertoire of themes and because their treatment of these was governed by similar conventions. Thus it was only appropriate that Phidias, as Alberti remarked, should have found inspiration in Homer. But on this basis one could hardly claim that Isabella d'Este accorded Perugino the status of a poet. Not only did her program deprive him of an opportunity to display his inventiveness; its strongly moralistic and allegorical character also set it apart from the conventional themes of the most admired poetic writing—it belonged, in effect, to the world of the *Ovide Moralisé* and the

[74] Michael Baxandall, "Guarino, Pisanello and Manuel Chrysoloras," *Journal of the Warburg and Courtauld Institutes*, 28 (1965), 186-88.

[75] Bodo Guthmüller, "Ovidübersetzungen und mythologische Malerei. Bemerkungen zur Sala dei Giganti Giulio Romanos," *Mitteilungen des Kunsthistorischen Instituts in Florenz*, 21 (1977), 35-68; Hugh Brigstocke, *Italian and Spanish Paintings in the National Gallery of Scotland* (Edinburgh, 1978), pp. 163 and 165, n. 6 (citing an unpublished paper by C. Ginzburg); Philipp P. Fehl, "The Cows," in Philipp P. Fehl and Paul Watson, "Ovidian Delight and Problems in Iconography: Two Essays on Titian's *Rape of Europa*," *Storia dell'arte*, 26 (1976), 24-28.

[76] R. W. Lee, "*Ut pictura poesis*: The Humanistic Theory of Painting," *Art Bulletin*, 22 (1940), 197-269.

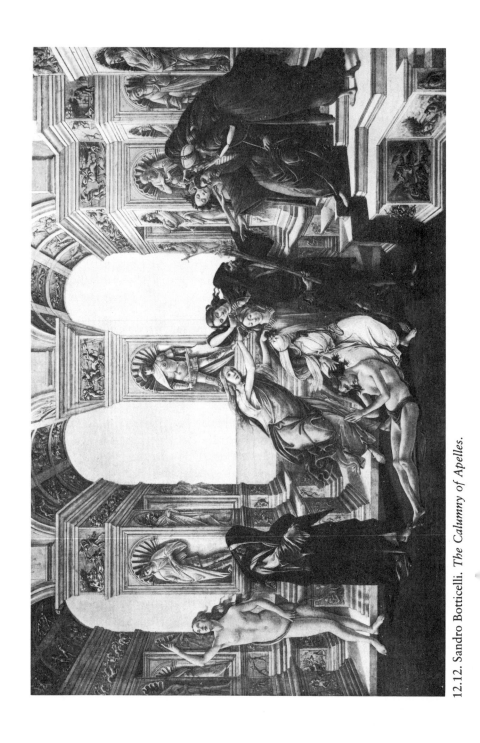

12.12. Sandro Botticelli. *The Calumny of Apelles.*

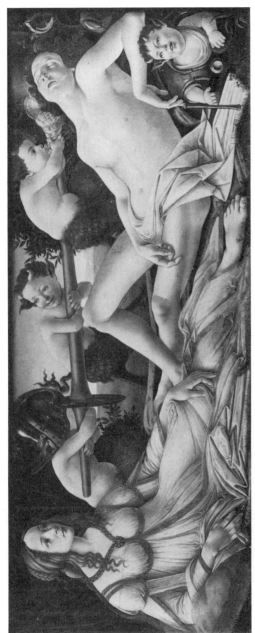

12.13. Sandro Botticelli. *Mars and Venus.*

medieval commentaries rather than to that of the *Metamorphoses* itself. Perhaps it is no accident that the one sixteenth-century theorist who specifically denied to painters the status of poets should have been Isabella's friend Mario Equicola, who may well have designed iconographic programs for her.[77]

Much more representative of sixteenth-century taste and in complete contrast to the views of Equicola and Isabella is the following letter written to Cosimo I by a prominent Florentine scholar, Vasari's friend Giovan Battista Adriani, dating from the late 1550s:

> The prior of the Innocenti (Vincenzo Borghini), who is my great friend and as close to me as anyone can be, has told me that Your Excellency wishes to have some rich tapestries made for the decoration of your room, and that you would like them to illustrate some story of a king, either of the Persians or the Medes or some other famous race, which would be beautiful and pleasing, and appropriate to such a place. I have searched my memory and consulted books to see if there is anything concerning Cyrus or Cambyses or Darius or Xerxes or others that would be suitable; and to tell you the truth, either on account of my ignorance or because there is nothing there of the kind that one would want in such decorations (since these are for the most part barbarian subjects, and not too well documented) I have found nothing that greatly pleases me. This is mainly because it seems to me that these painted objects are the more attractive and pleasing the more they have in common with the work of poets, rather than being novel inventions. For painting and poetry have a great deal in common with one another, and what goes well in the one and gives pleasure almost always delights in the other;[78] and likewise, by contrast, it seems to me that a picture of a new subject is more pleasing when one already has some idea about it. In other words, when one can easily make out all the rest from what one brings to a painting this is something that gives great satisfaction to the beholder, in that each person on his own

[77] Paola Barocchi, *Scritti d'arte del Cinquecento* (Milan and Naples, 1971-77), I, 259ff.; E. Verheyen, *The Paintings in the* Studiolo *of Isabella d'Este at Mantua* (New York, 1971), pp. 28ff.

[78] At this point Adriani says exactly the opposite of what I take him to mean, since the word "nè" appears instead of "e" (see note 79). This is presumably due either to a slip of the pen on the part of the writer or to a misprint in the printed text.

account feels that he has discovered the meaning for himself. Thus, when a subject is well represented and portrayed it delights the eye and the mind equally, whereas another subject that is less familiar may indeed please the eye on account of the skill of the artist, but will in no way satisfy the mind, which recognises and understands nothing. I am afraid that this may happen with these barbarian subjects, should any of them take your fancy, and for this reason I would be of the opinion that it would be risky to deviate from stories that are known to many people. Among these is the Greek legend or fable of Theseus and Athens, recounted by many poets with credit and greatly admired by other writers, the details of which are very well known; and I believe that anyone who depicted those episodes which are at the same time the most poetic and graceful would not do badly. . . . This story, as I said at the outset, I offer Your Excellency not as something new, but as something beautiful, charming and pleasing, since it contains those elements that seem to me suitable for painting. For in my opinion he who paints something entirely unknown, or known by very few, will give less satisfaction, especially as these decorations are being made for display and are meant to please a wide public. Moreover, the masters—the painters—who delight the more people are the more admired. Nor does it disturb me in the least if this subject has already been painted by other artists; on the contrary, the more frequently and skilfully it is represented the happier I shall be.[79]

[79] My translation of part of Adriani's letter: "Il priore delli innocenti, amicissimo et intrinseco mio, quanto esser si possa, mi ha ragionato che l'Eccellenza vostra desidera farsi tessere alcuni panni darazzo ricchi per ornamento della camera sua, e vi amerebbe drento ritratta alcuna storia di Re o de Persi o de Medi, o d'altri celebrati, che fosse bella, o piacevole e da quel luogo. Io ho ricercato nella memoria mia, e nelle lettere se, o di Cyro, o di Cambie, o di Dario, o di Xerse o d'altri, vi fussi quello che si desidera, e in vero, o per non sapere io tanto, overo per non vi veder drento quello che si ricerca in cotali ornamenti, per essere per lo più cose barbare, nè così bene infra di loro conservate, non ve ne ho trovata niuna che molto mi piaccia; massimamente che queste cose di pittura mi pare che allhora sieno graziose e piacevoli quante più s'accostano a poeti che fantasie: perciocchè la pittura e la poesia hanno molto similitudine infra di loro, nè quello che sta bene nell'una e piace, quasi sempre nell'altra diletta, e così, in contrario, parmi ancora che la pittura nuova piaccia molto più, quando della storia dipinta si ha alcuno lume da sè. Perciocchè facilmente da quello che tu ne fai vi si riconosce dentro tutto il restante, cosa che assai aggrada ariguardanti che ciascuno da per sè pare imparare senza aiuto d'altrui. E così, ove è ben figurata et atteggiata una cotale storia, porge diletto

Adriani, it is to be noted, did not choose the general theme of Theseus on account of any hidden meaning, and his selection of individual subjects was governed by their potential as attractive works of art, as the following passage indicates:

in the first scene I would think the depiction of that horrible tribute (to the Minotaur) would turn out very well, since one would show the site of Athens, the port of Piraeus and those promontories that one sees there, accurately represented, with seven young men of noble and handsome appearance, and an equal number of graceful girls of similar rank, varied in their appearance, together with their mothers, their fathers and other attendants, and finally a whole crowd of different people accompanying them to the harbour. I leave it to Your Excellency to consider whether this story contains something through which a good painter could display his art, and thus acquire praise. He could show a plentiful variety of figures, either more or fewer depending on how many attended those unfortunates, not to mention the fact that looking at Athens and its ports and the other places in the area, which are often mentioned in histories, would give great pleasure. I should like the second scene to be the island of Crete, with something by which it can be recognised (for in this case too we know how it looked at this period); the picture should show king Minos with his court, represented with the majesty and gravity he was said to possess, together with his wife Pasiphae and his beautiful daughter

all'occhio et a l'animo insieme; mentre dove un'altra, non così conosciuta, può bene dilettare la vista per virtù dello artefice, ma l'animo non vi si sadisfarà drento giamai non vi conoscendo o non vi riconoscendo cosa alcuna, il che dubito non advenisse a queste storie barbare s'alcuna però ve ne fussi da piacere, e per ciò io sarei d'animo che non fussi sicuro il discostarsi da quelle delle quali molti hanno notizia. Tra le quali nelle greche è la storia, overo la favola, di Teseo et di Athene, del quale molti poeti hanno honoratamente favoleggiato, o gli altri scrittori l'hanno estremamente lodato, li cui fatti sono assai ben chiari; e chi ne ritraessi quelli che hanno più del poetico et insieme del grazioso, per mio adviso non farebbe male. . . . Questa storia, come dissi nel principio, a Vostra Eccelentia non la dò per nuova, ma per bella, per leggiadra e per piacevole, havendo in sè quelle parti che mi pare si convenghino a pittura. Perciò che a mio giudizio chi dipinge cosa non punto conosciuta, o da pochi, non diletta ugualmente, massimamente faccendosi cotali ornamenti a pompa, et sodisfazione delli più; et anco li maestri, li pittori che più gente dilettono ne sono più aggraditi. Nè mi muove punto se forse questa storia fussi stata dipinta da altri, che sempre più mi piacerà quanto e quanto e più volte, più e meglio, ritratta sarà" (Alessandro del Vita, "Lo Zibaldone di G. Vasari," *Il Vasari*, VII [1935], 106ff., 110ff.).

Ariadne, lightly seated on a little couch, and Theseus, who respectfully but eagerly presents himself to the king to explain the purpose of his visit, and Ariadne, who gazes so intently at him that it seems she has felt the impact of his beauty. This scene could be richly adorned with figures and objects by someone who knows what he is doing; for this is what gives the subject its merit and beauty.[80]

Adriani, like Caro in his letter about the *Venus and Adonis*, evidently did not expect the artist to follow a literary text with slavish accuracy. The advice he gave is in accord with what we find in sixteenth-century treatises. Several writers, such as Pino, mention that painters sometimes chose subjects for themselves, even though these were usually provided by the patron.[81] Gilio, too, saw the role of the patron as merely that of providing the general theme; and this view was entirely conventional.[82] In 1584 Raffaello Borghini noted with disapproval that painters had taken the same liberty as poets in matters of invention, wrongly interpreting Horace's

[80] My translation of part of Adriani's letter: "Et in prima giudicherei che molto leggiadro riuscisse il ritratto di quello horribile tributo, dove fusse dipinto il sito d'Athene, il porto Pirèo con quelli promontori che vi si vedono descritti apunto, perciocchè si vedrebbono dipinti sette giovanetti di bellissimo aspetto e nobili, ed altrettante vezzose donzelle di simile qualità, meste ne sembianti, et insieme le madri, i padri e li altri attenenti e finalmente tutto un popolo mesto che li accompagnassi al porto. Lascio hor pensare a Vostra Eccellentia se in questa storia un buono pittore harebbe dove adoperare l'arte, et acquistare loda. Vi fare' assai figure meste, altre più et altre meno, secondo che più o meno fussino congiunti a quelli miseri; senza che il riconoscere Athene et il suo porto e li altri luoghi di quella provincia, che per le storie sono assai conti, diletterebbe assai. La seconda storia vorrei che fusse l'isola di Creti con segni da riconoscerla, che anco questa si sa come a quel tempo stava, ritrahendosi il re Minos con la corte sua in quella gravità e maesta che si tiene che egli fussi, et insieme Pasifae, sua moglie, e Ariadna, vezzosissima sua figliuola, che sopra un lettino morbidamente si sedessero, e Teseo insieme che, riverente et ardito, se apresentasse al cospetto del Re aprendoli quello che fussi venuto a fare, e Ariadna, che così fiso il guardassi, che apparissi che dalla bellezza di lui si sentisse punta. Questa parte si potrebbe molto ornar e di figure e deffetti da chi li sapesse bene condurre; che in questo consiste il buono et il bello della cosa" (Del Vita, "Lo Zibaldone di Giorgio Vasari," pp. 109ff.).

[81] Paola Barocchi, *Trattati d'arte del Cinquecento* (Bari, 1960-62), I, 115; Caro, too, in his letter to Vasari quoted above, sees nothing strange in artists choosing their own subjects.

[82] Barocchi, *Trattati d'arte del Cinquecento*, II, 1-115. The subject of decorum and artistic license, which is not only the theme of Gilio's treatise but central to much sixteenth-century art theory, is, of course, based on the premise that painters were not wholly constrained by their patrons in matters of invention.

words as a justification for a virtually unfettered display of their imagination.[83] He was the first writer to criticize an artist for not following a poetic text when one was available; his example was Titian in *Venus and Adonis*.[84] But even Borghini accepted that when artists could not find a suitable "fable or story" to display the excellence of their art, they devised their own, citing Michelangelo's *Battle of Cascina*; in such instances, he declared, greater license was permissible.[85] His criticisms about the way artists reinterpreted poetic subjects obviously have much in common with Counter-Reformation theory about the treatment of religious subjects; indeed, he expressly mentions Gilio with approval.[86] But the practice of disregarding canonical texts even in religious pictures was not a recent development: St. Antonino had complained of it around 1450.[87]

The evidence discussed so far hardly supports the belief that detailed instructions were regularly given to artists, whether compiled by patrons or learned advisers. Even when a particular subject was required, the way in which it was treated was often left very largely to the painter or sculptor. Moreover, the idea that such people ought to be no more than the executants of programs supplied by the patron—Isabella's attitude to Perugino—is given singularly little support by theorists of art. This obviously does not mean that Renaissance artists were free to paint what they liked, or that iconography was commonly a matter of indifference to their employers; but the degree of control that the latter exercised depended on the nature of the commission. In certain circumstances humanists were consulted, but for the most part their role was a limited one with two quite distinct aspects. Firstly, they suggested suitable subjects, often in very general terms; and they were asked to do so especially when a decorative project involved a number of separate compositions with a related theme. Thus the problem facing Caro at Caprarola, or Bruni in the case of the Baptistery doors, was first and foremost that of thinking of enough subjects to fill the spaces available. In most cases the primary consideration was to devise a coherent, appropriate, and attractive program; its

[83] Raffaello Borghini, *Il riposo* (Florence, 1584), pp. 53ff.; Barocchi, *Scritti d'arte del Cinquecento*, I, 340.

[84] Borghini, *Il riposo*, pp. 64ff.

[85] Borghini, *Il riposo*, p. 61; Barocchi, *Scritti d'arte del Cinquecento*, I, 345.

[86] Borghini, *Il riposo*, p. 53; Barocchi, *Scritti d'arte del Cinquecento*, I, 340.

[87] Gilbert, "The Archbishop on the Painters of Florence," p. 76.

precise significance was seldom of great importance. Secondly, humanists were asked for advice by artists on specific points of iconography. Instances of this practice involving Ghiberti and Vasari have already been mentioned. Further evidence can be found in a dialogue by Battista Fiera in which Mantegna recounts how he asked various philosophers how best to represent Justice and how all of them of course made different suggestions.[88] The dialogue is satirical, but it is a satire on justice rather than on painting; its point depends on the fact that Fiera's description of the relationship between artist and humanist reflects, to some extent at least, a typical situation.

Why then have historians given prominence to complex programs and learned advisers? The answer seems to lie less in compelling historical evidence than in the development of iconography as a subject of academic study. Having tried to use some of the more esoteric Renaissance texts, particularly those of Florentine Neoplatonism, to explain "problem pictures" like Botticelli's *Primavera*, scholars then tended increasingly to assume that writings of this kind were relevent even to works of art with more readily identifiable subjects. Their main justification lay in the fact that such texts often allude to mythology, for example to Venus and Cupid. But the same can be said of virtually every other type of contemporary literature from alchemical treatises to bawdy *novelle*: every educated person in the Renaissance knew that Venus was the goddess of love, that Cupid was her son, and that the Graces were her companions. Before assuming that any category of texts is applicable to the study of iconography, one therefore has to demonstrate that patrons thought it appropriate that the ideas to be found there should be illustrated by artists. In the case of humanist writing, whether Platonically inclined or not, the evidence for such an assumption is negligible.

If one examines the very few works of art of the early and high Renaissance known to be based on programs devised by humanists, one finds the content straightforward and even banal. This is certainly true, for example, of a series of eighteen fresco lunettes by Garofalo illustrating the legend of Eros and Anteros, painted around 1517 in the palace of Antonio Costabili in Ferrara after a program

[88] Battista Fiera, *De iusticia pingenda* (1515; rpt. ed. James Wardrop, London, 1957).

by Celio Calcagnini.[89] This legend in particular was amenable to the most erudite interpretations; but virtually none are relevant to these paintings, whose meaning is made perfectly clear by inscriptions under each scene.[90] The subject was chosen, in fact, because of its obvious suitability for the decoration of a bedroom, not for its philosophical implications.

Although Calcagnini was not trying to be clever, Isabella and her adviser certainly were when they devised the program for the *Combat of Love and Chastity*. As a result, the picture itself is predictably unsuccessful as a work of art. Despite the evident self-satisfaction of the patron, the type of subject is by no means original; indeed, it is such a commonplace that even tournaments were devised around similar themes. In Bologna in 1490, for example, Alfonso d'Este participated in a tournament between the knights of Wisdom and Fortune; another event of this kind is recorded in London in 1509, between the champions of Pallas and Diana, and there must have been countless others of much the same type.[91] The contribution of the learned Paride da Ceresara was the pedantic insistence on meaningful detail in the principal figures and the addition of a mass of mythological love stories in the background. If the program had not survived, it is very doubtful that we would be able to reconstruct it, not because of the sophistication of the ideas involved, but because of its very clumsiness and in particular because of the lack of narrative coherence between foreground and background. The subsidiary episodes, after all, contribute nothing to the main theme; they are space-fillers, added to give the program a veneer of erudition.

Neither the program for Garofalo nor that for Perugino is anything as complex or ingenious as many interpretations of works of art from this period recently proposed by art historians. There is no evidence to suggest, for example, that any of the various Neoplatonic explanations of the *Primavera* correspond with what a contemporary adviser would or could have devised.[92] The nearest

[89] Erkinger Schwarzenberg, "Die Lünetten der 'stanza del tesoro' im Palast des Lodovico il Moro zu Ferrara," *Arte antica e moderna*, 7 (1964), 131-50, 297-307.

[90] The only unexpected erudite allusion appears in the sixteenth lunette, showing Eros and Anteros seated on storks, which are symbolic of filial piety (Schwarzenberg, "Die Lünetten," pp. 304ff.).

[91] Sydney Anglo, *The Great Tournament Roll of Westminster* (Oxford, 1968), p. 31, n. 1, and pp. 46-49.

[92] For these interpretations see Lightbown, *Botticelli*, II, 52; Lightbown's own theory (I, 73-81) is simpler and more plausible, apart from his suggestion that Botticelli has shown the Garden of the Hesperides.

approach to learned allegory by Botticelli is provided by the Villa Lemmi frescoes; but their iconography, with personifications of the liberal arts and so on, is transparently simple and still belongs to an essentially medieval tradition. More succinct and learned imagery might be found on medals, but these are a different kind of object from paintings, subject to different conventions. The same is true of the belt buckle sent by Marco Parenti to Filippo Strozzi in 1450, of which Parenti's detailed description still survives.[93] It consisted of three devices, one to recall the sender, another the recipient, and the third the kingdom of Naples, where Strozzi was living. The iconography is certainly ingenious: the last device, for example, consists of "a landscape, in which an armed king is lying, to denote that in a kingdom the power of the ruler extends everywhere."[94] But Parenti's cavalier references to poets, ancient philosophers, and modern theologians (whose works he had obviously never checked), his comment that an attribute of Diana had been omitted by mistake, and his wholly idiosyncratic program provide a certain corrective to the views of many historians. In the same way Lotto's proposal, mentioned above, to include *Lot and his daughters* among the Bergamo *intarsie* must appear to some scholars inconceivably frivolous. But this kind of casualness is by no means unparalleled. Thus when the municipal authorities of Modena decided in 1546 to decorate the town hall with scenes from Roman history, they specified the basic theme quite wrongly in their contract with Nicolo dell'Abate, and the individual subjects were apparently chosen simply on the basis of looking up the entries referring to Modena in the index to Appian.[95]

In the era of mannerism, however, a taste for complex imagery and genuinely learned allusions was unquestionably in fashion in painting and sculpture as well as in lesser art forms, even though it was very far from an invariable rule. An incidental consequence was that someone like Vasari could be tempted to overinterpret works from an earlier period, as he did when he identified the two women in Titian's *Worship of Venus* as Bellezza and Grazia, whereas in fact they were almost certainly intended as unspecified

[93] J. Russell Sale, "An Iconographic Program by Marco Parenti," *Renaissance Quarterly*, 27 (1974), 293-99, especially 298ff.

[94] "La terza è nota, che volendo significare che se nel reame, vedi un paese, nel quali ghiace un re armato a dinotare che in un reame per tutto se distende la potenza del re" (Sale, "Iconographic Program," pp. 298ff.).

[95] E. Langmuir, "*The Triumvirate of Brutus and Cassius*: Nicolò dell'Abate's Appian Cycle in the Palazzo Comunale, Modena," *Art Bulletin*, 69 (1977), 188-96.

mortals.[96] But the conventions that governed the contemporary use of visual imagery were well understood by artists, advisers, and patrons alike, and its interpretation was based on generally recognized principles. In certain contexts even *ex post facto* interpretations could be perfectly acceptable. Vasari's suggestion that the fresco of the *Arrival of Saturn in Italy* in the Palazzo Vecchio could be taken as an allusion to the meeting of Charles V and Clement VII in Bologna—a type of reading totally absent from Cosimo Bartoli's programs—is presumably typical of a whole class of flattering comments by Medici courtiers.[97] This does not mean, however, that such readings would have been regarded as appropriate elsewhere. In particular, Isabella d'Este's taste for "beautiful meanings" cannot be adduced as a parallel, for such meanings were the actual subjects of her pictures, rather than functioning on a secondary level.

The attitude she displayed in the decoration of her *studiolo*, however much it may agree with the outlook of some modern scholars, is wholly inconsistent with the behavior of other patrons of the fifteenth and sixteenth centuries. The ample documentary evidence for their awareness of differences in artistic style suggests not only that individual artists would have been employed because of their particular abilities with certain types of subjects, but also that subjects would have been chosen to suit the special skills of certain artists. It was well known that this had occurred in antiquity, and we know that it happened in the Renaissance. Thus we find Piero di Cosimo, to cite one example among many, painting similar themes for different clients—themes that are distinctive to him alone.[98] In the same way it can hardly be fortuitous that the only

[96] Vasari, *Le opere*, VII, 434; Fehl, "The Worship of Bacchus and Venus," pp. 62-67.

[97] The program for this room does not survive, but those for two other rooms in the same apartment, the Sala degli Elementi and the Sala della dea Opi, do (Frey, *Der literarische Nachlass Giorgio Vasaris*, I, 410-15). That Vasari's own reading is *ex post facto* is even suggested by his own words: "Dico che l'arrivare doppo il suo esilio Saturno in Italia fuor della nave, e recevuto da Iano e da' padri antichi, si può facilmente simigliare allo esilio di Clemente" (Vasari, *Le opere*, VIII, 39).

[98] The provenance of Piero's pictures of "primitive" and mythological subjects is still controversial (see Mina Bacci, *L'opera completa di Piero di Cosimo* [Milan, 1976], and most recently C. Cieri Via, "Per una revisione del tema del primitivismo nell'opera di Piero di Cosimo," *Storia dell'arte*, 29 [1977], 5-14). But it seems clear, at least, that the *Discovery of Honey* (Worcester, Mass.) and the *Misfortunes of Silenus* (Cambridge, Mass.) were painted for Giovanni Vespucci, and that the panels with "primitive" subjects in New York, Oxford, and London, as well as the canvases in Hartford and Ottawa, have a different provenance, some of them possibly having

patrons of the fifteenth century to commission a monumental painted reconstruction of a Roman truimph, the Gonzaga family, should have employed their court artist Mantegna, the very artist whose talents were preeminently suited to this type of undertaking. It would seem that taste played an important and on occasion a decisive part in the thinking of Renaissance patrons. This is scarcely surprising if one recognizes that people who commission works of art very often do so because they find them beautiful, even though other considerations may also be involved. Unfortunately much recent work on Renaissance iconography, based as it is on highly dubious premises about the role of learned advisers, has to a great extent obscured this more significant aspect of the patronage of the period.[99]

belonged to Francesco del Pugliese. And one cannot envisage any patron asking Botticelli, for example, to show subjects of this kind, even though both he and Piero tackled the more conventional theme of *Mars and Venus*.

[99] The valuable discussion of fifteenth-century advisers by Creighton E. Gilbert (*Italian Art, 1400-1500: Sources and Documents*, Englewood Cliffs, 1980, especially pp. xviii-xxvii) appeared after my manuscript was delivered to the publishers; fortunately, his conclusions are very similar to my own.

THIRTEEN

⊠

The Birth of "Artistic License": The Dissatisfied Patron in the Early Renaissance

⊠

H. W. Janson

THE term *artistic license* has a variety of meanings. In this essay I shall deal with only one of these: the changes made by an artist in executing a commission without prior authorization from his patron, or even against the patron's explicit instructions.

In the later Middle Ages, painters and sculptors were subject to the rules of their guild—rules specifically designed to regulate the relations between guild members and their customers. These customers, whether private individuals or, more often, public bodies, laid down the specifications of their commissions in elaborate and detailed contracts that not only dealt with delivery dates and prices but included explicit statements concerning the materials to be employed and the subjects to be represented. Often the contracts were accompanied by drawings that permitted the customer to visualize the project in advance.[1]

There are numerous examples on record of conflicts between artist-craftsmen and their customers arising from late delivery or disagreements about cost. These problems are in no way peculiar to the early Renaissance. What interests me here is another kind of conflict that could not be resolved by guild rules and that reflects the artist's new estimate of himself and the nature of his activity. As we all know, during Antiquity and the Middle Ages painters and sculptors were classed with the mechanical arts or crafts, whereas the Renaissance gradually raised the artist to a new and higher status as a member of the community of the liberal arts, the equal of poets and philosophers. Artists who viewed themselves in this

[1] See Hannelore Glasser, *Artists' Contracts of the Early Renaissance* (Ph.D. Dissertation, Columbia University, 1965; New York, 1977).

light asserted a new independence of spirit; they claimed to be guided by their "genius," their inspiration, whether or not this inspiration coincided with the terms of the contracts they had signed. And their customers gradually turned into patrons. The change of terms is significant in itself: customers are "steady," they keep going back to the same source of supply because they know they will get what they got before, while patrons are by definition "fickle"; they don't quite know what to expect, they like—within limits—to be surprised, and they have to make up their minds in each individual instance about the work they have commissioned. Patrons acknowledge, although at times grudgingly, that the artist may be guided less by their wishes than by his genius, his inner voice whose commands take precedence over what the patrons had specified.[2] The artist-patron relationship is thus basically different from that of the craftsman and his customer, who deal with each other in a businesslike way, the rights and duties of each party to the contract being clearly defined and accepted, in principle, by both.

The idea that the artist—or at least the great artist, such as a Giotto—ought to be given liberal arts status is voiced for the first time around 1400 in Florence, by Filippo Villani. But its earliest stirrings go back to the middle of the fourteenth century. When Petrarch, in his last will and testament, says of the Madonna by Giotto, which he owned, that the common man will not appreciate it while it leaves the experts mute with admiration, he expresses an "elitist" view of both artist and patron: the great master does not work to please the multitude; he appeals, rather, to a special limited audience that has the necessary background to appreciate him.[3] Boccaccio, in his defense of poetry appended to his *Genealogia Deorum*, gives vent to a similar attitude; before Giotto artists had painted merely to please the senses, while he revived the classical tradition of appealing to the beholder's mind. Boccaccio even claims license for both the painter and the poet to deal with immoral subjects: who would condemn Apelles, he asks, or Giotto, his modern equal, if they depicted the loves of Jupiter?[4]

[2] For the evolution of the artist's liberal arts status and its consequences, see Rudolf and Margot Wittkower, *Born Under Saturn* (London, 1963), *passim*.

[3] See Theodor E. Mommsen, *Petrarch's Testament* (Ithaca, N.Y., 1957).

[4] See Charles Osgood, trans. and ed., *Boccaccio on Poetry* . . . (New York, 1956), and the praise of Giotto in the *Decameron*, VI, 5; similar passages elsewhere are cited in Edgar Zilsel, *Die Entstehung des Geniebegriffs* (Tübingen, 1926), p. 336, n. 4.

In the Trecento such assertions remained on the level of theory, but in the Quattrocento, at least in Florence, they seem to have had repercussions in actual experience. These are reflected in a series of anecdotes about artists that assert the artist's right to deal with his patron in cavalier fashion, on the ground that the patron is ignorant and the artist obeys a higher law that gives him the freedom of a sovereign in his own domain. In the High Renaissance and after, when the artist of genius was acclaimed as a creator second only to God and people habitually spoke of the "divine" Michelangelo, such stories are not surprising. But they actually begin a good deal earlier. We find them, for instance, in a collection recorded in the 1470s and known as the "Diary of Politian."[5] The most frequent hero of these stories is Donatello. Not that we need to take these anecdotes literally; they are significant not for their factual content but for the tendency they reflect. There is, characteristically, Donatello the absolute ruler in his own domain: when summoned before the Patriarch of Venice he refuses to go, with the words, "I am as much of a sovereign in my field as he is in his."[6] When, in an emotional outburst due to a conflict with the authorities, he had knocked off the head of his Gattamelata statue and the authorities threatened to cut off his own head, he replied, "That's quite all right with me if you know how to put it back on as I know how to put the Gattamelata's head back in its place."[7] Another story, transmitted by Vasari, concerns Donatello's statue of St. Mark for the niche of the guild of the *rigattieri* at Or San Michele: when members of the guild criticized the figure, Donatello put a wooden enclosure around the niche and pretended to work on the statue for two weeks while in reality he did nothing. After removal of the enclosure, the formerly critical officials declared themselves fully satisfied. Oddly enough—perhaps on the basis of a common source—Vasari tells a very similar story about the young Michelangelo: when the Gonfaloniere of Florence criticized the nose of the marble David, Michelangelo mounted the scaffolding and pretended to retouch the nose without actually changing it at all, whereupon the Gonfaloniere declared himself fully satisfied. The artist, according to Vasari, "descended with feelings of pity for

[5] Albert Wesselski, *Angelo Polizianos Tagebuch, zum ersten Mal herausgegeben,* (Jena, 1929).

[6] Wesselski, *Angelo Polizianos Tagebuch*, p. 27.

[7] Wesselski, *Angelo Polizianos Tagebuch*, p. 28; cf. Giorgio Vasari, *Le vite . . . ,* ed. Giovanni Milanesi (Florence, 1878-85), II, 407.

those who wish to pretend that they understand things of which they know nothing."[8]

To what degree such tales had their origin in actual events we have no way of knowing. They bear a telling kinship with a cluster of anecdotes, easily accessible to the Renaissance as retold in Book xxxv of Pliny's *Natural History*, about the pride and high station of certain artists of the fourth century B.C.: Apelles reproaches Alexander for a stupid remark about art but nevertheless is ceded Alexander's mistress Campaspe; Parrhasius calls himself "a prince of the arts"; Zeuxis gives his pictures away because no patron can afford to buy them at the price they deserve. For the Renaissance, these stories were a welcome antidote to the prevailingly negative or belittling attitude of ancient authors toward the fine arts.[9] Their fifteenth-century descendants, whatever their factual base, can at least claim a symbolic truth, for we know of a number of instances where Donatello got his way in situations of conflict with his patrons.

A striking example is the outdoor pulpit of Prato Cathedral. The contract of July 1428 between the local authorities and Donatello, in partnership with Michelozzo, stipulates that the work must follow the design of the model the two artists have made, which shows the parapet of the pulpit divided into six compartments; each of these is to hold a marble relief of two angels displaying the coat of arms of Prato. By May 1433 the framework of the pulpit was well advanced but Donatello had delivered none of the balustrade reliefs and was working in Rome. At this point the Prato authorities sought the help of Cosimo de'Medici, Donatello's most important patron, whose emissary managed to persuade the artist to return to Florence. There, however, Donatello received the commission for the Cantoria (singers' pulpit) above the door of the second sacristy of the Duomo, which he must have regarded as a far more challenging task, especially since he found himself competing with Luca della Robbia, who had been commissioned a year earlier to do the Cantoria above the entrance to the first sacristy. So he let the Prato authorities wait; a year after his return from Rome he finally signed a second contract for the completion of the balustrade reliefs, but the first of these was not finished until a month later (i.e., June 1434). In April 1436 three more panels were delivered, and the last

[8] H. W. Janson, *The Sculpture of Donatello*, 2 vols. (Princeton, 1957), II, 18-20.
[9] See Ernst Kris and Otto Kurz, *Die Legende vom Künstler . . .* (Vienna, 1934), pp. 47ff.

of the group did not reach Prato until 1438. Their number had grown from six to seven, and instead of showing the city's coat of arms held by standing angels, they depict violently dancing angel-putti. In some panels, these look as if they were fighting with each other rather than dancing, and in fact Donatello has here borrowed the design of a Roman sarcophagus that shows putti in the role of athletes, boxing and wrestling. If Donatello obtained the consent of the Prato authorities to this change of program, the documents give no hint of it. Apparently the patrons in this case were so awed by the sculptor that they were glad to get whatever he gave them. In another respect, too, Donatello failed to live up to the terms of the 1434 contract: it specified that the master was to carve all the panels "with his own hands" (*propria manu*). This, we may be sure, was not meant to exclude the use of assistants—the modern concept of *Eigenhändigkeit* did not yet exist then—but several of the reliefs are so clumsily carved that Donatello could at most have provided a hasty sketch, leaving the actual execution to rather inexperienced members of his shop.[10]

Donatello's work on the Cantoria, extending from 1433 until 1439, also involved an unforeseen (and, probably, unauthorized) change of plan. Originally, its design was to follow the pattern set by Luca's Cantoria; i.e., the balustrade was to consist of a series of separate panels divided by paired pilasters as in the Prato pulpit. Soon, however, the master decided to substitute a continuous frieze of dancing angels, apparently under the influence of the Roman child-athlete sarcophagus we mentioned earlier. I rather suspect that some of the Prato panels are based on designs Donatello had originally made for the Cantoria and discarded when he switched to the continuous frieze. Such a hypothesis would explain his procrastination in starting work on the Prato panels as well as the unexpected change in their subject matter. Having introduced the concept of the continuous frieze into his Cantoria plans, Donatello also had to change the architectural framework; the new framework was of so unorthodox a kind that it brought him into conflict with his old friend Brunelleschi, then head architect of the Duomo.[11]

If the anecdote we have cited about the St. Mark at Or San

[10] Janson, *Donatello*, II, 108-18, and "Donatello and the Antique," in *Donatello e il suo tempo, atti del viii° convegno internazionale . . .* (Florence, 1968), pp. 77-96 (reprinted in *Sixteen Studies* [New York, 1974], pp. 249-88). For a fuller transcription of the documents concerning the pulpit see Margrit Lisner, *Münchner Jahrbuch der bildenden Kunst*, 9/10 (1958/59), 117-24.

[11] See Janson, *Donatello*, II, 119-29, 140.

Michele has no factual basis, the one concerning the head of the Gattamelata may well reflect some of the many difficulties Donatello encountered in carrying out that commission. He left Florence for Padua late in 1443 in order to execute an equestrian statue of the famous general, who had led the Venetian armies until his death at the beginning of that year. The terms of the original commission are not known, but on the basis of all available precedents the equestrian statue called for must have been intended as part of a wall tomb, and the material would have been stone. What Donatello eventually produced, in the course of a ten-year struggle with the general's heirs (and, very likely, the Venetian senate as well), was a free-standing bronze monument of entirely secular character celebrating the general's fame by representing him *all'antica*. In ancient Roman times, such statues had been the prerogative of the Emperor. The Quattrocento knew two surviving examples, the Marcus Aurelius monument in Rome and the *Regisole* in Pavia (which was destroyed during the French Revolution); the equestrian monument of Justinian in Constantinople, soon to be destroyed by the Turks, was known only from drawings. The first bronze equestrian statue since Antiquity, that of Nicolò d'Este in Ferrara (destroyed in 1796) was begun soon after 1441, but it, too, honored a sovereign. For a mere general, and one in the service of a republic at that, such a monument was so revolutionary, so contrary to the then prevailing sense of decorum, that we can hardly credit the idea to the general's heirs and executors, especially since the cost far exceeded the 700 ducats set aside for his funeral and tomb in the general's last will. It thus seems highly probable that Donatello, who may well have stopped in Ferrara on his way to Padua, learned about the bronze equestrian monument of Nicolò d'Este from the two Florentine sculptors who were then at work on it, and as a consequence decided to enhance his commission from a stone statue attached to the Gattamelata's tomb to a free-standing bronze monument *all'antica*. Nothing else could explain the almost endless delays and financial as well as political difficulties he encountered until, ten years after he received the commission, he finally completed it and returned to Florence. Meanwhile, several years before it was put on public display, the fame of the monument had spread as far south as Naples, where Alfonso of Aragon wanted to secure the sculptor's services for a bronze equestrian statue of his own.[12] Once it was unveiled, the Gattamelata monument attracted, along with high

[12] See George Hersey, *Master Drawings*, 7 (1969), 21ff.

praise of its aesthetic qualities, various satirical comments likening it to "a conquering Caesar" and pointing out that no ancient military hero had ever been thus exalted.[13]

It was, then, Donatello's own overly ambitious goal that accounts for the troublesome history of the statue. While waiting for the difficulties to be resolved, he accepted another major commission from a different source: a new high altar for the church of St. Anthony (known as the "Santo"), made possible by an individual donation in 1446. Here the artist was to encounter troubles of another sort. He carried out the task, with the aid of numerous assistants engaged for the purpose, within three years; but the Franciscan authorities failed to square accounts with him. After the consecration of the altar, they owed him close to 1,700 lire, and as late as 1456 Donatello was still trying, from Florence, to collect this debt (so far as we know, he never succeeded). Apparently the source of the conflict was a disagreement over the degree of finish necessary for the bronzes that constitute most of the sculpture on the altar. Of the seven statues, only the first two, the St. Francis and St. Louis of Toulouse, show the full extent of surface chasing the authorities demanded; the other five, including the Madonna, are clearly "unfinished" by their conservative standards. It would seem that Donatello was guided in this matter by the position of the various pieces: the reliefs, which were close to the beholder's eye, are meticulously chased, while the statues, farther away and less well illuminated, did not need the same degree of detailed care. The reliefs of the Cantoria, which could be seen only at a distance, show the same lack of detailed finish, as Vasari notes. To him, this was evidence of a praiseworthy trait he calls *sprezzatura*, a term difficult to translate (it means a kind of intentional negligence). Ironically enough, Vasari also tells us that Michelangelo, that genius of the *non-finito*, praised Donatello highly except in one respect— he "lacked the patience to give his pieces a clean finish, so that they looked marvellous from a distance but did not live up to their reputation when viewed at close range."[14] The friars of the Santo, needless to say, could hardly be expected to show any greater understanding of *sprezzatura*.

"Artistic license" as defined in our introductory paragraph does not have to involve changes in subject matter, general plan, or the

[13] See Janson, *Donatello*, II, 151-61.

[14] For the history of the Santo altar see Janson, *Donatello*, II, 162ff.; for *sprezzatura*, pp. 36, 40.

nature of the commission. In at least two instances, Donatello did not overstep the bounds of his commission yet reinterpreted the subject in so revolutionary a manner as to make it either unrecognizable or (to conservative eyes at least) offensive. Some of the five marble prophets he carved for the niches of the Campanile in Florence between 1416 and 1435 are of this sort. The documents, for the most part, do not refer to these statues by name, but there is no doubt that all of them were meant to be prophets. Still, only the earliest of the series, the so-called Beardless Prophet, conforms to the established image by conspicuously displaying a long scroll (apostles, in contrast, carry books, as does Donatello's St. Mark). The second statue, the Bearded Prophet carved in 1418-20, is modeled after a classical philosopher deep in thought; his scroll is rolled up and barely visible. The last two, the Zuccone and the "Jeremiah," have become Roman orators, so far removed from the accepted image of prophets that the Florentines soon ceased to recognize them as such. By the end of the century they were popularly regarded as portraits of Giovanni di Barduccio Cherichini and Francesco Soderini, two prominent members of the conspiracy against Cosimo de'Medici in 1433. The choice of these names dates the legend to the years 1494-1512, after the second expulsion of the Medici, when the memory of these earlier "champions of republican liberty" was likely to be revived. The absurdity of assuming that Donatello could have thus honored the enemies of his greatest patron did not prevent the story from being given credence as recently as a hundred years ago.[15] For us, it merely documents the artist's departure from what was expected of him, although in this instance there is no hint that the Duomo authorities were dissatisfied. The Zuccone ("pumpkin," because of his bald head) had in fact become so popular that it became the subject of another legend. Its "oratorical" character was so pronounced that the statue was said to "lack only the power of speech"; and it was said that the artist, while working on it, kept shouting, "Speak, speak, or the plague take you!"[16] Here we encounter the echo of a very old legend, according to which the earliest statues, those of Daidalos, were able both to speak and to move. This story, like several others, also serves to stamp Donatello as a predecessor of Michelangelo, who was conceded even greater powers: a story already current during Michelangelo's lifetime credits

[15] See Janson, *Donatello*, II, 33-41.
[16] For the texts see Janson, *Donatello*, II, 35.

him with the ability to make the statues of the Medici tombs move and speak.[17]

The most daring transformation of an assigned subject in Donatello's entire oeuvre, however, is his bronze David. According to the most recent interpretation, this puzzling figure must have been commissioned about 1425 by the city fathers of Florence as a civic-patriotic monument for conspicuous public display (probably on a column in an open-air setting such as the Mercato Vecchio) to rally the confidence of the citizenry in the face of the threat posed by the armies of the Duke of Milan, Filippo Maria Visconti. The sculptured image of the victorious David, with the head of Goliath at his feet, had assumed the role of a civic-patriotic emblem of Florence in 1416, when the marble David Donatello had carved for the Duomo in 1408-9 was transferred to one of the great public rooms in the city hall, the Palazzo Vecchio, and equipped with an inscription assuring divine help "for those who bravely fight for the fatherland."[18] In contrast with this earlier David, which had been commissioned as part of a cycle of prophets for the buttresses of the Duomo, the bronze David was conceived from the very start for its secular, political function. Its iconographic details relating to this function were surely agreed upon in advance between artist and patron, such as the winged helmet of Goliath, a unique feature that served to identify Goliath with the Duke of Milan, and the character of the statue as a free-standing monument. Throughout the Middle Ages, free-standing statues on columns had been abominated as "idols," and none had been produced. In the early years of the fifteenth century, at least in Florence, this thousand-year-old idolophobia was evidently on the wane. Still, Donatello's bronze David, so obviously modeled after a nude classical *ephebos*, exhibits the qualities of an "idol" with such conviction that it must have shocked the more conservative members of the city council. This was an aspect of the work they had not bargained for and that could hardly have been dealt with in the contract. We have, to be sure, no documentary proof for such a reading of the early history

[17] For the ancient sources, see Verena Brüschweiler-Mooser, *Ausgewählte Künstleranekdoten* . . . Ph.D. Dissertation, Bern, 1969 (Zürich, 1973), pp. 7-40; the story about Michelangelo's statues, from Anton Francesco Doni, *I marmi* (Florence, 1552), is summarized in Kurz and Kris, *Die Legende*, pp. 109ff.

[18] For the history of the marble David see Janson, *Donatello*, II, 3-7; the interpretation of the bronze David is based on H. W. Janson, "La signification politique du David en bronze de Donatello," *Revue de l'Art*, fasc. 39 (1978), pp. 33-38.

of the bronze David, but circumstantial evidence tends to bear it out. Despite the severe military and financial crisis that gripped Florence between 1423 and 1428 (among other things, it led to the imposition of the *catasto*, an early ancestor of today's income tax) and continued in less severe form until the death of Filippo Maria in 1447, the bronze David was never put on public display and was eventually acquired by the Medici, probably around 1450, to embellish the center of the courtyard of their new palace. Meanwhile—sometime during the 1430s—Donatello carved a stone statue of *Dovizia* ("wealth"), which stood on a column in the Mercato Vecchio until it was destroyed by lightning in 1721. The appearance of the *Dovizia* is not known in detail, but we do know that it was clothed and a personification, hence less offensive to idolophobes than the bronze David. We are thus tempted to assume that it was commissioned as a substitute for the bronze David. The latter did not achieve its original status as a civic-patriotic monument until after the expulsion of the Medici in 1494, when it became public property once again and was installed in the center of the courtyard of the Palazzo Vecchio. Soon, however, it had to cede its symbolic role to the colossal marble David of Michelangelo. The intervening years—roughly three quarters of a century—not only had wiped out any lingering residues of idolophobia; they also had so fortified the artist's new status that "artistic license" was on the point of being taken for granted.

FOURTEEN

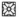

Patterns of Preference: Patronage of Sixteenth-Century Architects by the Venetian Patriciate

⊠

DOUGLAS LEWIS

IN two essays in this volume Charles Hope and H. W. Janson have examined painters' intelligence and sculptors' independence in the Italian Renaissance. I should like here to explore the theme of architects' cooperativeness by examining some of their relations with their patrons. What I propose is to carry the discussion from the artists themselves to those sometimes neglected collaborators whose commissioning and funding were essential to the successive processes of inspiring and producing an actual work of architecture. And I should like to investigate these relationships within one small and self-contained world, that of Venice: first, because its uniquely romantic beauty still sparkles with some reflections of sixteenth-century splendor; and second, because its conservative society poses intriguing questions about architectural innovation and continuation, questions which in a larger state are often difficult to anatomize but which Venice's restricted ambience helps to provide, I think, with some discernible patterns of solution. It takes a long time, unfortunately, to get to know even one family of Venetian Renaissance patrons with anything like adequate thoroughness, and it sometimes seems that a modern lifetime hardly affords the opportunity to proceed very far at all through the registers of the reigning oligarchy in the *Libro d'Oro*. Very much remains to be done, then, before we can even begin to talk about a Venetian index of Renaissance patrons, although this grandiose dream shimmers seductively over the cobwebs of my interminable documentary researches and constitutes one of the reasons I hope to proselytize for a more thorough study of the "tastemakers" of the Serenissima.

Even at the beginning of the sixteenth century such patricians

were sufficiently sophisticated to commission, presumably through a kinsman of the reigning Doge named Andrea Loredan and apparently from the architect Mauro Coducci, the wonderful Palazzo Loredan on the Grand Canal (Figure 14.1), which seems certain to have been completed, after Coducci's death in 1504, by the sculptural and architectural workshop whose effective head was by then Tullio Lombardo.[1] The number of qualifications in my description of this masterwork, whose effect is essentially that neither its patron nor its program, its architect nor its date, are yet precisely determined, emphasizes that even for some of the most sublime creations—by which, as in this case, the architecture of the lagoons rivals or transcends its grandest central Italian parallels—we still have everything to learn.

A more specific personality who may serve to establish our investigations on firmer ground is also one of my favorites, since her best portrait is under my curatorial care in Washington. This is the very determined lady named Agnesina Badoer Giustinian: her bronze portrait in the National Gallery of Art (Figure 14.2) had been much discussed for its uncosmetic directness,[2] but was unidentified until I recognized its terracotta prototype, labeled with her name, in the chapel of the villa that Agnesina built in one of the remoter villages in the Veneto. She is significant in the history of Renaissance patronage because she was the sole heiress of the main branch of just about the oldest family in the Venetian aristocracy and because she used her resulting wealth and prominence to commission at least three capital works of architecture that had a whole series of influences.

The first work was a sculptural memorial to Agnesina's father in the old church of San Francesco della Vigna, with reliefs produced by Tullio Lombardo and his shop during the first decade of the Cinquecento.[3] This first commission of Agnesina Badoer's is a small but impressive ecclesiastical work by the same sculptor/architect who was simultaneously completing the Palazzo Loredan; a slightly

[1] Pietro Paoletti, *L'Architettura e la scultura del rinascimento in Venezia* (Venice, 1893), pp. 187-88; Giovanni Mariacher, *The Vendramin Calergi Palace* (Venice, 1965).

[2] "La Sculpture," in Wilhelm Bode, *La Collection Spitzer* (Paris, 1892), IV, 96-97, 114, n. 15; Bode, *Die Sammlung Oscar Hainauer* (Berlin, 1897), pp. 20-21, 76, n. 101; and Bode, "Two Venetian Renaissance Bronze Busts in the Widener Collection in Philadelphia," *Burlington Magazine*, 12 (November 1907), 86-91.

[3] Anne Markham Schulz, "The Giustiniani Chapel and the Art of the Lombardo," *Antichità Viva*, 16 (March/April 1977), 27-44.

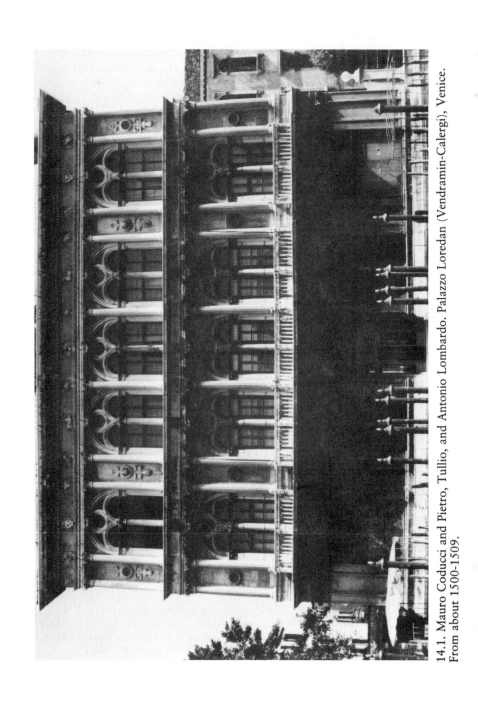

14.1. Mauro Coducci and Pietro, Tullio, and Antonio Lombardo. Palazzo Loredan (Vendramin-Calergi), Venice. From about 1500-1509.

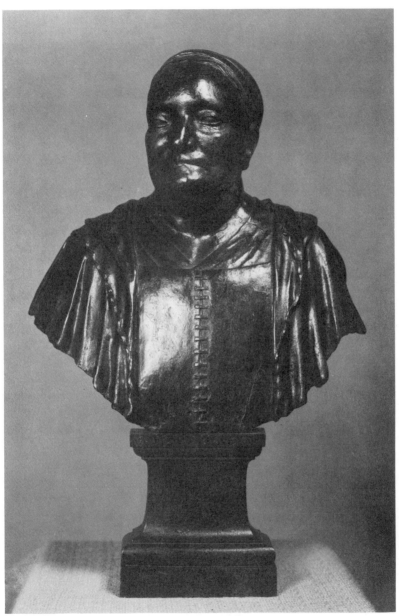

14.2. Venetian School. *Agnesina Badoer Giustinian*. From about 1542.

later, grander production is his beautiful Benedictine abbey at Prag-
lia, and there for a long time Tullio Lombardo's architectural oeuvre
was thought to end. A newly published monograph, however, now
establishes, on the basis of a careful study of its patrons, that the
great castellated manor built at Roncade by Agnesina Badoer and
her husband Girolamo Giustinian (Figure 14.3) may be securely
attributed to Tullio as well; and this highly distinguished master-
work of 1511-13 presents, within its battlemented walls, no less an
innovation than the first free-standing pediment since antiquity to
be found on a domestic building—in other words, a fascinating
blend of medievalizing conservatism and the latest word in revived
antique classicism.[4] Before returning to the third of Agnesina's com-
missions, we might briefly note one of the echoes of Tullio's Ron-
cade design as it influenced a villa commission by a fellow member
of the higher aristocracy. A facade ordonnance closely related to
Roncade's was recreated about fifteen years later in the country
house at Treville, near Castelfranco, built around 1528 by Federico
Priuli (Figure 14.4); but its plan demonstrates interesting connec-
tions with Serlio, then lately arrived in the Veneto from Rome, and
an architect who (at least during the next decade) lived in a house
in Venice belonging to this same patrician.[5] Because of that con-
nection an architectural collaboration on the villa at Treville has
been proposed, with an up-to-date Tusco-Roman plan deriving
from Serlio and a more distinctly Venetian facade perhaps reflecting
the tastes of the patron, as an amateur of architecture. This is
interesting, since Federico Priuli not only came from an ancient
family at Santa Maria Formosa that was fully as influential as Ag-
nesina Badoer's, but Vasari and Ridolfi concur that he decorated
his palace at Treville with fresco figures of saints enframing a relief
Madonna, accomplished respectively by two other recent central
Italian arrivals, Giuseppe Salviati and Jacopo Sansovino. Federico
Priuli's association with Sansovino was long-standing, and with his
joint commission of 1536 for Jacopo's *Carilla* relief at the Santo
in Padua he attests to a connection between that artist and his own

[4] Carolyn Kolb Lewis, *The Villa Giustinian at Roncade* (New York and London, 1977).

[5] C. K. Lewis, "Portfolio for the Villa Priuli: Dates, Documents, and Designs," *Bollettino del Centro Internazionale di Studi di Architettura* (hereafter cited as *Bollettino C.I.S.A.*), 9 (1969), 353-69.

close friends in the Cornaro family.[6] But before turning to them via Agnesina Badoer once more, we should note a specific influence of Federico Priuli's villa on Sansovino's architectural development, especially since it affords a startling example of architectural patronage from an unexpected quarter of Venetian society.

The transitional character of Federico Priuli's villa, bridging the shift in taste from a conservative Venetian image reflecting Tullio to a central Italian freedom and openness of plan, has only been possible to visualize since 1969, when a rare woodcut of its south facade was rediscovered and published (Figure 14.4).[7] We can now augment it as well with a reconstruction of the villa's hitherto unglimpsed north facade (Figure 14.5) making it appear possible that Sansovino may have responded to an unsuspected appeal in this hybrid work when he came to design his famous villa for Alvise Garzoni at Pontecasale (Figure 14.6). The Villa Garzoni is Sansovino's only country house, and it has usually been called purely Roman in conception.[8] Its lower Tuscan loggia opens like Treville's directly onto another overlooking a densely sculptural courtyard; and its interior decoration extends to two exceptionally impressive chimneypieces. The one in the richly vaulted western salon is sustained by two noble masculine figures, while their feminine counterparts in the eastern state chamber bear the unique distinction— unparalleled even by his comparable elements in the Ducal Palace itself—of being individually signed by Sansovino. I think it may be illuminating to offer a couple of observations from the viewpoint of patronage about this maverick masterpiece: first its date, for it is now possible to establish that its patron married in 1539, and I believe he commissioned the palace during his previous ten years' ownership of the property in preparation for that event; and second a clue to its uniqueness, for the truly astonishing thing about Alvise Garzoni is that he was not an aristocrat, not of the patrician class at all, but rather a member of the second order of Venetian society,

[6] Bernardo Gonzati, *La basilica di S. Antonio di Padova* (Padua, 1852-53), I, 103, doc. XCVI.

[7] C. K. Lewis, "Portfolio for the Villa Priuli," pp. 358-61 and plate 133.

[8] Lionello Puppi, "La Villa Garzoni a Pontecasale," *Prospettive*, 24 (1961), 51-62, 84; Puppi, "La Villa Garzoni ora Carraretto," *Bollettino C.I.S.A.*, 11 (1969), 95-112; Puppi, "Minuzia Archivistica per villa Garzoni di Jacopo Sansovino," *Antichità Viva*, 13 (1974), 63-64; and Bernhard Rupprecht, "Die Villa Garzoni des Jacopo Sansovino," *Mitteilungen des Kunsthistorischen Institutes in Florenz*, 11 (1963), 2-23.

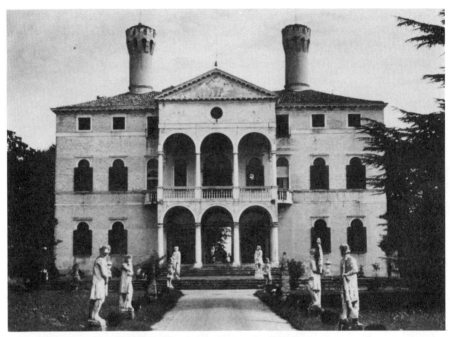

14.3. Tullio Lombardo. Villa Giustinian, Roncade, 1511-13.

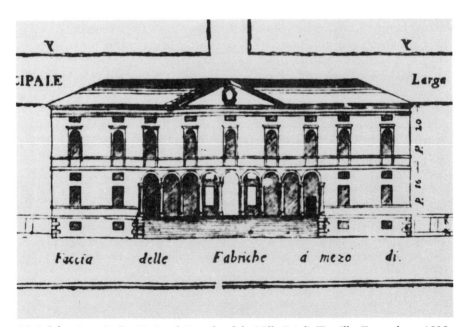

14.4. Sebastiano Serlio (?). South Facade of the Villa Priuli, Treville. From about 1528.

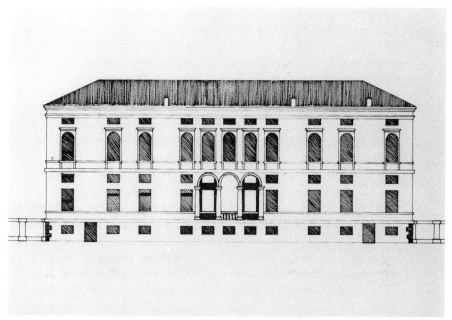

14.5. Sebastiano Serlio (?). Author's reconstruction of the North Facade of the Villa Priuli, Treville. From about 1528.

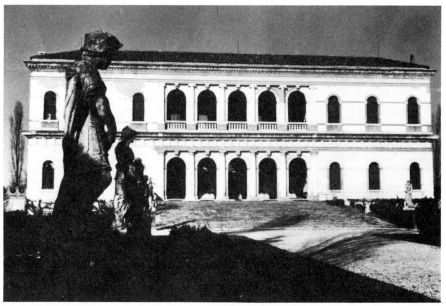

14.6. Jacopo Sansovino. Villa Garzoni, Pontecasale. From after 1539.

a common citizen—albeit a very rich one indeed.[9] The idea of a non-noble citizen putting up a country house substantially bigger, as Vasari observed, than the most prominent public building at Rialto is quite unprecedented.[10] Of course, some middle-level and even minor aristocratic families did erect prominent palaces (such as Sanmicheli's Palazzo Gussoni at S. Fosca), but citizens did not; their architectural pretensions were traditionally expressed through their control of the great charitable confraternities, called the Scuole Grande.[11] Among these latter institutions, for example, the two attracting the most architectural attention in this period were the Misericordia by Sansovino in which the Garzoni were members, and the still richer but more retardative Lombardesque structure of S. Rocco, even more representative of its type—the citizens as a class of patrons evidently supporting an elaborated last gasp of the most conservative architectural style. But it is the very unexpectedness of a more adventurous commission by the Scuola della Misericordia to Sansovino, and a private commission to him from an associated citizen within the same decade, that helps, I think, to explain the anomaly of the vast and imposing palace at Pontecasale, superficially evocative of traditionalist conservative ideas but obviously Romanizing in spirit, which an aspiring citizen millionaire built on his remote Paduan plantation. With respect to Sansovino as a manorial architect, I suspect that the aristocracy demurred, not because of any of various difficulties that have been alleged in the design of Pontecasale, but because of its all-too-clear implications: an unfranchised but very rich commoner turning to a Scuola architect of Tusco-Roman proclivities for a disturbingly

[9] Girolamo Alessandro Capellari, *Campidoglio Veneto*, MSS. Cons., Biblioteca Nazionale Marciana, II, fol. 112ᵛ: "rimase fra Popolari; la cui linea . . . havendo havuto nell'ordine de'Cittadini, alcuni huomini chiari"; Marco Barbaro, *Nozze*, c. 1538ff., Biblioteca Nazionale Marciana, Venice, MSS. Ital. Cl. VII, Cod. 156 (=8492), cc. 87, 207-8, 248; Douglas Lewis, "Some Implications for the Dating of the Villa Garzoni," paper presented at the Titian-Aretino-Sansovino conference, King's College, Cambridge, 18 April 1973.

[10] Giorgio Vasari, "Jacopo Sansovino," *Le Vite de' più eccelenti pittori scultori ed architettori*, ed. Gaetano Milanesi (Florence, 1881), VII, 503: "più largo per ogni verso che non è il Fontigo de' Tedeschi tredici passa."

[11] J. C. Davis, *The Decline of the Venetian Nobility as a Ruling Class* (Baltimore, 1962); Brian Pullan, *Rich and Poor in Renaissance Venice* (Oxford, 1971); Deborah Howard, *Jacopo Sansovino* (New Haven and London, 1975), especially ch. 5. "Charitable Institutions," pp. 96-119.

grand result. So far as we know, Sansovino received no more villa commissions.

In such a context it is interesting that at least one family of more lately arrived and aspiring nobility resorted to the same technique, sponsoring an aggressively avant-garde central Italian style for their country house. I refer to the commission from the Soranzo family to Sanmicheli for their palace of La Soranza near Castelfranco (Figure 14.7); a project also to be dated, from a study of its patronage, at just before or around 1539.[12] In the sharpest possible contrast to these ponderous giants of imported taste, a third villa project from this same year, which returns us to the older nobility through a family we shall soon hear more about, is the lost manor rebuilt by Sanmicheli for Girolamo Cornaro at Piombino. From the documents and some later drawings we know that it probably looked a good deal like the surviving Palazzo Saraceno "delle Trombe" at Agugliaro (Figure 14.8).[13] This is a most instructive contrast: whereas Sansovino at the Villa Garzoni and Sanmicheli at La Soranza were hired around 1539, respectively by rich commoners and the more recent nobility, to produce ostentatiously grandiose essays in a very modern and almost experimental style, Sanmicheli felt obliged, when he obtained in the same year a commission from a prominent and respected member of the older nobility, to produce something apparently as chaste and austere, and as sternly evocative of old-fashioned republican gravity, as the comparable Saraceno house, probably also his, for an old mainland family near Vicenza.

Exactly this same distinction had in fact marked Sanmicheli's career since the moment of his arrival in Venice; this is illustrated by a splendid project discovered not long ago in the Museo Correr (Figure 14.9). Here again a careful study of patrician land ownership provided the means by which this important invention could be recognized, not only as the sole surviving drawing by Sanmicheli, but also as the first evidence for his activity in the Veneto after the Sack of Rome. It represents a projected commission of 1528 for a

[12] Rupprecht, "Sanmichelis Villa Soranza," *Festschrift Ulrich Middeldorf* (Berlin, 1968), pp. 324-32; Puppi, *Michele Sanmicheli* (Padua, 1971), pp. 86, 156, n. 254.

[13] Puppi, *Sanmicheli*, p. 85, and Renato Cevese, *Ville della provincia di Vicenza (Veneto 2)* (Milan, 1971), II, 285-87, for Agugliaro; D. Lewis, "The Rediscovery of Sanmicheli's Palace for Girolamo Corner at Piombino," *Architectura*, 6 (1976), 29-35.

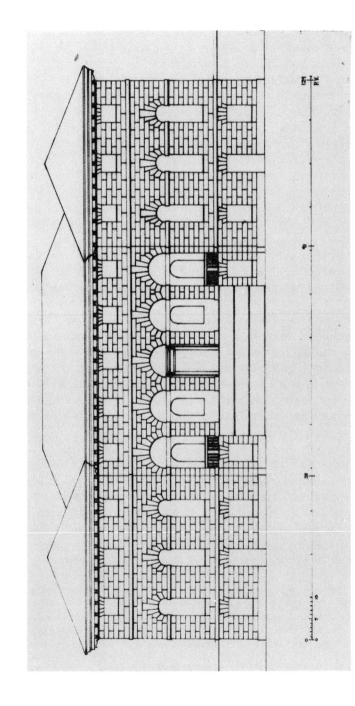

14.7. Michele Sanmicheli. Author's reconstruction of the Villa Soranzo, La Soranza, Castelfranco. From after 1539.

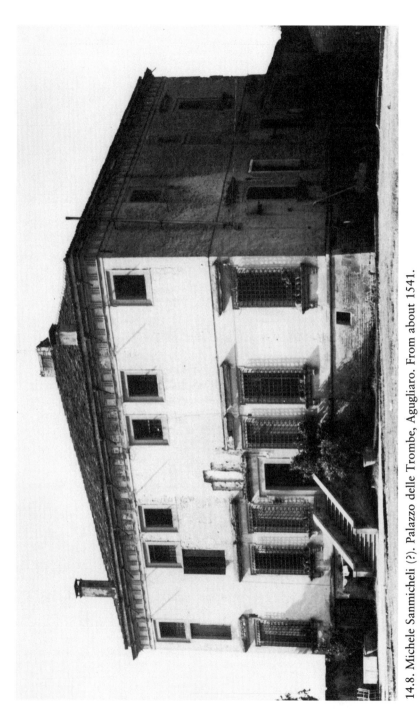

14.8. Michele Sanmicheli (?). Palazzo delle Trombe, Agugliaro. From about 1541.

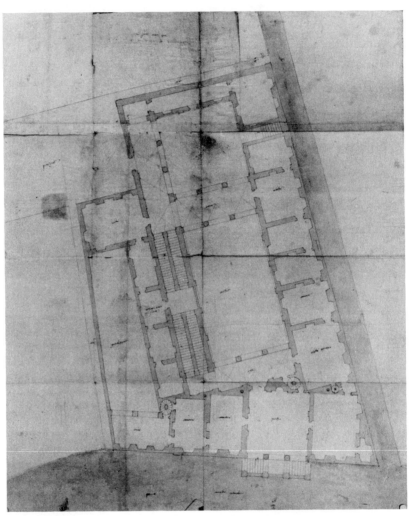

14.9. Michele Sanmicheli. Project for the Palazzo Grimani at the Ca' del Duca, Venice, 1528.

spectacular new palace on the Grand Canal site of the Ca' del Duca, ordered by one of the richest and most distinguished patrons of the Venetian Cinquecento, Vettor Grimani.[14] Although as a Procurator of St. Mark he was one of the men occupying the highest rank in the Venetian state below the Doge (who until 1523 was actually his grandfather), Vettor's more recently ennobled family actually commanded a somewhat less luminous prestige, in Venice's conservative cultural hierarchy, than the Badoer, the Priuli, or the Cornaro. For this reason his precocious patronage of Sanmicheli, only momentarily arrived from the collapse of Clementine papal patronage in Rome and Orvieto, is all the more neatly diagnostic of Vettor's own "papalist" persuasions, his iconoclastic interest in introducing into Venice a radically innovatory architectural style, and Sanmicheli's responding to the importunities of this brash young nobleman by projecting a palace of such weighty Roman grandeur that it would have appeared, if built, as a metropolitan prototype for the same architect's Palazzo Canossa of 1529-31 in Verona, which almost exactly reproduces its unused design.[15] Within a year of its commission, alas, Vettor found other uses for his money than a programmatically extravagant gesture of *Romanità* on the Grand Canal, and he returned to more prosaic lodgings on the top floor of the ancestral Palazzo Grimani at S. Maria Formosa, where he and his brother Zuanne commissioned Sanmicheli to accomplish some tamer remodelings between about 1532 and 1537.[16]

One of the most interesting things about Vettor Grimani's renunciation of his Tusco-Roman project for an ambitious new palace on the Canal Grande is that he abandoned it—as witnessed by his partial sale of the site—in the same week as the death of his wife's father, the Procurator Girolamo Giustinian (Vettor had clearly sought to raise both his rank and fortune by a strategic marriage), and the consequent return to active prominence, as the senior member in this united clan, of Vettor's mother-in-law: none other than

[14] D. Lewis, "Un disegno autografo del Sanmicheli e la notizia del committente del Sansovino per S. Francesco della Vigna," *Bollettino dei Musei Civici Veneziani*, 17 (1972), 7-36, n. 3, 4.

[15] D. Lewis, "Disegno . . . e la notizia del committente," pp. 22-24; Puppi, *Sanmicheli*, pp. 46-57.

[16] Rodolfo Gallo, "Michele Sanmicheli a Venezia, 5: Il palazzo Grimani a Santa Maria Formosa," *Michele Sanmicheli 1484-1559; raccolta di studi . . .* (Verona, 1959-60), pp. 125-29, 157-58.

our former heroine Agnesina Badoer Giustinian, now aged sixty. With characteristic energy Agnesina seems to have conceived almost immediately a scheme to construct a lavish memorial chapel to her father and her late husband, by encouraging Sansovino's rebuilding of her family's local church of San Francesco della Vigna—all by means of attracting to the sponsorship of the project the formidable organizational abilities of her aspiring procuratorial son-in-law.[17] Vettor Grimani (for an inventory recording his commissioning and retention of the models of the church proves definitely that it was he) soon made San Francesco the most highly visible campaign in the private sector of Venetian architecture, and the resulting building (Figure 14.10) and its documents form a gold mine for the student of patrician patronage.[18] It has consistently been maintained—though with only desultory enthusiasm—that the new Doge Andrea Gritti must have been the moving force behind the project, because he lived nearby, laid the cornerstone, and paid 1,000 ducats to be buried in the chancel. But he was, after all, a very close political associate of Vettor Grimani's, and we may find it far more indicative that Agnesina Badoer on one side and her husband's relations on the other obtained title to the two best new chapels, flanking the high altar; that her brother-in-law Lorenzo Giustinian bought a neighboring chapel at the junction of the nave and transept; that two of her sons-in-law also acquired nave chapels (the Grimani being typically a little too ostentatious in their insistence on a lavish central Italian decoration for theirs); and that the monks of San Francesco actually ceded to the Grimani, *gratis*, both the interior facade wall and the whole exterior facade, as settings for that family's personal and Ducal tombs.[19] Some seven years after Vettor's death in 1558 his brother Zuanne Grimani commissioned Palladio to complete the church by adding the celebrated facade, so different from Sansovino's (and Vettor's) intended model.[20] But this anticipates our story, for the first collaboration on San Francesco actually initiated the long partnership by which Vettor Gri-

[17] Lewis, "Disegno . . . e la notizia del committente," p. 27.

[18] Lewis, "Disegno . . . e la notizia del committente," pp. 25ff.

[19] Ibid.; D. Lewis, *The Drawings of Andrea Palladio* (Washington, D.C., 1981), pp. 186-87.

[20] Rudolf Wittkower, "The Genesis of an Idea: Palladio's Church Facades," *Architectural Principles in the Age of Humanism* (New York, 1971), pp. 89-97; John Sparrow, *Visible Words: A Study of Inscriptions (The Sandars Lectures for 1964)* (Cambridge, 1969), pp. 41-48. The facade can be dated no more accurately than ca. 1565-70, since Vasari during his visit to Venice in 1566 saw only its base or pedestal zone in place: Milanesi, ed., *Vite,* VII, 529-30.

14.10. Jacopo Sansovino and Andrea Palladio. S. Francesco della Vigna, Venice. From after 1533 and about 1565-70.

mani and Jacopo Sansovino—as patron and *proto* in the Procuracy of St. Mark—jointly contributed four more primary works in the state-supported campaign to embellish the city center: the Library and Loggetta, the church of S. Geminiano at the head of the Piazza, and the wonderful Scala d'Oro in the Palazzo Ducale, long seen as one of the tangible results of Vettor's embassy to the Court of France in 1547.[21]

Another foreign embassy, on which the resplendent Daniele Barbaro left for England in 1549, leads us by a particularly interesting episode into the patronage of Andrea Palladio, by far the most prolific sixteenth-century architect of the Venetian and Venetan patrician landowners. Palladio's metropolitan success must have had a good deal to do with his close friendship with Daniele Barbaro, as the preeminent Venetian humanist of his day: by the date of Daniele's commission for his new country house at Maser he had probably already known Palladio for about ten years, first in the university ambience at Padua, and then even more intimately in their collaboration, throughout the later 1540s, on the commentaries and illustrations of the great *Vitruvius* edition that they published jointly in the next decade.[22] In late April of 1549 Daniele's father died, apparently in the old house at Maser; since this event (as it did so often) provided the catalyst for his son's commission of a new villa and since Daniele left in early June for England, we can postulate that Palladio's first sketch for this famous work (Figure 14.11) is probably therefore to be dated to the intervening month of May; after Daniele returned in 1551 it was substantially revised in execution (Figure 14.12), but it remains one of Palladio's very few designs to survive in successive projects, and the only one for which we have, thanks to the testimony of its patronage, such an unusually precise date of inception.[23]

One of the clearest benefits from the study of architectural patrons can be demonstrated through the country house commission that

[21] Manfredo Tafuri, *Jacopo Sansovino* (Padua, 1969), pp. 84-86; with previous literature.

[22] D. Lewis, "Introduction to the Patronage of Palladio's Works in Domestic Architecture," paper presented at the Folger Institute's Washington Renaissance Colloquium, Washington, D.C., April 1972, pp. 9, 17.

[23] D. Lewis, "Disegni autografi del Palladio non pubblicati: le piante per Caldogno e Maser, 1548-1549," *Bollettino C.I.S.A.*, 15 (1973), 369-79. Howard Burns, in the Palladio Symposium at Wuppertal-Elberfeld in November 1980, announced the discovery of a second preliminary project for Maser—one that is now lost, but preserved in a copy drawing by John Webb at Worcester College, Oxford.

14.11. Andrea Palladio. Preliminary Sketch Project for Villa Barbaro, Maser, 1549.

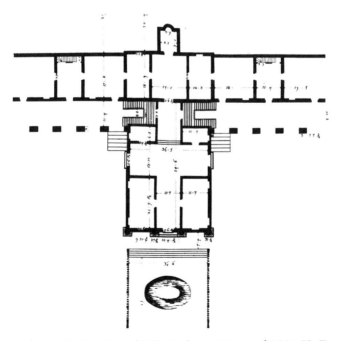

14.12. Andrea Palladio. Plan of Villa Barbaro, Maser, of 1551-58. Engraving.

Palladio received from the Cornaro family; and this relationship is particularly interesting since two other branches of the same clan were simultaneously erecting colossal new city palaces to the designs respectively of Sansovino and Sanmicheli. These grandiose residences in ultra-modern style were both being constructed on the sites of older ancestral palaces that had recently burned, by younger cadet members of this powerful and extended family. Its senior member, in the decade of the 1540s preceding our Palladian commission, lived in a famous old palace that had formerly belonged to his aunt the Queen of Cyprus, and he could therefore remain indifferent to his brothers' ostentatious pursuits of current architectural fashion.[24] This was Girolamo Cornaro, a senator of old-fashioned military virtue: as a prominent member of the Council of Ten it had been his constant association with Michele Sanmicheli on official fortification projects that, as a reflection of his own taste, had encouraged him to order from the same architect the unusually sober rebuilding of his country house at Piombino. When Girolamo Cornaro died early in 1551 his elder son Andrea claimed that handsome structure by right of primogeniture, but he was uninterested in using it; while his younger brother Zorzon, who was devoted to the estate, could get no more than title to half the park, which he promptly used as the site for a major new commission to Palladio (Figure 14.13).[25] After a long period of neglect, his father's palace by Sanmicheli descended to the Emo family and was demolished in the eighteenth century;[26] but Zorzon's beautiful Palladian villa still stands at Piombino, and its character can only fully be appreciated through an understanding of its exceptionally competitive siting and the special aims of its patron. To compete with the bulk of the Sanmicheli palace pressing against it (whose role as a generating predecessor has not previously been realized, since the unique images of it come from maps that have just been rediscovered

[24] R. Gallo, "Michele Sanmicheli a Venezia, 2: I Corner ed i loro palassi," pp. 112-18, 154-56. For Sansovino's Palazzo Corner della Ca'Grande at S. Maurizio (of 1545-66), see Howard, *Sansovino*, pp. 138-40; for the dating of Sanmicheli's Palazzo Corner at S. Polo to 1555-64, see D. Lewis, "Sansovino and Venetian Architecture," *Burlington Magazine*, 121 (January 1979), 41.

[25] D. Lewis, "La datazione della villa Corner a Piombino Dese," *Bollettino C.I.S.A.*, 14 (1972), 381-93.

[26] The demolition apparently occurred from about 1772 to 1778: Puppi, "Novità per Michele Sanmicheli e Vincenzo Scamozzi appresso Palladio," *Storia dell'Arte* 26 (1976), 16-18; and D. Lewis, "The Rediscovery of Sanmicheli's Palace," p. 35.

14.13. Girolamo Tomasoni. Map of Piombino of 1707 with Palazzo Cornaro by Sanmicheli of 1539 on the right and Palazzo Cornaro by Palladio of 1551 on the left.

through a search of the family archives), Palladio decided on an exceptional height, which he articulated with two unusually tall loggias of superimposed colonnades; and the entrance front toward the village he embellished with a pair of long wings lighted with round-headed windows, with a projecting double portico whose superimposed loggias are crowned with a high pediment (Figure 14.14).[27] All these devices, for Palladio, are new at Piombino, which through its many parallels and echoes is in fact Palladio's most influential early commission from the Venetian aristocracy. Considering that this house is one that established an enduring image of the Venetian villa, and one that brought Venetian patrons back from their flirtations with Mannerist experiments to the achievement of a persuasive indigenous style through an imaginative re-creation of antique practicality, it is fascinating to realize that its architect's model was none other than the precocious masterpiece at Roncade that Tullio had designed forty years before for Agnesina Badoer Giustinian (Figure 14.3). Or rather, perhaps, its patron's model: for here I feel that Venetian Cinquecento domestic architecture comes full circle. The elegantly pragmatic classical style that Agnesina and Tullio had adumbrated at Roncade was reestablished, through Palladio's work at Piombino for Zorzon Cornaro—a conscious proponent of old-fashioned virtues of landed proprietorship, using the same iconographic associations of antique republican simplicity—as the dominant mode for serious domestic architecture throughout the century. I think we can now begin to understand why Zorzon's hitherto unexpectedly close associates Alvise and Nicolò Foscari asked Palladio to use a plan prototype for Piombino at their famous villa called the Malcontenta (Figure 14.15).[28] We can also understand how the Foscari's single story of twin suites intended for two bachelor brothers had to be expanded—Zorzon, significantly, celebrated his marriage in the year of Piombino's completion—to accommodate not only the patron and his bride, but the enormous retinues of servants and friends who followed their every sojourn to the country.

[27] "Program and Image in the Planning of Zorzon Cornaro's Republican Manor House," in D. Lewis, *The Villa Cornaro at Piombino (Corpus Palladianum 9)* (Vicenza and University Park, Pa. in press).

[28] D. Lewis, "The Social Context and Sequence of Palladio's Projects around 1550," *The Villa Cornaro*; D. Lewis, "Introduction to Patronage," pp. 18-20; Puppi, *Andrea Palladio* (Milan, 1973), pp. 128-35, 328-30.

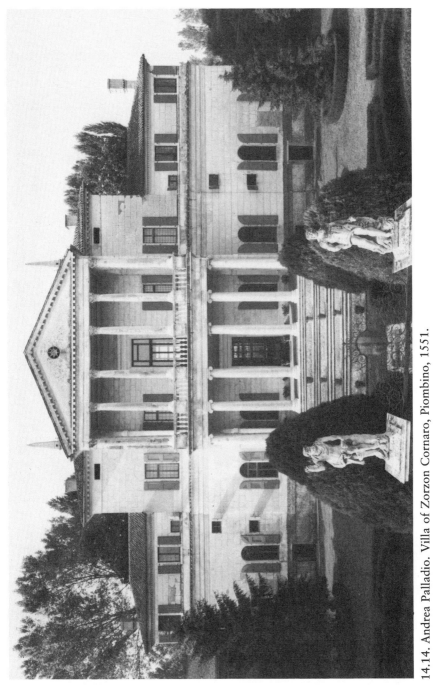

14.14. Andrea Palladio. Villa of Zorzon Cornaro, Piombino, 1551.

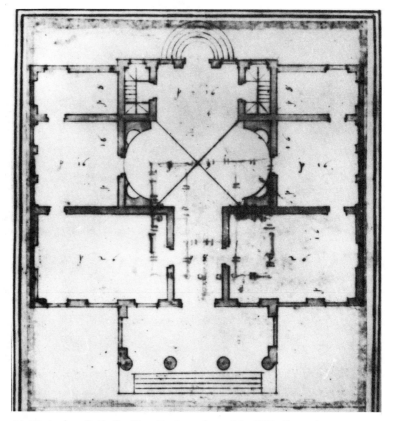

14.15. Andrea Palladio. Plan Project adapted for Villa Foscari,
Malcontenta. From about 1547-48.

The tightly-knit network of the Cornaro and Foscari families'
cultural and political associates, whose aesthetic concurrence in-
sured Palladio's preferment around mid-century as the fashionable
domestic architect of a highly visible and influential Venetian es-
tablishment, even extended into the next generation to govern the
collaboration of the patrons' and Palladio's heirs. A substantial
number of Palladio's buildings were completed by his principal
successor Vincenzo Scamozzi, beginning in the year of Palladio's
death with the Teatro Olimpico and extending to the famous Villa

Rotonda, where Scamozzi not only redesigned and executed the dome, but built a large service building beside the entrance.[29] Here again I think the evidence of patronage is important, for Zorzon's son Girolamo Cornaro, who had encountered Scamozzi through an assignment as Governor of Vicenza, had commissioned from him both a comparable stable building and a parallel completion of the upper portions of the villa at Piombino. Through these and other commissions, as well as his own political eminence, he seems certain to have been instrumental in furthering the enormous vogue of Scamozzi's even drier Palladian classicism among the conservative Venetian aristocracy.[30] In the fourth quarter of the sixteenth century almost all of the oldest Republican families commissioned projects from Scamozzi. And although these are mostly very dull— as is, for example, his villa for the Contarini at Loreggia (Figure 14.16)—a happier fate befell the descendants of these same patrons, in discovering by the close of our hundred-year trajectory, at the moment of Scamozzi's death in 1616, that one of his pupils was emerging as a brilliant young designer destined to revolutionize Venetian architecture. This was Longhena, who reshaped the legacy of Sanmicheli, Sansovino, and Palladio with a dynamism that soon came to rival the Roman masterworks of his great contemporary Bernini. This youngster was providentially first patronized by a recently created knight of the same Contarini family that had just commissioned Scamozzi's villa at Loreggia and a large metropolitan palace to build a new country house on the Brenta (opposite an older Contarini villa at Mira)—now, alas, smothered by a soap factory. The dramatic windmill plan of radiating wings that this eighteen-year-old prodigy produced for that crusty old cavaliere assured his instant notoriety among our familiar patrician elite (Figure 14.17).[31] It therefore comes as no surprise that it was our early Scamozzi supporter, Zorzon Cornaro's son, now the Cavalier and Procurator Girolamo, who, as a senatorial commissioner, shortly afterward obtained the appointment of "Architect of Santa

[29] Puppi, *Palladio*, pp. 188-95, 226-30, 380-83, 435-39. See also Camillo Semenzato, *La Rotonda di Andrea Palladio (Corpus Palladianum 1)* (Vicenza and University Park, Pa., 1968).

[30] D. Lewis, "Girolamo II Corner's Completion of Piombino, with an Unrecognized Building of 1596 by Vincenzo Scamozzi," *Architectura*, 7 (1977), 40-45.

[31] D. Lewis, "Baldassare Longhena," *Arte Veneta*, 27 (1973), 329.

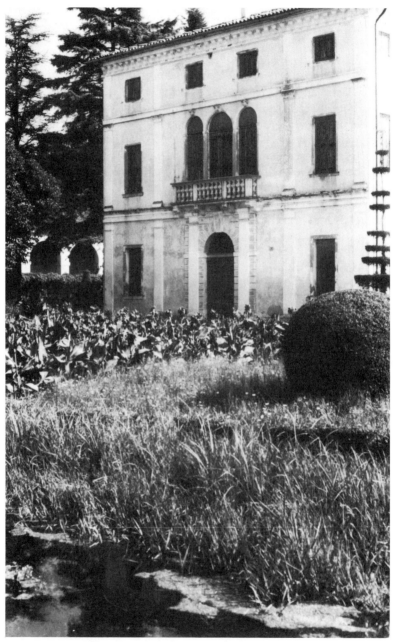

14.16. Vincenzo Scamozzi and others. Villa Contarina, Loreggia. From about 1600 (?).

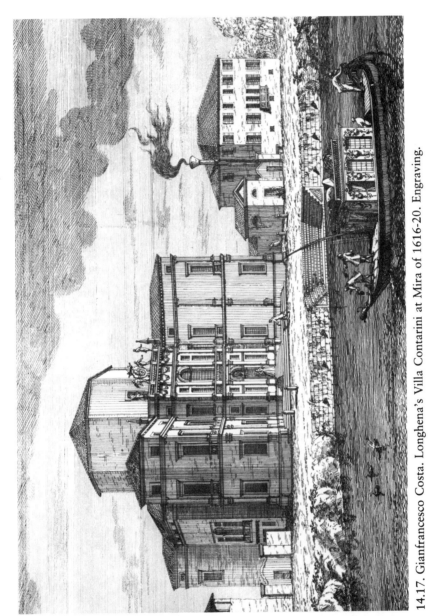

14.17. Gianfrancesco Costa. Longhena's Villa Contarini at Mira of 1616–20. Engraving.

Maria della Salute" for Baldassare Longhena.[32] In so doing, he not only launched the official career of Venice's greatest native architect, but endowed the city itself, whose architectural fortunes his own family had so profoundly influenced, with its most memorable and evocative masterpiece of all (Figure 14.18): the Republic's thanksgiving for the intercessory patronage of the Queen of Heaven.

[32] Wittkower, "S. Maria della Salute," *Saggi e memorie di storia dell'arte*, 3 (1963), 34.

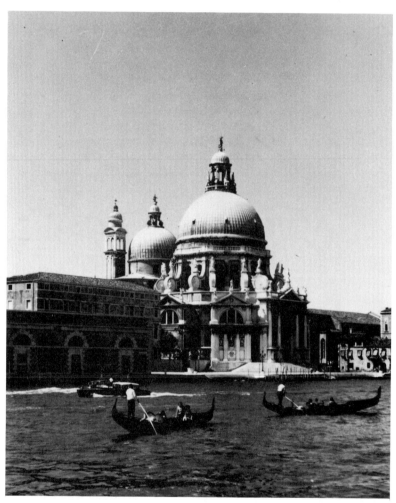

14.18. Baldassare Longhena. S. Maria della Salute, Venice. From after 1630.

BIBLIOGRAPHIC NOTE

Subjects do not remain static. Since the Folger conference, there have been at least two major gatherings devoted to Renaissance patronage: "The Culture of European Courts in the Sixteenth and Seventeenth Centuries" in Wolfenbüttel, West Germany, 4-8 September 1979, and "Court Patronage and the Arts" in Columbus, Ohio, 22-23 February 1980. While scholars have awaited publication of the proceedings of these meetings and of the many works-in-progress discussed at the final seminar of the Folger conference, a number of other studies have appeared. Although the following list is intentionally limited, each work makes a notable contribution to the interdisciplinary study of patronage in the age of the Renaissance: A. G. Dickens, ed., *The Courts of Europe: Politics, Patronage and Royalty, 1400-1800* (London, 1977); H. R. Trevor-Roper, *Princes and Artists: Patronage and Ideology at Four Hapsburg Courts 1517-1633* (London, 1976); D. Kent, *The Rise of the Medici* (Oxford, 1978); F. W. Kent, *Household and Lineage in Renaissance Florence* (Princeton, 1977); C. D. Ross, ed., *Patronage, Pedigree and Power in Later Medieval England* (Gloucester, 1979); A. Newcomb, *The Madrigal at Ferrara, 1579-1597* (Princeton, 1979); M. B. Hall, *Renovation and Counter-Reformation: Vasari and Duke Cosimo in Sta. Maria Novella and Sta. Croce, 1565-1577* (Oxford, 1979); M. Heinemann, *Puritanism and Theatre: Thomas Middleton and Opposition Drama under the Early Stuarts* (Cambridge, 1979); C. C. Christensen, *Art and the Reformation in Germany* (Athens, Ohio, 1979); R. Goldthwaite, *The Building of Renaissance Florence* (Baltimore, 1980); D. C. Price, *Patrons and Musicians of the English Renaissance* (Cambridge, 1981); C. H. Clough, *The Duchy of Urbino in the Renaissance* (London, 1981); M. M. Bullard, *Filippo Strozzi and the Medici: Favor and Finance in Sixteenth-Century Florence and Rome* (Cambridge, 1980); I. Fenlon, *Music and Patronage in Sixteenth-Century Mantua* (Cambridge, 1981); H. G. Koenigsberger, "Republics and Courts in Italian and European Culture in the Sixteenth and Seventeenth Centuries," *Past and Present*, 83 (1979), 32-56; and the reissue of the book that inspired much of the current interest in patronage, Francis Haskell's *Patrons and Painters*, rev. ed. (New Haven, 1980). There are two very useful collections of translated source material: C. E. Gilbert (ed.), *Italian Art, 1400-1500* (Englewood Cliffs, 1980); and I. Fenlon (ed.), *Music in Medieval and Early Modern Europe: Patronage Sources and Texts* (Cambridge, 1981). Patronage studies have always been

381

informed by parallel literature in sociology and anthropology: for the most recent theoretical study, with copious references, see S. N. Eisenstadt and L. Roniger, "Patron-Client Relations as a Model of Structuring Social Exchange," *Comparative Studies in Society and History*, 22 (1980), 42-77.

G.F.L.

INDEX

Index

Index

LIBRARY OF CONGRESS CATALOGING IN PUBLICATION DATA

Main entry under title:

Patronage in the Renaissance.
 (Folger Institute essays)
 Bibliography: p.
 Includes index.
 1. Renaissance—Congresses. 2. Art patronage—
Europe—History—Congresses. I. Lytle, Guy Fitch,
1944- . II. Orgel, Stephen. III. Series.
CB361.P27 940.2′1 81-47143
ISBN 0-691-05338-3 AACR2
ISBN 0-691-10125-6 (lim. pbk. ed.)